STUDIES IN
SEICENTO ART AND THEORY

DENIS MAHON

STUDIES IN
SEICENTO ART AND THEORY

GREENWOOD PRESS, PUBLISHERS
WESTPORT, CONNECTICUT

ERRATA

Page 82, line 7 of text. Read " nobiltà " instead of " nobilità."

Page 130, line 6 of notes. Read " borne " instead of " born "

Page 180, line 4 of text. Read " a batch of four letters " instead of " a batch of five letters."

Page 180, line 2 of note 55. Read " pp. 509-519 " instead of " pp. 509-520."

Page 291, line 2 of note 31. Read " *Bescheiden in Italië* " instead of " *Bescheiden in Itali".* "

Originally published in 1947
by The Warburg Institute,
University of London, London

First Greenwood Reprinting 1971

Library of Congress Catalogue Card Number 73-114544

SBN 8371-4743-3

Printed in the United States of America

To my Mother
and in memory of my Father

CONTENTS

LIST OF ILLUSTRATIONS

INTRODUCTION[1]

GUERCINO's style underwent a remarkable *volte-face*. The writer was primarily interested in discovering why this occurred, and became involved, during the course of his investigation, with certain aspects of Seicento art theory: hence the rather disjointed shape of this book. The Introduction, by giving some account of its genesis and scope, seeks to enlist the tolerance of the reader towards its unusual form.

*　　　*　　　*

Before committing himself to an appraisal of the relative quality of a particular work of art, it is incumbent upon the art-historian to make a serious effort to satisfy himself that he is in fact seeing it at all—seeing it, that is to say, as nearly as possible in the way in which its creator saw it; for unless he attempts this there is always a danger that his criticism will be open to the damaging accusation of inapplicability. One of the most obvious prerequisites to any genuine interpretation and judgment is familiarity with the general methods of expression which were available to the individual artist concerned. These qualitatively neutral constituent elements of a work of art are simply part of the given framework within which the artist had

[1] I am greatly indebted to Professor Fritz Saxl, Director of the Warburg Institute, for his encouragement at a difficult moment during the writing of this book and for his comments upon it, to Dr. Otto Kurz, Assistant Librarian at the Institute, for his interest, advice and assistance on many occasions, and to Dr. Rudolf Wittkower for the very great trouble he took in smoothing my path into print. I also owe a very special debt of gratitude to Dr. Jacob Hess, whose exemplary edition of Passeri will be familiar to all serious students of the Seicento, and who is now engaged in the preparation of a critical edition of Baglione which will certainly prove indispensable to them; in the course of this work Dr. Hess has acquired a profound and enviable knowledge of the Seicento *ambiente* from which I have greatly profited in innumerable casual conversations.

to operate, the mere grammar and syntax through which he had to speak: yet in order to distinguish the poetic spirit and achievement the tongue in which they are embodied must be fully understood.

If we are concerned with the given materials (or more exactly, vehicles of expression) which a Seicento artist was likely to find ready to his hand, we shall probably have to take into consideration those two opposed stylistic languages the baroque and the classic—we are using the terms more or less in the Wölfflinian sense. Wölfflin's contrast in *Kunstgeschichtliche Grundbegriffe* between the predominantly classic High Renaissance and the predominantly baroque Seventeenth Century was perfectly legitimate, but the antithesis is of course at bottom the perennial one between form and colour, the plastic and the pictorial, the tactile and the optical, and so on, almost indefinitely: both opposites are present everywhere, only the one may tend to play a relatively more important part than the other in a particular period, place, or artist. Nevertheless, even though we may not accept all Wölfflin's conclusions, it is usually agreed that his subtle analyses brought into existence clearer and more sensitive methods for the investigation and discussion of those questions of language which are common to large groups of artists, whether good, bad, or indifferent: thus his general classifications (as he was careful to point out) were in no way to be regarded as carrying, in the abstract, any inherent qualitative connotation.

The fact that one mode of artistic expression in this general sense could not be better or worse *per se* than another has not always been as obvious as it may seem to us to-day. Art criticism has, during the greater part of its history, laboured in varying forms under the delusion that artists who expressed themselves by means of some specific stylistic language must be *a priori* and collectively good or bad just because they did so.[2] The fallacy was much to the fore during the Seicento, with the addition of a further complication: a fundamental discrepancy between

[2] The whole theory of "the progress of art" was based upon a misapprehension of this nature.

art and theory. Though the prevailing artistic language was the baroque, the predominant trend in art theory was strongly accentuated in the opposite direction, towards the classic.[3] That is the particular background with which it is necessary to be familiar in order to understand the somewhat unusual phenomenon of Guercino's change of style.

The present book originated as an attempt to throw light on why this change took place. At first sight we might appear to be faced by an art-historical problem of routine type, to be tackled by the normal method, the investigation of potential influences from the paintings of other artists. In dealing with Guercino, however, such a line of approach, though by no means fruitless, does not by itself yield a really satisfactory or comprehensive solution. The transformation which his artistic language underwent was of a very drastic nature, since it amounted to a most categorical shift of emphasis between our two ever-present opposites. In modifying the baroque style of his early years Guercino does in fact approach more closely to the classic point of view of the majority of the theorists. Moreover, when looking at his late works we feel some doubts as to whether he was altogether comfortable in expressing himself in a more classic fashion: his natural instincts seem at odds with his more reasoned convictions. In view of this, should we not seek the ultimate origin of the change in words as much as in strokes of the brush? That is the question with which we are concerned in Part I.

Obviously the difference in style as we analyze it to-day in the paintings cannot and does not correspond at all exactly in form with the contrast as we find it reflected in Seicento theory, where it carries a qualitative connotation and is closely related to a particular literary background. The essential source or core of any genuine criticism of art was of course the same in the Seicento as it is now: a matter of instinct in relation to an individual work of art. But the theoretical framework into

[3] Naturally there were appreciable minority tendencies in both fields. We may cite the mature Poussin among the artists, and Scannelli and (above all) Boschini among the writers.

which this criticism had to be fitted (and by means of which it has been transmitted to us) was naturally quite different then, because the given means of expression were different. As in the case of a work of art, we do not find a critical standpoint springing up without any roots in the past. And, since art theory has a history of its own, it was no more possible for a writer on art during the Seicento to express himself after the fashion of a Wölfflin than it was for a primitive to use his brush in the manner of a Rubens.

The fact that the raw materials of art theory can have an historical pedigree of their own, that a principle, a concept, or an expression can persist for centuries, undergoing transformation and re-interpretation, yet always retaining some connexion with its past in spite of its association with the contemporary scene, was demonstrated in a masterly way by Dr. Panofsky.[4] Now it so happens that the particular critical tradition with which he was concerned in his study is the one with which the young Guercino clashed. As a consequence, our treatment in Part II of its individual representative in Guercino's time (Giovanni Battista Agucchi) involves the insertion of the good Monsignore into his proper position, as the precursor of Bellori, within the general scheme elaborated by Dr. Panofsky. Though we are of course dealing with the classic-idealist theme in a somewhat different and narrower context from that of Dr. Panofsky, acknowledgment of his valuable work is called for here and is most gratefully made.

These essays on Guercino and Agucchi are studies of certain works of particular individuals in relation to their background, rather than of the background itself as illustrated by individual examples. We are not dealing, as our primary objective, with the history of a particular critical *cliché*; our real concern is not a general trend in the history of art theory but the precise

[4] Erwin Panofsky, "*Idea*," *ein Beitrag zur Begriffsgeschichte der älteren Kunsttheorie* (Studien der Bibliothek Warburg, V), Leipzig/Berlin, 1924. An important study on rather similar lines was that of Professor Rensselaer W. Lee ("*Ut Pictura Poesis*: the Humanistic Theory of Painting," in *The Art Bulletin*, XXII, 1940, pp. 197-269).

character of the interrelation of art with theory in certain specific cases. And perhaps our approach from the point of view of the individual may be justified as a necessary reaction against that type of generalization which has led to so much misunderstanding with regard to the Seicento in the past, and of which we shall meet with some examples in our two concluding essays. We hope it will be apparent from Parts III and IV that if Federico Zuccaro and Annibale Carracci had been thoroughly investigated as individuals, and their convenient traditional labels had not been so frequently taken for granted, much confusion would surely have been avoided: both Zuccaro as the leader of an "academic" opposition to Caravaggio, and, even more, Annibale as the learned propagator of the so-called "eclectic" theory would have been recognized as figures of straw whose semblance of reality was largely due to the fact that they fitted so conveniently into a preconceived general picture.

In our examination of the Agucchi-Bellori phase of the classic-idealist theory we shall not only have had occasion to note the toughness of the literary tradition, but also the fact that the relative cogency and consistency with which the theory was expounded is largely due to its exponents having been laymen, experienced *letterati* with antiquarian orientations, or, if artists, principally minor ones with literary tendencies.[5] And no doubt the strength which it drew from its backbone of learning had a great deal to do with its survival in spite of divorce from the prevailing artistic language of the day, the baroque. Still, there was a minority of artists of some importance whose style roughly corresponded with it. Besides, interchangeability is often assumed between the expressions "classic theory" and "academic theory," with the possible implication that it was the professed doctrine of "academicians" and was taught in Academies. In view of these facts, are we to regard it as a

[5] We are referring, of course, to the Seicento. In the next century the theory is made use of by Reynolds, but we observe that, in the hands of a considerable artist endowed with a fund of common sense, it is purged of much that is artificial and merely traditional.

practical theory of working artists as much as one of *dilettanti*
and *letterati*? Accordingly the question is posed of the precise
character of its relationship to art. Does it precede art, or
follow it? Does it play the part of a positive guiding principle
for art, or was its fundamental nature rather that of a literary
rationalization derived from art?

That is the problem which we turn to next, reaching the
conclusion that the theory did not take root in the principal
Academies until comparatively late in the Seicento and that
the role which it then played did not have any very marked
effect on art. In other words, the theory was above all literary
and interpretative rather than artistic and creative.[6] But (and
this is the main theme of Part IV) the reverse has often been
assumed to be the case, with the result that misunderstanding
of the true character of the theory has led to a misreading of
the type of art which it originally sought to interpret. The
summit of confusion is reached with the alleged eclectic pro-
gramme of the Carracci. The documentary basis for the sup-
position that the "doctrine" was advocated by those three
particular individuals is entirely inadequate, as we shall see,
and the fantasy itself can only be described as a Seicento theory
by an excess of courtesy. Yet, after receiving an impressive
baptismal name in the Settecento, and acquiring popular
"scientific" status during the last century, it has become a sort
of rooted obsession. The wholesale swallowing of these mis-
judged interpretations of the past has unfortunately occurred
again and again with really surprising lack of critical acumen.[7]

[6] There are (it may be taken for granted with due gratitude) exceptions
to every generalization or rule in artistic matters, so we must not be accused
of suggesting that the theory had *no* effect on art, more especially as our
study of Guercino attempts to assess the extent to which it did in fact influence
the brush in his particular case; another possible example is Domenichino
(cf. note 11 of Part IV); very likely further instances can be cited, particu-
larly in France. But that does not entail any alteration of our view as to
the essential character of the theory, and the consequently rather limited
scope (despite its literary success) of its genuine influence on art. Poussin,
we may feel, would not have been substantially different if he had never
met Bellori.

[7] This lack of critical acumen is not confined to interpretation of works

The deplorable consequence is that, in approaching the art to which they refer, we are liable to find ourselves in a position of comparative illiteracy. And how can any qualitative judgment which is largely coloured by a questionable interpretative reading escape the awkward charge of mere irrelevance?

* * *

As has been inferred, the arrangement of the book is not such as to encourage generalizations. This is intentional, for in the writer's opinion we have reached a stage in the study of Seicento painting when the outlines established during the past thirty years should be filled in—and, where necessary, modified—by the detailed examination of particular problems. But such an approach unfortunately entails two disadvantages from the point of view of the reader.

The first is that the necessary documentation becomes proportionately heavier as the field narrows: statements of fact

of art but extends to the handling of the written sources as well. As an example of a type of treatment which is all too rare in dealing with Seicento sources, we may cite Mr. Anthony Blunt's excellent article on the true character of Poussin's notes on painting (*Journal of the Warburg Institute*, I, 1937-38, pp. 344-351). These notes, published by Bellori, had long been regarded as genuine and independent compositions by Poussin (whether treated with awe as the sibylline books of classicism, or dismissed as the chaotic and ill-considered literary aberrations of a great painter), whereas they are, as Mr. Blunt convincingly demonstrates, in great part notes by Poussin on his reading; as with the sad story of the "eclecticism" of the Carracci, the disproportionate attention paid to them was due to an uncritical and unimaginative attitude towards the printed word. Perhaps we may point out that a passage in a letter of 29 May 1679 from André Félibien to the Abbé Claude Nicaise (*Archives de l'Art Français*, I, 1851-52, pp. 12 f.) seems to fit in excellently with Mr. Blunt's conclusion. In this letter Félibien acknowledges receipt of a letter from Nicaise "laquelle estoit accompagnée de celle du seig. Bellori," and continues "J'ay esté bien aise d'aprendre ce qu'il vous escrit des memres que M. Poussin a laissez, qu'aparament il n'avoit faits que pour son instruction." Félibien adds that he is just about to work on the section of his *Entretiens* which was to include the life of Poussin, and it seems perfectly plausible that he got Nicaise to enquire from his (Nicaise's) friend Bellori just what the significance was of the notes published by the latter seven years previously.

become more frequent, and the precise sources on which they rest must be specified. The reader who is persuaded by the arguments put forward in the text will not require to devote much attention to the footnotes; but he will perhaps concede that the evidence must be available for the information of the reader who does not so agree. The second disadvantage is that certain terminological definitions must be made especially clear, the more so because of the misleading part formerly played by loose terminology in Seicento studies. Hence the somewhat lengthy analyses of particular paintings, which, if their purpose is misconceived, will very likely appear pedantic. Many readers —the majority, it is to be hoped!—will soon grasp the particular sense in which the terms baroque and classic are to be employed, and they may be well advised to skim very quickly through these analyses. Nevertheless, the fact that the two expressions can have so many different shades of meaning makes the avoidance of merely verbal misunderstandings an important consideration: so important, indeed, for our thesis that we have ventured to trespass in this respect on the forbearance of our readers, who, we trust, will accept our explanation as a valid apology.[8]

[8] For some remarks on the general scope, from the art-historical point of view, of the terms which we propose to employ for broad classifications of style, see note 90 of Part I. It is unfortunate, though unavoidable, that various expressions commonly used to bring out particular aspects of a style are necessarily ambiguous if divorced from their context. To take a single example, if the adjective "plastic" is applied to the forms in a *painting*, the idea conjured up is one of static solidity, and consequently of classicism. If on the other hand the term is applied to *architecture* it changes colour and conveys the precise opposite—dynamic flexibility, movement of a not very obviously controlled type, and thus the baroque. We may accordingly visualize "sculpture" situated between the other two arts; from a pictorial point of view the solid material is felt as a limitation of movement, while from an architectural point of view it is the partial overcoming of the implicit solidity of that material which seems to come to the fore, the fact that the suggestion of movement does emerge at all. In short, the abstract concept of sculpture changes in relation to the context in which it is invoked, and with it the allied adjective plastic. Other potential ambiguities of this kind will have to be left to the good sense of the reader.

PART I

GUERCINO'S CHANGE OF STYLE: ITS NATURE AND ORIGINS.[1]

"Aggiugnerò ancor questo, che douerebbe ciascuno contentarsi di fare volĕtieri quelle cose, allequali si sente da naturale instinto inclinato; e non volere por mano, per gareggiare à quello, che non gli vien dato dalla natura, per non faticare inuano, e spesso con vergogna, e danno."

(Giorgio Vasari, 1568).

1. Analysis of the Change

AN early and a late Guercino are strikingly different in appearance. What is the essential character of the difference? When, why, and in what circumstances did this stylistic transformation take place? Obviously we must provide as clear an answer as possible to the first question before attempting any solution of the second; the essence of our problem must first be brought out and defined by an analysis of the contrast between Guercino's treatment of comparable subjects at different stages of his career.[2]

[1] Perhaps it may appropriately be noted here that Giovanni Francesco Barbieri, nicknamed *Il Guercino* on account of his squint, was baptized at Cento, a small country town in the Emilia between Bologna and Ferrara, on 8 February, 1591, and died at Bologna (where he had settled in 1642) on 22 December, 1666. Three further preliminary remarks may be added. First, the greater part of the works of art and manuscripts referred to were examined before 1939, and to my regret I cannot guarantee that they are all still to be found in the places in which I saw them. Secondly, though we are mainly concerned with a relatively short period of Guercino's career (1620-26), our illustrations must not be assumed to be more than a selection of his surviving *œuvre* during that time, chosen for their bearing on our argument. Thirdly, the present is hardly a suitable occasion to give full chapter and verse in questions of the "history" of individual works of art; the proper place for that is a monograph on Guercino which I hope to be able to produce in the somewhat distant future and of which these studies are an offshoot. Nevertheless (and this applies particularly to matters of dating), I propose to give some general indication of the premises (whether written sources or otherwise) on which my assumptions rest. It should however be pointed out that these are frequently part of a larger complex. For example, involved in many problems of dating is the general question of Malvasia's reliability as a source for Guercino, which is considerable (in view of his acknowledged access to documents in Guercino's house), but which has to be weighed against such lapses as his tendency to misread his sources, his overlooking of small but not always innocuous misprints, and his occasional failure to revise his text where it gives rise to misleading implications. Similarly, it will be appreciated that a date based on considerations of style may very well be part of a larger and more complicated whole than can be illustrated and discussed here.

[2] Though we are in no way proposing rigidly to follow Wölfflin's system

In 1620,[3] at the age of 29, Guercino painted a picture of *Elijah fed by ravens* (Fig. 1) ; in 1645,[4] at the age of 54, he painted an altarpiece representing *S. Francis* (Fig. 2). On the one hand

as laid down in *Kunstgeschichtliche Grundbegriffe* (Munich, 1915), we are of course indebted to his example and shall make use of his expressions *malerisch* and *klassisch*. In the English edition (London, 1932, as *Principles of Art History*) the baroque quality *malerisch* appears as "painterly," and the general system of expression which embodies its linear antithesis as "classic" (*klassisch*) ; these translations will apply here, while "classical" will be taken to denote a relation to classical antiquity in particular. It is hoped that the sense in which we employ the terms will be clear from the context. Perhaps we may here emphasize our view that the two concepts exist only by virtue of their opposition to each other, and that it is this relationship of contrast which is the essential fact, not the strict formal symmetry of the opposition. Thus we do not regard the concepts as part of a fixed system with precise laws, but merely as a means of discussing in words nuances which were conceived and expressed in quite other materials.

 [3] This picture (on canvas, 1.95 × 1.565 m.) was identified, when in the Barberini Gallery in Rome, by Dr. Hermann Voss (Thieme-Becker, *Künstlerlexikon*, XV, 1922, p. 217) as the *Elia profeta nel diserto* referred to by Count Carlo Cesare Malvasia (*Felsina Pittrice, Vite de' Pittori Bolognesi*, Bologna, 1678, II, p. 364) as painted in 1620 for Cardinal Jacopo Serra, Papal Legate at Ferrara; it was acquired by the present writer from the *Collezione Fidecommissaria* of the Barberini Family in 1936, and was exhibited at the Royal Academy in London in 1938 (17th Century Art in Europe, No. 288). Dott. Mario Pallone kindly informs me that it is listed in a manuscript inventory dated 22 August 1812 and entitled *Divisione dei quadri appartenenti all'Ecc^ma Casa Barberini* (Vatican Library, Archivio Barberini, indice secondo, maz. CIII, No. 48); it is recorded as on exhibition in the Barberini Gallery in *Beschreibung der Stadt Rom* by Ernst Platner and others (Bd. III, Abt. II, Stuttgart-Tübingen, 1838, p. 432), and in various later guide books of Rome.

 [4] Guercino's Account Book, begun in 1629 by his brother, Paolo Antonio Barbieri, carried on by himself from the time of the latter's death in 1649 until 1665, and completed by his nephew, Benedetto Gennari, is preserved in the Biblioteca Comunale dell'Archiginnasio at Bologna (MS. B331). I have not yet been able to make a thorough comparison of the manuscript with the published text, but, as the latter is certainly somewhat free (though apparently without loss of the essential sense), I propose to quote direct from the manuscript. The Account Book was first published by Jacopo Alessandro Calvi (*Notizie della vita, e delle opere del Cavaliere Gioan Francesco Barbieri detto il Guercino da Cento*, Bologna, 1808, pp. 59-160) and reprinted in the 1841 edition of Malvasia's *Felsina* (II, pp. 307-343). The relevant entry in the Account Book runs as follows: "il di 14 Aprile [1645] Ducat^ni 180. dati da P. P. di S. Giovanni in Monte p[er] il San Fran^co fatto p[er]

we are struck by loose *mouvementé* excitability, on the other we have an impression of compact unruffled calm; one picture is "readable" only after we have made imaginative adjustments, the other is clear at once.

In the *Elijah* the light is allowed to pursue an independent and even capricious course, tending to obscure the linear structure of objects, and resulting in an atmospheric composition of patches of light and shade rather than an arrangement of obviously coherent tangible substances. In the *S. Francis* the light is, comparatively speaking, kept subsidiary to the forms and tends to emphasize their structure, which is further brought out by the long informative lines so conspicuously absent in the *Elijah*. We may compare the uninterrupted contour, stressed by a long dark band of shadow, which extends from S. Francis' left shoulder to his left foot (a categorical statement of isolated form) with the absence, to put it mildly, of any emphasis between near drapery and distant landscape in the *Elijah* (above the figure's right thigh and knee). In this latter picture the artist is obviously not interested in the clear definition of the barriers of space and substance which in fact exist between one form and another, and much more is left for us to fill in: for instance, the relationship of Elijah's left hand to his body and, more strikingly, the connexions between his body and legs are intended to be imagined in the mind of the spectator rather than instantaneously felt by him to be tangible facts.[5]

There is one field in which there is a very large gulf indeed between the two paintings: the contrast between what we may call centrifugal as against centripetal composition. Given a picture of which the principal subject is the full-length figure of a man, it is clear that the comparative relationship between the size of that figure and the picture space will tend to differ

la Sua [sic] Chiesa fano Scudi 225." The altarpiece was soon afterwards noted in the church (Antonio di Paolo Masini, *Bologna Perlustrata*, 1st ed., Bologna, 1650, p. 290), and has remained there ever since.

[5] It is no accident that one of the longest unbroken streaks of light in the picture aids and abets one of the darkest shadows in parting Elijah's right leg from the main torso, and that the leg so severed is made to appear particularly substantial.

in so far as the artist is, on the one hand, indifferent to, and indeed resentful of, the discipline of the lines of the frame and the imaginary barrier or "window" between the objects depicted and the spectator, or, on the other hand, recognizes those limits and is inclined to withdraw from conflict with either. And so it is between the *Elijah* and the *S. Francis*.

In the *Elijah* we have a large disjointed figure which gives the impression of bursting out star-like in several directions, and which is placed so close to the spectator that the left foot practically touches our imaginary window. The vigorous *contrapposto* of the pose leads to a kind of competition in emphasis between the dramatic centre of the composition (Elijah's head) and the steadiest and most solid object in it (his right leg). Elijah's gaze, though directed towards something actually within the frame (the bread), is made use of to stress the underlying diagonal movement upwards, which is deliberately provoked by the position of his left foot, and which, violently opposed by the general direction of the light, is so important a factor in preventing the composition from coming to rest. Although Elijah's right leg finds a weaker ally in the hands and drapery on the other side, the issue is decided (as it was bound to be) in favour of the head, near which a strong central nucleus is created which does much to hold back a complete "explosion." The method employed to accomplish this has, significantly, nothing to do with structure, but is in strict conformity with the general painterly (*malerisch*) character of the picture: it involves placing the strongest high light on Elijah's left shoulder, and, most vital of all, the dominant colour in a relatively stable position on his right shoulder, squarely in the centre of the painting.[6]

In short, the young Guercino, being interested in what is elusive and mobile in the appearance of the world rather than the structural facts of the individual objects of which it is com-

[6] The cream white high light on Elijah's left shoulder is very slightly overemphasized in the reproduction, but unfortunately the extremely important light brownish red on his right shoulder hardly comes out any differently in it from the rest of the drapery, which, including the fold sweeping across his right elbow, is a fairly warm slate grey. In the actual painting the red is the most striking colour and the picture centres round it to an extent which is quite inapparent in the reproduction. I ought also to add that Elijah's right leg is actually somewhat lower in tone.

posed, seems to be making use of apparent instability,[7] asymmetry, and lighting independent of the forms, together with vivacious and impressionistic passages in the actual handling,[8] in order to create the effect of a passing moment cut, seemingly, by mere chance out of the kaleidoscope of the world as we see it. Does not the artist himself confirm this last impression by casting a shadow on the slab and roll of parchment by means of an imagined object conceived to be just outside the picture frame?

In the *S. Francis* we have, relatively to the picture space, a much smaller figure, a concentrated unit posed centrally and moved back from the "window" in a clear and definite manner with the assistance of the crucifix. The general arrangement of the forms, based on two long, slow-moving, intersecting diagonals (of alternating light and shade, robe and rock), results in centring our attention at the crossing, that is to say, the upper part of the figure of S. Francis, the importance of which is discreetly emphasized by the silhouetting and lighting. The figure is posed upright on a stable triangular base of irreproachable symmetry and receives sympathetic support from the slighter uprights to be found in the rocks and the hill-side to the left, the general character of which is certainly deferential to the line of the picture frame. The composition is closed at the bottom in a most definite and symmetrical way by three full stops: the skull, the crucifix, and S. Francis' left foot. The first two face inwards, and the position of the foot and its relation to the body is such that we cannot think of it in terms of outward movement.[9] It is especially interesting to note how carefully and unobtrusively the diagonals are prevented from seriously upsetting the structure of the main form. They have given stability below, and the artist intends to prevent its dissipation when the diagonals re-emerge above. The heavy shadow down the back and

[7] We may note that the principal deliberate vertical in the *Elijah* is an "unimportant" piece of drapery which does not even succeed in reaching the ground; also the solidity of the right leg is somehow undermined by the glimpse of the stream.

[8] Cf. in Fig. 47 (detail of the head). If this kind of loose handling were characterized in Italian, the words *macchia* and *tocco* would probably be involved.

[9] What a difference from Elijah's right knee, which is scarcely connected with his body and is apparently about to hurtle out of the canvas under its own power!

the position of the hands contribute to side-track the rising impetus of the diagonal movements and to concentrate much of it at the vital point. The upward tendency is further checked by S. Francis' gaze, which is firmly fixed downwards on two of our full stops and adds a final touch of stability.

To sum up, we may say that, by comparison with the early picture, we find the painter of the *S. Francis* paying much greater attention to the structure of objects seen as individual wholes, and showing inclinations towards a clear co-ordination of them with a view to creating an impression of stability. Effects of *tocco* and capricious light[10] are rigidly eschewed as likely to unsettle the forms. A certain quiet symmetry finds favour. Solid fact is more important than shifting appearance.

At this juncture it is necessary to qualify the conclusion arrived at; the contrast between our two examples (the anti-thesis painterly-classic, as we shall take leave to call it) is sufficiently striking to permit such a modification without damage to our main argument. By contrast with the classic (*klassisch*) art of the High Renaissance, in the sense of Raphael, both these paintings are baroque. Let one illustration suffice: a more thorough-going classic painter would have disliked allowing the diagonals to re-appear *at all* in the upper part of the *S. Francis*, since, even though broken, they tend to merge the figure in its environment—a typically anti-classic conception. The fact is that many of Guercino's late pictures appear far from classic *pur sang* even by comparison with some contemporary work; for, though the prevailing accent during the Seicento was a painterly one, exponents were not lacking of styles reacting against it in a classic direction. Witness two examples which contrast with each other in style to a not inconsiderable extent but which are in some sense brought together if compared with the bulk of Guercino's work (including many of his least painterly productions): on the one hand the delicacy of the subtle linear melodies of an *Aurora* or an

[10] The three flicks of light between Elijah's legs would scarcely have been at home in the later picture.

Atalanta and Hippomenes by Reni, and on the other hand the calm but telling majesty of the mature Poussin's potent distillations.[11]

We have seen that a striking stylistic change, in a classic direction, took place in Guercino's painting between 1620 and 1645. No doubt it could be argued that the technique of a drawing lends itself more readily to effects of a painterly character: nevertheless, the extent to which Guercino's original compositional ideas were in fact still conceived along painterly lines as late as 1645 is very remarkable. As an example let us look at one of his preliminary studies[12] for the lay-out of the *S. Francis* (Fig. 3). It shows the crucifix, the skull and the hands combining with the left shin and foot in a completely subversive semi-circular movement, continued in the branch above, and somehow receiving encouragement from S. Francis' well-lit left thigh and arm, both of which act like the spokes of a wheel. The most stable object is the tree seen as a whole, but it is in the background and placed on one side. There are fundamental changes in the painting. In it the tree is transformed into a wooded hillside and pressed up against the frame, of which it is made the slavish buttress.[13] A balance to this, missing in the drawing, is supplied on the opposite side of the picture, and the foot, skull and crucifix there conspire to quite other ends, as we have already seen. Finally, we must note an adjustment which will play a recurrent part in our investigation. It is simply that Guercino has tended to "flatten out" the figure. By that I mean that the S. Francis of the painting is placed in a more frontal position in relation to the spectator and the main

[11] It is possible that some of my readers may be thinking at this juncture that I am getting rather too free with my concepts. To any such I should like to say that this is quite deliberate, and to reiterate what I suggested earlier. Such concepts are, in my view, means rather than ends, and exist only by virtue of their opposition to each other. I should therefore regard as futile logomachy any argument as to what might or might not be a classic picture, *as defined in the abstract.*

[12] Windsor Castle, Royal Library; inventory no. 2582; pen and wash, 280 × 185 mm.

[13] Cf. the spreading effect of the tree in the drawing and the glimpse of the sky between it and the left-hand edge.

picture plane. In this case it is less noticeable at the shoulders than at the knees, where it is very striking. Though the change is of course bound up with the moving of the crucifix, I think it is true to say that it forms part of a whole complex which seeks to give the individual forms the clearer and more stable definitions of a square front view rather than the vaguer and more restless suggestions of a diagonal (recessional) view-point.[14]

Let us take stock of our evidence up to the present. Our first example was thoroughly painterly in conception and execution : indeed the impression of consistency in that respect is so remarkable—and here of course we must needs approach the inevitable *ipse dixit* of qualitative judgment—that the reader may be able to agree with the writer's view that it is *réussi* in a way which suggests complete accord between the natural temperament of the artist and the vehicle he uses, the painterly method of expression. Our second example showed a very evident movement in the classic direction, though not however a thoroughgoing one. And in this case—again as the writer sees it—the impression of an end attained does not strike us to the same degree as it did in the early work : how much more convincingly Reni (we mean the real Reni, not the legion of his copyists and imitators) could make use of a pictorial language of this kind ! Guercino's picture is accomplished and yet it lacks something : the artist seems out of his element, like a duck out of water. But we cannot quite say the same of a preliminary idea for the composition—from which, however, Guercino has been most careful to eliminate just those factors which it had in common with the early work. In fact, the suspicion begins to arise that, for some reason or other, Guercino had become dissatisfied with his own intuitive mode of imagination, and that he accordingly tended to "correct" and discipline it during the process of creation. *Tout court*, may not the true Guercino be the young Guercino, as Professor Matteo Marangoni has maintained?[15]

[14] I do not want to insist too much on deductions from the comparison of a single drawing with the relative painting; but I think it is a fair and typical illustration of what appears to me to be a general tendency.

[15] "Il vero Guercino" in *Dedalo*, I, pp. 17-40 and 133-142 (June and July

The present writer agrees with the main contention of that thesis, and would restate it to the effect that it was only in Guercino's youth that his natural artistic instincts were able to express themselves to the full by means of a personally congenial pictorial language. The scope of our investigation is to discover as precisely as we can how and why this curious state of affairs occurred, and, it follows, to ascertain exactly when the change of language began. In order to do this we must be able to recognize the process in the embryo, for which we shall require a somewhat wider and deeper grasp of the application of our two antitheses than can be obtained from representations of single figures alone.

Accordingly we now turn to much more elaborate compositions. The *S. William receiving the habit* (Fig. 5) dates from 1620[16] (the same year as the *Elijah*), and is Guercino's culminating composition before his journey to Rome in the following year. Though it is built up on an extremely intricate system of diagonals and variations in recession, its structural backbone is

1920); rewritten in "Il Guercino" (one of the series *Piccola Collezione d'Arte*), Florence, 1920 (Dec.), and *Arte Barocca*, Florence, 1927, pp. 69-83. I do not suppose that Professor Marangoni would claim that his study was intended as more than a first sketch to bring the artist forward into the field of modern criticism. Spirited ice-breaking ventures of this kind (to which subsequent students owe a great debt) invariably present the explorer with a series of snares, all of which Marangoni has not managed to avoid. But, disregarding certain chronological and other errors, and some over-dogmatic remarks originating from the polemical character of the study, the fact remains that he was the first to segregate the essential problem and to epitomize it succinctly in what must be one of the most felicitous titles ever given to an article on art history.

[16] Malvasia says (*Felsina*, 1678, II, p. 364): "Fece quest' anno [i.e., 1620] la tavola senza paragone bellissima in S. Gregorio di Bologna all'Altare del Sig. Christoforo Locatelli, per mezzo del Padre Mirandola, e gli la pagò 150. scudi." Readers familiar with the diary of John Evelyn, who visited Bologna in the summer of 1645, may be interested in the following passage in it: ". . . there is in the Church of St. Gregorie an excellent picture of a Bishop giving the habit of St. Bernard to an arm'd souldier, with severall other figures in the piece, the work of Guerchino." The picture was removed from San Gregorio by the French in 1796 and went to the Louvre; on being returned to Bologna in 1816/17 it was placed in the Pinacoteca, where it now is. The size of the canvas is 3.45 × 2.30 m.

concealed and caused to appear haphazard by the use made of light and atmosphere. We are conscious of a tendency towards a dissolution of the individual forms into an effect of a general cascade which sweeps diagonally across the rectangular canvas from the top left corner to the bottom right corner. The basic ingredient of this effect is of course the lighting, which gives direction and a common factor, and takes advantage of every (apparently) casual juxtaposition of form to stress its own independence. A further impetus is given by the contrast with the two opposing corners, which are comparatively free of incident, and which seem to act as stable transverse boundary posts between which the shimmering movement wends its way.

The objectives common to both the *Elijah* and the *S. William* (the neutralization of the rigidity of the frame, the disintegration of solid mass, and the fusion of the fragments with their environment[17]) are attained by different means in the two pictures. As we have seen, the principal positive factor in the *Elijah* is the attempt to disrupt by violent *contrapposto* the single solid form implicit in the subject to be represented. The position is reversed with the *S. William*, where the subject consists from the start of a number of smaller[18] units "ready made": a scene with numerous figures. In the *S. William*, then, our painterly-minded artist can go straight ahead with the relation of each one of them to their environment at the expense of the individual articulation of each. To take a very noticeable example, the Bishop's left hand and arm are placed in such a position that their connexion with his body would not be particularly clear even though the light were mild and diffused. In actual fact, Guercino's system of lighting fastens upon a situation of this kind with the greatest satisfaction. The body to which the arm

[17] The meaning of "fusion with environment" may be clarified by the following illustration: it is much easier to imagine a figure with classic tendencies, e.g. the S. Francis, cut out of its environment (the painting as a whole) than is the case with a more painterly figure such as the Elijah; the latter seems somehow more rooted in his picture.

[18] That is to say, smaller than the figure of Elijah in relation to the whole canvas.

is attached is plunged in gloom on the relevant side, and the arm itself is strongly lit, with the result that we always have a vague suspicion at the back of our minds that it is a kind of floating spirit arm held firm more by S. William's steadfast gaze than by any physical connexion! It is to the ready availability, in a composition of this type, of pretexts for such passages that we must attribute Guercino's abandonment here of vigorous disruptive physical movements similar to those of the Elijah. The problem of obtaining a baroque state of flux did not involve the difficult task of attempting to deny that the large single form was such; in general, it was hardly necessary to go much further than to place relatively calm figures at subtly varying angles and to bring a strong concentrated side light to bear upon them.

But the subject also contained a difficult problem for the painterly (*malerisch*) mind, one which could not easily be solved by light alone. If a true baroque effect was aimed at, it was necessary to establish a close connexion between the two separate groups, upper and lower, which had to appear in the picture: how does Guercino bring this about?

Our attention is drawn, by the sweep of a wing and an exchange of looks and words, to a connexion between the Madonna and the angel; and, on looking more closely, we perceive this relationship to have been insisted upon very forcibly by the painter. The Madonna's knee inserts itself between the angel's wing and arm (an effect further stressed by the shadow on the wing), and her foot appears below his arm and between his hands. Moreover we observe that, because of a sense of direction emanating from the emphatic pose of the Madonna's head, the two together convey the most positive *suggestion* of movement of mass which we find in the picture. The result is that, in spite of several checks (the Baby, the angel's right arm) there is a definite impression of a diversion downwards of that comprehensive movement across the picture which we noticed as originating in the side lighting. This downward diversion receives support from the existence of a sympathetic echo of the same movement below, based on the fact that the Bishop is placed on a higher level than the S. William.

The effective alliance between the movement of light and a mere suggestion of movement in the forms results in an impression of union between the upper and lower halves of the picture, but in doing so the possibility arises of causing too great a landslide, of pushing the prin-

ciple of disintegration too far.[19] The real problem at this juncture is therefore how to introduce the necessary stabilizing factor in as exiguous a form and in as casual-looking a manner as possible.

The principal part in this process is played by an object which, giving an impression of complete stability, is to be found in the critical place at the lower right-hand edge of the canvas. The voluminous folds of the monk's robe (Fig. 4) act as a kind of sponge, absorbing the light and deadening its movement towards this very point. The bunch of drapery is made discreetly to appear to protrude beyond the picture plane, causing several slight recessional movements back into the picture and thereby rounding off its own importance. We are not, however, allowed to think of it as an accent of mere solid form (this would have brought a discordant note into the composition) but rather, and primarily, as a gathering together of light.[20] The monk is balanced symmetrically on the other side by the Bishop; both face into the scene and turn their backs on the spectator, as a result of which two inward diagonal movements are suggested, centering on the kneeling figure of S. William and giving an element of autonomy to the lower half of the picture. Just sufficient autonomy, in fact, to put the seal on that supremacy over the composition as a whole for which the lower half was always destined, but which the painter did not wish us to take too much for granted. Such uncertainties are part and parcel of the spirit of the baroque.

We enter quite a different world with the *Purification of the Virgin* (Fig. 6), which is comparable in subject to the lower part of the *S. William*. Painted in the second half of 1654,[21] when

[19] We may point out in parenthesis that so considerable a degree of "flux" is remarkable from a historical point of view at such an early date (over 20 years before Rembrandt's *Night Watch*).

[20] A potentially rigid accent such as the line of the standard is carefully broken so that the part it plays is a secondary one.

[21] There are two relevant entries in Guercino's Account Book; I quote from the manuscript (cf. note 4 of this Part):

(i) "A di 15. Giugno 1654. Dal Sig:re Dott:re Claudio Bertazoli da Ferra:ra si e riceuto Ducatoni Cento che sono L 500. p[er] Capara di un quadro da Altare [nel] qualle vi[?] sia[?] espressa, la purifficatione della Madona, e queste sarano in tuto Cinque figure, pagandoli come fano li altri Ciove ducatoni Cento p[er] figura, fano questi Scudi 125."

(ii) "A di 26. Gennaro. 1655. Dal Sig:re Dottore Claudio Bertazoli si e riceuto lir due milla di moneta di Bologna, per saldo et intiero pagamento, del quadro, della Purifficatione della Madona, fatto per la Chiesa de'

Guercino was 63 years of age, the *Purification* exhibits even more radical classic tendencies than the *S. Francis* of nearly ten years before; hard and fast boundaries and long constructive lines are everywhere apparent.

In both the *S. William* and the *Purification* a figure kneels before an ecclesiastical dignitary placed upon a raised daïs. We have seen that in the early picture the figure of the prelate is not shown complete (being cut into by the architecture), and is turned away from the spectator. S. William too is placed diagonally in relation to the main picture plane, since his left leg comes forward and his right shoulder recedes. Moreover, the relationship between the two figures is not stated within a single plane, but takes place as part of a recessional movement. In the *Purification*, on the other hand, we get an uninterrupted view of the priest, whose body is turned squarely towards us. In the case of the Madonna, who, for obvious reasons, must face towards the priest, the artist seeks to eliminate the effect of a three-quarter (i.e., recessional) pose by giving her a strongly accented profile at an exact right-angle to the main picture plane. We need hardly stress that an emphatic profile of this type is a pre-eminently classic motif;[22] nor is it a mere coincidence that the profile is classical in the sense that an attempt is being made to produce an ideal noble type akin to those of classical antiquity.

Unlike S. William and the Bishop, who are brought together as part of a common recessional movement, the Madonna and the priest are separate units related by the fact that they are clearly placed at an equal distance from the spectator, or, in

Pri: Teattini di Ferrara, e questi sono Ducatoni quatro Cento, che fano poi di questa moneta, Scudi 500.''

The altarpiece is recorded soon after as in the Church of S. Maria della Pietà de' Teatini at Ferrara (Andrea Borsetti, *Supplemento al Compendio Historico del Signor D. Marc' Antonio Guarini*, Ferrara, 1670, pp. 127 and 262), and has remained there ever since.

[22] This clear firm profile is a very different matter from the concealed profile of the Madonna in the *S. William*. There the even surface of the face is disturbed and the nose isolated by a band of shadow; and various other circumstances all round the head prevent it from acting as a "planimetric signpost."

other words, in a single plane. This treatment is an example of the flattening-out process which we noticed in the *S. Francis*. The figures are given a clearly defined front or side view, tending to avoid a three-quarter view, and have to be "read" straight across the canvas in strips rather than in the in-and-out zig-zag fashion which is necessary in the *S. William*.

In the *Purification* there is no stream of light across the picture; the effects of light and shade are not allowed to break up the individual forms but are made use of to stress them. The Madonna's head and shoulders are deliberately isolated from their surroundings by the bright light and dark shadow concentrated on them; so much so indeed that the whole group of the Madonna and Child tells like a sculpture. The silhouette, a typically classic motif, is represented here by the acolyte carrying the candle. He is not merged in the background, but stands out with great distinctness against a lighter field; the individual form is one thing, and the background another. Nor do we find those challenges to the frame and the imaginary "window" which we felt in the *S. William*. The foremost figures are moved back from the immediate foreground (avoiding any possible suggestion of protrusion and consequent recession) and are placed at a uniform distance parallel to the horizontal line of the frame.[23] The mists of the *S. William* have blown away to reveal, not a few isolated fragments of architecture, but a solid structure which does much to support the verticals of the frame. The figures, which are smaller and more compact than those in the *S. William*, do not clash with these verticals; when a figure is cut into, this is done unobtrusively, in striking contrast to the early picture. One final comparison, apparently trifling, but actually quite significant. Both dignitaries are wearing embroidered robes. We realize this with some difficulty in the case of the early picture, whereas in the later one we are left in no doubt about the pattern; in one instance the appearance under particular conditions, in the other the intrinsic substance.

We can now summarize the principal characteristics of Guercino's change of style. First, there is a general "flattening

[23] It is instructive to compare the treatment of the inward curve of the daïs in the two paintings. In the *S. William* it contrives to lose itself, winding its way serpent-like into the picture; in the *Purification* it is abruptly stopped in the most categorical manner possible at the plane occupied by the two principal protagonists, the Madonna and the priest.

out," by which we mean an avoidance of markedly recessional poses in individual figures or groups, and a tendency to arrange the figures in parallel rows or planes. Secondly, there is stabilization of the composition, by which we mean an encouragement of verticals and horizontals, which are naturally inclined to collaborate with the lines of the frame, at the expense of motives which would work against such collaboration. Thirdly, there is solidification of, and differentiation between the forms *as such*, by which we mean an insistence on the clearer articulation of the individual figures and their isolation from each other; involved in this is the use of light for constructive as opposed to disruptive purposes, and the consequent strengthening of linear definitions of structure.

Naturally enough our examples up to the present have been chosen with a view to emphatic contrast, and a quarter of a century or more divided the early from the late pictures. Our next step in trying to discover how and why Guercino's change of style began should be to narrow down the interval considerably. In accordance with this, both of the later paintings in the two paired comparisons which we now propose to consider were produced as early as 1626. Clearly we must not expect fully-fledged works of the classic type to emerge abruptly from a painterly background; but we may with reason hope to find paintings of a transitional type, exhibiting traces, not yet pushed to their logical conclusions, of those characteristics which we saw to be typical of the late works.

Guercino painted our first example, *S. Benedict and S. Francis, with an angel* (Fig. 7), in 1620,[24] the same year as the *Elijah* and

[24] The date 1620 is given by Malvasia (*Felsina*, 1678, II, p. 364) in the margin, covering the following passage: "Fece un S. Francesco in S. Pietro di Cento, con un'Angelo che suona il violino, & un'altra d'un S. Benedetto." This is a typical example of a misreading of his MS. source (cf. note 1 of this Part) by Malvasia, who has made two pictures out of one; there is no reason, however, to doubt the entirely acceptable date originally supplied by that source. Eighteenth century records, both MS. and printed, agree in referring to a single painting with both saints as in San Pietro. I may quote from two manuscripts in the archives of the Palazzo Comunale at Cento which I had the opportunity of consulting with the kind assistance of

the *S. William receiving the habit*. All the painterly constituents which became familiar to us in them are present here also. We are hard put to it to be able to find any objects which can be comfortably related to each other on a planimetric basis; everywhere we feel the in-and-out zig-zag pull of small recessional movements. The whole composition is built up on a series of diagonals which are quite at variance with the lines of the frame and with the initial picture plane. The misty atmosphere and flickering lighting both contribute to the general impression of instability; and, as in our other specimens of this period, the light-effects are made use of as a solvent in the general interest of the picture as a whole rather than as a means of exploring details of individual structure.

Let us turn for comparison to the *Assumption with S. Peter as Pope and S. Jerome* (Fig. 8), which was painted in 1626.[25] This

the Archivista, Sig. Giovanni Gilli. (i) The historian of Ferrarese art Girolamo Baruffaldi (1675-1755), who held the post of Arciprete at Cento for many years, gives a complete list of the pictures in the Chiesa di S. Pietro in his MS. guide book of that town, of which a later copy of the lost original is preserved in the Archivio del Comune (No. 159, entitled *Visita delle Pitture della Terra di Cento per Istruzione del Passaggiere e de' Dilettanti del Dissegno*). The only passage which could have any connexion with Malvasia's statement is that which describes the thirteenth altar in the Church (p. 22): "N. 13 Prosseguendo avanti si vede un quadro che rappresenta un S. Benedetto molto bello in abito bianco, e ancora si vede S. Francesco d'Assisi che resta astratto nel sentire l'arcata del violino toccata da un Angelo Opera delle più memorabili perchè di prima maniera del Guerzino." (ii) Baruffaldi's *un quadro* is supported by a certain Gianfilippo Monteforti, who (in a manuscript list of the pictures in Cento churches written in 1755 in Latin) describes a picture by Guercino in S. Pietro as "Tabula divum Benedictum et Franciscum repraesentans," but does not refer to any pictures by Guercino showing these two saints singly (Archivio del Comune, No. 52, being a case containing various loose MSS. by Monteforti; the list in question is headed *Auctores Tabularum quae in Sacris Aedibus Centi servantur*). Finally, there can be no doubt that the picture now in the Louvre came from the Chiesa di S. Pietro at Cento, since its provenance is recorded by a catalogue of that Museum which was published two years after its removal (*Notice des principaux tableaux recueillis dans la Lombardie*, An VI [1798], p. 60. The size of the canvas is 2.80 × 1.83 m.

[25] The date 1626 is given by Malvasia (*Felsina*, 1678, II, p. 367) in the margin, opposite the following passage: "Un' Assonta per li Canonici di Reggio, & un S. Girolamo, & un S. Pietro per li medesimi." Malvasia has

altarpiece certainly does not strike one at first glance as a classic composition, and we could never describe it as such in the sense of the *Purification* of 1654; the absence of diffused light and the crowding together of the forms deprive the picture of the requisite clarity. Yet on closer examination we see that there are some significant differences from the paintings of six years earlier, and that these differences are cast in precisely the same mould as the broad distinctions between an early and a late Guercino which we have just epitomized. Above all, there is a weakening of the tendency to subject the particular to the general: the sense of crowding together, which we noticed as anti-classic, is at any rate partly due to the enhanced solidity, and consequently independence, of the individual forms. And on analysis we find that this effect of solidity is the result of methods which contrast strongly with those employed in the painterly productions of 1620; thus we have a change in the classic direction reflected in the treatment of a part, without yet being integrated into the whole.

again misread his MS. source, and has split a single picture into three (as already pointed out with some indignation by Giuseppe Campori, *Gli artisti italiani e stranieri negli Stati Estensi*, Modena, 1855, p. 36). But the reliability of the source itself in the matter of dating is supported by the following extracts from a manuscript entitled *Atti Capitolari compendiati dal 1590 al 1753*, which I have seen, with the kind assistance of the Rev. Monsignore D. Leone Tondelli, in the Biblioteca Capitolare at Reggio nell'Emilia. The relevant passages are as follows:

(i) "1624—6 7bris . . . che si faccia fare il Quadro della Girolda dal Sr Gio: Fran:co Barbiero d. il Guercino da Cento."

(ii) "1626—die 15 Aprilis . . . Si scrive che venga pure il Sr Gianfranco Barbieri Cavl Pittore da Cento e le spese si facciano dagli eredi di don Giaco Anto Acerbi Massaro che ordinò do Altare e stii in Casa del Massaro del Capto."

It appears from these extracts that negotiations for *il Quadro* were begun in September 1624 and that Guercino was about to pass through Reggio on his way to Piacenza (cf. note 27 of this Part) in April 1626. I imagine that he brought the altarpiece with him then, received payment for it, and, assuming that it was at once placed in position in the Duomo, possibly took the opportunity to add a few final touches, if any such seemed to him to be desirable. The identity of the *Cappella Girolda* is established by a tablet beginning *Ad expiandos Geroldi Florebelli manes* . . . , which was set up in 1634, and is still to be found there, together with Guercino's painting, which has been recently cleaned (cf. *Le Arti*, II, 1939-40, p. 286).

In the lower half of the *Assumption* we find two compact figures whose bodies are set squarely towards the spectator. Their relationship to each other is stated in planimetric terms; S. Peter is seated in the foreground, S. Jerome kneels on a step, one plane or strip further back. No opening is permitted for such subtle recessional relations as exist between the figures of the Bishop and S. William or between those of Saints Francis and Benedict. Not only are the figures in the later picture not placed at an angle from the main picture plane or from each other, but any devices which might impair their solidity (such as allowing the line of the frame to cut into them, or permitting them to adopt anything in the nature of the disruptive or corkscrew-like poses of the Elijah and the early S. Francis) are carefully avoided. Moreover the composition as a whole is much more obviously firmly based (in the classic sense) than the delicately poised irregular diamonds of the *S. William* and *Saints Benedict and Francis*. The light is, significantly, most powerful where there is a piece of structural definition to be done; a shadow such as that across the chest and face of the violin-playing angel in the earlier picture would be out of place in the later one. The sense of fusion between the upper and lower halves, which is so noticeable in the compositions of 1620, is much less evident six years afterwards. Finally, many significant comparisons of detail can be found: for example, the treatment of the angel's wing in the three pictures.

We may next try to find confirmation of our conclusions in a different field, that of fresco painting, a medium in which we shall not of course look for those niceties of light and atmosphere which are possible in oils. Not long after arriving in Rome in the summer of 1621 Guercino was put to work by Cardinal Ludovico Ludovisi, *Cardinal Nipote* to the newly-elected Pope Gregory XV, on the decoration of a Casino, or summer-house, situated in the Villa acquired by the Papal family on the Pincio. He painted the well-known *Aurora* on the curved ceiling of the principal ground-floor room, and his *Fama* with other allegorical figures is to be found (on a flat ceiling in this instance) in a large room on the upper floor.[26] It is with the group of subsidiary

[26] Considerations of style strongly suggest that this fresco was painted during the first half of Guercino's two year stay in Rome between the summer of 1621 and that of 1623. This view is partly supported by the fact that G. B. Pasqualini's engraving of the *Aurora* in the room below (in reverse, with considerable variations) originally bore the date 1621; Malvasia (*Felsina*, 1678, I, p. 125) was aware of this original state, of which a copy

figures in this latter fresco (possibly representing Honour and Virtue) that we are here concerned (Fig. 9), and we can have little hesitation in recognizing the passage as something in the nature of a *tour de force* of recessional composition. After the first impact of its freshness and poetry, we begin to enjoy the subtlety of its construction, with its interweaving of curves and diagonals, now pushing forward, now falling back, resulting in a gentle rocking movement, exquisitely balanced. Such a precarious equilibrium of masses is quite another matter to the assured rhythm of line in a classic composition.

In 1626[27] Guercino received the commission to complete the

exists in the British Museum. Malvasia incorrectly describes the principal figure in the fresco with which we are concerned as *La Pace* (*Felsina*, 1678, II, p. 365); in this instance he appears to be writing from personal observation and has probably been misled by the olive branch carried by the figure.

[27] Immediately after the passage quoted at the beginning of note 25 of this Part, and under the year 1626, Malvasia says (*Felsina*, 1678, II, p. 367): "Adì 12. Maggio partì verso Piacenza per fare la famosa cupola cominciata dal Morazone pittore Milanese, non avendo potuto far' altro che li duoi Profeti prima della sua morte. Fù ricevuto con gusto da quel Vescovo, e Canonici. Ebbe di fattura 1900. ducatoni d'argento, oltre li utensilij, & occorrenze d'una casa. . . . Lavorò nella cupola del mese di Luglio sino à Decembre, e compì il tutto; aggiongendovi sei Profeti. Le due istor[i]e grandi laterali furono fatte l'anno seguente [1627], essendo ritornato in Cento à far le feste." Malvasia's account is, on the whole, strikingly supported by documents in the Archivio del Duomo at Piacenza (where my researches were most kindly facilitated by Count Emilio Nasalli-Rocca, Director of the Biblioteca Comunale). It appears that certain special legal arrangements had to be made in connexion with paying Guercino from various funds at the chapter's disposal; in a document relating to this and dated 13 December 1627 (Scanzia IX, Cassetta XXX, No. 22) the following passage records that Guercino had by then completed the work: ". . . non potest in presentiarum satisfacere Ill.[ri] Dño Joanni Fran.[co] Barberio pictori iuxta conventa absolutis iam per eum et perfectis picturis concordatis in Cuppola ecclesiae praedictae . . ." Another document (Scanzia IX, Cassetta XXX, No. 21), dating from the completion in 1689 by Marcantonio Franceschini of further frescoes (now removed) below Guercino's work, embodies a short résumé (presumably derived from the Cathedral archives) of the history of the paintings in the cupola. The relevant passage reads: [The Chapter] "scielse l'eccellentiss.[mo] penello del Sig[r] Gio: Fran.[co] Barbieri, d.[o] communem.[te] il Guercino da Cento, col quale fù stabilita la mercede in ducattoni mille nove cento oltre la casa mobiliata, principiò detta opera nel

frescoes in the cupola of the Duomo at Piacenza left unfinished by Morazzone, who had only painted two of the eight compartments; the subject to be portrayed in each of these was a prophet, with the usual attendant angels or *putti*. We are justified in selecting for our illustration the composition which appears to provide the most striking contrast with the group in the Casino Ludovisi. The *Micah* (Fig. 10) is clearly arranged on a planimetric basis. We have two main planes, the foreground strip containing the *putti*, and that to the rear occupied by the principal protagonists. Guercino's treatment of the latter group provides fruitful material for our comparison. The two figures are, as it were, re-subdivided planimetrically, the prophet in front, the angel very slightly behind; they tell as separate compact entities, autonomous within their allotted space. We are surprised to see, in view of our past experience of the young Guercino's use of light as a dissolver of form, that that role is here exactly reversed. Our apprehension of the fact that the prophet and the angel are situated in different planes is chiefly based on the existence of the emphatic band of light which runs from the top of the angel's wing[28] to the lowest tip of his book,

mese di Maggio 1626, e la terminò . . . Novembre 1627." There are two typical small ambiguities in Malvasia's account. He says that Guercino *partì verso Piacenza* on 12 May 1626 and started work on the cupola in July; whereas the résumé says that Guercino began it in May, and we know (see note 25 of this Part) that word had been received at Reggio on 15 April *che venga* (naturally on his way to Piacenza). On the other hand, if Malvasia's *partì* is taken to refer to Guercino's departure from Reggio rather than his original departure from Cento, and if the résumé's *Maggio* is assumed to be derived from documents recording his arrival in Piacenza rather than his actual commencement of the work, our two sources can be reconciled, and the information available to Malvasia is seen to be basically sound. He rather spoils this good effect by his vague remark about the work done in the next year. There are in fact four scenes or *istorie* by Guercino on the vertical walls between the springing of the ribs, as well as two figures of Sibyls in each of the four alternate spaces; it seems probable that Malvasia supplied the *due* himself or has misread "2" for "4" in his MS. source. The above small points are dealt with in some detail because they throw light on the value of Malvasia as a source for Guercino.

[28] We must discount the unnaturally bright patch (which is apparently due to damage) immediately above the angel's shoulder; but even so I think Guercino's intention is clear.

which latter, though potentially a recessional motive, is here rendered curiously powerless as such. (How different is the part played by the slight tilt to the flower pot in the earlier fresco!) The strong silhouetting of the figure of the prophet, deriving from this selective use of light, adds greatly to its effect of solidity as an independent unit. The movement in the composition takes the form of sweeps of line in a more or less shallow field rather than a to-and-fro vibration of masses.

2. *The Evidence from the early Writers*

The evidence from the works of art has shown us that a transformation in the direction of the late style was already in progress five or six years after the production of some of the most thorough-going examples of the early, or painterly, type. What had occurred during this short period to cause such a fundamental change of front? The principal event in what we may call the physical life of the artist at this time was of course his two years' stay in Rome[29] between the summer of 1621 and that of 1623, during the short Pontificate of Gregory XV Ludovisi, who had already commissioned several paintings from Guercino when Cardinal Archbishop of Bologna.

But before we narrow down our search to this short period in Rome, it will be advisable to review the general evidence afforded by the Seicento writers and theorists. The transformation is so radical that we must not neglect to take into account the possibility that Guercino's brush may have been influenced by the views of contemporary theory as to what constituted good or bad in art. In that event the process of careful corrective adjustment which we saw the artist working out in the case of the composition of the late *S. Francis* would represent the intervention of the intellect in the interests of a supposed æsthetic canon which, even if it were to convince his reason, could never really harmonize with that method of expression which was

[29] Cf. Malvasia, *Felsina*, 1678, II, p. 365.

natural and instinctive to him. What we are to consider, there-
fore, is the possibility that Guercino's change of style may have
had an intellectual rather than an intuitive origin, that opinions
or theories, primarily finding expression in words rather than
in paint, had lodged in the artist's mind and were in the habit
of getting control of his brush.[30]

The first stage of our investigation of Seicento art theory in
relation to Guercino may be sketched out by asking two ques-
tions. Was our painterly-classic contrast, or something similar
to it, felt to be a live issue in Italian painting at that time, and,
if so, in what form was this feeling rationalized? And, secondly,
in what way might such general theoretical views have been
considered applicable to the particular case of Guercino?

Let us begin with the more general question. We are fortu-
nate in having an account of the artistic situation in Rome as
it appeared, immediately before Guercino's arrival, to a *dilettante*
who is just the type of informant in whose views we are in-
terested. The main text of Giulio Mancini's manuscript
Treatise on painting seems to have received its final form be-
tween the years 1619 and 1621;[31] and the author was a lay
amateur of relatively wide sympathies and possessed, for his
time, of more than the average knowledge and experience,

[30] Perhaps the writer's view may be stated here that Guercino (certainly
not an intellectual type) was by no means equipped to work out for himself
any reasoned theoretical justification for his early style; thus (provided of
course that he paid any attention to reasoned theory at all) he was the less
likely to reject the verdict of learned authority as to *bellezza* in art. In any
case, we are not entitled to rule out a sincere admiration on his part for
those great classic works of art so extolled by the theorists (e.g., Raphael),
but we submit—and this is the crux of the matter—that he did not fully
realize, until it was too late, the temperamental obstacles which stood in
the way of the adoption of a classic style in his own practice. If he had
grasped the implications of the principle so admirably expressed by Vasari
in the quotation at the beginning of this essay, he might have avoided what
all who prefer his early works must regard as an unfortunate error of judg-
ment.

[31] For information relating to the chronology and development of
Mancini's *Trattato*, see Appendix 2 below: our quotations will be from
MS. No. III in the list given there (namely, MS. it. 5571 of the Biblioteca
Nazionale Marciana at Venice).

though he cannot be acquitted of much of the pedantry then prevalent, shows a distinct inclination towards gossiping, and is by no means always careful or reliable as to matters of fact. Mancini sees a contrast (no doubt not emphasized as deliberately as with some later writers, but still a definite contrast) between *Caravaggismo* and *Carraccismo*. He characterizes the former as employing a specially emphatic method of lighting which he describes as unnatural; he stresses the strict dependence of the Caravaggio group on the presence of the model, coming to the conclusion that this method is all very well for unpretentious *genre* pieces, but unsuitable for the more elaborate, imaginative (and the inference is, more serious and learned) "historical" compositions.[32] He also deplores the actual models chosen. His attitude as regards Caravaggio's *Death of the Virgin* is that it is a fine picture spoilt by the portrayal, as he puts it, of *qualche meretrice sozza*,[33] *qualche sua bagascia*,[34] in the character of the Madonna; such a point of

[32] Quotation from Marciana MS. 5571, fol. 144 verso f.: ". . . proprio di q.ta Scola è di lumigiar [Mancini corrects: *eggiare*] con lume unito e [Mancini crosses out *e* and inserts *che*] venghi da alto senza reflessi, come sarebbe in una stanza da una finestra con le parieti colorite di negro, che così havendo i chiari e l'ombre molto chiare, e molto oscure, vengano a dar rilievo alla Pittura, mà però con modo non naturale ne fatto, ne pensato da altro Secolo ò Pittori piu antichi, come Raffaello Titiano, Correggio, et altri. Questa Scola in q.to modo d'operare è molto osservante del vero, che sempre lo tien d'avanti me[n]tre che opera, fà bene una figura sola, mà nella composition dell'historia, et esplicar affetto pendendo q.to dall'Immaginatione e no[n] dall'osservanza della cosa . . . no[n] mi par che vi vaglino . . ." Mancini's interesting reaction to Caravaggio's lighting is of course that of the traditionalist faced by the unfamiliar. For a somewhat longer transcription of this passage, cf. that given by Prof. Roberto Longhi in *Proporzioni*, I, 1943, p. 40, note 26.

[33] Quotation from Marciana MS. 5571, fol. 152 recto f.: ". . . si puol vedere q[ua]nto che alcuni de moderni faccin' male quali p[er] discriver una vergine e ñra donna vanno retrahendo qualche meretrice sozza delli Ortacci, come faceva Michelangelo da Caravaggio e fece nel transito di ñra donna in quel quadro della Mad.na della Scala, che p[er] tal rispetto quei buon padri no[n] lo volsero."

[34] Quotation from Marciana MS. 5571, fol. 160 recto: [Mancini refers to Pliny's story that the figures of a certain Roman painter (evidently Arellius, cf. *Historia Naturalis*, XXXV, §119)] "erano sempre ritratti di qualche sua

view[35] was of course no novelty, its immediate ancestor being the theory of decorum which was particularly rife during the second half of the Cinquecento.

On the other hand Mancini sees the Carracci and their school as "serious" painters *par excellence*, capable of welding together an "historical" composition in the grand style, and of expressing emotion without offence to decorum or good taste; for him they are soundly based on nature but do not feel bound to reproduce it without selection or improvement; moreover their method of lighting is a natural one (in contrast, Mancini obviously

bagascia, et in questi tempi haviam visto che i Padri Scalzi per tal lascivia levorno quel bel quadro del Caravaggio, com' s'e detto." We are of course only concerned here with establishing the fact that such stories were current about 1620, or in other words that the theory of decorum (in connexion with which Mancini introduces his remarks) was evidently available as a more or less arguable theoretical basis for criticism of Caravaggio. The complicated question of the precise reasons why various pictures by Caravaggio did not find permanent homes in the churches for which they were destined (over a decade before Mancini wrote) is a different matter altogether; in this particular case it does not seem improbable that *ecclesiastical* prejudices of some kind (thus, a form of decorum) may really have been involved in the rejection, with the rider that the picture was apparently in no way thereby discredited in *artistic* circles (cf. letter of 24 February 1607 published in Ch. Ruelens, *Correspondance de Rubens*, Antwerp, 1887, I, p. 364: [il quadro] "non resta punto discreditato per esser . . . rifiutato dalla chiesa a quale era stato donato"). We cannot be sure that Mancini actually saw it during the week it was on exhibition in Rome at the beginning of April 1607. For another reference to Arellius in connexion with contemporary painting, cf. the *Satira contra la Lussuria* by Monsignor Lorenzo Azzolini (died 1632), first pub. at Venice in 1686 in *Scelta di Poesie Italiane* (p. 11).

[35] The possibilities which this kind of criticism opened up to anyone who (for whatever reason) wished to get in a dig at Caravaggio did not escape later writers. For example, the classically-minded Bellori says (Giovanni Pietro Bellori, *Le Vite de' Pittori*, Rome, 1672), with regard to Caravaggio's representations of the *Supper at Emmaus*: ". . . mancano nella parte del decoro, degenerando spesso Michele nelle forme humili, e vulgari" (p. 208), and ". . . le forme rustiche delli due Apostoli, e del Signore figurato giovine senza barba" (p. 213). Baglione, who had personal reasons for disliking Caravaggio (cf. A. Bertolotti, *Artisti Lombardi a Roma*, Milan, 1881, II, pp. 51-64), makes several criticisms in the same vein (Giovanni Baglione, *Le Vite de' Pittori*, Rome, 1642, pp. 137 ff.), and many others will be found set out by Miss Margot Cutter in *Marsyas*, I, 1941, pp. 89-115. For the theory of decorum, cf. also note 61 of Part II.

means, to what he feels to be the over-emphasis of *Caravag-gismo*).[36] On the whole (bearing in mind remarks which Mancini makes elsewhere in his Treatise) it is fair to say that, although he is certainly not without praise for Caravaggio, he considers Annibale Carracci the greatest painter of his own time.

A reading of Mancini gives one the impression that he is mainly concerned with getting the new movements sorted out and brought into rough focus. The contrast he makes should not be assumed to imply that any very conscious rivalry was felt between Caravaggio and Annibale when alive;[37] on the

[36] Quotation from MS. it. 5571, Biblioteca Nazionale Marciana, Venice, fol. 145 recto: "Questa [i.e., seconda scuola] ha per proprio l'Intelligenza dell'arte con gratia espression d'affetto, proprietà e composition d'historia, havendo congiont' Insieme la maniera di Raffaello con quella di Lombardia, perche vede il naturale, lo possiede, ne piglia il buono, lascia il cattivo lo migliora, et con lume naturale gli dà il colore, e l'ombra, con le movenze e gratie." Though Mancini's third group, headed by the Cavaliere d'Arpino, have no very direct bearing on the present argument, perhaps his charac-terization of them in relation to the other two will be of interest. We quote from Marciana MS. 5571, fol. 145 verso: "La 3.ª [i.e., scuola] è quella del Cavalier Giuseppe che hà per proprio un Spirito e proprietà di natura, con buona compositione e gratia, et in particolar delle Teste, et se ben non và osservando tanto esattam.te il naturale, come q[ue]lla del Caravaggio, ne quella gravità e sodezza di quella dei Caracci, nondimeno hà in se quella vaghezza, che in un tratto rapisce l'ochio, et diletta, et d'essa mi ricordo haver sentito dire da Agostin' Caracci, vi è il buono p[er]che v'è il rapimento é diletto." Fourthly, Mancini mentions miscellaneous artists who work "con un modo proprio e particolare senz'andar p[er] le pedate d'alcuno."

[37] Bellori says that Caravaggio praised Annibale (*Vite*, 1672, p. 32); this is borne out by Caravaggio's opinion, given in a law-suit (cf. Bertolotti, *Artisti Lombardi*, 1881, II, pp. 58 f.) that he was a *valentuomo* (i.e., one of the best painters in Rome), and it further transpires that the explosive Cara-vaggio was on speaking terms with Annibale, which surely would not have been the case if the latter had been in the habit of making derogatory remarks about Caravaggio's pictures. The so-called "satirical" picture attributed to Annibale Carracci in the Museo Nazionale at Naples (No. 369) is of no value whatever in this connexion, unless a trustworthy early source is adduced relating the subject to Caravaggio. As it is, the four earliest references of which I am aware are entirely silent on the matter, and they include the voluble Malvasia, who would hardly have missed his chance if the Caravaggio interpretation had then been current. Incidentally, Malvasia favours Agostino's authorship (*Felsina*, 1678, I, p. 498), not without

contrary it seems to be nothing more than his own attempt to give some stylistic and critical classification to fresh departures which had established themselves a mere twenty years before, and were only just beginning to get into historical perspective. Later on in the Seicento the sort of contrast which we find in embryonic form in Mancini is gradually developed and rigidified into a commonplace by later writers to suit their own arguments, and we must beware of over-emphasizing our case by unjustifiably projecting such opinions back into the first decade or two of the century. For example, Malvasia (Bologna, 1616-93) found the Caravaggio-Carracci antithesis convenient fuel for his ardent local patriotism, and sums it up with the bias of the partisan in a passage purporting to record the reactions of Lodovico and Annibale Carracci to the arrival of a picture by Caravaggio at Bologna; any examination of Malvasia's general methods discourages us from taking his story or its setting literally,[38] but it serves to illustrate the fact that the clash

plausibility, while the three early inventory references (1662, ca. 1680, and early eighteenth century) give it to Annibale. I should not be at all surprised if the idea that the subject is a satire on Caravaggio turns out, on systematic investigation, to be untraceable further back than early in the last century.

[38] Malvasia's report of the supposed opinions of the Carracci in this connexion is no more to be accepted as a verbatim contemporary report than a conversation purporting to be, for example, by Edouard Manet, and first published at the present time, could unreservedly be treated as such. As regards the setting, Annibale almost certainly left Lodovico and Bologna for Rome in 1595, by which time Caravaggio had only just entered his twenties; though not impossible, the presence in Bologna of one of Caravaggio's pictures in time to support the strict accuracy of the supposed setting of Malvasia's anecdote must certainly remain open to doubt. Malvasia's prejudices in favour of the artists of his native Bologna are well known, and indeed his *campanilismo* has been criticized ever since the publication of *Felsina Pittrice*. Perhaps however it is relevant to draw attention to yet another typical instance of his manipulations in this respect. In a rhetorical panegyric of the Carracci Malvasia quotes every author known to him who bestowed praise on his heroes; he knew something of Mancini's writings, and purports to record (*Felsina*, 1678, I, p. 450) the latter's high opinion of the Carracci in the following passage: "Chi [ardirà di chiamare] inconsiderato il Mancini, quando nel suo *Discorso di Pittura*, delle quattro scuole, alle quali ridusse il secolo moderno, *la prima* (scrisse) *diremo esser quella de'*

of conflicting ideals which he finds it so convenient to embroider upon did actually develop into a recognized subject for discussion during the course of the Seicento. Malvasia represents the style of the Carracci as more noble and thoughtful, and indeed on a higher intellectual level, than that of Caravaggio; furthermore not only do the Carracci know how to rise above the imperfections and vulgarity of crude unrefined nature, but (this was probably considered to be an effective point) they have no "technical" deficiencies to conceal under a cloak of darkness.[39]

Carracci?" Now, as far as I am aware, it is only in the first short version of the Treatise that Mancini put the Carracci first, and neither this arrangement, nor that adopted in all the later revised versions (whereby Caravaggio is dealt with first) was intended by Mancini to be interpreted as having any relation to merit. Malvasia must certainly have been familiar with the first short version (No. I of Appendix 2 below), and must equally have known Mancini's remark as to why he began with the Carracci (p. 283 below); as a matter of fact Mancini leaves no openings in this context for any "qualitative" deductions pro or con. It is true that it appears from passages in the later and longer versions of the Treatise that Mancini was in fact inclined to rate the Carracci school as the best, but if any of these versions was known to Malvasia—actually the evidence is against this—, he must also have been aware that in them Mancini did not start with the Carracci but with Caravaggio. So he seems to be convicted of disrespect for his sources in either case! The truth is that no one could be further than Malvasia from the detached outlook of the real historian, the scrupulous respecter of fact; but, once this is said, let credit be given where it is due. If it had not been for Malvasia's inexhaustible enthusiasm and tireless assiduity in collecting masses of material, much vital information about the Bolognese Seicento would certainly have been lost to us. Even the vivid pictures he provides of the local artistic *ambiente* are not without interest and value, provided we are resolved not to take them *alla lettera* and are prepared to exchange logical continuity for a string of unrelated, but often suggestive, "slices of life."

[39] Malvasia, *Felsina*, 1678, II, p. 10: "Rimase stordito [Lodovico] quando altro non seppe rintralciarne, che un gran contrasto di lumi e d'ombre, che un'ubbidienza troppo fedele al naturale; senza decoro, con poca grazia, minor intelligenza . . . una ruina manifesta del buon disegno. [Then Annibale is supposed to have said, comparing his own aims with those of Caravaggio:] . . . a quel colorito fiero vorrei contrapporne uno affatto tenero: prende egli un lume serrato, e cadente; & io lo vorrei aperto, e in faccia: cuopre quegli le difficoltà dell'Arte fra l'ombre della Notte; ed io a un chiaro lume di mezzo giorno vorrei scoprire i più dotti, & eruditi ricerchi. Quanto ved'egli nella Natura, senza isfiorarne il buono e'l meglio, tanto

Now, turning to our second question: if we grant the existence
of a tendency (exemplified in the early Seicento by Mancini)
to divide the principal contemporary trends in painting between
two very rough and ready compartments of this kind, it seems
reasonably clear into which class Guercino would find his way.
The powerful effects of light and shade in his early pictures,
and the unpretentious peasant models to be seen in them, would
surely result in his having to take over, in working order, the
same sort of criticisms as Caravaggio's work was apt to en-
counter.[40]

mette giù; ed io vorrei sciegliere il più perfetto delle parti, un più aggiustato,
dando alle figure quella nobiltà, ed armonia di che manca l'originale." In
his enthusiasm for pressing, *coûte que coûte*, a piece of reasoning on which he
is engaged at a particular moment, Malvasia has no qualms about contra-
dicting another of his own arguments elsewhere in his massive work—so it
is hardly possible to accuse him of having any very clear or comprehensive
views on æsthetics. But, rash though it is to speculate on Malvasia's real
opinions, I should be surprised if they were quite as derogatory to Caravaggio
as a literal reading of such a propagandist passage would imply.

[40] In the writer's view we should hardly be justified in making any very
definite deduction from the fact that Mancini has a reference to Guercino
in the fourth, or unattached, group, as he does not seem to have been really
familiar with Guercino's work, at any rate before the latter came to Rome
in 1621. The sequence of Mancini's short comments on Guercino is rather
complicated. He begins by confusing Guercino with another artist (a
follower of the Cavaliere d'Arpino, according to Mancini); this passage
occurs on p. 152 of MS. No. II in the list in Appendix 2 below, and, though
erroneous, reappears in the later MSS. Nos. III (fol. 75 recto f.), VA (fol.
224 recto) and VB (fol. 111 recto). He was apparently put on the right track
by Lodovico Carracci (the suggestion may be thrown out—cf. note 45 of
Appendix 2—that the latter came to Rome in 1618 to take charge of the
infant son of Antonio Carracci, who died in that year, and that Lodovico
met Mancini on this occasion). At any rate two passages recording Lodo-
vico's high opinion of Guercino's work now make their appearance in MS.
No. III (neither figured in MS. No. II). The first passage is that putting
Guercino in the fourth, unattached, class; it is repeated in MSS. Nos IV
(f. 59 v.) and VA (f. 86 r.), and runs: ". . . mà singolarissimo Il Guercin
da Cento del q.le il S.r Lud.co Caracci faceva gran conto, e meritevolm.te
perche nel colorito nell'Inventione e nella facilità dell'operare con buon
sapere no[n] sò chi adesso li passi avanti" (quoted from MS. No. III, fol.
146 verso). The second passage is an entirely new biographical note on
Guercino which was probably intended to take the place of the earlier
mistaken account, the elimination of which from the text was however over-

We can find a reflection of this, long after the event, in the writings of Giovanni Battista Passeri[41] (Rome, *ca.* 1610/16-79), whose theoretical point of view reveals (as we should expect from one who was in his youth an admiring friend of Domenichino) certain pro-classic tendencies, without however going anything like as far as Bellori in that direction. Passeri has obviously confused Guercino with Reni in his story of an association with Caravaggio, which was of course chronologically impossible for Guercino, but the way in which he prefaces that story clearly shows that he himself saw an affinity between the styles of Caravaggio and Guercino, which evidently struck him as having boldness and vigour in common.[42] Passeri's critical comments on two of Guercino's pictures will be quoted later in connexion with the relative illustrations; meanwhile, a summary of his attitude towards Guercino strikes some familiar notes. The latter's work is said in general to fall short of a certain standard of nobility and dignity (this term here includes *decoro*); and in particular his drawing lacks grace and correctness, there is an absence of pleasing outlines, and his poses are inelegant. He remains faithful to undiluted nature in its baser aspects (a criticism which may perhaps be illustrated by Passeri's adverse comment on the markedly rustic appearance and bearing of the Madonna in *S. William receiving the habit*[43]); nor does Guercino display much fluency in "historical" compositions with well-disposed draperies in the grand style. Passeri, who normally shows considerable broad-mindedness,

looked. A transcription of this revised *Vita* from fol. 87 recto of MS. No. III (to which Mancini has added various fragmentary *postille* in his own hand at different times during the years 1621-23) will be found below, on pp. 310 f.; the fact that Guercino is classified here with the Bolognese group might well have followed naturally from the fact that Mancini's informant (before Guercino himself arrived in Rome) was Lodovico Carracci.

[41] *Die Künstlerbiographien von* Giovanni Battista Passeri, *herausgegeben von* Jacob Hess, Leipzig/Vienna, 1934.

[42] Passeri, *op. cit.*, ed. Hess, p. 347.

[43] Passeri, *op. cit.*, ed. Hess, p. 346: ". . . un'aria di testa, et un portamento assai rusticano." Even if Passeri did not see the picture, this comment is of interest in that it must reflect one of the points of view then current.

but who obviously regards the foregoing as a serious indictment, is careful to point out that his remarks are less a matter of personal prejudice than a widely accepted view on Guercino.[44]

Our supposition that Guercino probably had to undergo the same type of criticism as Caravaggio at the hands of the more classically minded theorists finds confirmation in the fact that Bellori mentions Guercino in his chapter on Caravaggio. And indeed most Seicento writers are agreed in classing the two artists more or less together, resulting ultimately in the manufacture of a *cliché* in the matter, which has persisted in one form or another down to the present day.[45] A comparison of their renderings of the same subject will serve a dual purpose: it will illustrate the fact that there was sufficient similarity to appear striking against the contemporary background, but insufficient to justify (in modern times, and in the light of more rigorous standards of analysis and classification) a claim that Caravaggio was a formative rather than a purely incidental influence on Guercino.

When we compare a work of Annibale Carracci's Roman period, the *Coronation of the Virgin* formerly in the Villa Aldobrandini[46] (Fig. 11), with Caravaggio's *Martyrdom of S.*

[44] Passeri, *op. cit.*, ed. Hess, p. 352: "Quello, che si è detto di lui circa al giudizio del suo stile, e del suo modo d'operare, è quello del quale ha sempre discorso il comune del parere . . . Egli, come ha detto sempre il publico, non hebbe mai gran facondia nel componimento dell'istoriare, ne nel bel modo di vestire, e di piegare li panneggiamenti." The testimony of Passeri in this respect seems to me to be worthy of credence, in spite of its relative lateness and the fact that his point of view was primarily a Roman one.

[45] Bellori, *Vite*, 1672, p. 212. We may cite Florent le Comte (*Cabinet des Singularitez*, II, Paris, 1699, pp. 85 ff.) as an example of this classification taking still firmer root in art literature. Le Comte places Guercino in the Roman School, immediately after Caravaggio, and at the head of the latter's "pupils"! Thus Guercino is even made to precede Manfredi, a genuine follower of Caravaggio.

[46] This picture (on canvas, 1.18 × 1.42 m.) was first recorded as in the *Giardino Aldobrandino a Monte Magnanapoli* on p. 7 of the anonymous *Nota delli Musei, Librerie, Galerie . . . di Roma*, Rome, 1664, the author of which was G. P. Bellori, who also refers to it in his *Vite* (1672, p. 84). Thereafter it is mentioned in the Villa (which passed by inheritance into the possession of the Pamfili and Borghese families successively) by Malvasia, Félibien, and

Peter[47] (Fig. 13) and the young Guercino's treatment of the same subject[48] (Fig. 14), we can see that certain common factors as between the two latter could have struck Roman eyes[49] of about 1620, not fully familiar with developments north of the Apennines. The irregular, disorderly compositions, the intensity of the light-effects, and the emphasis on the uncompromisingly faithful reproduction of coarse or plebeian types would have contrasted strongly with Annibale's balanced compositional framework,[50] gentle harmonious figures, and flowing unassertive

in innumerable guide-books of Rome; it was engraved in 1741 by J. J. Frey as *in Aede . . . Principis Panphili Romae*. Towards the end of the eighteenth century it passed to the Palazzo Borghese (the younger branch of the Borghese family having inherited the *fidecommesso Aldobrandini* on the extinction of the Pamfili family). Shortly afterwards (*circa* 1800) it was purchased thence by the artist Alexander Day, and was subsequently in the collections of the poet Samuel Rogers and the Dukes of Newcastle. It was acquired by the present writer in 1939.

[47] For a document providing a *terminus ante quem* of May 1601 and describing Caravaggio as *famosissimo pittore*, cf. *Roma*, XIII, 1935, p. 185.

[48] The date 1618 is given by Malvasia (*Felsina*, 1678, II, p. 364) in the margin covering the following passage: "Fece una tavola della Crocefissione di S. Pietro per un gentiluomo da Carpi, dal quale sopra l'accordo, gli furono accresciuti cento scudi, & altri regali." Campori (*Gli artisti . . . negli Stati Estensi*, 1855, pp. 34 f.) informs us that it was commissioned by Orazio Cabassi and placed in S. Bernardino at Carpi, whence it was transferred in 1751 to the Galleria Estense at Modena. It has remained there ever since, with the exception of a visit to France between 1796-1815. The size of the canvas is 3.42 × 1.99 m. If Malvasia is right about the date, stylistic considerations would seem to put it at the end of the year; I am tempted to think it may have been painted early in 1619.

[49] This particular picture of Guercino was of course chosen to suit our own convenience in illustrating both the similarities and the differences in the two artists' approach to the same subject; the fact that no Roman observer is ever likely to have seen Guercino's version tucked away in Carpi naturally does not affect our argument that if seen it would very probably have been roughly classified with the Caravaggesque group.

[50] This composition fits in remarkably well with a precept attributed to Annibale Carracci in notes to both of the original editions of the didactic poem *De Arte Graphica* by the theorist and painter Charles Alphonse Dufresnoy. This poem, which was originally composed during the author's stay in Rome (where he lived *ca.* 1634-53), was not published until shortly after his death; in spite of Dufresnoy's love of Titian, it is in effect a fairly comprehensive statement of the classic canon from a Roman point of view, as might be expected from the author's intimacy with G. P. Bellori during

rhythms (however much baroque variety may be discerned on closer examination). And indeed we readily admit the possi-

its composition (cf. note 150 of Part II; for a further note on *De Arte Graphica*, cf. note 80 of this Part). The two original editions came out in the same year. The first consisted simply of the Latin poem with a few notes in Latin added by Dufresnoy's inseparable companion for over thirty years, the painter Pierre Mignard; this rare edition (*Caroli Alfonsi Du Fresnoy De Arte Graphica Liber*, Paris, 1668) I know only from the reprint by Paul Vitry in *De C. A. Dufresnoy pictoris poemate quod "De Arte Graphica" inscribitur* (Paris, 1901, pp. 85-100). Another edition, with a French translation and extensive notes by Roger de Piles (who was a close friend of Dufresnoy during the last decade of his life) was published very shortly afterwards (*L'Art de Peinture de Charles Alphonse Du Fresnoy*, Paris, 1668). The notes in question illustrate a passage in which Dufresnoy advises against too many figures in a picture (lines 152 ff.). Mignard says (note to line 154): "Ut ex ore Annibalis Albanus retulit mihi, qui ultra duodecim figuras negabat, optimam fieri posse tabulam in tribus ut opinor partibus quas hic exposuimus." De Piles' note to line 152 reads: "Annibal Carache ne croyoit pas qu'un Tableau pust estre bien, dans lequel on faisoit entrer plus de douze Figures: c'est l'Albane qui l'a dit à nostre Autheur [Dufresnoy], de qui je l'ay appris; & la raison qu'il en apportoit, estoit premierement qu'il ne croyoit pas qu'on deust faire plus de trois grands Grouppes de Figures dans un Tableau; & secondement que le Silence & la Majesté y estoient necessaires, pour le rendre beau: ce qui ne se peut ny l'un ny l'autre dans une multitude & dans une foule de Figures." For the three groups, cf. also the text of the poem, line 280. Though there is nothing improbable in supposing that Annibale held some such opinion in his Roman days, perhaps these passages are mainly of interest in the present instance as a justification of our choice of the *Coronation of the Virgin* to represent the classic tendency. Judging by Dufresnoy's poem as a whole, it was on this general type of composition that the classic theorists of the period tended to base their arguments; and incidentally there can be little doubt that Dufresnoy actually knew the *Coronation* well, as Félibien (*Entretiens sur les vies et sur les ouvrages des plus excellens peintres, seconde édition*, II, Paris, 1688, p. 665) tells us in his life of Dufresnoy that the latter copied several pictures in the Villa Aldobrandini, including the landscapes from Titian's *Bacchus and Ariadne* and Bellini's *Feast of the Gods* commissioned by himself. As is well known, the controversy with regard to a greater or lesser number of figures was lively during the Seicento, and appears to have come to a head in the Accademia di S. Luca under the presidency of Pietro da Cortona (1634-38), that is to say, during the first years after Dufresnoy's arrival in Rome: Andrea Sacchi (and probably Nicolas Poussin) supported the classic view as against Pietro da Cortona, who at that time was blossoming out into full baroque. There are many instances in Alberti of the foreshadowing of classic theories, among which we find this matter of the number of figures (cf. *La Pittura di Leonbattista Alberti tradotta per M. Lodovico Domenichi*, Venice, 1547, fol. 28 verso).

bility of Guercino's second-hand derivation[51] from Caravaggio, perhaps through Leonello Spada, of such an idea as that of the representation of one of the protagonists with the top of his head turned towards the spectator.[52]

[51] The suggestion that Passeri's story (*op. cit.*, pp. 347 ff.) of a chronologically impossible meeting between Guercino and Caravaggio may actually conceal a grain of truth in the shape of a visit by Guercino to Rome before 1621 (and consequently a first-hand acquaintance with some of Caravaggio's principal works) has been advanced by Dr. Jacob Hess in the footnotes to his edition of Passeri and in *Bollettino d'Arte* (XXVI, 1932-33, p. 44). But the passage from which this theory originates is at any rate open to suspicion in view of the fact, duly pointed out by Dr. Hess, that Passeri has made an error of no small dimensions by obviously confusing Reni with Guercino (cf. Malvasia, *Felsina*, 1678, II, p. 15). Nor is Passeri by any means a first-class authority on Guercino, whereas Malvasia unquestionably is, even though we take his carelessness into account. The proper use and interpretation of Malvasia is, as we have seen, a matter of great complexity, requiring the patience of a Job, the judicial capacities of a Solomon, and a great deal of space; all I can do here is to place on record my opinion that the omission of any specific mention of such a visit in its proper place in Malvasia's MS. source for his account of Guercino seems incredible. I consequently find myself compelled with much regret (for, like most students of the Seicento, I have found that my labours have been greatly lightened by those of Dr. Hess) to take the opposite view to him in this matter; I do not believe that Guercino was in Rome before 1621. My use of the term "second-hand" for describing the origins of such Caravaggesque motives as we find in Guercino must not of course be taken to exclude an occasional Caravaggio composition, either in original or copy, which may have found its way to North Italy. For the general question of the extent of Caravaggio's influence on Guercino from the point of view of style, cf. (in addition to the text) note 54 of this Part.

[52] Whatever precise value is to be attached to Malvasia's questionable stories about Leonello Spada, the latter was certainly in touch with *Caravaggismo* round about the end of the first decade or the beginning of the second, and, as has already been pointed out by Dr. Nikolaus Pevsner (*Barockmalerei in den romanischen Ländern*, Wildpark—Potsdam, 1928, p. 150), was probably the channel whereby *Caravaggismo* of a modified and diluted kind penetrated into Bolognese circles. His huge canvas (reproduced by Pevsner, *loc. cit.*) of *S. Dominic burning the heretical books* (in which appears, for example, a youth with his head more or less in our "Caravaggesque" position, blowing on the beginnings of a fire) was painted at Reggio nell'Emilia for S. Domenico at Bologna, and its temporary exhibition at Modena, on its way there, was recorded by the Modenese chronicler Spaccini on 31 July 1616 (cf. Campori, *Gli artisti . . . negli Stati Estensi*, 1855, p. 448). There can be no question that Guercino was familiar with a picture

And yet how deep a gulf there is between the two conceptions when we look at them with modern eyes! Caravaggio's clear unadulterated light throws into strong relief the sharp cutting outlines of his figures, which are placed before a completely neutral background like some sculptured group in hard wood. Guercino's flickering light, filtered through an ever-changing atmosphere, streams capriciously across the scene in its by now familiar fashion, striking the forms "accidentally," impairing their structural solidity, and losing them in their environment ("background" does not seem to describe it fully).[53] Any exhaustive discussion of the Caravaggio-Guercino question would be out of place here, but it seemed necessary to make it

of such importance; moreover, we have a letter from Lodovico Carracci dated 19 July 1617 stating that both Guercino and Spada were in Bologna (first published by Giovanni Bottari, *Raccolta di Lettere sulla Pittura*, I, Rome, 1754, p. 209; reproduced in facsimile by A. W. Thibaudeau, *Catalogue of the Collection of Autograph Letters and Historical Documents formed . . . by Alfred Morrison*, I, [London], 1883, Plate 36, opp. p. 167). Our "Caravaggesque" motive is however not Caravaggio's own invention (Longhi has published a rendering of it by so provincial a painter as Simone Peterzano), but he may well have given it a new lease of life during the Seicento. Actually it seems to have been of Venetian origin, and in this connexion we ought not to lose sight of the fact that Guercino was in Venice only a few months before painting his *Martyrdom of S. Peter*. Malvasia says (and we can well believe it) that he made a special study of Titian there, and the probability is that he saw and admired the famous *Martyrdom of S. Lawrence* in the Church of the Crociferi (now Gesuiti). Here we have the motive again, and doubtless the light-effects would have interested our young student. I am inclined to think, too, that the general lay-out may have impressed itself on Guercino's mind: the principal protagonist in the centre, with two overlapping triangular accumulations of form rising diagonally to the frame on either side, leaving a sort of V-shaped space in the centre. Certainly the formal arrangement of Guercino's picture has much more to do with this sort of thing (translated into Seicento language, be it understood) than with Caravaggio. An amusing story told by Francesco Scannelli (*Il Microcosmo della Pittura*, Cesena, 1657, p. 231) of a meeting between an aged friend of Titian and "the leading modern master," when at Venice on a *Studienreise* in his young days almost certainly refers to Guercino's visit in 1618 (cf. the designation Scannelli gives to Guercino on pp. 79, 93, 101, 278, and 364).

[53] The almost complete absence of landscape and atmospheric backgrounds with Caravaggio, and their comparative frequency with the young Guercino, is a characteristic manifestation of the opposed standpoints of the two artists.

clear that a suggestion that the two artists would have been roughly classed together in the Seicento does not involve unqualified support of such a classification to-day. In my view Guercino is essentially the offspring of the predominant tradition of North Italy, loose, colouristic, atmospheric,[54] of which we illustrate a typical example[55] (Fig. 12) in the shape of an

[54] On the other hand, important elements in Caravaggio's style derive, as Prof. Longhi has pointed out in a well known article, from the more plastic "opposition" trends in the North. I claim no originality for insisting that the influence of *Caravaggismo* on Guercino was not of a fundamental formative nature; both Dr. Hermann Voss and Prof. Matteo Marangoni have already (in my view, convincingly) rejected it as a direct and major factor in Guercino's artistic make-up. Some evidence in support of their contention that Guercino's interest in light-effects derived from sources quite other than Caravaggesque will however be found in two of the present writer's articles in *The Burlington Magazine* (LXX, Jan.-June 1937, pp. 112-122 and 177-189); Guercino's unsophisticated types are to be seen from the start and are, in my opinion, primarily to be ascribed to his peasant origin and rustic environment when young. The only modern attempt to put forward anything in the nature of an argued case for *Caravaggismo* is to be found in an evidently hastily written article by Professor Roberto Longhi, who on this occasion unfortunately falls somewhat short of his own standard (*Art in America*, XIV, 1926, pp. 133-148; cf. comment by Voss in *Zeitschrift für Kunstgeschichte*, II, 1933, pp. 198 f.). The faulty translation of this article tends to obscure the argument, which is further weakened by certain errors of fact and, in my judgment, of connoisseurship (e.g., the ex-Hermitage *S. Sebastian*, which I saw at Moscow in 1936, is certainly not by Guercino); but Prof. Longhi is very well aware of the non-Caravaggesque side of Guercino, and one is left with the impression that even here he regards the Bolognese-Ferrarese tendencies as the most significant. Perhaps we should add here that what may conceivably turn out to be reflections of *Caravaggismo* (though if so, exceedingly pale and distant ones) do make a momentary appearance in Guercino's work at a much later date, but that is of course no present concern of ours. On the whole, an over-stressing of *Caravaggismo* is most prevalent among writers on general subjects, who, without special knowledge of the Seicento, find the *cliché* a convenient one; for example, Caravaggesque influence has recently been noted in a drawing which is in fact an imitation of Guercino, probably dating from the second half of the eighteenth century!

[55] Lodovico Carracci painted this picture for the now demolished Capuchin Church of the SS. Trinità just outside Cento; it is signed, and is dated 1591, the year of Guercino's birth (cf. *Le Arti*, V, 1942-43, p. 104: "Ludovicus Caraccius Bononien. Fecit 1591"). Removed by the French in 1796, it arrived back in Cento in 1816. G. B. Pasqualini seems to have changed the principal monk from S. Francis to S. Felice Cappucino when

altarpiece by Ludovico Carracci[56] for which Guercino is known to have had a special admiration in his earliest years.[57] This tradition of a *luminismo* which was impressionistic rather than constructive was of radical importance for Guercino's outlook from the beginning, an outlook which would not have been fundamentally altered if the incidental Caravaggesque graftings which we undoubtedly come across from time to time had been omitted altogether. The question is really one of emphasis: to attempt to explain Guercino (and in particular his *luminismo*) in terms of Caravaggio is, in my opinion, to misunderstand both artists, and to exaggerate out of all proportion the occasional modified echoes of *Caravaggismo* which may be found in the younger painter's work.

making his engraving (which I have not seen) at about the time of the latter's beatification; thus A. Foratti's conclusion that the monk in the *painting* is S. Felice (*I Carracci*, Città di Castello, 1913, p. 113, note 4) probably requires revision.

[56] Fig. 12 may be taken to symbolize the contribution which Lodovico made to the painterly trends of North Italy; while Annibale's picture (Fig. 11) shows him in that midway position between the classic and the baroque which characterizes his Roman works—in this case a classic structure organized from component parts which are unmistakably painterly. The contrast between the two will only surprise those who have inherited the unfortunate habit of thinking of "the Carracci" collectively. In Part IV below we shall be discussing some of the inaccurate and trouble-saving generalizations which have done the family such ill service during the course of history: in particular the indiscriminate use of the expression "eclecticism" (originally derived from a misinterpretation of imperfectly studied sources), together with a certain failure to get under the conventional "antiquarian" skin to the rich and smiling core of that essentially original achievement the Galleria Farnese, has led to a wide-spread misunderstanding of "the Carracci," both historically and æsthetically.

[57] The influence of this picture on the young Guercino (naturally more marked in works earlier than those with which we have been concerned) is amply supported by documentary evidence. Malvasia was told several times by Guercino himself of his youthful admiration for the picture (Malvasia, *Felsina*, 1678, I, p. 406, and II, p. 360). Francesco Scannelli (another acquaintance of Guercino) also refers to his interest in it (*Il Microcosmo della Pittura*, Cesena, 1657, p. 361). Finally Giulio Mancini mentions, in a small addition in his own hand (*circa* 1621-23) to MS. it. 5571 in the Marciana Library at Venice (fol. 87 recto), that he studied *una tavola che e a Cento di Lodovico* (for a transcription of Mancini's *Vita* of Guercino, in which this note occurs, cf. below, pp. 310 f.).

So far, we have ascertained that there were elements poten-
tially unfavourable to Guercino's early style in the contem-
porary critical atmosphere as a whole, but we have not yet
reviewed such evidence actually relating to his particular case
as may have been recorded during the Seicento. What informa-
tion have we from the early sources bearing upon how Guer-
cino's contemporaries saw, and accounted for, his change of
style?

Both Passeri[58] (died 1679) and Sandrart[59] (1675) notice an
alteration which they agree in deploring and which they
characterize as a forsaking of Guercino's dark powerful manner
in favour of a lighter, more delicate, and less naturalistic style;
they refer to this in connexion with his decision to settle in
Bologna in 1642, immediately after the death of Reni, and the
inference is that Guercino more or less stepped into Reni's
shoes.[60] In the time of Baruffaldi, writing in the first half of
the eighteenth century, this seems to have been the generally
accepted view.[61] Malvasia supplies us as usual with some studio

[58] *Die Künstlerbiographien von* Giovanni Battista Passeri, *herausgegeben von*
Jacob Hess, Leipzig/Vienna, 1934, p. 354. Anecdotes by writers of *Vite* are
usually suspect, but Passeri has one which is so apt that we cannot omit it. It
is to the effect that when Guercino was in S. Gregorio with some of his pupils,
the latter praised his *S. William receiving the habit,* whereupon the master
commented (p. 357): "*Ma allora bulliva il pignattone,* volendo inferire, che in
quel tempo era nel fervore del suo operare."

[59] Joachim von Sandrart, *Academie der Bau-, Bild-, und Mahlerey-Künste,*
herausgegeben von A. R. Peltzer, Munich, 1925, p. 284.

[60] We should however mention that Passeri (who was conscious that there
was a strong current of originality in Guercino's character) seems to qualify
our Reni inference later on (*op. cit.,* p. 355): ". . . egli fù Pittore unico nel
suo stile, proprio settario della sua maniera, e si conosce non essersi mai
incaminato con la traccia di nessun Maestro, ma di suo genio haversi fabri-
cato lo stile, e la disposizione."

[61] Girolamo Baruffaldi, *Vite de' Pittori e Scultori Ferraresi,* II, Ferrara, 1846,
p. 463. Baruffaldi also relates (II, p. 239) a story of advice supposed to have
been given by the aged Guercino in 1662 to his pupil Giovanni Bonati (about
whom Baruffaldi evidently had reliable sources of information). Guercino
is alleged to have warned Bonati "di non invoglirsi mai delle maniere,
quantunque vaghissime e fondatissime, d'altri pittori, anche eccellenti;
lodarle, applaudirle, e stimarle doversi, dicea, ma non mai talmente in-
vestirsene che si smarrisse la propria, e divenir scolaro dove prima s'era

gossip. The contrast between Guercino and Reni is summed up in two stories about the latter,[62] who is supposed to have said of Guercino: *pesca le mie idee, e cerca il mio fare.*[63]

But our most promising source of information seems to be Francesco Scannelli, about whose book, *Il Microcosmo della Pittura* (1657), a few preliminary remarks may be desirable. Scannelli, a physician like Mancini, and a native of Forlì in the Emilia, gives us a change from the classic tendencies of Roman theory, which one may occasionally become inclined to equate with that of Italy as a whole.[64] He is an enthusiast for the

maestro." Baruffaldi adds: "E questo documento lo dava il Guercino, per così fare ch'altri non inciampasse dov'era esso caduto," but makes no further comment.

[62] Malvasia reports Reni's opinion of Guercino as follows (*Felsina*, 1678, II, p. 78): ". . . un gran coloritore, . . . ma non Rafaellizava." Elsewhere (II, p. 80) he gives an anecdote about the idealization of coarse models: [Reni] "Pregato un giorno del Sig. Co. Filippo Aldovrandi, ad istigazione, si crede, del Guercin da Cento, del quale tanto era parziale quel Signore, a conferirgli, e palesargli di qual donna ei si valesse a ricavare quelle sue bell'arie di Madonne, di Maddalene, e simili; fatto ben tosto sedere il suo macinator di colori, ch'avea ceffo di rinegato, comandandogli guardasse il Cielo, nè cavò la testa di una Santina in quella vista così mirabile, che parve al Co. fosse fatta per incanto, quando: Sig. Co. mio, soggionse, dite pure al vostro Centense, che le belle idee bisogna averle quì in testa, che ogni modello poi serve."

[63] Malvasia, *Felsina*, 1678, II, p. 67. All these stories, though very likely apocryphal, probably represent a fairly widely-held opinion.

[64] When reading Scannelli we must not be discouraged by the pseudo-learned framework, with its medical allusions, within which he has thought fit to operate. On penetrating this smoke-screen we find a man of intelligence and sensibility, with a real understanding of the painterly qualities of North Italy. But the most remarkable writer in the minority (anti-classic) camp in Seicento Italy was undoubtedly that whole-hearted Venetian Marco Boschini (*ca.* 1613-1678), whose critical point of view is set out in *La Carta del Navegar pitoresco* (Venice, 1660; the present writer's copy comes from the enemy headquarters—Colbert's library!) and in the preface to *Le Ricche Minere della Pittura Veneziana* (Venice, 1674); Dott. and Signora Pallucchini have a most welcome critical edition of both of them in preparation. Boschini is an instinctive empiricist, interested above all in colour, light, atmosphere and movement, and is in every way a complete antithesis to the rational theorist of the Bellorian type (cf. also note 87 of this Part and note 40 of Appendix 1); Bellori very understandably did not approve of him (cf. Giovan Pietro Bellori, *Vite di Guido Reni, Andrea Sacchi e Carlo Maratti,*

painterly tradition of North Italy, and, though he respects Raphael, his real affection is reserved for Correggio and the Venetians; he is the partisan of the "instinctive" rather than the "intellectual" type of painter; he favours natural beauty[65] rather than ideal beauty, and values colour and atmosphere more than drawing and structure. To take a concrete example more or less within the scope of our investigation, he regards Annibale Carracci's Bolognese works as *assai più facili, e di miglior gusto, & alla verità, e vista maggiormente uniformi* than his Roman ones.

Obviously, we feel, here is a man who will appreciate Guercino's early work and may throw some light on his change of style. But the fact that the book was published during Guercino's lifetime, and that the author was a personal friend of the artist, inevitably impose a certain discreet reserve on the subject, with the result that we have to do some reading between the lines. Scannelli makes a definite contrast Reni-Guercino on the lines sketched out above, with Reni roughly playing the part of Raphael and Guercino that of Correggio;[66] and it is clear from the context (the pictures he mentions are almost all

ed. Michelangelo Piacentini, Rome, 1942, p. 116). Attention was first drawn to Boschini in modern times by Dott. Lucia Lopresti (*L'Arte*, XXII, 1919, pp. 13-33), and his considerable importance has been justifiably emphasized by Prof. Lionello Venturi (*History of Art Criticism*, New York, 1936; the English edition is poorly translated, but a revised and improved Italian edition appeared in 1945 as *Storia della Critica d'Arte*); Prof. Venturi points out (Eng. ed., pp. 128 ff.; Ital. ed., pp. 194 ff.) that in his preoccupation with colour Boschini was a kindred spirit to Roger de Piles, who was to play such an important part in the first major counter-attack of painterly criticism, the battle of the Rubénistes against the Poussinistes. The rest of Prof. Venturi's chapter on baroque art theory deals with the classic-idealist trend, and it must be said that this is one of the least reliable sections, historically speaking, of his interesting and important book. His personal sympathies were not engaged and this has unfortunately led to a relaxation of vigilance in the matter of establishing the facts on which much of his comment is based: the resulting damage to his general argument in this section is not inconsiderable.

[65] It is characteristic of Scannelli's painterly outlook that Caravaggio's naturalism strikes him as superficial and inadequate: it is *still* life. Boschini would almost certainly have agreed with this view.

[66] *Il Microcosmo della Pittura*, Cesena, 1657, pp. 358 ff.

early or at least transitional) that the Guercino he refers to and admires is the young Guercino. Elsewhere he devotes a chapter[67] to the consideration of a change of style which he sees in several artists of his time, including Guercino. The principal characteristic of the new manner, of which Scannelli strongly disapproves, is stated to be the adoption of a brighter and clearer system of colouring and lighting, and an abandonment of dark shadows; he considers the prime mover in the matter to be Reni, and the inference is that Guercino followed Reni's example.

Nevertheless Reni does not really seem to meet the case, except in a general way. The *chiarezza* to which Scannelli refers is of course typical of Reni's late manner, and of most varieties of classic painting. But this is the very characteristic which is missing when Guercino is in the process of changing his style; for some little time his colour, not being broken up to the same extent as in his early period by streaks of light and shadow, on occasion seems even to gain in depth and intensity. Much later, even after he had settled at Bologna, Guercino was still far from speaking Reni's language, as witness his *S. Michael* painted there in 1644[68] for Fabriano. His spirited, painterly

[67] *Microcosmo*, 1657, chapter XVII of book I, pp. 107-119.

[68] There are two relevant entries in Guercino's Account Book; I quote from the manuscript (Bologna, Biblioteca Comunale dell'Archiginnasio, MS. B331; cf. note 4 of this Part):

(i) "il di 15. Gennaro 1644. Dal Sigr Pinto fatorelli da Fabriano, si è riceuto Scudi di Paoli nõ 50. p[er] caparra di un Quadro d'un San Michele Arcangelo, d'acordo in Scudi 200. di Paoli, fano questi Scudi 61 L 1.13."

(ii) "Il di 3. Decembre [1644]. Dal Sig. Pinto Fatorelli da Fabriano si è riceuto s[c]udi di Paoli nõ 150. p[er] il residovo del Quadro del San Michele, che fano L 721, et sono la soma di Scudi 180 L 1."

A contributor to *Memorie Originali risguardanti le Belle Arti*, writing from Fabriano in 1843 to the editor, Michelangelo Gualandi, indicates that Guercino's *S. Michael* "esisteva un tempo" in the chapel of that saint in the Dominican Church (*op. cit.*, V, Bologna, 1844, p. 85); Gualandi, in a note, seems to have made the error of taking this to mean not only that the altarpiece was not in its original position, but also that it was no longer to be seen in Fabriano. A very small strip at the top of the painting, including the tip of the sword, was unfortunately omitted from the photograph. The peeling of the paint appears to be due to the canvas having been rolled;

study[69] (Fig. 16) provides a connecting link between it and such a conception of his early style as the figure of *Day*[70] (Fig. 15), so fresh and unsophisticated, wafted into the room on his chariot of clouds. And yet, even though the S. Michael of the drawing undergoes the by now familiar adjustments in the classic direction in the process of transfer to canvas (Fig. 18), how far we are from the clear diffused light, transparent paint and graceful linear rhythms which are so essential an ingredient of Reni's late style[71] (Fig. 17). Though there are many passages in the *S. Michael* which would have been inconceivable in earlier years (for instance, the silhouetting in hard relief of S. Michael's right arm), the totally different attitude of the two artists towards drapery in movement is particularly striking. For Guercino it is an excuse for a patchwork of light and shade, in which, even now, some of the solidity of the figure contrives to lose itself; for Reni, on the contrary, it is an opportunity (by integrating the drapery with the figure in a sense which is quite foreign to Guercino) for the accentuation of the

perhaps the story told me by a local bystander in the church that the damage was caused by an unsuccessful robbery some forty years ago is correct.

[69] Pen and wash, 242 × 234 mm. Bouverie mark (Lugt 325). I am much indebted to Sir Thomas Fowell Buxton, Bt., for kindly allowing me to reproduce his drawing.

[70] *Il Giorno* is painted in fresco in the Casino Ludovisi on the same ceiling as the *Aurora*, and corresponds with the well-known figure of *La Notte* on the opposite side of the room; it probably dates from the first half of Guercino's stay in Rome (cf. note 26 of this Part).

[71] Guido Reni's *Europa* (on canvas, 1.74 × 1.29 m.) was purchased in 1741 by Sir Jacob de Bouverie (afterwards 1st Viscount Folkestone, and ancestor of the Earls of Radnor), and was placed in Longford Castle, Salisbury, where it remained until 1945, when it was acquired by the writer. Dr. Otto Kurz, to whom we are indebted for the only modern study of Reni (*Jahrbuch der kunsthistorischen Sammlungen in Wien*, Neue Folge, XI, 1937, pp. 189-220), kindly allows me to quote his view that Reni painted this picture during his last years, between 1630-1642; in Dr. Kurz' opinion neither the cut-down versions in the Galleries at Dulwich, Leningrad, and Tours, nor the small oil sketch among the unexhibited pictures of the Pinacoteca Capitolina are originals. Malvasia states (*Felsina*, 1678, II, p. 30) that this subject was commissioned by Charles I ("L'Europa del Rè d'Inghilterra"), but I have not yet been able to investigate the matter further.

sweeping and elegant flow of line in which he is primarily interested.

The worthy Scannelli is however far from being useless, even though his half-suggestion of Reni does not really get to the root of the matter. We were inclined to locate the beginning of Guercino's change of style in Rome, and Scannelli has one discussion which seems to the writer to fit in with this remarkably well. The question is considered whether or not Correggio would have produced still greater masterpieces if he had had the advantage of more than provincial opportunities and patronage. Guercino's opinion is quoted to the effect that Correggio (whom he obviously regards as an independent natural genius) would have lost his instinctive touch if he had come into contact with and studied styles contradictory to his own (and in this connexion Scannelli uses the term *prima scuola*, by which he customarily refers to the Florentine-Roman, Raphaelesque, and therefore classic type).[72] It is difficult to avoid the impression that, in expressing this opinion, Guercino had his own case and his visit to Rome under Papal patronage very much in mind.

Scannelli has another passage of very considerable interest; he evidently asked Guercino point-blank why he had forsaken his early dark manner, and gives the artist's reply. The gist of

[72] Scannelli, *Microcosmo*, 1657, pp. 93 f.: "E però in ordine alla parte negativa si ritrova con gli altri l'autorità di primo Maestro di questa Professione [in margin: *Gio. Fra[n]cesco Barbieri*], il quale con ragioni assai probabili non sà credere, che occasioni d'altra sorte, con tutto che fortunate, e degne havessero in tal caso se non servito per deviare dalla solita sua suprema, e connaturale sufficienza, mentre stimano, che non havesse potuto ricevere veruna mutazione senza la sicura perdita; apportano per pruova della loro opinione, che egli incitato dalla natura, ed essendo giunto mediante l'aiuto del proprio talento ad operatione eccellente, e sublime, nè poter per lo più, che osservare differenti, & inferiori dipinti, dove stimano, che di facile l'havriano potuto levare dalla buona strada, & in somigliante guisa per seguir l'incerto havrebbe di facile perduto anco il sicuro, asserendo, che se bene venga considerato all'applicatione de' maggiori Maestri di prima Scuola, pare però non possa, che restar contrariato anco in buona parte con la maniera il proprio genio, dovendosi rendere in tal caso principiante, ed inferiore di quelli, a' quali si considera al presente eguale, ed anco maggiore . . ."

this is that the responsibility must be laid at the door of the great majority of those who commissioned his pictures, who in turn were governed by the general consensus of public taste. Of particular significance is the passage in which Guercino tells of criticisms which were directed at his early works: it was complained that the eyes, mouths, faces, limbs and even actions of the figures were concealed by excessive darkness, and sometimes it was even thought that the pictures were "technically" incomplete.[73] Now, accusations by Guercino's patrons that his figures were "unfinished" had a particularly awkward implication owing to the method he had adopted in fixing the prices of his work. This involved computation by the number and type of the figures painted, full-lengths being reckoned at a certain rate, half-lengths at half that sum, and heads at a quarter;[74]

[73] Scannelli, *Microcosmo*, 1657, p. 115: ". . . pare, che sia anco più valevole ragione quella, che già in tal proposito mi significò il medesimo Pittore da Cento, vene[n]domi a dimostrare ciò succedere per ritrovarsi di tal forma il gusto della maggior parte, e di quelli in particolare, che vengono a richiedere l'opere loro, e l'haver' egli sentito più volte dolersi coloro, che possedono i dipinti della propria sua prima maniera, per ascondere (come essi dicono) gli occhi, bocca, ed altre membra nella soverchia oscurità, e per ciò non havere stimato compite alcune parti, coll'asserire bene spesso non conoscere la faccia, e tal volta anco l'attioni particolari delle figure, e così per sodisfare a tutto potere alla maggior parte, massime quelli, che col danaro richiedevano l'opera, havea con modo più chiaro manifestato il dipinto." The idea that darkness could be used to conceal "technical" imperfections, which we came across previously (cf. note 39 of this Part), is also to be found, e.g., in Malvasia's life of Mastelletta (*Felsina*, 1678, II, p. 94) and in Luigi Scaramuccia (*Le Finezze de' Pennelli Italiani*, Pavia, 1674, p. 205), who, though he censures its use for this purpose, elsewhere praises strong relief by means of chiaroscuro (p. 207), and criticizes too clear a manner (p. 198). Cf. also end of note 178 of this Part.

[74] Guercino's system is well illustrated by a letter written by him to an unknown patron in 1639, which, as far as I am aware, has never been published. The original is preserved in the private Archives of the Borromeo family at Milan (Autografi, Lettera No. 57), and reads as follows:

"Ill.mo Sig.r Proñ: Col.mo

Il merito di V. S. Ill.ma richiede, che io ambisca le occasioni di servirla, che però non posso se non reputarmi a favore il comando che da lei mi viene p[er] l'adempim.to del suo desiderio intorno a i duoi quadri di pittura significatimi con la sua delli 27 del passato. Resta, che V. S. Ill.ma si compiaccia darmi cenno di quelle Istorie, che più siano per agradirle, che se poi

incidentally, a "valuation" on these lines[75] was not his own invention or monopoly, having been used, for example, by two of his seniors, Reni and Domenichino,[76] and also by many other Italian contemporaries of the first rank. Two observations appear relevant: first, such a system, though widespread during the Seicento, is for obvious reasons more suitable for a classic than a painterly artist; secondly, a classic style, in which the principal figures are sharply differentiated from the background, lends itself more readily to the studio assistance which a large output would doubtless call for.

To such practical considerations favouring a classic style we

rimetterà à me l'electione procurero di sciegliere quelle che in riguardo della grandezza de i quadri, e delle figure, e de i lumi che ella mi dovrà significare giudicarò meglio convenirsi p[er] beneficio dell'opera che veddo desiderarsi da V. S. Ill.ma alla quale sogiungo, che i molti oblighi ch'io ho con diversi Personaggi non mi permettono di poterla servire cosi presto, come sarebbe il mio pensiero. E poi che veddo esser suo meente [sic], ch'io le dica più oltre il mio sentimento, non le taccerò, che per le figure intiere io sono riconosciuto p[er] lo meno di cento ducatoni d'Argento p[er] ciascuna e p[er] le mezze cinquanta. Qui riverentem.te le bacio le mani con augurarli somma felicita. Cento, li 8 Giug.o 1639.
D. V. S. Ill:ma

Devotiss.mo ser.re humiliss.mo
Gio: fran.co Barbieri."

We already came across the rate of 100 ducats for each (whole) figure in Guercino's Account Book (cf. note 21 of this Part). A study of the Account Book (for which cf. note 4 of this Part) will show that such a system was in use from the beginning, in 1629, onwards, though not of course with absolute rigidity. Moreover, one's calculations are complicated by differences in exchange between the enormous number of different varieties of money then current. The silver ducat, referred to in the above letter, seems to have been used as a sort of general standard; it was usually about equal to one *scudo di paoli*, and to $1\frac{1}{4}$ *scudi* of the type used by Guercino and his brother for their final calculations in the Account Book. Malvasia has a note on Guercino's prices (*Felsina*, 1678, II, p. 382), but, as so often, is somewhat misleading in the details, though correct on the system in general.

[75] Such a method of pricing no doubt seems natural in countries with a long tradition of portrait painting; it is perhaps less so in a country whose artists had been primarily concerned for centuries with multi-figured religious, "historical" and decorative compositions.

[76] For Reni's prices, cf. Passeri, *op. cit.*, ed. Hess, p. 95, and Malvasia, *Felsina*, 1678, II, p. 63; for Domenichino's prices, cf. Bellori, *Vite*, 1672, p. 333, and Malvasia, *Felsina*, 1678, II, p. 333.

have to add the fact that the most impressive, reasoned section of contemporary theoretical opinion was apt to regard pictures conforming to the classic canon as more "correct," which was to say better, than those which transgressed it;[77] thus a formidable argument, purporting to be based on a rational æsthetic, could be put up in defence of classicism.[78] In the absence of

[77] Perhaps it should be pointed out at this juncture that classic theory is best looked upon in general as an all-round defence of classic art, the opponent of which manifests itself in widely-varying anti-classic forms with the passing of time. Thus, towards the middle of the century *Caravaggismo* had passed into history, and, though useful as a stock theoretical antithesis to the classic ideal, did not present such a "live" challenge to classic art as that of the full baroque, with which, e.g., Dufresnoy was doubtless largely concerned. The ammunition used is, however, designed to explode on striking any anti-classic target, whether intentional or accidental. Plausible though such theories seemed to many at the time (particularly *letterati*), it must not be assumed that they were invariably blindly accepted by artists, even when the latter happened themselves to be working in the classic tradition. For instance Simone Cantarini (1612-48), the follower of Reni, is supposed to have shown appreciation of *S. William receiving the habit* in spite of its defects from the classic point of view; the comment which Baruffaldi records (*Vite*, II, p. 444: "piedacci, manaccie, e testaccia, e pur bisogna che mi piaccia") is so succinct that we feel it ought to be true, even though we cannot be sure of it. Marcantonio Franceschini, whose own work can hardly be accused of *tenebrosità*, is quite clear in letters to Prince Johann Adam Andreas von Liechtenstein (for whom he was acting as a picture-buying agent) that in his opinion (which was evidently corroborated by the relative prices asked) Guercino's *prima maniera* was his best (cf. *Jahrbuch des kunsthistorischen Institutes der k. k. Zentral-Kommission für Denkmalpflege*, V, Beiblatt, 1911, esp. cols. 127 f. and 130 f.).

[78] It is of course no accident that the case in defence of a rational style tended above all to appeal to, and (within the contemporary context) to impress, the reason. Even Roger de Piles (who not long after was to strike his first blows in favour of Rubens and colour) says in his preface of 1668 to Dufresnoy's *De Arte Graphica*: ". . . comme vous sçavez, il n'y a point d'Art qui n'ait ses Preceptes. Je me contenteray seulement de vous dire que ce petit Traité vous en donne d'infaillibles, puis qu'ils sont fondez sur la raison & sur les plus beaux Ouvrages des meilleurs Peintres, que nostre Autheur a examinez l'espace de plus de trente années." The opposite view (for which Roger de Piles himself had meanwhile done much to prepare the ground) was already possible by the time of the Abbé Jean Baptiste Du Bos, in whose *Réflexions critiques sur la Poésie et sur la Peinture*, first published anonymously at Paris in 1719, we find the following passage: "On goûte le ragoût & même sans sçavoir ces regles [of cooking] on connoist s'il est

any very straightforward and concise source for Poussin's views
on æsthetics,[79] we may take Charles Alphonse Dufresnoy (whose
poem, *De Arte Graphica*, was probably originally composed in
Rome between 1640-1646[80]) as a typical representative of this
classic school of thought, in spite of the admiration for Titian
which he shared with Poussin. Dufresnoy's fundamental prin-
ciple was a well-worn one: it is not sufficient for the painter
to devote himself to the slavish imitation of nature as a whole,
without selection of her beauties or correction of her defects;
he must deliberately choose that which is most beautiful in
nature, and in doing so should be guided by the taste and
manner of the ancients.[81] Coming down to specific details, we
find that Dufresnoy urges that care should be taken to avoid
the concealment of the joints and extremities of the human
figure,[82] and the presentation of it in complicated poses, with
violent movements and "unpleasing" foreshortenings.[83] Further,
in dealing with draperies, voids (wide patches or troughs of
dark shadow) should be mitigated and bridged by the bringing
out of folds from them into the light; the underlying structure

bon. Il est de même en quelque maniere des ouvrages d'esprit & des
tableaux faits pour nous plaire en nous touchant" (1719, II, p. 307). Though,
according to Du Bos, discrimination is only given to those who have ex-
perience and *goût de comparaison*, the "rules" are definitely shelved.

[79] Cf. note 7 of the Introduction. It is of course possible to deduce Poussin's
opinions from evidence scattered here and there. However, he would
probably not have found much reason to quarrel with Dufresnoy on the
points with which we are particularly concerned, so we make use of the
latter's *De Arte Graphica* for the sake of convenience.

[80] A footnote added by Pierre Mignard (Dufresnoy's lifelong companion)
to the last line of his edition, in Latin only, of 1668, purports to give the date
of the poem's original composition: *Romae. Anno 1640 et quinque sequentibus
annis*. Dufresnoy however certainly worked over it from time to time until
his death in 1668. For Dufresnoy and his poem, cf. note 50 of this Part; for
his close intimacy, when composing it, with the principal Italian theorist
of classicism, Giovanni Pietro Bellori, cf. note 150 of Part II.

[81] Cf. especially lines 37 ff., 49 ff., and 184. Just to make it perfectly clear
what is meant by "Ancients," Mignard thinks fit to note to line 39: *Graecorum
et Romanorum*!

[82] Lines 161 f. In other words, Dufresnoy advocates that the structure
and articulation of the human figure should be clearly shown.

[83] Lines 166 ff.

should be allowed to reveal itself in the same way.[84] Contrasts of light and shade should be gradual, not sudden and violent.[85] Finally, when solid opaque bodies are placed against luminous or transparent grounds, such as the atmosphere or clouds, their solidity should be sharply emphasized in contrast to their surroundings.[86] Naturally we have deliberately selected passages from Dufresnoy which seem to be most strikingly relevant to our particular problem; but I think it is true to say that, if one reads *De Arte Graphica* in the presence (so to speak) of the *œuvre* of the young Guercino, one is impressed by the extent to which his practice ran counter to many of the most fundamental tenets of classic theory.[87] On the other hand such a picture as the

[84] Lines 202 f. and 212 ff. Mignard notes to line 212 (relative to the "swelling out" of the form through the draperies into the clear light): *Ut Guido Rhenus saepius et multifariam usus est.* For this, cf. also Fig. 17.

[85] Lines 274 ff. Dufresnoy here sees light as the handmaid of structure.

[86] Lines 302 ff. This is of course the classic silhouette, the exact antithesis of that integration of the forms into the atmosphere which we saw to have been characteristic of the young Guercino.

[87] That attractive enthusiast Marco Boschini (for whom cf. also note 64 of this Part) is the critical writer—we cannot call him an abstract theorist—who comes nearest to the work of the young Guercino. Boschini's characteristically Venetian terminology is quite unlike that of the classic-idealist writers: *macchia, tocco, lo sfumar de' dintorni, il tratto pittoresco, il colpo sprezzante di pennello,* and so forth. The following quotations from the unpaginated preface to his *Le Ricche Minere* (Venice, 1674) serve to illustrate his anti-Roman, anti-classic point of view: "Alcuni credono, che il Dissegno consista solamente ne i lineamenti . . . ma io dico, che i lineamenti sono ben sì, necessarij al Dissegno, ma bisogna valersene come fà lo Scrittore della falsa riga, che sino che scrive, se ne vale, ma doppo haver scritto, la getta da parte: poiche la Pittura vuole esser rappresentata tenera, pastosa, e senza terminazione, come il naturale dimostra." "Per farsi eruditi in questo Dissegno alcuni tengono opinione, che servino le statue di vero esemplare e chi non le studia non possi divenir buon Pittore, con asserzione, che siano Statue cavate dall'esquisito Naturale, ed accresciute di perfezione da quei valorosi Scultori; e che si trovano pochi naturali perfetti. Sopra di che vi è anco opinione in contrario; concedendosi, che tutti i Naturali non siano perfetti, ma che pur anco delle Statue dir si deve lo stesso. Rispondono, che è vero, ma che parlano delle buone; ma replicano quelli che parlano nella stessa forma de Naturali; aggiungendovi, che il Naturale non riceve la perfezione dalle Statue, ma ben si le Statue dal Naturale." ". . . con la difformità deve l'occhio rimaner ingannato, e deve la perfezione con l'imperfezione apparire." ". . . il Pittore forma senza forma, anzi con forma difforme la

Ferrara *Purification* (Fig. 6) would no doubt have met with Dufresnoy's complete approval, as indeed it may conceivably have done in actual fact. Guercino was at work on it during the second half of 1654, and Félibien tells us that Dufresnoy, during his stay in North Italy in the middle fifties, paid Guercino a visit for the purpose of reading *De Arte Graphica* to him and getting his opinions on the poem![88]

The position we have now reached is that we have found a number of motives of various kinds bearing upon why Guercino should have persisted in the re-orientation of his style in the classic direction, but no very definite reason, beyond the word "Rome," why that process should have started precisely when it did. Accordingly our next step must be to investigate the artistic situation in Rome in 1621-23, with special reference to art-theory.

3. Guercino and Agucchi

During the previous twenty-five years, in spite of her powerful bulwark of classical antiquity, Rome had undergone invasion, and indeed part conquest, at the hands of the unorthodox and robust "naturalism" of Caravaggio and his followers. This tide of barbarity, as prejudiced classicists might have been tempted to call it, had now begun to recede; indeed the future of *Caravaggismo* as a living and active movement in Rome was

vera formalità in apparenza; ricercando cosi l'Arte Pittoresca" (and cf. also note 40 of Appendix 1). The appropriateness of all this to the art of the young Guercino (with its strong Venetian elements) need not be stressed, and we must regret that Boschini did not appèar on the scene at the beginning of the century. Kristeller has pointed out (Thieme-Becker, *Künstlerlexikon*, IV, 1910, p. 393) that Boschini's own style of engraving is much in the manner of G. B. Pasqualini's work after Guercino.

[88] Félibien, *Entretiens, seconde édition*, II, 1688, p. 666. We are of course discussing Dufresnoy's theories merely as a typical manifestation of the classic outlook, and not as a definite influence on Guercino. But I must confess I am much intrigued (in a regrettably Malvasia-like fashion, no doubt) by the possibility of Guercino having been at work on the *Purification* in the presence of Dufresnoy; a slim *Dialogo* between Il Centese and Il Parigino would have made interesting reading!

now becoming open to doubt, with the disappearance of that *éclat* of fashionable novelty which had doubtless, in the early days, acted as a counterweight to the more conventional and traditional currents of ecclesiastical opinion.[89] The last decrepit traces of Mannerism were moribund. The Full Baroque, in the sense of Lanfranco's cupola of Sant'Andrea della Valle (1625-1628) and Pietro da Cortona's Barberini ceiling (1634-39), had not quite begun. There remained the Classic Baroque, which had originated with the Roman period of Annibale Carracci (who died in 1609), and of which the principal modern representative was his pupil Domenichino (1581-1641).[90]

As we have seen, Guercino was summoned to Rome by the newly-elected Bolognese Pope, Gregory XV, who as Cardinal

[89] Caravaggio had died in 1610, and by 1621 most of his surviving followers had left Rome or were on the point of departure (a notable exception being Le Valentin, who died there in 1632); *Caravaggismo* of course still had a flourishing future before it, but not at Rome, where it only survived spasmodically and in transitory forms. The question soon begins to arise whether the application of the term to certain watered-down Roman productions after this date can really be justified, except when used in a very general way. Cf. also note 172 of this Part.

[90] A word or two seems necessary here on the subject of terminology. Though the relatively recent understanding of Mannerism as a quite different artistic language from Baroque has somewhat curtailed the original scope of the latter (involving the secession of such figures as Tintoretto and El Greco), the use of the expression Baroque as a general term in its widest sense (such as Gothic), seems to have come to stay, owing to the influence of the work of Dr. Wölfflin and others. Accordingly it would appear to be desirable to abandon its use without qualification when reference to a particular phase of the style is required. For example, to equate Roman Full Baroque with Baroque *tout simple* is ultimately to invite misunderstanding. In my view that classification is most usefully adopted which regards (Early) Baroque as beginning with the Carracci at Bologna, and with Annibale Carracci and Caravaggio at Rome, in each case against a background of the local types of Mannerism; this of course involves an understanding of the Carracci as students of nature, a jettisoning of the dead weight of the eclectic fable (cf. Part IV below), and a realization that the Galleria Farnese is not a return to Renaissance Classicism, but an entirely new Baroque Classicism. The momentary predominance of classic ideas during the short Pontificate of Gregory XV (1621-23) has been emphasized recently by Mr. John Pope-Hennessy ("Two Portraits by Domenichino," *The Burlington Magazine*, LXXXVIII, 1946, pp. 186-191).

Alessandro Ludovisi, Archbishop of Bologna, had been one of his principal patrons for some years previously.[91] The future Pope had also taken a very special interest in Domenichino, as extracts from three letters written in April 1620, by the then Cardinal Alessandro to his nephew Ludovico (afterwards Cardinal) bear witness;[92] and Passeri tells us[93] that as soon as Domenichino heard of Ludovisi's election (9 February, 1621) he came *volando* to Rome, and was immediately appointed Architect of the Papal Palace.[94] A passage in *Felsina Pittrice* may serve to introduce the connexion between the Ludovisi family and the Bolognese prelate Monsignor Giovanni Battista Agucchi (1570-1632), who had befriended Domenichino from the time when he arrived in Rome as a beginner; it is one of Malvasia's typically vague and ambiguous passages, but the fact does seem to be established from it that Ludovico Ludovisi (who as *Cardinal Nipote* was to be the most influential personage at the Papal Court during the short Pontificate of Gregory) had, before his uncle's election, made the acquaintance of Agucchi, and that they had found common ground in the discussion of art, with particular reference to Guercino and Domenichino.[95] Ample testimony is available as to Agucchi's high opinion of

[91] The letter from Lodovico Carracci of 19 July 1617 referred to in note 52 of this Part mentions that Guercino had come to Bologna to carry out commissions from the Archbishop (for extract, cf. note 92 of Appendix 2).

[92] Cf. Ludwig Freiherr von Pastor, *Geschichte der Päpste*, XIII, Abt. 1, Freiburg im Breisgau, 1928, p. 40 (Eng. Ed. XXVII, p. 47).

[93] For Domenichino's close relations with the Ludovisi at this time, cf. Passeri, *op. cit.*, ed. Hess, pp. 43 ff.; Passeri was of course a friend of Domenichino towards the end of the latter's life.

[94] Cf. the Papal Brief of 1 April 1621 published by A. Bertolotti (*Artisti Bolognesi . . . in Roma*, Bologna, 1885/86, pp. 127 f.), and records of various salary payments in 1621 to Domenichino as *Architetto di Palazzo* published by J. A. F. Orbaan (*Documenti sul Barocco in Roma*, Rome, 1920, pp. 352 f., 355 f. and 360 f.); cf. also Thieme-Becker, IX, 1913, p. 402, and note 123 of this Part.

[95] Malvasia possessed, or had access to, an enormous collection of letters written by Agucchi to his friend at Bologna the Canonico Bartolomeo Dulcini. The passage given below appears in *Felsina Pittrice*, 1678, II, p. 314; the quotation italics are Malvasia's own. "Delle sue [i.e., Agucchi's] seicento lettere al Canonico Dulcini in una così scrive: *Guido comincia con*

Domenichino; the following extract (published by Malvasia[96]) from one of his letters may be taken to typify it:

"Se non è conosciuto adesso, serà conosciuto col tempo, e in quella guisa, che lasciando i dipinti del Francia, di Pietro Perugino, e de' Bellini, che prima sembrauano miracoli, hanno atteso à studiare i nostri maggiori l'opre di Michel Angelo, di Raff[a]elle, e di Titiano, lasciando anche questi i nostri successori, si esserciteranno sù quelle di Annibale, come già fanno, andando tutti alla Galeria, e sù quelle del nostro Domenico, morto, che sia, già che anche vivo hà questa gloria di vedere tutto il dì copiare il suo bel quadro del S. Girolamo, e disegnar le istorie della Santa Cecilia."

Have we any further information with regard to this ardent admirer of Domenichino, both as regards his connexion with Guercino's patrons, Gregory XV and Cardinal Ludovico Ludovisi, and as regards his interest in art? At the time of Gregory's election Agucchi was *maggiordomo* or secretary to Cardinal Pietro Aldobrandini, who died the next day. On that very same evening Agucchi was appointed Secretary of State to the new Pope.[97] The Venetian *obbedienza* envoys, in their report of the same year, are in no doubt as to the importance of his position; they describe him as *Segretario di Stato et il principal Ministro che oggidì si trovi in Palazzo*.[98] When we

lui [Domenichino] *à perderla, ancorche habbia dalla sua la fortuna:* & in un altra: *che il Guercino non vi haveva che fare &c.* dando a quel Canonico parte, che il Nipote del Card. [Alessandro] Ludovisio, che fù poi Papa Gregorio XV. era stato di lui, e gli aveva parlato assai di pitture, delle quali si mostrava molto vago: che gli aveva fatto vedere un quadro di quel pittore da Cento, soggionge: *mà non gli pare di haver mirata cosa più bella di questi tempi, che due quadri di Domenico, che hà il Sig. Cardinal Burghese, posti in paragone di cento altri di valenti Maestri, anche de' tempi andati.*"

[96] Malvasia, *Felsina*, 1678, II, p. 341 (where the whole passage is printed in italics to convey that it is a quotation from Agucchi's original letter).

[97] Pastor, *Geschichte der Päpste*, XIII, Abt. 1, pp. 56 f.; Eng. Ed., XXVII, p. 70.

[98] Nicolo Barozzi and Guglielmo Berchet, *Relazioni degli Stati Europei lette al Senato dagli Ambasciatori Veneti*, Serie III (Italia), Relazioni di Roma, I, Venice, 1877, p. 130.

add that Agucchi had the reputation among the *letterati* of being well versed in artistic matters, that he had been a friend of the Carracci, that Domenichino had actually lived in his house for many years, and finally that he wrote a Treatise on painting, it becomes evident that he was particularly well suited and equipped for influencing artistic policy under the new Pontificate. In consequence it is obviously desirable to ascertain as much as we can about his views on art. A preference for the more classic tendencies might be inferred by what has already been said, and from various scattered quotations from Agucchi's writings which we find in Malvasia and Bellori and which are fairly well known. But the fullest and most comprehensive evidence as to his opinions is provided by a rather long extract, published posthumously in 1646, from his Treatise on painting (the composition of which is probably to be placed roughly between the years 1607 and 1615). This document is of interest to us in our present enquiry in that it makes Agucchi's sympathies with the classic style abundantly clear, but its more general importance, which has been hitherto overlooked, lies in the fact that it reveals Agucchi as part-progenitor of the classic-idealist theories systematized afterwards by Bellori. This last aspect will be dealt with separately in a study of the position occupied by Agucchi's views in the history of art theory, together with some notes on his life and his relations with the Carracci and Domenichino.[99]

Our concern here is to get some idea of the "official artistic atmosphere" in which Guercino found himself on his arrival at the Papal Court; in other words, we are trying to ascertain the general direction in which it seemed likely that official patronage would be bestowed, and whether this could be interpreted as favouring a particular style. With this end in view we may proceed to summarize the salient points of Agucchi's theory of artistic excellence as set out in his *Trattato*. Agucchi asserts that some painters, concerning themselves only with the imitation of

[99] See Part II below: "Agucchi and the *Idea della Bellezza*: a stage in the history of a theory." A reprint of the complete text of the surviving fragment will be found in Appendix 1.

that which is ordinarily visible to the eye, have made their final aim the exact reproduction of nature, *come all'occhio appare*, without seeking for anything more. But the understanding and intellect of others aspire to more lofty heights, for they embody in their conception that excellence of beauty and perfection which nature herself (though in practice invariably prevented by a multiplicity of material circumstances) would nevertheless wish to attain. The works of these *valorosi artefici* represent the world (*le cose*) not as it actually is, but as it ideally ought to be, bringing together with subtle artistry those elements of beauty which they see that nature has contrived to scatter here and there, perfect parts of necessarily imperfect wholes. It is easy to understand, says Agucchi sarcastically, how much praise those painters deserve who merely imitate nature. It is because they are not capable of understanding that beauty which nature would wish to bring into existence that they remain content with what they see to have been expressed in actual fact, even though they find it exceedingly imperfect. Moreover the public[100] approves of a close imitation of nature, because it derives pleasure from the representation of things with which it is familiar; but the enlightened and discerning man (*l'huomo intendente*) lifts up his thoughts to that *Idea del bello* which nature shows that she wishes to achieve, and looks upon it, enraptured, as upon a thing divine. Even in portrait painting (which one would assume to be more tied to mere appearance than religious or "historical" compositions) the artist can rise above nature; the best (*più valenti*) painters, without detracting from the likeness, have brought art to the help of nature and represented the faces of their sitters as more beautiful and impressive than they actually are, showing an understanding, even in this type of work, of that extra measure of beauty which nature would have wished to add to particular individuals, in order to perfect them completely.

So much for our synopsis of Agucchi's "Ideal of Beauty." In my view the following is the correct interpretation of the

[100] The sense is: the uneducated *volgo*.

circumstances which gave birth to the theory.[101] Here, as so
often, we have an instance of a critical standpoint which
originates in the rationalization of a personal preference, but
which is afterwards expanded into a theory intended to be
universally applicable. In order to clothe it effectively with
this general validity, Agucchi seems to have cast about in the
then existing theoretical literature for ideas which would supply
him with a plausible justification of his own inclinations.[102]
His theoretical attitude sprang from, and remains based upon,
his liking for a particular vehicle of artistic expression,[103] a
stylistic tendency to which we have attached the term classic;
we know for a fact that he had a very special admiration for
the works of Annibale Carracci[104] and Domenichino, and re-
gard his theory (to the effect that they, like their equally
admired forerunners Raphael and the sculptors of antiquity,

[101] I am assuming that the authorship of the *Trattato* is what it purports
to be; in other words, that it is in fact substantially the work of Agucchi
himself. The question is discussed more fully in Part II below.

[102] For suggestions with regard to the literary origins of Agucchi's theory,
cf. Part II below.

[103] Some of Agucchi's uses of that hydra-headed expression *maniera* may
be noted. He has some intelligent remarks on the personal *maniera* of the
individual, but we are more concerned here with the general, collective
maniera of a group; to this he tends to give a part descriptive (*genere, sorte*),
part qualitative, connotation. Thus we get a potential association between
merely natural (i.e., vulgar) models and low quality (an association which,
as we shall see in Part II, goes back as far as Aristotle). The touchstone of
relative excellence is evidently the point of view adopted by the group
towards the reproduction of nature. The best manner (*una maniera d'una
sovrana perfettione*) is connected with the *Idea* in theory and with the Carracci,
Raphael and the *statue antiche* in practice; the inference being of course that
the mere imitation of nature is a different, and less good, manner. But
Agucchi also criticizes the other extreme, what we should now describe as
the Mannerist style, using the expression *maniere lontane dal vero*; this connects
up with that simple use of the term in a disparaging sense which had already
been employed, e.g., by Lodovico Dolce (*Dialogo della Pittura*, Venice, 1557,
f. 50 v.: "maniera, cioè cattiva pratica"), and which was ultimately to
become the most common. Both meanings are given by Baldinucci (Filippo
Baldinucci, *Vocabolario Toscano dell'Arte del Disegno*, Florence, 1681, p. 88),
maniera ideale being favourable and *ammanierato* unfavourable, but both
relating to a deviation from strict adherence to nature.

[104] The stress is on Annibale's Roman, and therefore more classic, works.

were aiming at the identical and true ideal of beauty) as a perfectly natural line of argument in defence of that taste.

We may now suggest some inferences which could be drawn from Agucchi's general standpoint. Since we have had occasion to refer to those *statue antiche* which were so revered by him we may take the opportunity here to point out his apparent feeling that idealized, as opposed to mere, nature comes more easily to the artist who works in isolated, tangible material, the sculptor, than to the painter. "Demetrio," Agucchi says, "*benche*[105] questi fosse Scultore, andò tanto dietro alla simiglianza, che alla bellezza non hebbe riguardo;" thus beauty is somehow connected with that defined solidity which is implicit in sculpture. Given Agucchi's premises, this was an entirely logical point of view, and, though it is not followed up by an explicit advocacy of the isolation of the individual forms from each other, it falls in well with the "sculpturesque" tendencies which are in fact an essential element in the type of painting which he favours.[106] When Agucchi deals in general terms with the inadequacies of painters who are content simply to copy nature we have a shrewd suspicion as to the contemporary painter he has in mind. However, towards the end of the *Trattato* he removes any possible doubt on that score in the following passage: ". . . il Carauaggio eccellentissimo nel colorire si dee comparare à Demetrio, perche hà lasciato indietro l'Idea della bellezza, disposto di seguire del tutto la similitudine."[107] In his final paragraph Agucchi implies that

[105] My italics. The passage is quoted from p. 256 below.

[106] Cf. Malvasia's use of the adjective *statuino* in connexion with the Roman influence in painting (which, as a good Bolognese, he deplored); e.g., *quel fare Statuino* (*Felsina*, 1678, I, p. 359), and *dando nello statuino* (*op. cit.*, I, p. 484). Bellori, we are not surprised to see, objected to the use of the term in this deprecatory sense (*Vite di Guido Reni, Andrea Sacchi e Carlo Maratti*, ed. Michelangelo Piacentini, Rome, 1942, p. 115). We recall that a resemblance to sculpture suggested itself above in connexion with the Madonna in Fig. 6.

[107] This comparison between Caravaggio and Demetrios, a reputed naturalist of classical antiquity (quoted from p. 257 below), is of course taken over by Bellori and opens his account of Caravaggio (*Vite*, 1672, p. 201); for Demetrios, cf. also notes 78 of Part II and 39 of Appendix 1. The characterization of Caravaggio as a "colourist" became the accepted

those in authority (*i Principi*) should be guided in their judg-
ment and understanding of these matters (and consequently
in their patronage) by the well-founded conclusions of those,
dal conoscimento illuminati, who are blessed with genuine discern-
ment in artistic matters, rather than by the superficial opinions
of *altri, privi di quel lume*, who are merely impressed by the
thoughtless applause of the multitude or the forceful language
of certain painters who are more adept in the use of the tongue
than the brush; only so will the truly great artist be given the
opportunities he deserves and the enlightened patron win the
renown which is his due. This passage obviously reflects
Agucchi's partisanship of Annibale Carracci (who is to be
identified with the *vero Virtuoso* of the context), but its prin-
cipal interest for us lies in the conception which seems to under-
lie it of the role of the cultured and artistic mentor of the great
patron; he can visualize himself in this part, and an oppor-
tunity to play it on the boards occurred in 1621.

As we have seen, Agucchi's judgment in matters of art was
largely influenced by the qualitative differences which he sees
intorno all'investigare più ò meno la perfettione del bello. Can we
have any doubt as to the category in which the style of the
young Guercino, fresh from the North, would have been placed?
Meno, Agucchi must surely have thought; *eccellentissimo nel
colorire, ma* . . . We can see many reasons for Guercino falling
short of the highest classification in Agucchi's estimation. No
doubt his light-effects brought Caravaggio to mind; still more
his unsophisticated plebeian types, so obviously contrary to the
Idea della Bellezza. The strict classicist always dislikes liberties
with the human form, that foundation of *buon disegno*; here
Guercino offends much more than Caravaggio, and indeed his
povertà di contorni almost rendered him liable to the same sort of

thing during the Seicento (cf. Margot Cutter, *op. cit., Marsyas*, I, 1941,
pp. 95 ff.), but Agucchi's use of it (with the connotation of *limited* praise)
must be one of the earliest instances. Cf. also Malvasia's report of Reni's
opinion of Guercino, quoted at the beginning of note 62 of this Part. The
idea that too much devotion to colour was incompatible with the highest
art was an ancient one (e.g., cf. note 92 of Part II).

criticism as the Mannerists. Let us illustrate the difference between Guercino and the classic point of view in one particular field: "history painting," as it would have been loosely termed in the Seicento. Here it must be understood that we are not concerned with the contrast as we now see it, more or less through Wölfflinian spectacles, but simply as we imagine Agucchi to have seen it. To a *letterato* of that time a "history" appeared the most exacting subject-matter for an artist, and the manner in which he treated the dramatic aspect of the scene would bulk large in any estimate of his work. It is from this angle that we shall proceed; and in doing so we shall take the opportunity to give a proper balance to our picture of Agucchi as the highly cultured connoisseur. It would be most misleading if what we have said on the subject should give rise to any implication that the classic style and the taste of the educated man were at that time *necessarily* to be equated. Such an equation only comes near to the truth if our man of learning was specially interested, like Agucchi, in working out some reasoned theory of art.[108] But there was another type of educated *dilettante* (we find more of the amateur and less of the professional about him), who has a natural instinctive flair for artistic matters without feeling any urge towards explicit rationalization.

This sort of enthusiast is never very uncommon, and, if I am not mistaken, we have an example of him in Cardinal Jacopo (Giacomo) Serra (1570-1623), with one of whose commissions, the *Elijah*, we have already had occasion to deal. The Cardinal, who as Legate administered Ferrara (and consequently Cento, where Guercino was then living) on behalf of the Papal Government, came into contact with him in 1619 and 1620, and seems to have been fascinated by his work. Malvasia[109] mentions

[108] Cf. Part III below for some remarks on the difficulties in producing a reasoned polemic, which would pass muster in literary circles, in favour of an "un-learned" form of art.

[109] Malvasia, *Felsina*, 1678, II, p. 364. He says that the Cardinal was particularly attracted by the relief which Guercino gave to his figures; certainly all the compositions carried out for Serra are conceived in a bold and powerful manner which presented opportunities, on occasion, for a striking piece of foreshortening.

three pictures painted for Serra in 1619,[110] and two in the subsequent year, of which one is the *Elijah* (Fig. 1) and the other *Jacob blessing the sons of Joseph* (Fig. 19).[111] Malvasia's

[110] One of these three pictures, *The Return of the Prodigal Son*, is in my opinion identical with that in the Kunsthistorisches Museum at Vienna (No. 543); it is reproduced in Ernst H. Buschbeck, *Führer durch die Gemälde-galerie* (Vol. 3 of *Führer durch die kunsthistorischen Sammlungen in Wien*), 4th ed., Vienna, 1936, p. 119. The other two I only know from copies and from some fine composition drawings, but their general character fits perfectly into the group.

[111] The identification of this picture (canvas, 1.70 × 2.115 m.) with the *Giacobbe che benedisce il figlio* of 1620 referred to by Malvasia (*loc. cit.*) was first made by Dr. Hermann Voss (*Zeitschrift für Kunstgeschichte*, II, 1933, p. 198); it was acquired by the present writer in Paris in 1934. The painting has a somewhat chequered history, part fact and part speculation, of which we may give a summary here. During the middle of the last century it was very probably in the collection of Lord Northwick at Thirlestane House, Cheltenham. It was engraved in 1808 in Madrid by Rafael Esteve y Vilella from a drawing by Josef Martinez, and both plate and drawing are in the Calcografía Nacional at Madrid; they show that the canvas has been cut down (I calculate at least 11 cm. at top, 9 cm. on left, 6 cm. on right, and perhaps very slightly at the bottom), but Martinez' drawing settles the identification by reproducing in the form of a kind of side-whisker on the face of the younger boy what is in fact an old restoration in the painting. There can be no doubt that the picture drawn by Martinez is that described by D. Antonio Ponz (*Viage de España*, V, Madrid, 1776, pp. 43 f.) as being in the Sacristy of the Church of San Pascual at Madrid: "Del Güercino es el quadro . . . con quatro figuras, y representa á Jacob en su lecho dando la bendicion á Efrain, y Manasés, obra de grande efecto, y mucha naturalidad." It is also mentioned in the anonymous *Paseo por Madrid, ó Guia del Forastero en la Corte* (Madrid, 1815, p. 40) but the fine collection of works of art with which the Church was filled in the time of Ponz had already been much depleted, and the church itself was finally suppressed *circa* 1836. San Pascual, founded in 1683, received the greater part of its numerous pictures from its founder, D. Juan Gaspar Enriquez de Cabrera, 6th Duque de Medina de Rioseco and 10th hereditary Admiral of Castile (Almirante mayor de Castilla), who died in 1691 and was buried there. His father D. Juan Alfonso (Alonso) Enriquez de Cabrera (1597-1647), 5th Duque and 9th Almirante, was reported in 1638 to be making a collection of pictures, and was later appointed to the coveted Spanish viceroyalties in Italy, with their great opportunities for the acquisition of works of art. After being Viceroy of Sicily in 1641-44 and of Naples in 1644-46, the Almirante was appointed *obbedienza* Ambassador to Innocent X and spent the period between 24 March-4 June 1646 in Rome. In connexion with this visit, Francesco Mantovano, envoy of the Duke of Modena (to whom Guercino was no

testimony as to Serra's enthusiasm for the work of the young painter is well supported by other evidence. There exist various manuscript copies of the *Croniche di Cento* written by the Canonico Biagio Bagni down to 1621 and continued by another hand until late in the Seicento. This chronicle (which for our purposes represents a contemporary account) describes a visit of the Legate to Cento, where he arrived on 8 September, 1619, and was entertained for two days by the *Comunità*, which is reported to have presented him on his departure with a picture by Guercino. It transpires that Guercino had already spent several months at Ferrara painting for Serra, who had apparently lodged him in the Castello, and whose esteem for his

stranger), reports in a despatch from Rome dated 19 May 1646 and preserved in the Archivio di Stato at Modena (Cancelleria Ducale Estense; Estero, Italia, Ambasciatori da Roma, busta 199): "L'Almirante quando visitò il Card.[1] Sacchetti, lodò un quadro del Guerzino da Cento, et Sua Em.[za] subito glie l'hà donato." It is true that there were two Guercinos in San Pascual, but the probability is that the other was received by the Almirante (during the same mission) from D. Niccolò Ludovisi, Principe di Piombino, the nephew by marriage of the Pope (cf. note 167 of this Part). Thus there is a fair *prima facie* case for supposing that *Jacob blessing the sons of Joseph* was the picture referred to in Mantovano's despatch, and that the Almirante acquired it as a gift from Cardinal Giulio Sacchetti (1587-1663), whose interest in art was well known, and who at this time was undoubtedly anxious to create a good impression in Spanish circles, as the Spanish vote had blocked his election to the Papacy two years earlier. That the picture should have found its way into Sacchetti's hands is not so extraordinary. Serra was still Legate at Ferrara when he had suddenly to make the journey to Rome for the election of the new Pope in 1623: he died there as a result of an illness contracted during the conclave. Sacchetti went to Ferrara as Legate three or four years later, and could very well have acquired the picture then, possibly from Serra's heirs. It is interesting to note that Velazquez paid his respects to Sacchetti at Ferrara in 1629, and, presumably at the Legate's suggestion, visited Guercino at Cento on his journey southwards (F. J. Sánchez Cantón, *Fuentes literarias para la Historia del Arte Español*, II, Madrid, 1933, pp. 139 f., and IV, Madrid, 1936, pp. 154 f.). It may be that there are reminiscences of Guercino in *Joseph's Coat* and *Vulcan's Forge*, painted by Velazquez in Rome during the subsequent year; attention has already been drawn to this possibility by Sr. D. Juan Allende-Salazar in his edition of the volume on Velazquez in the *Klassiker der Kunst* series (1925, p. 276), though he cites Palomino (1724) as the source for the story of Velazquez' visit to Cento, whereas it actually originated with Pacheco (1649).

work was consequently well known.[112] Whether or not Guercino was present on this occasion and the Cardinal carried him off again to Ferrara we cannot be sure, but he writes from there a few days later to the Duke of Mantua (who evidently wanted a painting from him) regretting that he could not find time to pay his respects to the Duke in person.[113] Later in the same

[112] I have seen five manuscript copies of this chronicle, which have the usual variations from each other: three are in the Biblioteca Universitaria at Bologna (Nos. 210, 2401, and 195; Nos. 280, 1412, and 270 respectively in the printed inventory), and two in the Archivio Comunale at Cento (Nos. 160 and 170). I quote the passage mentioning Guercino from the Bologna MS. No. 210 (fol. 130 verso): ". . . stato che egli [i.e., Cardinal Serra] fu p[er] duoi giorni in Cento rientrò a Ferrara, e nel partire la Comunità li donò un belissimo quadro dipinto p[er] mano di Gio: Fran⁰ Barbieri Centese, sapendo quanto egli teneva care le opere sue, havendolo tenuto in Ferrara alcuni mesi molto honoratamente apresso di se p[er] farlo dipingere alcuni quadri che sono stimati eccelentissimi et essendo d⁰ pitore remunerato assai . . ." The writer, D. Biagio Bagni of Cento, gave Guercino in 1613 one of his first important commissions in his native town.

[113] Letter dated from Ferrara on 17 September 1619 and published by A. Bertolotti, *Artisti in relazione coi Gonzàga Signori di Mantova*, Modena, 1885, pp. 59 f. From this letter we get some light (of the usual kind) on Malvasia's methods. Under the year 1618 he says (*Felsina*, 1678, II, p. 363) that Guercino made a series of drawings for the instruction of beginners and that the booklet was engraved by Oliviero Gatti with a dedication to the Duke of Mantua, to whom a copy was sent; the Duke thereupon ordered a picture from Guercino, who took it in person to Mantua. If one read Malvasia *alla lettera* one would assume that all these events occurred in the one year, 1618. Actually (as Malvasia was aware in another context, I, p. 109) Gatti's work was dated 1619; and it is clear that our letter refers to its delivery in that year to the Duke. It further appears that Guercino's own visit to Mantua with his picture was put off until 1620 at any rate; since some acquaintance with Rubens' work was possible there, and Domenico Fetti was in charge of the Duke's famous and extensive gallery (including, e.g., Caravaggio's *Death of the Virgin*), the fixing of the date of Guercino's visit some two years later than a literal reading of Malvasia would lead one to suppose is not entirely without interest. The origin of the misunderstanding in *Felsina Pittrice* is probably due to Malvasia having come across a (correct) reference in his source to the drawings having been carried out and taken to Venice in 1618, which however caused him to plunge straight into a related sequence of events regardless of the fact that he was giving the impression that they all occurred in the single year. The supposition that Guercino's visit to Mantua took place not very long before his journey to Rome in the early summer of 1621 is supported to some extent by Mancini,

year, on 10 December, he writes two letters from Cento to unnamed gentlemen at the Mantuan court making it perfectly clear that he cannot visit Mantua without the "buona licenza dall' Ill.mo Legato di Ferrara, a cui di già sono obbligato di parola."[114] The *Elijah* and *Jacob blessing the sons of Joseph* were painted during the next year, 1620, at the end of which Guercino was granted the title of Cavaliere[115] by the Legate.[116]

We now turn to our contrast between the young Guercino's attitude towards the rendering of an *istoria* with dramatic possibilities, and that of an artist who conformed more strictly to the classic standpoint. The story commissioned from

the main text of whose Venice MS. (Marciana MS. it. 5571) was completed in that year. Mancini scribbled some additional notes, obviously written at different times, in the margin of his account of Guercino on fol. 87 recto. That reading "dico[no] esser apresso al Sereniso di Mãtova" must reflect a rumour which reached Mancini during the first half of 1621 before Guercino's arrival in Rome (to which two other subsequent *postille* on the same page are related, cf. pp. 310 ff. below); such dating falls in very well with various other additions to the Marciana MS. which refer to events which occurred in 1620 or early in 1621 (cf. note 42 of Appendix 2). Cardinal Serra had to go to Rome for the conclave in February 1621, and Guercino (if he had not been able to pay his visit to Mantua during the previous year) may possibly have taken advantage of the Legate's absence to do so then.

[114] A quotation from one of these letters (Bertolotti, *Artisti in relazione coi Gonzaga*, pp. 60 f.) may serve to illustrate Guercino's position in relation to Serra: "Sarò sempre prontissimo alli seruitii del sereniss.o sig.r Duca di Mantova quando sarò sbrigato da obblighi che tengo a diversi signori, ma principalmente all'Ill.mo legato di Ferrara senza del cui consenso non potrei già mai partirmi: onde V. S. che intende faccia che ui sia il compiacimento di questo Ill.mo che io uedrò poi robbare alcuni giorni per sodisfare in parte a sua altezza . . ."

[115] The original patent of *cavalierato*, dated 8 December 1620, was first published in a footnote to the 1841 edition of *Felsina Pittrice* (II, pp. 284 f.). Malvasia will be seen to have indulged in his usual procedure by inserting his reference to the honour conferred on Guercino soon after the first appearance of Serra in his text, thereby giving rise to the implication that Guercino received it in 1619 rather than in 1620. According to Malvasia, Guercino also received the title from the Duke of Mantua, on the occasion of his visit to that town.

[116] Jacopo Serra, who seems to have had financial ability, was for some time in charge of the Papal Treasury, and had relations with artists in this capacity (e.g.: payment of Rubens for the pictures in Santa Maria in Vallicella; clash with Reni, cf. Malvasia, *Felsina*, 1678, II, pp. 20 f.).

Guercino by Serra in 1620 is that told in Genesis,[117] when Joseph brought his sons, Manasseh and Ephraim, to their aged grandfather, in order to receive the latter's blessing; the crux of the incident from the dramatic point of view is of course Jacob's unexpected decision (against which Joseph protests) to give the right-handed blessing, usually reserved for the first-born, to the younger grandson Ephraim.[118] At the beginning of this essay, when analysing the formal character of the *Elijah*, we particularly noticed the apparent instability of the composition, and gained the impression that Guercino's interest appeared to lie in the capture of a fleeting instant. Obviously an artist attracted by the changeability of the world rather than by its intrinsic substance was likely to welcome a theme with strong dramatic possibilities, in that such a subject carried with it some literary justification for the expression of what was in reality an artistic instinct; and we may well believe that this was the case with *Jacob's blessing*. As Dr. Stechow has put it in an excellent analysis of the composition: "The most transitory moment of the story has been selected with an unfailing instinct for dramatization."

Everything essential in the episode is crystallized into this single vital instant. Nothing can last. The creak of the stool on which Joseph kneels and his hurried words to his father are over in a trice; the old man's hands cannot hover for more than a second or two, nor can his uncomfortable position be maintained; his head must soon turn towards the boys, and Manasseh's head must be lowered; we cannot believe that the position of the bedclothes can remain unaltered. This, we are meant to feel (and we may guess that such *verismo* was a great part of the attraction for the less conventional type of Seicento amateur) is just how the incident must have occurred in actual

[117] Genesis, chapter XLVIII, verses 8-20.

[118] Verses 17 ff.: "And when Joseph saw that his father laid his right hand upon the head of Ephraim, it displeased him: and he held up his father's hand, to remove it from Ephraim's head unto Manasseh's head. And Joseph said unto his father, Not so, my father: for this is the firstborn; put thy hand upon his head. And his father refused, and said, I know it, my son, I know it . . ."

fact, no stage-managing, no rehearsals, the intimate drama of
the significant embodied in the apparently casual; the partici-
pants seem to be ordinary individuals, not remote figures
symbolizing the prophetic importance of the occasion.[119]

From what we know of Agucchi's opinions we can hardly
doubt that he would have considered treatment of this kind
as excluding the artist from the highest category. What some
observers[120] would have welcomed as the astonishing truth to
ordinary life of the presentation as a whole, Agucchi would
have merely regarded as the point at which the more lofty
flights of art begin. One should not try to visualize, he says,
what the appearance of Alexander or Caesar actually was, but
what that of a king or a strong magnanimous leader *ought to be*.
It is obvious that such a doctrine is readily applicable to the
treatment of dramatic incidents from the scriptures. These, it
would be argued, should not be portrayed in terms of the bare
bones of the story and in the superficial, chaotic language of
everyday life; instead the artist should rise above the individual
to the ideal and should make the spectator conscious of the
deeper implications of the event which he is interpreting. It
should be painted not as it may actually have happened in this
imperfect world, but as (in the light of our subsequent know-
ledge of its inner significance) it ought to have occurred. The
Holy Women at the Tomb (Fig. 20), a picture by Annibale
Carracci which there is good reason to believe actually belonged
to Agucchi,[121] may be taken to illustrate the idealized treat-

[119] Dr. Wolfgang Stechow has dealt with the iconography of the subject
in "Jacob blessing the sons of Joseph from early Christian times to
Rembrandt," *Gazette des Beaux Arts*, New York ed., 6th Series, XXIII,
Jan.-June 1943, pp. 193-208. He points out that two symbolic interpreta-
tions were attached to the story: first, "the decline of the Jewish people as
exemplified by the elder son, and the rise of the Christians as exemplified
by the younger—in other words, the substitution of the New Covenant for
the Old;" and secondly, supplemental to it, the idea that the crossing of
Jacob's hands was prophetic of the Cross of Christ. Dr. Stechow's remarks
on the present picture will be found on pp. 203 f.

[120] Agucchi would have said *il popolo*, ignoring amateurs of the type of
Serra.

[121] Malvasia (*Felsina*, 1678, I, p. 501) describes the picture as follows:

ment for which he clearly reserves the greatest praise. We may suppose that for Agucchi the special merit of Annibale's interpretation of the scene lay in the fact that, going beyond a statement of mere facts, of sorrowing women startled by an apparition, he sought to symbolize one of the supreme events in the history of mankind in the noble and dignified bearing of those taking part. The contrast is complete between these monumental, statuesque personages, to whom time is of no consequence,[122] and the lively matter-of-fact bustle of Guercino's homely characters.

What sort of relationship between Agucchi and Guercino during the years 1621-23 can be deduced from such facts as we have been able to ascertain? We do not of course possess explicit evidence that they met, but in view of the fact that Guercino painted the Pope's portrait, decorated the Casino Ludovisi, and provided San Pietro in Vaticano with an altarpiece, we may regard it as extremely probable. If they did

"In Napoli: Presso il Sig. Duca della Torre, Nipote del già Sig. Card. Filomarino Arcivescovo di quella Città, il famoso quadro, detto comunemente delle trè Marie; cioè le stesse, che ritrovano il graziosissimo Angelo *in vestimentis albis* al monumento, pittura inarrivabile, fatta da Annibale al suo tanto diletto paesano l'antiquario Pasqualini, da questi passato per eredità a Monsig. Agucchi, e dopo la morte del Prelato e Nuncio a Venezia, nel Sig. Cardinale sudetto . . ." I do not think Malvasia is very likely to be incorrect over a matter such as Agucchi's ownership of the picture, which is in any case a typical classic version of a dramatic *istoria* and therefore suitable for our contrast. The picture was engraved by Jean Louis Roullet (1645-99); it is mentioned by Carlo Celano (*Delle notitie del bello . . . della città di Napoli*, Naples, 1692, IV, pp. 36 f.) as in the possession of the nephews of Cardinal Ascanio Filomarino, and remained during the eighteenth century in the Palazzo della Torre, where it was noted by Cochin and Lalande; after passing through the collections of Prince Lucien Bonaparte and W. G. Coesvelt it was acquired by the Hermitage in 1836. The canvas measures 1.21 × 1.45 m. Cf. *Bulletin of the City Art Museum of St. Louis* (XV, 1930, pp. 64 ff.) for the same group of figures in a landscape; the St. Louis picture is not by Annibale himself, and appears from a photograph to be a slightly later free derivative of the Hermitage picture.

[122] Notwithstanding various painterly features (for instance, in the handling of light and shade), this atmosphere of seriousness and gravity serves to illustrate Annibale's position as part-ancestor of classic "history-painting," of which we may cite Poussin's *Death of Sapphira* in the Louvre as a developed example.

meet, we can hardly imagine that the Agucchi we know from the *Trattato* would have expressed unqualified praise for the rather daring work of this unsophisticated young newcomer. Without suggesting that Agucchi solemnly read Guercino a lecture on the theme of the *Trattato*, we may well believe that he let drop hints in line with its general principles and with his personal tastes; for example, some indication that Guercino's types were too plebeian, and would benefit by an extra measure of nobility, dignity and grace. We may hazard a guess, too, that he might have referred to his view (as we find it in the *Trattato*) of the profit which Annibale is supposed to have obtained from Raphael and the *Statue di Roma*, finding in them "più alto intendimento, e maggior finezza del disegno, che nell'opere di Lombardia." Such opinions, coming from one who was not only in the confidence of Guercino's patrons, but had also been a friend and partisan of Annibale, the "father" of the Bolognese group in Rome, were likely to carry a certain weight. Finally, whatever the form Agucchi may have employed to give expression to his classic preferences, the practical consequence for Guercino must have boiled down to a suggestion that he should study a particular type of art, and indeed the works of a particular artist, the then Architetto di Palazzo— Domenichino. The likelihood that Guercino would have paid more than routine attention to Domenichino's work can be postulated even though we leave a meeting with Agucchi on one side, for the fact that Domenichino had been a protégé and special friend for many years of the Segretario di Stato was common knowledge in artistic circles. Accordingly, we shall combine our examination of a selection of Guercino's paintings produced during and soon after his visit to Rome with that of some of the principal works of Domenichino available to him for study there.

4. Guercino and Domenichino

Giulio Mancini, writing just before Guercino's arrival, gives
us a short list of paintings by Domenichino at or near Rome,
which we may take to cover those then considered to be the
most important. After mentioning the frescoes in S. Onofrio,
at Grottaferrata, and in S. Gregorio, he says:[123] ". . . fece . . .
in S. Luigi la Cappella di S. Cecilia, e doppo Il transito di
S. Girolamo nella Chiesa di S. Girolamo della Carità e l'Assun-
tion della Mad.na nella soffitta di S. Maria in Trastevere con
alcuni quadri fatti p[er] l'Ill.mo Borghese, frà quali è una Sibilla
di grand'arte e p[er]fettione."

Let us begin with Domenichino's well-known altarpiece of
the *Communion of S. Jerome* (Fig. 21), of which, as we have seen,
Agucchi had a very high opinion; it was painted in 1614 for
the Church of S. Girolamo della Carità, and is now in the
Pinacoteca Vaticana.[124] Certainly we can find considerable
painterly elements in this picture, notably the general reces-
sional character of the group on the left, but even so we cannot
but describe it as classic when compared with Guercino's
S. William or *Martyrdom of S. Peter*. The three clearly articulated
figures on the right tell separately in a way which is the precise
reverse of Guercino's practice, and even the recessional move-
ment on the left is seen to be tempered by a carefully arranged
fan-like subdivision of the forms. Domenichino's different use
of light-effects is particularly noticeable. If we compare the
method of lighting of the surplice of the kneeling youth with
that of the shirt of the man in the bottom right corner of

[123] Quotation from MS. it. 5571, Biblioteca Nazionale Marciana, Venice,
fol. 74 recto, main text; Mancini has apparently struck out the words
di S. Girolamo after *Chiesa*. Mancini adds a note in his own handwriting on
the verso of this sheet: ". . . adesso e stato dichiarato Architetto di S. B.
Greg.o 15" (for this appointment, cf. also note 94 of this Part).

[124] The canvas, 4.19 × 2.56 m., is signed and dated 1614. It was reported
as exposed to view in September 1614 (cf. J. A. F. Orbaan, *Documenti sul
Barocco in Roma*, Rome, 1920, p. 227). Bellori tells us (*Vite*, 1672, p. 309)
that it was greatly admired by Nicolas Poussin and Andrea Sacchi.

Guercino's *Martyrdom of S. Peter* (Fig. 14), we see that Domeni-
chino has deliberately made use of the lighting to bring out the
solidity of the figure as an isolated whole, whereas with Guer-
cino it serves further to disrupt an already fragmentary state-
ment of form. The figure of S. Jerome is fully lit all over and
his drapery does not render its clear articulation in any way
less apparent. The S. Peter, however, is cut in half by a very
emphatic dark blue drapery, his left shoulder is plunged into
shadow, and his left hand appears from nowhere with the un-
expectedness of a conjuring trick. One further example must
suffice to complete our illustration of the difference. S. Peter's
right wrist and the standing deacon's right hand (holding the
chalice) are both in shadow. With Guercino the result of this
is that we are in danger of losing the exact line (structure) of
the arm, because patches of darkness tend to connect up with
their neighbours, irrespective of the underlying forms. Domeni-
chino, however (in a passage in which, as I see it, he was
particularly interested), has made judicious use of the shadow
to bring the hand and chalice into strong relief silhouetted
against the lighter cope of the priest, while the actual arm
itself receives assistance in isolating itself from its surroundings
by means of a relatively strong effect of light on colour; both
light and shade respect the form and help to define it as such.
Guercino, on seeing this picture, must have realized that it was
based on entirely different principles to those hitherto employed
by him. Perhaps he would have summed them up in this sort
of fashion: more diffused light, more refinement and grace in
the characters,[125] quieter posing of the figures and more dif-
ferentiation from each other, and, finally, a greater interest in
the subtleties of formal contour—this last being, we imagine,
roughly equivalent to Agucchi's *finezza del disegno*.[126] Guercino

[125] The young kneeling deacon provides the most obvious example. We
may note in passing that this type of shadowed profile was probably in-
herited from Annibale Carracci (cf. Fig. 20, the most prominent of the three
women).

[126] A sentence from Bellori's analysis (some fifty years later) of the
Communion of S. Jerome may serve to illustrate the sort of connotation the
expression *disegno* had for a writer with classic sympathies: "L'esattezza del

must have been struck by the even greater contrast provided by *S. Cecilia distributing clothes to the poor* (Fig. 23), one of those frescoes in S. Luigi dei Francesi which Agucchi evidently regarded as the most important of the contemporary "history paintings," and would doubtless have recommended to Guercino for study as such.[127] Here Domenichino treats his figures as statuesque solids arranged in planes and bathed in a clear diffused light; their movements, however superficially lively, have something of the permanence of sculpture. Nothing could have been more congenial to Poussin, or less so to the young Guercino.[128]

However difficult the adoption of classic *disegno* and solidity might have seemed to a painterly artist in the case of a "history picture" in which the action was confined to *terra firma*, it would clearly have gone still more against the grain to introduce it into a subject involving vivacious movement in mid-air; in other words an *Assumption* or kindred subject, in presupposing certain effects of impermanence or even of atmosphere, would present an invitation difficult to resist. And indeed it does appear that traces of the study of classic works are least evident in Guercino's treatment of three such themes (one painted at Rome, and the others painted just after his return to Cento) when compared with three similar subjects which he would have seen during his stay in Rome. The slowly rotating vortex

disegno comprende tutte le forme; nè solo ciascun membro hà il suo contorno preciso, e corretto, ma continua ogni tratto all'operatione di tutta la figura nel modo più proprio della natura" (Bellori, *Vite*, 1672, p. 307.)

[127] For the dating of the S. Cecilia frescoes (after 1611, before 1617), see footnote by Dr. Jacob Hess to his edition of Passeri (*op. cit.*, p. 37, note 1); if Mancini's *doppo* quoted above is to be taken literally they were finished by 1614, which would agree with the later of the two inscriptions in the chapel. They are in an extremely bad condition, having been damaged by damp and several times retouched; however, they still record the lay-out of the compositions and can tell us something about the general intentions of the artist.

[128] A comparison between this composition and its prototype, Annibale Carracci's pre-Roman *Almsgiving of S. Roch* in the Dresden Gallery (reproduced by H. Voss, *Die Malerei des Barock in Rom*, Berlin, 1924, p. 157), makes it clear how much further Domenichino had travelled towards classicism.

of Annibale Carracci's *Assumption of the Virgin* (Fig. 22) in Santa Maria del Popolo is too crowded to justify our describing it as a typically classic composition, and yet if we study it in conjunction with Annibale's previous versions clear classic tendencies emerge; the symmetry of the arrangement and the monumental solidity of the forms (emphasized by the lighting) are pointers in that direction.[129] The figure of S. Cecilia in Domenichino's much damaged *S. Cecilia in glory* (Fig. 24) on the ceiling of the chapel in San Luigi dei Francesi obviously originates in part from Annibale's Madonna, but the general effect of the whole is remarkably different, even if we make due allowance for the fact one is an altarpiece in oils and the other a ceiling fresco. Instead of a massive, more or less homogeneous, spiral movement gradually gathering momentum, we have a symmetrical arabesque, a fretwork of individual silhouetted units tossing hither and thither with quick jerky motions. The single movement of Annibale is broken up, not into painterly patches of light and shade, but into classic fragments of form. Domenichino's *Assumption of the Virgin* (Fig. 25), let into the centre of

[129] This is of course the altarpiece of the Cerasi chapel, which also houses Caravaggio's *Martyrdom of S. Peter* (Fig. 13) and *Conversion of S. Paul*. There is no mention of Annibale in the document of May 1601 referred to in note 47 of this Part, so it seems likely that his picture was placed in position shortly after that date; the earliest document recording both artists' work there seems to be the *Viaggio per Roma* of Giulio Mancini (ed. Ludwig Schudt, Leipzig, 1923, p. 94). Perhaps some of the solidity in this picture is to be attributed to the example of Caravaggio. It would be incorrect to describe it as Caravaggesque, but it is the closest approach Annibale makes to one aspect of Caravaggio; its artistic offspring, as we have occasion to see here, have nothing whatever to do with Caravaggio. These first few years of the Seicento seem to have been the high-water mark of the influence of Caravaggism in Rome, with some of Annibale's pupils becoming momentarily affected by it. This may perhaps have been the case with Domenichino in his early *Liberation of S. Peter*, painted for Agucchi in 1604 (though we must not lose sight of the still stronger influence of Lodovico Carracci in the picture); in any case, Caravaggesque or not, it had no sequel. Reni also had a short episode of interest in Caravaggism, of which his *Crucifixion of S. Peter* (dated by Dr. Otto Kurz *ca.* 1601-03) is the outstanding example. But the only member of the Bolognese group in whom it seems to have found a more or less permanent, though not at all deep, root was Leonello Spada (cf. note 52 of this Part).

the carved and gilt ceiling of Santa Maria in Trastevere does not give quite such a *staccato* impression as the *S. Cecilia in glory*, but what a deliberate insistence on making the forms clear! Even the clouds are almost modelled solids.[130]

A short distance from Santa Maria in Trastevere stands the Church of San Crisogono, for which Guercino was commissioned in 1622[131] by Cardinal Scipione Borghese to paint *S. Chrysogonus*

[130] This was exposed to view in December 1617 (cf. J. A. F. Orbaan, *Documenti sul Barocco*, 1920, p. 252), and was a commission of Cardinal Pietro Aldobrandini, in whose service Agucchi then was. It is not impossible that the Cardinal's Secretary referred to by Passeri (*op. cit.*, ed. Hess, p. 42) as having doubts about the accuracy of the foreshortening was in fact Agucchi. In that event the bet of 10 *doppie* against a painting that the *Assunta* would turn out incorrect when placed in position would have been a matter of friendly raillery; and the acid tone of Passeri's story would have been a gratuitous addition of his own, providing a convenient pretext for pointing the moral that non-artists should not meddle in artistic matters. Cf. also note 158 of this Part.

[131] The present shape of the canvas (which measures approximately 4.80 × 2.96 m.) is due to some small additions having been made to it round about 1840 in order to adapt it to its present position. The composition originally showed two right angles instead of one at each point where the semicircles reach a parallel with the straight lines; perhaps this can be made out in the reproduction, since the nineteenth century additions have embellished themselves with a distinct *craquelure*. Malvasia says (*Felsina*, 1678, II, p. 365): "Servì il Card. Borchese con molta stima, e per lui fece un soffito nella Chiesa di S. Grisogono," and gives the date 1622 in the margin immediately opposite this passage; the style, which suggests that it was painted when Guercino had just about completed the first year of his Roman sojourn, entirely corresponds with Malvasia's date. A note recording Guercino's work *nella soffitta* was added by Giulio Mancini in his own hand to f. 181 v. of the Marciana MS. of his *Viaggio per Roma* (cf. p. 63 of Dr. Schudt's edition); the painting is also mentioned by Pompilio Totti (*Ritratto di Roma Moderna*, Rome, 1638, p. 75), who states that the gilt ceiling was placed in position in 1620, and records the inscription dated 1623 which commemorated Cardinal Scipione Borghese's embellishments. J. A. Calvi, writing in 1808 (*Notizie della Vita . . . del Cavaliere Gioan Francesco Barbieri*, Bologna, 1808, p. 163, note 26), says he has heard from Rome that a copy had been inserted *ultimamente* in the ceiling, and the original sold and taken to England. After being for some time in the collection of Alexander Day (the same referred to in note 46 of this Part), who seems to have been the importer, it was acquired by the Duke of Sutherland, placed in Stafford House, and eventually installed in its present position in the ceiling of the then picture gallery. When the London Museum took over the building

in glory (Fig. 26) on a canvas which was to be placed in a carved and gilt ceiling in exactly the same way as Domenichino's *Assumption*. Guercino must surely have known Domenichino's picture not far down the street and yet there are many stylistic leagues between them. In this work at any rate we still recognize the authentic spirit of the young Guercino; it is a painterly ceiling picture *par excellence*, and, apart from its considerable artistic merits, is altogether a remarkable performance for its date from the historical point of view.[132] To take one major divergence from the previous three examples, we note that Guercino has completely ignored the firm central axis which can so readily be suggested by the symmetrical outstretched arms of the principal figure; it is true that both S. Chrysogonus' arms are raised, but their potential capacity for the introduction of an accent of balanced symmetry into the composition is obviated by their diagonal, recessional, unequal relationship. We may select one characteristic minor detail as typical of the contrast. In Domenichino's *Assumption* (Fig. 25), a classic *putto* rests upon the clouds as if they were pillows, whereas his painterly colleague in the bottom left corner of Guercino's canvas is so entangled *among* them that, bewildered by the light and shade, we have some difficulty in differentiation between him and them. Nevertheless we must hint at the slightest of qualifications, for even in this festival of the painterly we can find some very faint traces of changes to come. Here and there a contour stands out a trifle more insistently than before (S. Chrysogonus' left leg, the flute-playing angel's right arm); the face of an angel (top right) no longer boasts the rustic mien

(re-named Lancaster House) in 1914 the painting was left *in situ*. The full-size copy is still to be seen in the original position in San Crisogono in Trastevere.

[132] Calvi says (*op. cit.*, 1808, p. 20): ". . . trovo memoria che Pietro Berettini da Cortona non potea saziarsi di contemplarla, e la celebrava con somme lodi." Calvi does not cite his authority, but it is certainly probable that this painting possessed considerable attractions for the young Pietro da Cortona; Lanfranco, though nearly nine years older than Guercino, may also have been interested in it. Though relatively small, it is in every way an accomplished prelude to the approaching Full Baroque.

of that in the *Martyrdom of S. Peter* (Fig. 14), but approaches a
little nearer to the "nobility" of the upturned head of the youth
in the centre of Domenichino's *Communion of S. Jerome*. It may
be noted that these scanty concessions to the classic point of
view (if such they be) did not exempt Guercino from the
strictures of Passeri half a century later; though praising the
work, he observes that it lacks "una certa nobilità nel costume,
che sarebbe conveniente ad un soggetto simile," and that it is
"anche mancante in una certa esatezza, e leggiadria di disegno,
e di contorni vezzosi nel buono stile."[133]

Immediately on returning to Cento in 1623 Guercino was
commissioned to paint a large *Assumption of the Virgin* (Fig. 27)
for Count Alessandro Tanari or Tanara of Bologna.[134] There
are of course strong painterly elements in this picture, particu-
larly the lop-sided appearance given to the composition by the
group of the Madonna, the angel and the two *putti*, an effect
emphasized by the arrangement of the Madonna's hands. It is
only when we compare it with the *S. Chrysogonus* or Guercino's
pre-Roman works that we are conscious of a certain difference.
The long clear unbroken silhouette plays a more definite part
now (the Madonna's left side, S. John's back).[135] The shimmer
of light has lost some of its apparent capriciousness, and its
lively assertive quality: it *diffuses* itself more soberly over
draperies which have a new formal articulation of carefully

[133] *Die Künstlerbiographien von* Giovanni Battista Passeri, *herausgegeben von*
Jacob Hess, Leipzig/Vienna, 1934, p. 351. For a further example of the
classic attitude towards this sort of subject, see Domenichino's *Vision of S.
Paul*, painted for Agucchi and now in the Louvre; the resemblance between
Domenichino's and Poussin's versions has been frequently noted, as has the
ultimate derivation of the whole group from Raphael's *Vision of Ezekiel*.

[134] Malvasia (*Felsina*, 1678, II, p. 366) describes this picture, the first
mentioned by him as having been painted after Guercino's return from
Rome, as follows: ". . . un' Assontione della B. V. con li dodici Apostoli al
Sig. Co. Alessandro Tanara, & è fra l'altre pitture superbe di quel real
palagio." It was acquired for the Hermitage, direct from the family,
ca. 1840; the canvas measures 3.065 × 3.32 m.

[135] We may contrast the strong silhouetting of this Madonna with the
relative absence of it in the case of her counterpart in the *S. William* (Fig. 5),
and may point out that the band of light employed to bring out the contours
of S. John's back foreshadows that which we noticed in the *Micah* (Fig. 10).

arranged, and indeed often parallel, ridges. The clouds have gained in compactness. Have we any clues as to what Guercino has been looking at? The regular features of the S. John and the reliefs on the sarcophagus may provide the slightest of hints that he has not entirely ignored the antique. The "flattened-out" draperies suggest some kinship with those in certain works of Annibale's Roman period, and the apostle gazing upwards on the extreme left is reminiscent of him. The angel and one of the *putti* seem to have adopted scrupulously combed and curled wigs *à la Domenichino* instead of the unruly mops which have been usual up to now; indeed most of the apostles seem to have had a tidy-up at the barber's! The new Madonna is less of a peasant and more of the Roman, and can claim some cousinship to Domenichino's idealized types. Another *Assumption of the Virgin* (Fig. 28), let into the ceiling of the Church of the Rosario at Cento, is not dated by any early source, but seems to the writer to be sufficiently close in style to the previous two pictures to warrant the supposition that it was painted immediately after Guercino's return to Cento in the summer of 1623.[136] Here the signs of restraint which we observed in the "history" version of the subject have disappeared, since the *sotto in sù* requirements of its destined position enabled Guercino to give freer rein to his painterly instincts. Nevertheless, we take note of the fact that the principal figure is strongly silhouetted.

Having disposed of works in which the painterly mode of expression remains more or less to the fore, let us now turn to the immense picture which Prof. Marangoni has already rightly pointed out to be the real turning point in Guercino's development. *The Burial and Reception into Heaven of S. Petronilla* (Fig. 29)

[136] The only Seicento writer who mentions this picture is Francesco Scannelli (*Microcosmo*, 1657, p. 364), who refers to ". . . un particolar Quadro, che si vede nel volto d'essa Chiesa [del Rosario in Cento] della prima, e più gagliarda maniera . . ." The picture looks too small for its present position, but (if my dating is correct) it must have been painted for the old Chiesa del Rosario, which was replaced by the existing building not long afterwards.

was painted for San Pietro in Vaticano in 1622-23,[137] towards
the end of Guercino's stay in Rome. In this picture we can see
a very definite break with the principles typified by the *S.
William*. We do not deny that there are certain similarities,
which indeed were to be expected after so short a lapse of time;
from a strictly classic point of view, for example, the composi-
tions of both are too "irregular," and in both there is a strong
light-effect resulting in a patchy appearance. But these are
broad generalizations which, though perfectly true as far as
they go, are of little value in the present special circumstances.
The left-to-right feeling in the *S. William* (Fig. 5), the import-
ance of which as a solvent we noticed previously, originates
from a close alliance between the direction of the light and the
disposition of the forms. With the *Santa Petronilla* we have no
comparable impression of fluidity: the composition seems some-
how more congealed. How is this brought about? In the first
place, there is conflict rather than alliance between the light
and the forms; the light, coming from the right, strikes against
a thick accumulation of figures on the left of the picture.
Moreover its progress from right to left has nothing of the
impetuous character which we felt in the *S. William*; it is
watered down by claims made upon it for the more exact

[137] The canvas, measuring 7.20 × 4.23 m., is signed in the right bottom
corner: "GREGO XV PONT MAX / IO: FRANC BARBERIVS
CENTENS / FACIEBAT / MDCXXIII." Various documents published
by Oskar Pollak (*Die Kunsttätigkeit unter Urban VIII*, II, Vienna, 1931,
pp. 564 ff.) indicate that it was completed in the spring of 1623. It was
replaced in S. Peter's by Cristofari's copy in mosaic (dated 1730), and went
to the Quirinal Palace, whence it was removed by the French in 1797. It
returned to Rome in 1815, and, after a short stay in the Vatican, reached
its present home in the Pinacoteca Capitolina. It has undergone retouchings
several times, but, in my opinion, without any major loss of its essential
character. Malvasia (*Felsina*, 1678, II, p. 365) begins his account of
Guercino's stay in Rome with the various commissions carried out for the
Pope and his family, among which he mentions the *Santa Petronilla*. He deals
later on with the *S. Chrysogonus*, to which he gives the plausible date 1622;
Malvasia probably did not notice that he was in this way giving rise to the
implication (often repeated as a statement of fact) that the *Santa Petronilla*
was painted in 1621. It is however particularly important to realize that it
was painted towards the end of Guercino's Roman sojourn.

definition of formal details—here a silhouette is wanted, there the articulation of an arm or the exact formation of a drapery must be stated more clearly. The light is used rather as a means of bringing out the independent structure of the parts than as an autonomous common factor contributing to the unity of the whole. Any impression of mass movement in the forms is also firmly discouraged, and no cascade analogy is possible here. One of the reasons for this is the strict avoidance of recessional relationships, and a very marked tendency to split up the composition on a planimetric basis.

The keynote to this method of organization is given by the introduction of a horizontal step running straight across the canvas, parallel with the bottom of the frame; this leaves us in no doubt about the division of the lower part of the composition into first row, second row. Still further back is the third row, in the sky; even within this group there is planimetric sub-division, for the angel and *putto* (below Christ) act as an inter-mediate plane between the figures immediately below and above them. At first sight the Madonna and angel in the *S. William* and the Christ and S. Petronilla in the later picture seem to play roughly analogous parts; and yet here we have a succinct epitome of the gulf between the two pictures. In the *S. William* the two figures are very closely related (we might almost say interlocked), and the lower part of this fused group swings out slowly towards us: both as to the parts and as to the whole it is a statement in terms of recession. In the upper part of the *S. Petronilla*, on the other hand, care is taken to separate the two figures; this is done by the insertion between them of a bright patch of yellow sky, an emphatic accent which not only strongly insists on their division into two separate units, but which also contributes towards the definition of the independent structure of each. The formal connexion here is based on the fact that the two figures are placed on a common dark band of cloud, or, in other words, in a single plane, parallel to the main picture plane, from which they are not allowed to stray. Almost more striking than the contrast between the two pictures (after all, at least two years separate them), is the

fundamental contradiction between the compositional con-
struction of the finished painting and that of one of Guercino's
rejected ideas for it (Fig. 32). There is no sign of a plane in this
drawing.[138] The apparent chaos in the lower part resolves
itself into something like an exercise in recessional composition,
while we find above that the turning of the Saint and the inter-
position of an angel have started off a gyratory movement
which no plane can imprison![139]

Two small points of detail to conclude our case that something
new is happening in the *S. Petronilla* painting. Both below the
figure of S. Chrysogonus and below that of Christ in the
S. Petronilla we notice a flying *putto* with a fluttering dark green
drapery. In the earlier picture (Fig. 30) we have a side-view
with fragments of form crossing over one another, and the
articulation of the whole is confused by (apparently) capricious
macchie of light and by the losing of the structural facts in their
environment. With the *putto* in the *S. Petronilla* on the other
hand (Fig. 31) we have an unimpeded and "flattened-out"
back view with the principal structural facts clearly stated, the
feet being so lit that their connexion with the body is immedi-
ately grasped; we observe incidentally that the figure is much
more elegant looking than its predecessor. Finally, we may
note that the tendency towards solidification of the forms in the
S. Petronilla is reflected in a greater compactness in the actual
modelling than was to be found in the earlier works; this can
be readily seen in the group of mourners in the lower half
(Fig. 41), where the tight technique is something entirely
different from the loose, even impressionistic, touch employed

[138] Windsor Castle, Royal Library; inventory No. 2756; black chalk,
516 × 376 mm. Some time in its history the drawing has been damaged by
folding, particularly in the centre.

[139] Guercino seems to have been reluctant to abandon this motive. The
composition of a drawing at Darmstadt (Landesmuseum, No. AE 2110;
red chalk, 209 × 296 mm.) agrees roughly with Fig. 32. Another drawing
at Windsor Castle (No. 2392; red chalk, 213 × 295 mm.) shows the Saint's
body turned more or less towards the spectator as in the painting, but in
order to counteract this, the Christ is turned further round, away from the
spectator; the angel again appears between them.

hitherto. One example must speak for the whole: the fingers
of the hand holding the torch are modelled with emphatic
solidity, and are clearly defined (with the help of parallel high-
lights running carefully along each finger) as a row of struc-
turally consistent rounded objects. We can hardly describe such
a firm "sculpturesque" treatment of a row of fingers as a
commonplace in Guercino's previous work.

Guercino was by now over thirty years of age, and we must
take into consideration the possibility that the direct traces of
influence from other artists' work might be somewhat less
obvious than with a younger, less developed artist. Still, if we
are not mistaken, the *Santa Petronilla* does afford some half-
concealed hints of what he has been looking at. First, a couple
of suggestions of influences of purely momentary validity, with-
out any clear sequel in his later work. Malvasia says[140] that
Guercino painted an *Incredulity of S. Thomas* in the first half of
1621 immediately before setting out for Rome. I cannot deal
here with the ramifications of what is rather a complicated
question, but I believe this picture to be identical with that
now in the National Gallery, London; in any case, the original
state of Pasqualini's engraving of the composition bears the
date 1621. It seems to the writer that the gesture of the right
arm of Christ may be a reminiscence of that in Rubens' *Trinity*,
which Guercino must surely have seen at Mantua not so many
months before.[141] The motive appears to have particularly
attracted Guercino, who repeats it in the Christ of the *Santa
Petronilla*. Next, there is the matter of possible Caravaggesque
influence in the lower half of the *Santa Petronilla*. Hardly less
obstinate than the legend that any painter of this period who
is interested in strong light-effects must therefore be "Caravag-

[140] Malvasia, *Felsina*, 1678, II, p. 365.

[141] For the dating of Guercino's visit to Mantua, cf. note 113 of this Part.
There were of course three large early canvases of Rubens on view at that
time in the Jesuit Church there. As we have seen (cf. note 116 of this Part)
Cardinal Serra had already had relations with Rubens and very probably
realized that he had been in the service of the Duke of Mantua; it is not
beyond the bounds of possibility that the Cardinal suggested to Guercino
that he should look at Rubens' work when at Mantua.

gesque" are the similar *clichés* that all brawny villains or
nonchalant swashbuckling gallants must be labelled in the
same way.[142] With regard to the types, however, what strikes
one in the present picture is the fact that they are on the whole
less plebeian and more refined than in the earlier works of
Guercino. The kneeling bearded man, for example, is much
more "respectable," with his carefully brushed hair; and the
handsome features of the young gallant (the predecessor of the
S. John in Fig. 27) begin to approximate to the classic ideal of
manly beauty, not previously paralleled in Guercino's work and
equally far from the smooth round faces of Caravaggio's young
bravoes. Nor does the new compact modelling which we
noticed in the *Santa Petronilla* bear any real resemblance to the
modelling of Caravaggio, with his characteristic feeling for
suggestive linear outline. For a comparison to illustrate the
differences between Caravaggio's attitude towards lighting and
composition and that appearing in the *Santa Petronilla* we may
refer the reader to the older painter's *Entombment*, then in Santa
Maria in Vallicella and now in the Pinacoteca Vaticana. There
are, however, some hints that Guercino has been looking at
Caravaggio. For example I find it difficult to explain the right
sleeve of our young gallant except in terms of that Caravag-
gesque formula which we find in the sleeve of his *Madonna* in
S. Agostino, and elsewhere.[143] But such traces are incidental
and have no sequel or deeper significance.

On the other hand such a figure as that of the S. Petronilla
in the sky (Fig. 33), though equally without precedent in
Guercino's work, nevertheless foreshadows much that is to

[142] This sort of label (doubtless originating from the fact that Caravaggio,
quite apart from the wide-spread influence of his works, did epitomize in a
striking way certain general tendencies of his time) has the disadvantage
of introducing an air of simplification into Seicento studies which is more
superficial than real.

[143] Guercino very probably saw the *Madonna, Child, and S. Anne,* which
was then in Cardinal Scipione Borghese's collection, to which he must have
had access (cf. also the following note); the figure of S. Anne is something
of an exception among Caravaggio's *Roman* works, being more painterly and
less plastic than usual. Caravaggio's followers also made use of our drapery
formula on occasion.

come. Leaving aside the solidity of the figure, the silhouetting, and the more diffused lighting, let us turn to the Saint's dress. Guercino had not previously taken much interest in decking out his figures with fine clothes, nor, when he did so, paying any particular attention to their texture or design. We have seen an example of this in the almost invisible cope of the Bishop in the early *S. William* (Fig. 5), contrasting it with the careful reproduction of the robe of the priest in the late *Purification* (Fig. 6). An interest in rich stuffs is however not infrequently to be found in the works of Domenichino: a typical example is provided by the *Sibyl* (Fig. 35) in the Galleria Borghese, which Guercino had almost certainly seen not long before painting the *Santa Petronilla*.[144] There is considerable resemblance between the drapery over the Sibyl's right arm and that round the lower part of the figure of S. Petronilla, bearing in mind that what was a commonplace for Domenichino was a new departure for Guercino. Then there is something quite new about S. Petronilla's sleeves. In our search for a prototype for these narrow, rather carefully arranged, ridges rising to meet the light, may we not point to a method often employed by

[144] This picture (canvas, 1.23 × 0.94 m.) is presumably the *Sibilla di grand'arte e p[er]fettione* mentioned by Mancini (cf. p. 76 above, and J. A. F. Orbaan, *Documenti sul Barocco*, p. 111) as painted by Domenichino for Cardinal Scipione Borghese. Prof. Lionello Venturi records (*L'Arte*, XII, 1909, pp. 49 f.) that Domenichino received payment from the Cardinal in 1617 for two pictures, of which this may very well be one (cf. also end of note 95 of this Part). Guercino, as we have seen, carried out the S. Crisogono ceiling for the Cardinal in 1622, and must surely have had access to his celebrated collection. The subject of Domenichino's picture has been variously described: *Sibilla* (Mancini, *ca.* 1621); *Musa* (Jacomo Manilli, *Villa Borghese*, Rome, 1650, p. 85); *Sibilla* (Bellori, *Vite*, 1672, p. 353); *S^ta Cecilia* (Early eighteenth century inventory published in *Archivi d'Italia*, Serie II, Anno III, 1936, p. 201); *La Musica detta la Sibilla* (Catalogue of 1760 published in *Archivi d'Italia*, Serie II, Anno IV, 1937, p. 223). I cannot agree with Dr. Jacob Hess (footnote 1 to p. 42 of his edition of Passeri) that the *S. Cecilia* which Passeri says he believes to be in Paris is likely to be identical with this picture (which undoubtedly seems to have been in the Villa Borghese for the whole of Passeri's lifetime) rather than with the Louvre picture (which we know to have been in the possession of Louis XIV in the sixteen-seventies, and which had probably been in France for some time previously). For the Louvre picture, cf. note 158 of this Part.

Domenichino, for example in several passages on the extreme left of his *Communion of S. Jerome* (Fig. 34; and cf. also Fig. 38)? Elsewhere in Guercino's altarpiece we get occasional hints that he may have been looking at the work of Domenichino. For example, the angel (Fig. 31), quite unexpectedly "noble" in appearance for Guercino, is not very far removed from the youth looking upwards between S. Jerome and the priest (Fig. 34). And is there not some kinship between the new compactness of modelling which we noticed in certain passages of the *Santa Petronilla*, modelling by high lights disposed according to the requirements of structure (cf. Fig. 41), and Domenichino's rendering of hands, noses and the like in the *Communion of S. Jerome*? We may compare Guercino's hand holding the candle with Domenichino's hand holding the book.

In spite of all these deviations from Guercino's early style the picture still remains very far from being a classic one; indeed it is only in retrospect that we can identify the roots of the later, more clearly classic, developments. It probably did not strike Passeri as exhibiting any very marked difference from the earlier works; certainly (though he has praise for the picture) his criticisms are on the lines we should expect:[145] "E' dipinto in quel suo stile di tinte, e di costume, che mai s'accomodò ad un certo decoro, e convenienza di nobiltà, ne di forme leggiadre d'attitudini, e di panneggiamenti artificiosi; ma si posò sempre in quella schietezza del naturale; ma nella più vile." If Passeri, probably writing in the seventies, could adopt this point of view, it seems very probable that such an ardent devotee of classic idealism as Agucchi would have tended to look at the picture in a similar sort of way. I am in fact inclined to believe that something of Agucchi's mind is to be seen in the "adjustments" which Guercino has made in the *Santa Petronilla*. Provided that we do not lose sight of the fact that any

[145] Passeri, *op. cit.*, ed. Hess, p. 351. Passeri goes on to make what we may call a post-Lanfranco criticism to the effect that Guercino should have weakened the intensity of the colouring and chiaroscuro (i.e., also the firmness of the modelling) in the upper half, on account of the greater distance from the eye and the desirability for softness in a *gloria*.

such theory is speculative, with a general rather than a particular factual basis, it may not be irrelevant to draw attention to the circumstances in which this could very well have occurred.

After considering the site, lighting, size and so forth, and ascertaining the necessary iconographical data, Guercino's first step would have been to carry out some pen or chalk scribbles in shorthand, in order to fix his imaginings on paper. These, in no sense intended for the eyes of laymen and probably including very rough sketches of the whole composition and studies of individual figures or groups, would be the raw materials for working up a more formal and elaborate drawing of the whole composition, sufficiently "finished" to be intelligible to his patrons : a drawing, in short, of the character of that illustrated as Fig. 32. Some such drawing or drawings must certainly have been submitted to Cardinal Ludovico Ludovisi for his verdict, and it can hardly be doubted that they were also shown to Agucchi (who, as Secretary of State, was constantly working with the Cardinal).[146] In any discussions with the artist Agucchi's familiar point of view would have emerged. We can understand the retention, after due refinement, of the figure of Christ; it (we are thinking of the gesture) has that type of *grazia* which Agucchi would have appreciated, and from which, incidentally, the angel (later abandoned) would have tended to detract attention. As to the lower half we can imagine him perceiving in it, let us say, more *grossolanità* than seemed suitable or necessary, and *un certo disordine Lombardo* about the whole; very likely he would have encouraged Guercino by saying that Annibale was in the same position when he arrived in Rome, and by referring, as we suggested above, to the benefit which he supposed his old friend to have derived from the study

[146] Cardinal Ludovico Ludovisi exercised the effective administration of the Papal government and policy during the Pontificate of his uncle, whose health was poor. It seems probable that the Cardinal knew of Agucchi's interest in art before Gregory XV's election (cf. note 95 of this Part); in any case he cannot fail to have done so by 1622. Elaborate composition drawings of this type do not seem to have been part of Guercino's normal practice, but we may be sure that an exception would have been required of him in the present instance.

of Roman *disegno*. There are various reasons why Guercino should have paid serious attention to any comments of this kind by Agucchi. It would not be unnatural for the young peasant, a provincial even in Bologna, to be somewhat overwhelmed by Rome and the Papal Court. Moreover Agucchi had had much more familiarity with artists (during a period of twenty years) than the average learned prelate, and one might assume that he would have picked up sufficient of the current jargon to avoid *gaffes* of the cruder sort. Guercino very probably realized that some of the works of art which Agucchi praised were in fact good: why not make some experimental concessions to this method of picture-making so unlike that to which he himself had become accustomed? Finally, whether or not we are to believe Malvasia's story that Guercino was a potential candidate for the extremely important task of painting the Loggia della Benedizione in San Pietro in Vaticano,[147] we may be sure that, at the time when the *Santa Petronilla* was painted, he envisaged considerable opportunities in the Papal employment: to ignore the opinions of the Cardinal and the Secretary, especially in the important matter of a colossal canvas for San Pietro, could lead to a dashing of his hopes. One wonders whether such deference as Guercino may have paid to the taste of his patrons would in actual fact have furthered his career in Rome, or whether any significance is to be attached to Gregory's reservations when Guercino wrote to him requesting the unusually large remuneration of 1500 scudi for the *Santa Petronilla*, together with a refund of 137 scudi for the ultramarine he had used.[148] However, Guercino's prospects

[147] Malvasia (*Felsina*, 1678, II, p. 365) says that Guercino was to have been paid 22,000 scudi for painting the Loggia. An idea of the importance of a commission of this kind is afforded by the fact that Guercino's annual income from his painting only once exceeded 4000 scudi (1647, 4168 scudi), and did not exceed the 3000 scudi mark in more than three other years (1634, 1641, and 1644). Experience does not however encourage us to treat this sort of statement by Malvasia as an established fact.

[148] Cf. the letter published by Oskar Pollak (*Die Kunsttätigkeit unter Urban VIII*, II, 1931, p. 564) with the endorsement: "N. S^re intende che gli si dia quella sodisfatt(ion)e che merita l'opera."

became much less rosy after the death of the Pope on 8 July 1623, and he soon left Rome for Cento.

<p style="text-align:center">* * *</p>

The first picture mentioned by Malvasia as having been painted by Guercino on his return to his native town was the *Assumption* (Fig. 27); after the passage referring to it (cf. note 134 above), he continues: "Finì molti quadri in Cento, e furono 4. Evangelisti al S. Domenico Fabri, & un rame grande con la presentazione della B. V." Immediately following this sentence, which purports to be derived from the Casa Gennari documents, Malvasia adds his own long account of the history of the *Presentation*. According to him it was returned to Guercino by Fabri as part repayment of a loan, and hung for many years by Guercino's bed. After unsuccessful attempts to acquire it had been made by well-known collectors, it was finally sold for 100 *doppie* to a Frenchman, Raphael (Trichet) du Fresne, who presented Guercino with a suitably inscribed copy of his edition of Leonardo's *Trattato della Pittura*. Unfortunately, as experience has taught us, Malvasia cannot be relied upon for literal accuracy, and this instance is no exception.[149] However, I

[149] The passage relating to this picture in *Felsina Pittrice* will be found on p. 366 of Vol. II (1678). Three difficulties present themselves. First, it is stylistically quite impossible that Fig. 37 could have been begun before Guercino's visit to Rome; but in my opinion *Finì* should be taken to refer only to the set of four pictures of *Evangelists*, one of which, representing *S. John*, is in fact already listed by Malvasia as having been painted for this same Domenico Fabri before Guercino left Cento. Thus the reason why the sentence continues with the *Presentation* would be simply that it was painted for a member of the Fabri family. Which brings us to the second point, namely that Malvasia says later on (*loc. cit.*, pp. 367 f.) that Guercino painted in 1631 four landscapes in tempera for the same Fabri for whom he had painted the *Presentation*, and that they were later returned to Guercino with it; but here Malvasia gives the Christian name as Bartolomeo, which is strikingly supported by an entry in the Account Book of 15 March 1631 relating to the landscapes. Malvasia's third inaccuracy relates to the subject. Fig. 37 may be correctly described as the *Presentation of Christ*, the *Purification of the Virgin*, or even simply as the *Presentation*, but of course not the *Presentation of the Virgin*; in my view the words *della B. V.* should be looked upon in the same light, e.g., as *un'altra* in note 24 of this Part, namely as a gratuitous addition by Malvasia to the information available to him in his source.

have no doubt that the *Presentation* on copper of 1623 was in fact acquired by a Frenchman,[150] and that it is identical with that formerly in the Orléans Gallery[151] and now in the Collection of Lady Catherine Ashburnham[152] (Fig. 37).

This charming little picture, though obviously painted *con amore*, nevertheless represents a remarkable break with Guercino's pre-Roman outlook. The clear diffused light, the careful differentiation between the individual forms, and their arrangement on a planimetric basis all reveal quite a startling change

[150] Guercino scribbled an additional note in his Account Book (for which cf. note 4 of this Part) after the last entry for 1658: "Nel medemo Ano 1660 sotto li 22 Dece si fece esito del Rame depinto che stava apreso il Letto, il quale fu conprato da un Francesse per il prezzo di Doble 100. fano Ducatoni 300. che sono L1500. fano Scudi 375." Why Guercino should have inserted the note in that particular place is not very clear (Calvi prints it at the end of 1660, where there is in fact sufficient blank space for it in the MS.), but it is in his own handwriting, and the facts which emerge from it (the picture being on copper and hung near his bed, the purchaser being a Frenchman, and the price being 100 *doble* or *doppie*) correspond in a most remarkable way with Malvasia's story. A further confirmation is provided by Calvi (*Notizie della Vita*, 1808, pp. 21 and 163), who had evidently seen the presentation copy of Leonardo's *Trattato*, the inscription in which he copied, as he says, *esattamente*; we need hardly say that Calvi's version differs very slightly from that of Malvasia, who, e.g., appears to have inserted an ugly and unnecessary *sua* in the penultimate line!

[151] The Orléans picture is first mentioned in Dubois de Saint Gelais' *Description des Tableaux du Palais Royal* (Paris, 1727, pp. 225 f.), where the subject is correctly given as *La Présentation de N. S. au Temple* and the previous owner is stated to have been the Abbé de Camps (i.e., François de Camps, for whom cf. Edmond Bonnaffé, *Dictionnaire des Amateurs français au XVIIe siècle*, Paris, 1884, p. 49). It is mentioned in several later books as in the Orléans Collection, and was engraved in reverse by Patas in the series *Galerie du Palais Royal, gravée d'après les Tableaux* (which Jacques Couché began to publish in 1786). Its identification with the picture acquired from Guercino by Raphael Trichet du Fresne was first suggested by Charles Rogers in his text to *A Collection of Prints in imitation of Drawings* (London, 1778, II, p. 103).

[152] The painting (copper, 0.71 × 0.64 m.) is described in a manuscript list of 1793 at Ashburnham Place as "bought of Ld Gower, formerly in the Orleans Collection," and figured as No. 81 in a sale catalogue of the Earl of Ashburnham's pictures of 20 July 1850 (but was bought in). I am greatly indebted to Lady Catherine Ashburnham for her kindness in allowing me to examine and reproduce her picture.

of front. Though Guercino naturally retains much of his personal idiom, the language in the broad sense is that of Domenichino. We may take as a prototype the latter's damaged *Death of S. Cecilia* (Fig. 36), from that series of frescoes in San Luigi dei Francesi which Agucchi (we know) and Poussin (we suspect) so much admired. We should be justified in assuming that Guercino would have visited the chapel of S. Cecilia, if only as a matter of routine, during his stay in Rome; but further evidence on the matter is provided by an engraving of the *Death of S. Cecilia*, dated 1622, by Giovanni Battista Pasqualini. This engraver was a native of Cento whose activity was almost exclusively devoted to the reproduction of his fellow-townsman's work; so much so that we can almost describe him as a satellite of Guercino.[153] The fact that Pasqualini engraved the subject[154] can thus be taken as evidence of Guercino's knowledge of it, and probably of his interest also.

No doubt the most valuable evidence afforded by our comparison is that of a change in the general conception: Guercino is quite clearly veering from his former methods towards a classic system of representation. In support of this impression of the whole we can adduce a number of incidental details. The woman kneeling on the right in the *Presentation* appears to be a sort of amalgamation of the two women in the same position in the *Death of S. Cecilia*. We have in the priest's robe a

[153] As a very rough indication of the extremely high proportion of subjects after Guercino in the work of G. B. Pasqualini the reader may be referred to the incomplete and not invariably accurate lists in Nagler (*Künstlerlexikon*, 34 Guercinos to 6 others) and Le Blanc (*Manuel de l'amateur d'estampes*, 38 Guercinos to 6 others). Dated prints known to the writer cover the years 1619-31; in view of this it is surprising that the legend, possibly started in 1763 by Johann Rudolf Fuessli (*Allgemeines Künstler-Lexicon*, Zürich, 1763, p. 398), to the effect that Pasqualini was a pupil of Ciro Ferri (born *ca.* 1634) should be constantly repeated, down to and including the relative article in Thieme-Becker (1932).

[154] The engraving is in reverse. Both the foreground up to the first row of figures and the upper part above the angel's head have been omitted, thus altering the "airy" character of the composition and increasing the relative size of the figures. That the vacant strip of foreground should be omitted by an engraver familiar with Guercino's compositional practices up to 1622 does not strike one as unnatural.

Domenichino-like interest in the detailed depiction of rich
stuffs, and in the sleeves of S. Joseph and the priest something
similar to the curious drapery formula we noticed on the left
of the *Communion of S. Jerome* (Fig. 34). On the other hand, the
Madonna's drapery (structurally much more deliberately
studied than had been Guercino's wont, and carefully arranged
so that the bulk of it emerges into the light) may betoken some
interest in the Roman works of Annibale.[155] We can find no
precedent in Guercino's own previous work for the attention he
pays here to the rendering of reliefs carved in marble (the
altar, the steps), and yet this sort of antiquarian accessory—so
characteristic of the Roman *ambiente*—is part of Domenichino's
stock-in-trade; we may take the latter's *S. Agnes* (Fig. 40) as a
typical example.[156] No less striking is the way in which Guer-
cino has abandoned his occasional architectural stage properties
(often rendered the more fragmentary by the changing atmo-
sphere) in favour of an elaborate all-embracing architectural
setting. We recognize that those misty vapours which cause
such intriguing confusion in Guercino's early paintings would
be out of place in S. Cecilia's public square (Fig. 23), and note
that they are rigorously banned from the *Presentation*. Our
account of the reminiscences of Domenichino which we find
with Guercino may be completed by the reproduction of the

[155] For example, cf. the *Coronation of the Virgin* (Fig. 11). As an old servant
and protégé of the Aldobrandini, Agucchi must always have been in a
position to obtain access to their collections for any artist recommended by
him; moreover Cardinal Ludovico Ludovisi's sister Ippolita had married
D. (Giovanni) Giorgio Aldobrandini, Principe di Rossano, in April 1621.

[156] This painting (canvas, 2.13 × 1.52 m.) is not, as far as the writer is
aware, dated or mentioned in any Seicento source, and is therefore not illus-
trated as a particular work which it is suggested that Guercino must have
seen, but rather as a typical example which fits in well with the dated paint-
ings of the half-dozen or so years preceding the Pontificate of Gregory XV.
Voss (*Die Malerei des Barock in Rom*, 1924, pp. 509 f.) dates it *ca.* 1620. It was
already in the British Royal Collections in 1759, when it was stated to be
in Kensington Palace by Sir Robert Strange on his engraving (in reverse)
of that year, and must be the *St. Agnes* recorded as by *Dominichino* on p. 49
of the Kensington Palace Catalogue pub. by W. Bathoe (London, 1758) as
part of his collection of catalogues beginning with that of James II.

Guardian Angel (Fig. 39), which Guercino must have painted some time during the middle twenties,[157] side by side with the Louvre *S. Cecilia* (Fig. 38), typical of Domenichino's style not long before Guercino's arrival in Rome.[158] This method of representing draperies appears occasionally in Guercino's work for a few years after his Roman visit, and can hardly be explained without reference to Domenichino.

Two paintings conclude our survey and add some extra substance to this little explored period between Guercino's return to Cento in 1623 and his visit to Piacenza in 1626. The *Madonna and Child with S. Lawrence* (Fig. 42) has a *terminus ante quem* of

[157] This painting (canvas, 0.885 × 0.675 m.) is not dated or mentioned by any Seicento source. On stylistic grounds I would place it *circa* 1624-26, with which Voss (Thieme-Becker, XV, 1922, p. 220) seems to be more or less in agreement ("gutes Bild der mittleren Zeit"); he mistakes the subject for *Tobias and the Angel*. I believe the earliest published reference to the picture is in *Catalogo dei Quadri, e Pitture esistenti nel Palazzo dell'eccellentissima Casa Colonna in Roma*, Rome, 1783, p. 21, No. 121. The right bottom corner (lower part of the child) is much damaged.

[158] In my view it does not seem impossible that the Louvre picture (canvas, 1.59 × 1.17 m.) should be identical with Passeri's "mezza figura d'una Santa Cecilia, che credo che hora sia in Parigi," which he mentions (*op. cit.*, p. 42) as having been presented by Domenichino to the Secretary of Cardinal Pietro Aldobrandini at the time of the *scoperta* of the *Assumption* in Santa Maria in Trastevere (1617); it appears to me that Dr. Hess's suggestion (note to Passeri, *loc. cit.*) that the reference may have been intended to apply to the so-called *Sibyl* in the Borghese collection (for which cf. also note 144 of this Part) is difficult to reconcile with Passeri's belief that the *S. Cecilia* about which he was writing was in Paris. The possible connexion with the Ludovisi collection (from which the Louvre picture traditionally came) would be understandable if Passeri's story of the wager (cf. note 130 of this Part) was embellished in the telling, making an identification of Aldobrandini's Secretary with Agucchi more plausible. For the history of the Louvre picture cf. Nicolas Bailly, *Inventaire des Tableaux du Roy rédigé en 1709 et 1710*, ed. Fernand Engerand, 1899, pp. 163 f. Though I have not been able to investigate its history thoroughly, there is no doubt that the picture was in the possession of Louis XIV in the sixteen-seventies, when it was engraved by Étienne Picart; it may well have originally been in the Ludovisi collection, but the Seicento documentation for this does not seem to be very clear or satisfactory. A document relating to a *S. Cecilia* (apparently Domenichino's receipt dated 12 July 1625 for a replica of this picture) is published in a footnote to the 1841 edition of *Felsina Pittrice* (II, p. 244).

1626,[159] and there seems every reason from the point of view of style to accept Baruffaldi's statement that it was painted in 1624.[160] A very close kinship is noticeable between this altarpiece and the group of mourners in the *Santa Petronilla* (Fig. 41); we have the same firm compact modelling in both, the same rather hard silhouetting, the same type of lighting (disciplined and diffused, however powerful and cutting it may appear at first sight), the same intensity of colouring in the clear air. Perhaps it is not too far-fetched to suggest that the sheen on S. Lawrence's rich vestment betrays some memories of Domenichino (cf. Fig. 40); and the child Christ, though bearing no resemblance to Domenichino's characteristic *putti*, has a new suggestion of daintiness which may owe something to their example.

Finally we have the large[161] *S. Gregory the Great with SS. Ignatius Loyola and Francis Xavier* (Fig. 45), which appears to the writer, on stylistic grounds, to have been painted not long

[159] G. B. Pasqualini's engraving in reverse, with slight variations in inessentials, is dated 1626.

[160] Girolamo Baruffaldi, *Vite de' Pittori e Scultori Ferraresi*, II, Ferrara, 1846, pp. 448 f. Baruffaldi, whose MS. was written in the first half of the eighteenth century, usually follows Malvasia in his account of Guercino, but this may be one of those occasions when he had reliable local information of his own, in view of the striking appropriateness of his suggestion of 1624. Malvasia does not mention the picture, but Scannelli (*Microcosmo*, 1657, p. 361) describes it as in the *Chiesa detta di S. Nicola de' Padri Agostiniani* at Finale. Cesare Frassoni records it as in the *Chiesa di Sant'Agostino* in the account of the Churches of Finale which he appends to his *Memorie istoriche del Finale in Lombardia* (Modena, 1752, p. 189); in his *Memorie del Finale di Lombardia* published at Modena in 1778 (a completely different work from the preceding) he states (p. 117) that it was commissioned by Giovanni Battista Mirandello. I believe that a drawing of the Madonna and Child in the Albertina at Vienna (Inv. No. 2309) is a study for this picture; but the identification is no doubt a matter of opinion rather than a self-evident fact, as I think I intimated to Frau Dr. Anna Spitzmüller when she was collecting material for the catalogue. Perhaps therefore I may be permitted to add here the qualificatory *vielleicht* which she inadvertently omitted when quoting my opinion (Alfred Stix and Anna Spitzmüller, *Beschreibender Katalog der Handzeichnungen in der staatlichen graphischen Sammlung Albertina*, VI, *Die Schulen von Ferrara, Bologna, . . . ,* Vienna, 1941, p. 23, No. 225).

[161] Canvas, 2.96 × 2.11 m.

before Guercino set out for Piacenza in the spring of 1626; *circa* 1625-26, let us say. Other indications, though partly speculative, fall in very well with this view. The three Saints portrayed must allude to the canonization of the two Jesuits by Gregory XV (represented here by the greatest Pope who bore that name) on 12 March 1622, one of the great occasions of his Pontificate. The Jesuits were special favourites of the Ludovisi,[162] and soon after his uncle's death Cardinal Ludovico decided[163] to erect a church at Rome in honour of S. Ignatius in which the tombs of Gregory XV, the Cardinal himself, and other members of his family were to be placed; the foundation stone of Sant'Ignazio was in fact laid on 2 August 1626.[164] It appears not unlikely that the altarpiece with which we are concerned was originally intended to be placed in the church or the adjoining buildings,[165] so closely does the stylistic dating correspond with that of the decision to build.[166] However, Cardinal Ludovico Ludovisi died in 1632, and the building (which was under construction and decoration for about half a century) was carried on by his brother and heir, D. Niccolò Ludovisi, Principe di Piombino. The subsequent history of the picture and the political inclinations of Niccolò are consistent with its having been presented by the latter in 1646 to the Spanish Ambassador to Innocent X;[167] it remained in Spain until the

[162] Cf. Ludwig Freiherr von Pastor, *Geschichte der Päpste*, XIII, Abt. 1, 1928, pp. 98 f. (Eng. Ed., XXVII, pp. 126 f.) Both Gregory XV and his nephew had been educated by the Jesuits.

[163] The Deed whereby Cardinal Ludovisi made over 100,000 scudi for the purpose was dated 12 February 1626 (cf. Oskar Pollak, *Die Kunsttätigkeit unter Urban VIII*, I, Vienna, 1928, p. 144); the intention to bury Gregory XV there is mentioned.

[164] Pollak, *op. cit.*, I, p. 147.

[165] Apparently the Cardinal had the intention to collect all his religious pictures in a building adjoining the Church (cf. Pastor, *op. cit.*, XIII, Abt. 1, p. 99).

[166] In self-defence, I ought to place it on record that my dating of *ca.* 1625-26 on stylistic grounds preceded my realization of the coincidence in date of the beginning of the Sant'Ignazio project.

[167] This picture, like Fig. 19, is recorded by D. Antonio Ponz (*Viage de España*, V, Madrid, 1776, pp. 40 f.) as in the Church of San Pascual at Madrid: "Francisco de Cento, llamado el Güercino, es autor de la que hay

Napoleonic period, and then passed via France to England.[168]

Here again we find several characteristics which we observed in the other transitional works. The compact modelling, the rather intense colour, the trend towards refinement in the types all reappear. The rendering of rich stuffs is given special scope by the elaborate robes of the Pope. The sense of the crowding

en el altar al lado del Evangelio, en donde se representa S. Gregorio Papa sentado con ornamentos Pontificales, y de rodillas S. Ignacio, y S. Francisco Xavier, con algunos Angeles niños en bellas actitudes, y detrás un Angel mancebo tocando el violin. Es pintura de gran fuerza de claro, y obscuro, como generalmente son todas las de este Autor; y la que aquí se refiere se debe reputar entre las mejores de su mano." Particulars of San Pascual and the origin of its pictures will be found in note 111 of this Part; it is probable that many of the latter were collected by D. Juan Alfonso Enriquez de Cabrera (1597-1647), Duque de Medina de Rioseco, and hereditary Almirante mayor de Castilla, especially during his Italian viceroyalties which terminated with his mission to Innocent X as *obbedienza* Ambassador in 1646. Now, Niccolò Ludovisi was an ardent Hispanophil, his first two wives having strong Spanish connexions and bringing him possessions under the suzerainty of the Spanish crown; Titian's so-called *Bacchanals* (now in the Prado) were brought to Madrid in 1638 by Monterey, the retiring Viceroy of Naples, as a present from Niccolò Ludovisi to Philip IV, possibly as a sequel to the Viceroy standing godfather in the King's name to his baby son. Niccolò's third marriage, to Costanza Pamfili, niece of the then reigning Pope, Innocent X, took place at the end of 1644, and for the next few years he was an important personage at the Papal Court, being Generale di Santa Chiesa. In 1645 he was appointed to command an allied fleet which was assembled in connexion with the Turkish attack on Candia. This fleet included galleys despatched by Cabrera, then Spanish Viceroy of Naples, and it seems certain that when the latter visited Rome as Ambassador between 24 March-4 June of the subsequent year he must have met Niccolò Ludovisi. We know that Cabrera was interested in pictures and indeed had some taste for Guercino (cf. note 111 of this Part), and no gift could be more suitable than Fig. 45, depicting as it did two of the greatest of Spanish Saints and symbolizing their connexion with the Ludovisi family. After the death of Innocent X Niccolò moved completely into the Spanish orbit, becoming successively Viceroy of Aragon and of Sardinia.

[168] The painting was evidently no longer in San Pascual in 1815, as it is not mentioned in *Paseo por Madrid, ó Guia del Forastero en la Corte* published anonymously in Madrid in that year. It passed in 1837 from the collection of Baron Mathieu de Faviers (whose collection largely originated from Spain) to that of the Duke of Sutherland. It remained in Stafford House until 1908, when it was acquired for the Faudel-Phillips collection; it came thence into the possession of the present writer in 1941.

together of solid bulky forms is present here as in the Reggio altarpiece which we know to have been finished early in 1626 (Fig. 8). In the Leningrad *Assumption* (Fig. 27) we noticed the use of a band of light to throw up a dark contour (the back of S. John), a foretaste of the method employed later in the *Micah* at Piacenza (Fig. 10). In the present picture this system is pushed to much greater extremes, being the principal factor in the differentiation between the three principal figures. Such a deliberate use of contrasts of light and shade in large patches to bring out the isolated solidity of the figures is nearer to the general procedure of Domenichino, as in the group on the right of the *Communion of S. Jerome* (Fig. 21), than to Guercino's own pre-Roman practice. The disposition of the figures shows a remarkable paucity of strong recessional motives; the protagonists are given a planimetric and rather "frontal" arrangement, and the impression of the whole is one of relatively restful stability and balance, centred on the dominant figure of the Pope. Yet Guercino did not originally think of the lay-out in this way. One of his composition jottings in shorthand (Fig. 43), a mere scribble intended for his eyes alone,[169] shows the whole group swung round (almost as if on a hinge) so that it speaks with an entirely different accent, in terms of united, diagonal, recessional thrust. The figure of S. Ignatius, moved more towards the centre and turned away from the spectator, starts the movement, that of the Pope carries it on (see the changed position of his right shoulder, and the different relationship of his knees), while that of S. Francis Xavier completes it by facing the spectator; the three figures in the drawing are thus more welded together by a common factor than those in the painting. No doubt Guercino's instinctive idea for the composition, as indicated in his preliminary study, presented some

[169] Pen, 255 × 191 mm. The collector's mark (representing the Frankfurt version of Myron's *Athena*) is that of the discoverer of the statue, Dr. Ludwig Pollak, who most kindly allowed me to have his drawing photographed not long before the last war. With great regret I have to record that Commendatore Pollak, a distinguished scholar of very advanced age, was arrested by Germans at his Roman home on 16 October 1943, and has not been heard of since that day.

difficulties in execution,[170] but we cannot doubt that before his visit to Rome he would have solved these without sacrifice of that flow and pull of recessional composition with which he had so much natural sympathy.

5. Conclusion

We may now sum up our general findings. Guercino, born north of the Apennines, in an area where the predominant artistic language tended towards the painterly, exhibits in his early days a strong instinctive aptitude for that method of expression. But on coming to Rome under exalted auspices he enters an atmosphere which was in several ways unfriendly to it. First, there was not merely the almost inescapable classic flavour indigenous to the soil of Rome, but also the evident likelihood that the classic style, as exemplified by Domenichino and strongly advocated by the influential right-hand man of the Cardinal Nipote, would find most favour in official circles. Secondly (and conversely) was the fact that certain features of Guercino's early style could be theoretically equated with Caravaggism,[171] which had by 1621 passed the apex of its popularity in Rome (and was in any case certainly frowned upon by

[170] The position of the dove, at which both SS. Gregory and Francis are evidently looking in the drawing, was likely to be a difficulty. The physiognomy of S. Ignatius was familiar full face, but would not be very readily recognizable if turned away, and the baldness of his head would be awkward to deal with; Guercino may have considered turning this figure into S. Francis, but probably it was stipulated that S. Ignatius, as the founder of the Order, was to be the most prominent figure after the Pope. For the iconography of the two Jesuits, cf. *Bollettino d'Arte*, XXX, 1936-37 (pp. 151 and 160 for S. Ignatius Loyola, and pp. 155 and 161 for S. Francis Xavier).

[171] Perhaps it may be reiterated here that powerful light effects and the portrayal of plebeian types struck Seicento observers as being characteristic of Caravaggio, while the classic ingredients of the latter's art, which seem of great importance to us (namely, his plasticity and feeling for significant linear contour), appear to have largely escaped them. In stressing Caravaggio's firmness of structure we do not forget that he exhibits some signs of toning it down towards the end of his life, but this is hardly noticeable in the bulk of his Roman works (cf. note 143 of this Part).

Agucchi), leaving the classic aspects of Carraccism in a relatively stronger position.[172]

The effect of this *ambiente* on Guercino seems to have been that his confidence in his own innate ability to discern and seize the significant and valuable[173] in the art of painting was undermined; his temperament continued to tell him that such and such a treatment was more interesting and exciting, but its influence was disturbed and weakened by a new factor, the mistrust of his intellect. There is a feeling of perplexity and a lack of consistency and direction about the transitional works which reflects that clash. The most powerful impression on Guercino's mind during those two years in Rome must have been the discovery of a highly-praised formula of artistic expression directly opposed to his own, and he evidently spent much trouble in endeavouring to grasp the fundamental principles on which it operated. It is in the light of a radical re-orientation, based on what he had deduced from the study of classic works of art and on what he had picked up of the current theoretical arguments in support of them, that we should look upon his

[172] Our interpretation of the Caravaggio-Carracci antithesis (cf. also note 37 of this Part) may be epitomized as follows. There does not seem to be any reliable basis for the often repeated assertion that violent abuse was the order of the day between them; in fact we may venture a guess that, as the two most progressive painters in Rome, they very likely felt a certain respect for one another. It appears possible that during their lifetimes Caravaggio was on the whole the more successful and popular of the two; but a preference for Annibale began to gather adherents soon after their deaths (Agucchi is a symptom of this), and we have Mancini as evidence that by the time of Guercino's arrival in Rome Annibale's rating had drawn somewhat ahead of that of Caravaggio in the estimation of an observer with no particular axe to grind. It might also be inferred that Caravaggio's influence was waning from Mancini's statement (Marciana MS. it. 5571, f. 86 r.) that Honthorst arrived in Rome "in quei tempi ne quali la maniera del Caravaggio era communem.te seguitata" (i.e., about a decade before Mancini wrote), the implication being that a Caravaggesque manner was less common by 1621 (but cf. note 174 of Appendix 2). Thereafter, of course, the antithesis Caravaggio-Carracci was brought out into strong relief by writers who are far from contemporary (such as Bellori and Malvasia), and was ultimately developed into the "dramatic" story of their "rivalry."

[173] Obviously, this expression is used here in a strictly particular, and not in a general, sense.

change of style. To ascribe it to the influence of Domenichino *tout court*, and leave it at that, is not entirely adequate. The traces of the latter's work which we find in some of the earliest of Guercino's transitional paintings are not much more than a significant and instructive symptom of what has happened; they soon fail to reappear, and at no time does Guercino get really close to Domenichino.[174]

Though the transitional works stand together in bearing witness to a fundamental break with the pre-Roman style,[175] a curious uncertainty makes its presence felt as between the

[174] Ironically enough, Domenichino himself begins to move away from "the classic" soon after Guercino takes his first steps towards it. Mr. John Pope-Hennessy, whose forthcoming catalogue of the extensive collection of Domenichino's drawings at Windsor Castle will provide a new basis for studying the master, tells me that this modification of the classic outlook is noticeable in his later drawings also. I have often wondered if there are not some traces of the study of Guercino in Domenichino's allegorical figures of *Virtues* in Sant'Andrea della Valle, where he began four years' work in 1624. A further clue may possibly be provided by a *Magdalen* by Domenichino in my possession, which Mr. Pope-Hennessy dates *ca.* 1625 (cf. reproduction in *The Holford Collection at Dorchester House*, Oxford, 1927, I, plate LXXXV). The corner of twilit landscape background in this picture is unusual for Domenichino but commonplace for the young Guercino; an example accessible to Domenichino in Rome would have been Guercino's *Magdalen* of 1622 (sketched by Van Dyck in 1622-23), then above the high altar of the *Convertite al Corso* and now in the Pinacoteca Vaticana. These suggestions of a momentary influence in reverse are however quite tentative, and may prove to be unfounded if more evidence emerges.

[175] Any of my readers who are not surfeited with stylistic analysis may be curious to see if they can agree with my opinion that the *S. Francis with an angel* in the Dresden Gallery (derived from the 1620 picture, Fig. 7) is in fact a replica done by Guercino very soon after his return to Cento from Rome. The smaller picture is reproduced on p. 81 of *Meisterwerke der staatlichen Gemäldegalerie in Dresden* (pub. by Hanfstaengl, Munich, 1924, with introduction by Hans Posse). The differences are bound to be subtle (for Guercino is in general following his own pre-Roman idea), and the illustration is in some respects misleading, but such details as the enhanced silhouetting of the angel (his left knee, hair, etc.) are, I think, immediately evident. The contrast is better balanced in photographs, where the "drier" feel of the paint in the Dresden picture is more apparent; the question is moreover more complicated than I have been able to indicate here, so I merely place the suggestion on record without arguing a case.

individual paintings of the period: these children of com-
promise are rather uneasy companions. We may take as
examples of this the multiplication of the methods of rendering
drapery, and (even more noteworthy when we bear in mind its
former role) some doubts about the best system of lighting to
employ with a view to the fulfilment of its new function, the
definition of solid form. Yet we must not overlook the fact that
there are passages of high quality in these transitional paintings,
apart from the concentrations of colour which Guercino pro-
vides as a compensation. In the *Presentation* (Fig. 37), for
example, the drapery over S. Joseph's leg and that under the
child are admirably rendered.[176] Tucked away in the corner
of the *S. Lawrence* we find a very attractive scrap of romantic
landscape (Fig. 44). And in the Jesuit altarpiece (Fig. 45),
apart from some fine heads, we have those delightful *putti* which
Ponz so aptly described as "algunos Angeles niños en bellas
actitudes"[177] (cf. Fig. 48).

After a few years had passed it became increasingly difficult
for Guercino to retrace his steps,[178] and (as we have already

[176] These passages are carried out (and, we might add, "felt") exactly as
in pre-Roman days, in terms of light revealing structure seemingly by acci-
dent. It is no mere chance, the present writer would maintain, that they
comprise the best drapery painting in the picture: the contrast between
their convincing casualness and the *stento* of the more "careful" drapery
passages is not without significance.

[177] A chalk study of *putti* in the Royal Library at Windsor Castle (No.
2891), connected with this picture, has a new but charming elegance which
is irresistible.

[178] Corrado Ricci (*Rembrandt in Italia*, Milan, 1918, p. 11) interprets a
letter of 1660 (in which Guercino assents to a patron's request to paint a
picture in his first powerful manner) as indicating that Guercino could in
fact carry out work in his different manners at one and the same time. I
do not agree with that interpretation, which (apart from its inherent
improbability) has a quite decisive mass of evidence against it in the shape
of reliably dated pictures. The circumstances of this particular case were
that a patron of Guercino, D. Antonio Ruffo of Messina, had acquired
Rembrandt's *Aristotle* and wanted Guercino to paint a companion for it;
the relevant extract from Guercino's letter of 13 June 1660 to Ruffo runs as
follows (Ricci, *op. cit.*, p. 14): "Circa il particolare della mezza figura del
Reimbrant capitata alle mani della S. V. Ill.ma non può essere che di tutta
perfetione, perchè io ho veduto diverse sue Opere in stampa comparse in

seen) numerous considerations, including the requirements of the majority of his patrons, combined to encourage him to persist with his new trend. By the later thirties the waverings

queste nostre parti, le quali sono riuscite molto belle, intagliate di buon gusto e fatte di buona maniera, dove si può argomentare che il di lui colorire sia parimente di tutta esquisitezza e perfetione; et io ingenuamente [i.e., *sincerely*] lo stimo per un gran virtuoso. In quanto poi alla mezza figura che Ella desiderava da me; per accompagnamento di quella del Reimbrant, ma della mia prima maniera gagliarda, io sono prontissimo per corrispondere, et eseguire li di lei ordini. . . ." D. Antonio Ruffo evidently considered, understandably, that a work of Guercino's *prima maniera* spoke the same sort of language as a Rembrandt. Guercino had no very good reason to refuse the commission and doubtless introduced stronger light-effects than he was wont to do normally at this period; but to suggest that the picture could really have resembled an early work is going altogether too far. Moreover, among the valuable and copious extracts from the Ruffo Archives published by Duca Vincenzo Ruffo in six articles in *Bollettino d'Arte* (X, 1916) we find a suggestive sequel to this commission, which shows that D. Antonio (no doubt instructed by experience) does not repeat his request for the impossible, but instead shows himself desirous, as Guercino puts it in a letter of 9 March 1663 (*loc. cit.*, p. 106), *di qualche quadro fatto in mia Gioventù*. This wish for a picture actually painted in Guercino's youth was not satisfied until 1665, when Guercino presented him with a small picture which was recorded (*loc. cit.*, note 3, p. 112, and cf. also p. 126) on arrival at Messina on 9 April as "Un quadro originale della prima maniera del Guercino fatto cinquanta anni sono rappresentante la Madonna (mezza figura) S. Giovennino e N.S. (figure intiere)." The Flemish painter Abraham Breugel (Bruegel), who was acting at this time as picture-buying agent in Rome for D. Antonio Ruffo, was informed by the latter of its arrival, and comments in a letter of 22 May 1665 (*loc. cit.*, p. 174): "Mi rallegro che V. S. Ill.ma ha avuto un quadro del Guercino per che le prime opere sue sono stimate . . .", but adds "Quanto alli quadri del Rembrant qua non sono in gran stima. . . ." In a letter of 24 January, 1670 (reproduced by Ricci, *op. cit.*, pp. 34 f.) Breugel produces, in his quaint French-Italian, a typical example of the current classic jargon apropos of Rembrandt, disapproving of mere clothed half-lengths with a blob of light on the nose ("sola vene un lumino soupra il poynto del naso") emerging from the surrounding darkness ("tout il reste è ouscure"). He adds: "Li pictori grandi studine à fayre vedere un bel corpo niudo, è dove si vede il sapere del disegni, ma al contrario, un inniorante cherca di coprire de vestiti ouscuri goffi, et il contorno incognito. . . ." This view (the expression of which may possibly be related to his picture-dealing activities) makes an interesting contrast to Guercino's obviously genuine admiration for Rembrandt's etchings. For the Ruffo correspondence in relation to Rembrandt and Guercino, cf. also *The Art Quarterly*, VII, 1944, pp. 129-134.

of his transitional period were over and his late style was becoming established.

Before concluding, it should be made clear that we do not feel entitled to censure Guercino from a moral point of view: indeed his error of judgment seems to have lain in being too modest. It did not follow, just because great masterpieces had been achieved in terms of the classic language, that the mere use of the language itself was to be regarded almost in the light of a universally valid recipe for beauty. But Guercino was neither the first nor the last to be confused by the fallacy, and the writer's guess is that he only came to suspect that he had taken the less fruitful of two courses when it was too late. Nowadays we can claim greater objectivity in that this misconception has been overcome: we are less vulnerable to the charge that when we set greater store by an early Guercino than a late one we are simply reflecting a reaction of taste in favour of the painterly in general. A pictorial language is seen to be of no qualitative importance in the abstract: it is only in its particular connotation, when it is filtered through the personality of the individual artist, that any question of qualitative judgment can arise.

Our impression in the case of Guercino is that his *volte-face* was a mistake from the artistic point of view because it cramped his natural instincts. It is for this good reason that the paintings of his late period have in general less interest for us than the early ones. We are however by no means suggesting that the late works are devoid of artistic merit: it is true that as a whole they vary considerably in quality, but some of them are certainly still underrated, and there are often passages of detail which reward those who take the trouble to look twice. It may be well—in order to preserve a just balance—to glance at one such example, the modelling of the head of the dead Adonis (Fig. 46) in the picture painted for Cardinal Mazarin in 1646/47.[179]

[179] For this picture, which came from France to Dresden in 1744, cf. *Die staatliche Gemäldegalerie zu Dresden, vollständiges beschreibendes Verzeichnis*, Abt. I, *Die romanischen Länder*, Dresden/Berlin, 1929, p. 169, No. 364 (repr. on p. 170). There are two relevant entries in Guercino's Account Book; I quote

Nevertheless even here, though there is a world of difference between this relatively delicate shimmering *sfumato* and the impetuous accented luminosity of some of the early heads, such as that of the Elijah (Fig. 47, detail of Fig. 1), it is precisely its painterly character which gives the late detail its quality; and yet (that is the paradox) there is an ingredient in the overall mould in which the pictures of this period are cast which is basically antipathetic to that character. If we respond more readily to the contemporary drawings it is because they retain more spontaneity and *slancio*, and are not so often or so rigorously subjected to an organization according to classic principles —a discipline which (however fruitful in other cases) we feel was never wholly congenial to Guercino's individual temperament. Through them we seem to be in more direct contact with something of the true untrammelled spirit of a natural artist; that is the essence of the matter.

from the manuscript (Bologna, Biblioteca Comunale dell'Archiginnasio, MS. B331; cf. note 4 of this Part):

(i) Il di 28. Luglio [1646] Dal . . . Sigre Calvi il di sopra detto si è riceuto a nome dell'Em.mo Mazzarini p[er] caparra di un Quadro, con Vener[e] e Adone et un Amorino dacordo in duca.ni 250. si è riceuto ducatni 50., che fano Scudi $62\frac{1}{2}$.

(ii) Il di 29. Maggio [1647] Dall'Em.mo Sigre Cardinal Mazarini si è riceuto ducatni nõ 200—per intiero pagam.to del Quadro della Vener[e] et Adone, in tante dopie d'Italia le quali fano la soma di Scudi 248.

Malvasia lists the picture accurately under 1647 (*Felsina*, 1678, II, p. 375); he correctly adds that Cupid is holding the boar's ears ("Venere che piange sopra l'ucciso Adone, con Amore, che tiene afferrato per l'orecchie il Cingiale, per l'Eminentissimo Card. Mazzarino"), a fact which he may however have derived from knowledge of Louis Rouhier's engraving in reverse, which must have been completed not long after the painting itself. This detail is also recorded in Cardinal Mazarin's inventory of 1653 (*Inventaire de tous les meubles du Cardinal Mazarin*, ed. by Henri d'Orléans [i.e., Duc d'Aumale], London, 1861, p. 333, No. 344), and in that of 1661 (Gabriel-Jules, comte de Cosnac, *Les richesses du Palais Mazarin*, Paris, 1884, p. 328).

PART II

AGUCCHI AND THE *IDEA DELLA BELLEZZA*:
A STAGE IN THE HISTORY OF A THEORY

> ". . . non è da credere . . . che ci sia
> una sola forma del perfetto dipingere."
>
> (Lodovico Dolce, 1557.)

In our study of Guercino's change of style Agucchi necessarily played a relatively subordinate and restricted part. The learned Monsignore was however a not inconsiderable figure on his own account, and we shall be concerned in the present essay with the investigation of his status in the history of art theory. After giving some account of his life and his association with the Carracci and Domenichino, we shall examine the literary origins of his theoretical point of view and draw attention to the fact that it makes a noteworthy contribution to the classic-idealist theory as developed and popularized later by Bellori.

The most important early biography of Monsignor Giovanni Battista Agucchi[1] is that published in 1644[2] by the Paduan scholar Giacomo Filippo Tomasini (1597-1654), Bishop of Cittanuova.[3] The accounts of subsequent writers[4] are mainly

[1] Variously spelt: Agucchi, Agocchi, and with a final *a* added. The striking portrait of Monsignor Agucchi by Domenichino was identified recently by Mr. John Pope-Hennessy (cf. *The Burlington Magazine*, LXXXVIII, 1946, p. 184).

[2] [Giacomo Filippo Tomasini,] *Iacobi Philippi Tomasini Patavini Episcopi Aemoniensis Elogia Virorum Literis & Sapientia Illustrium*, Padua, 1644, pp. 13-28. A similar collection of biographies, published by Tomasini in 1630, is dedicated to Agucchi (*Iacobi Philippi Tomasini . . . Illustrium Virorum Elogia*, Padua, 1630).

[3] Earlier accounts of Agucchi will be found in eulogies published immediately after his death by Andrea Torelli (*Lachrymae Funebres in Obitu . . . Ioannis Baptistae Agucchii*, Bologna, 1632) and Marino Boliza (*Oratio in Funere . . . Io. Baptistae Agucchii*, Venice, 1632); after a quick glance at the copies of these possessed by the Biblioteca Comunale dell'Archiginnasio at Bologna, I made a note to the effect that they did not seem to supply any information not available from Tomasini, and that they did not refer to Agucchi's interest in art and artists. Ovidio Montalbani published (under his pseudonym Bumaldi) a short and unimportant note on Agucchi in *Minervalia bonon. ciuium anademata seu Bibliotheca bononiensis* (Bologna, 1641, pp. 124 f.). Giovanni Vittorio Rossi's account, though longer, is not over-accurate, and confuses our Giovanni Battista with his brother Girolamo Agucchi (*Iani Nicii Erythraei Pinacotheca Tertia*, Cologne, 1648, pp. 190 ff.).

[4] Gaetano Lenzi, *Vita di Monsignor Giambattista Agucchi*, Rome, 1850 (Extract from *L'Album*, Anno XVII, Distribuzione 6) is sometimes given as an authority, but there is hardly anything in it which is not derived, without much discrimination, from previous printed sources.

based on the work of Tomasini, to which we refer the reader for the principal facts of Agucchi's career.

He was born in 1570 of a noble Bolognese family, a younger brother of Cardinal Girolamo Agucchi and a nephew of Cardinal Filippo Sega. By the time of his uncle's death in 1596 he had already made himself useful to Cardinal Pietro Aldobrandini, the nephew of Clement VIII, and accompanied Aldobrandini on his embassy to France between September 1600 and March 1601.[5] On returning to Rome he held various appointments until the death of Clement VIII in 1605, at which time he was *Maggiordomo* to Aldobrandini,[6] who had recently become Archbishop of Ravenna. After the election of Paul V Agucchi returned with Aldobrandini to Ravenna, and remained there for a short time, but by 1607 he was back again in Rome and went into a temporary retirement from public life which lasted until 1615. It is in the context of this period of retirement, which Agucchi is said to have devoted to literary and historical studies, that Tomasini mentions[7] his patronage of Domenichino. In 1615 he re-entered the service of Aldobrandini; and on the day of the Cardinal's death (10 February 1621) he was at once appointed[8] secretary to the newly elected Gregory XV and became the right-hand man of the *Cardinal Nipote*, Ludovico Ludovisi. Towards the end of 1623, after the death of Gregory, Agucchi was sent as Papal Nuncio to Venice,[9] which post he held until his death in 1632.

Tomasini gives a long list of Agucchi's literary works known to him as existing in manuscript. Among them are the three following:[10]

[5] Cf. *Revue d'Histoire et de Littérature religieuses*, VII, 1902, pp. 487 ff.

[6] He succeeded his brother Girolamo in this office after the latter had been created Cardinal (9 June 1604); Girolamo died not long afterwards (27 April 1605).

[7] Tomasini, *op. cit.*, 1644, pp. 20 f.; the passage is reprinted by Malvasia, *Felsina*, 1678, II, p. 342.

[8] Cf. Ludwig Freiherr von Pastor, *Geschichte der Päpste*, XIII, Abt. 1, Freiburg im Breisgau, 1928, pp. 56 f. (Eng. Ed., XXVII, p. 70).

[9] Cf. Pastor, *op. cit.*, XIII, Abt. 2, 1929, pp. 714 f. (Eng. Ed., XXIX, pp. 176 f.); Agucchi was given the title of Archbishop of Amasia.

[10] Tomasini, *op. cit.*, 1644, p. 27.

Un' Orazione di Nerone per la Colonia Bolognese abbrugiata.[11]
Descrizione d'un quadro grande del famoso Pittore Annibal Caracci.
Trattato della Pittura.

The first is only of interest to us in that it was published
posthumously in Bologna in 1640 under the same pseudonym,
that of Gratiadio Machati,[12] as was to be used later when a
fragment of the *Trattato della Pittura* found its way into print;
Masini refers to the *Orazione* as "dell'istesso [Monsignor]
Agocchia, sotto nome di Gratiadio Macati" in the first edition
of *Bologna Perlustrata* published in 1650,[13] and Aprosio relates[14]
that a copy was given him in 1647 by one of the best known
scholars of Bologna, Ovidio Montalbani, who told him that it
was by "Monsignor Gio: Battista Agocchi, che fù Nuntio
Apostolico alla Sereniss. Rep. di Venetia." The second item is
doubtless the *Descrittione della Venere dormiente di Annibale Carrazzi*
which Malvasia published in 1678 in his *Felsina Pittrice*; we shall
have occasion to refer to this later on.[15]

The *Trattato della Pittura* has never been printed as a whole;
possibly a manuscript copy still exists and may be discovered
and published some day. Fortunately an important fragment
is preserved in the Preface to the first edition of Simon Guillain's
etchings after Annibale Carracci's drawings of the artisans to be
seen in the streets of Bologna. This discourse was written (under
the name of "Giovanni Atanasio Mosini") by the then owner
of the original drawings, who, in inserting the fragment of the
Trattato into it, states that the manuscript had been bequeathed
to him by its author, *un tale Gratiadio Machati, persona di lettere*

[11] Tomasini also refers to this as by Agucchi in an account of manuscripts
in his own possession (cf. Tomasini, *Bibliothecae Patavinae Manuscriptae Publicae
& Privatae*, Udine, 1639, p. 127).

[12] Variously spelt.

[13] Antonio di Paolo Masini, *Bologna Perlustrata*, Bologna, 1650, p. 672.

[14] [Lodovico, afterwards Angelico, Aprosio,] *La Visiera Alzata, Hecatoste di
Scrittori, che vaghi d'andare in Maschera fuor del tempo di Carnovale sono scoperti da
Gio: Pietro Giacomo Villani* [i.e., pseudonym for Aprosio], Parma, 1689,
pp. 67 f.

[15] Cf. p. 149 below (notes 133 and 134 of this Part).

non ordinaria. The Preface, which only appears in the first edition, is not well known, and has the rare distinction of having escaped the notice of Dr. von Schlosser in his monumental and invaluable book on art literature;[16] since (apart from its usefulness as an early source for the Carracci) it possesses a certain general interest as a document in the history of art theory, and deserves on that account to be made more readily accessible than in the comparatively scarce edition of 1646, it was thought that its republication below in its entirety might prove acceptable.[17]

We now turn to the examination of such evidence as we have which bears upon Agucchi's association with the Carracci and with Domenichino. Our principal testimony that Agucchi was well acquainted with the Carracci family is provided by Malvasia's extracts from several letters written by Agucchi to the Canonico Dulcini at Bologna.[18] There seems no reason to

[16] Julius Schlosser, *Die Kunstliteratur*, Vienna, 1924. A new edition, translated into Italian, was published at Florence in 1935 (Julius Schlosser-Magnino, *La Letteratura Artistica*). It was about this time that I came across the fragment, and drew the attention of Dr. Otto Kurz to it in time for inclusion in the *Appendice* to *La Letteratura Artistica* which he published in 1937 (p. 36).

[17] See Appendix 1 below.

[18] Malvasia, *Felsina*, 1678, I, p. 405 (n. d. [1602]); *ibid.*, p. 463 (23 March, 3 April, and 17 April, 1602); *ibid.*, p. 453 (3 April and 17 April, 1602, and 4 July 1607); *ibid.*, pp. 445 f. (15 July 1609); *ibid.*, pp. 517 f. (12 September 1609); *ibid.*, p. 521 (11 January 1617); *ibid.*, p. 459 (19 May 1618). Four undated letters from Agucchi were published by Luigi Crespi on pp. 8-13 of the seventh volume which was added by the publisher Marco Pagliarini (Rome, 1773) to Bottari's *Raccolta di Lettere sulla Pittura*. The first of these letters, to an anonymous correspondent, mentions a *S. Catherine* by Lodovico Carracci sent to Agucchi by a friend *un anno fa*, which (cf. *Felsina*, 1678, I, p. 453) dates the letter *ca.* 1603. The third and fourth letters were both addressed to Dulcini, and it seems clear from internal evidence that a relatively short period of time (not more than a matter of months) elapsed between them. The third describes in detail and eulogizes Annibale Carracci's *Pietà with SS. Mary Magdalen and Francis*, which, Agucchi says, has been placed on view *questa Pasqua* in S. Francesco di Trastevere (i.e., S. Francesco a Ripa); this is the picture now in the Louvre (cf. H. Voss, *Malerei des Barock*, p. 183). The fourth letter has a passage (*op. cit.*, p. 13) which probably refers to the same picture, and which is also reproduced by Malvasia (*Felsina*, 1678, I, p. 453) with the usual variations in transcrip-

doubt the genuineness of these letters as a whole.[19] To them we can add the epitaph of Annibale written by Agucchi and published by Bellori,[20] who states elsewhere[21] that the two used to discuss artistic matters together. Next there are two relevant statements which date from well over half a century after Annibale's death. First, Bellori records the rumour ("si tiene") that Agucchi was partly responsible for the *libretto* of the Galleria Farnese.[22] But whatever share Agucchi may have had in advising on the subject-matter (and I agree with Prof. Tietze's view[23] that he is unlikely to have played more than an incidental part in helping to formulate it), his *artistic* theories were cer-

tion, but with the useful addition of a date, 4 July 1607. From these letters it may reasonably be deduced: (a) that the picture is substantially by Annibale (and not by Domenichino, as Prof. Tietze and others following him have maintained), and (b), that it was finished in time for Easter, 1607. I can see no reason to quarrel on stylistic grounds with these conclusions, and would point out that we could hardly ask for a better informant than Agucchi on the respective activities of Annibale and Domenichino at this time.

[19] In spite of the fact that Malvasia (*Felsina*, 1678, I, p. 406) seems to give the impression that his obviously ridiculous story of Lodovico's "correction" of the Galleria Farnese is derived from Agucchi's letters. Actually the latter were probably simply the source for the date of Lodovico's brief visit to Rome, for which cf. also Malvasia, *Felsina*, 1678, I, p. 542, and the letters on pp. 453 and 463, in conjunction with Malvasia's remark on them in his index, II, p. 560; and Hans Tietze, "Annibale Carraccis Galerie im Palazzo Farnese und seine römische Werkstätte," in *Jahrbuch der kunsthistorischen Sammlungen des allerhöchsten Kaiserhauses*, XXVI, 1906-07, p. 56. Lodovico's letter of 8 June 1602 to Brizio from Rome, referred to by Prof. Tietze, was published by Dr. Heinrich Bodmer (*Lodovico Carracci*, Burg bei Magdeburg, 1939, pp. 157 f.), from MS. B153 in the Biblioteca Comunale dell'Archiginnasio, Bologna; though there is no reason to doubt the ultimate authenticity of the text, it is perhaps worth mentioning that when I saw this letter (No. 11 of the MS.) I made a note to the effect that it is headed *Copia*.

[20] Giovanni Pietro Bellori, *Le Vite de' Pittori, Scultori et Architetti moderni*, Rome, 1672, p. 78.

[21] Bellori, *op. cit.*, p. 73.

[22] Bellori, *op. cit.*, p. 32: ". . . la moralità dell'argomento, che è degnissimo, & in cui, oltre l'eruditione di Agostino, si tiene, ch'egli fosse aiutato dal suo amico Monsignor Gio: Battista Agucchi celebre in ogni studio di lettere."

[23] Prof. Tietze, in dealing with this matter at some length (*op. cit.*, pp. 90-94), points out that such an early authority as Mancini does not mention Agucchi in connexion with the Galleria; equally strange, if Bellori's rumour were really substantially true, is Mosini's silence, especially in view

tainly put on paper after the completion of the Galleria. As we have seen, he also refers in the *Trattato* to the death of Agostino (February, 1602), and in a letter written to Dulcini at that time Agucchi says:[24] ". . . era huomo che ci farà conoscere adesso ciò ch'egli valeua, & io in particolare, che sono affatto cieco nella sua professione, mi pareua d'esser linceo nello scuoprire il suo genio." This is consistent with the works of the Carracci, and the Galleria in particular, having been one of the principal origins of Agucchi's interest in art; and certainly there is no good case for any suggestion of influence in the reverse direction, on the style of the Carracci.[25] We now come to the second statement. Malvasia refers to the *Trattato della Pittura*, which, he says,[26] "Monsig. Agucchi, colla scorta, e consiglio prima di Annibale, poi del suo Domenichino intesseua." Did Agucchi's theories substantially originate from opinions expressed by Annibale? But Annibale's character as depicted in the Preface to the etchings (Appendix 1 below) is entirely in agreement with that recorded by other early sources,[27] and leads one to regard it as highly improbable that he would have had any-

of the probability (pointed out below, pp. 143 ff. and note 113 of this Part) that "Mosini" is a pseudonym for Monsignor Massani, a close friend of Agucchi himself.

[24] Malvasia, *Felsina*, 1678, I, p. 405.

[25] Agucchi was a youngish ecclesiastic of about thirty years of age when the Carracci were at work on the Galleria; surely a different figure to the learned and experienced Secretary of State of Guercino's Roman visit, some two decades later.

[26] Malvasia, *Felsina*, 1678, II, pp. 243 f. Malvasia has a somewhat similar passage in his index (II, p. 602; s.v. *Trattato di Pittura*): "Di Annibale Carracci prima, poi del suo Domenichino, & Monsig. Agucchi, del quale van fuore manoscritti frammenti, parte de' quali, sotto nome di Graziadio Macchati, si sono portati nella Vita de' Carracci."

[27] For example, cf. the passage from Mancini quoted in note 47 of Appendix 1. The present writer deals in that note with Annibale's ingenious explanation, recorded by Mosini, of the activity of the caricaturist. The significant fact is that the method of argument employed by Annibale is recognizably akin to that of classic-idealist theory, but in substance undermines by implication the latter's logical foundations. If this interpretation is correct, Annibale was by no means above poking a little sly fun at "theory," by means very similar to those of the portrait caricature—the invention of which should probably be credited to him.

thing to do with the writing of those effusive eulogies of himself and the Galleria Farnese with which the *Trattato* fragment and the theory embodied in it are so largely concerned; on the other hand, Agucchi's enthusiasm for both is quite evident in his letters. Besides, it is worth recalling that during the last five years of his life (the most plausible period for any possible collaboration with Agucchi) Annibale was in a most depressed condition. We know that his melancholia seriously interfered with his painting, and it might reasonably be doubted whether he was likely in these circumstances to play any considerable part in the writing of a theoretical treatise: but perhaps we are not sufficiently well informed about the illness to feel any real certainty on the point.[28] Doubtless theoretical questions must have arisen, directly or by implication, in conversations on painting between Annibale and Agucchi, but to suggest that Annibale was responsible to any great extent for the *Trattato* would put an unsupportable strain on a few casual words written at least seventy years later by a writer who, as we have frequently seen, was not over-particular in the matter of literal accuracy.

Malvasia's mention of Domenichino does however call for further consideration.[29] The close friendship between Agucchi and Domenichino was of course known to several early writers[30]

[28] Cf. Mancini: "Finita la Galleria ò perche no[n] gli paresse essere stato sodisfatto 2.º il merito o p[er] una certa altra disgratia e sopramano fattoli ò p[er] altro fù soprapreso da una estrema malanconia accompagnata da una fatuità di mente e di memoria che non parlava ne si ricordava con pericolo di morte subitanea pur con cura si ridusse in stato che operava qualche cosa . . ." (Biblioteca Nazionale Marciana, Venice, MS. it. 5571, fol. 55 verso; quoted by Tietze, *op. cit.*, p. 145, from Biblioteca Vaticana, Cod. Barb. Lat. 4315). Cf. also Giovanni Baglione, *Le Vite de' Pittori*, Rome, 1642, p. 108, and the very full account of Annibale's illness given by Tietze (*op. cit.*, pp. 145-149), who publishes extracts from letters of 1605-07 preserved in the Archivio di Stato at Modena.

[29] In addition to the passage quoted above, cf. also Malvasia, *Felsina*, 1678, II, p. 336: "con iscambievole participazione."

[30] Cf. Mancini: "Venne à Roma come s'è detto per veder, et esser appresso al S.ʳ Anibale, dal q.ˡᵉ era molto amato, et riputato, et essendo raccolto, et abbracciato da Mons.ʳ Agucchia gli fù dato trattenimento in Casa sua . . ." (Biblioteca Nazionale Marciana, Venice, MS. it. 5571, fol. 74 recto). Cf. also Baglione, *Vite*, 1642, p. 382, and Passeri, *op. cit.*, ed. Hess, pp. 23 ff.

besides Tomasini; and we have some evidence as to their rela-
tionship in six fragments of letters written by Agucchi in the
year 1609 dealing with plans for a memorial "in S. Giacomo"
to a Cardinal, identified by Malvasia as Sega, but who was
evidently Girolamo Agucchi.[31] There seems to have been a
fair amount of give and take between Agucchi and Domeni-
chino in discussing these plans; certainly Domenichino's part
does not appear to proponderate over that of Agucchi, who,
incidentally, is seen to have a very definite reverence for "the
antique" as a norm.[32] Bellori has an interesting passage,
striking a convincing note, which he prefaces to his extract from

[31] Agucchi's letters were published by Malvasia, *Felsina*, 1678, II, pp.
329-332. Malvasia's mention of Sega seems to have been a very careless
slip; in the account of S. Giacomo Maggiore in his *Le Pitture di Bologna* of
1686 he mentions (p. 88) that the statues, etc., by Gabriele Fiorini (i.e., the
younger) in the Porticella were dedicated "dal dottissimo Monsignor
Agucchi al Cardinal Agucchi suo fratello, e nipote del Cardinal Sega."
The memorial inscription placed in position by the Cardinal's brothers
Giovanni Battista, Annibale, and Federico Agucchi, still exists over the
door in S. Giacomo (for mention of Federico and the site over the door,
cf. letter of 12 September 1609, *loc cit.*, p. 331); Mr. John Pope-Hennessy
kindly informs me that, in the course of preparing his catalogue of the
drawings by Domenichino in the Royal Library at Windsor Castle, he
found a design for this memorial. Both Cardinals were buried in Rome,
Sega in S. Onofrio and Girolamo Agucchi in S. Pietro in Vincoli. Mancini
(Biblioteca Nazionale Marciana, Venice, MS. it. 5571, fol 74 verso) says
(handwriting of the "scribe") that these two tombs were designed by
Domenichino, but then the reference to that of Cardinal Sega is crossed
out, and Mancini adds in his own hand a half-illegible note including
the words "in S. Jacomo in Bologna del Cardinl Aguchia." All that now
exists in S. Onofrio is an inscription to Sega, but there is nothing improbable
about the attribution to Domenichino of the design of the more elaborate
monument to Cardinal Agucchi in S. Pietro in Vincoli.

[32] The following short phrases from these letters may be quoted as
examples of Agucchi's attitude towards antiquity. He praises a design by
Domenichino which "è insieme conforme all'antico così nel tutto, come
nelle parti," and adds "di tali capricci Domenico, che hà osservato la
maniera antica nell'anticaglie è copiosissimo inventore." Of two designs he
says that the second is the better "poiche rappresenta anche più un'arco
antico." He comments that a certain arrangement "sarebbe errore dell'arte,
ancorche si trovi in qualche fabrica antica, mà non fatta in buon secolo"
(my italics).

the *Trattato*.[33] This passage gives one the impression that when Agucchi and Domenichino discussed those parallels between poetry and painting which became such a commonplace during the Seicento, it was the *letterato* who took the leading part; and that our Treatise was in fact written by Agucchi, who however had Domenichino at hand for consultation.[34] Moreover the latter's role is not represented as having been that of an abstract theorist well versed in literature and philosophy, and we may suggest that it was rather that of a professional executant whose critical views were of an unsystematized, empirical nature—intuitive deductions from the particular, not reasoned generalizations. Further evidence on the subject is provided by Domenichino himself, in a letter which he wrote to Francesco Angeloni. An important extract from this letter, the genuine existence of which there is no reason to doubt, was published by Bellori,[35] and runs as follows:

"Speraua con la venuta à Roma del Signor Gio: Antonio Massani d'hauer nelle mani il discorso che scrisse Monsignor Agucchi, nel tempo che stauamo in casa. Mi adoperai nel distinguer, e far riflessione alli maestri, e maniere di Roma, di Venetia, di Lombardia, & à quelli ancora di Toscana: se la cortese diligenza di V. S. non mi aiuta, ne dispero. Io haueua due libri di pittura, Leon Battista Alberti, e Gio: Paolo Lomazzi, ma nel partir di Roma, m'andarono male con l'altre cose: mi fauorisca di far diligenza se si trouassero

[33] For Bellori's extract, cf. note 19 of Appendix 1 below.

[34] Bellori, *Vite*, 1672, p. 315: "Gli [i.e., to Domenichino] era di gran giovamento il leggere historici, e poeti, e se ne approfittava per l'introduttione havutane da Monsig. Gio: Battista Agucchi, il quale per lo diletto grande della pittura, soleva esporgli le bellezze della Poesia, con osservare i mezzi e li termini de Poeti, e de' Pittori nel rappresentare. In questo studio l'Agucchi communicando con Domenico, si propose di comporre un discorso sopra le varie maniere della pittura, dividendola in quattro parti, come l'antica, del qual discorso poniamo quì il principio tratto dal suo originale, benche inserto, e commutato da altri sotto oscuro nome."

[35] Bellori, *Vite*, 1672, p. 359. Bellori has much more of the historian's respect for his sources than Malvasia, and we should in any case expect him to be in possession of Angeloni's papers (cf. notes 115 and 116 of this Part).

à comprare. Non sò se sia il Lomazzo, che scriua che il disegno è la materia, & il colore la forma della pittura;[36] à me pare tutto il contrario, mentre il disegno dà l'essere, e non vi è niente che habbia forma fuori de' suoi termini precisi; nè intendo del disegno in quanto è semplice termine, e misura della quantità; & in fine il colore senza il disegno non hà susistenza alcuna. Mi pare ancora che dica il Lomazzo che vn huomo disegnato al naturale, non sarebbe conosciuto per il solo disegno; ma ben si con l'aggiunta del colore simile,[37] e questo è ancor falso; poiche Apelle col solo carbone disegnò il ritratto di colui, che l'haueua introdotto al conuito, e fù subito riconosciuto, con istupore dal Rè Tolomeo,[38] e tanto basta alla scoltura, che non hà colore alcuno. Dice ancora[39] che a fare vn quadro perfetto sarebbe Adamo, & Eua: l'Adamo disegnato da Michel Angelo, colorito da Titiano: l'Eua disegnata da Rafaelle, e colorita dal Coreggio hor veda V. S. doue và à cadere chi erra ne primi principij."[40]

[36] Cf. Giovanni Paolo Lomazzo, *Trattato dell'Arte della Pittura, Scoltura, et Architettura*, Milan, 1584, p. 24.

[37] Cf. Lomazzo, *Trattato, loc. cit.*

[38] Domenichino's refutation derives from Pliny the Elder (*Historia Naturalis*, XXXV, § 89); it had of course been retold, e.g., by Paolo Pino (*Dialogo di Pittura*, Venice, 1548, fol. 13 r.) and by Romano Alberti (*Trattato della Nobiltà della Pittura*, Rome, 1585, p. 17).

[39] Giovanni Paolo Lomazzo, *Idea del Tempio della Pittura*, Milan, 1590, p. 60: "Mà dirò bene che à mio parere chi volesse formare due quadri di somma profetione [i.e., *perfezione*] come sarebbe d'uno Adamo, & d'un Eva, che sono corpi nobilissimi al mondo; bisognarebbe che l'Adamo si dasse à Michel Angelo da disegnare, à Titiano da colorare, togliendo la proportione, & convenienza da Rafaello, & l'Eva si disegnasse da Rafaello, & si colorisse da Antonio da Coreggio: che questi due sarebbero i miglior quadri che fossero mai fatti al mondo." Dr. Ernst Gombrich has kindly drawn my attention to Lucian's Εἰκόνες (cf. especially §§ 5 ff.) as a possible exemplar for this passage. The dialogue was accessible in Latin also; Vincentius Obsopoeus' translation was published in 1529 (*Elegantissima aliquot Luciani opuscula, iam recens per Vincentium Obsopoeum latinitate donata*), and was reprinted later, e.g., in the *Luciani Samosatensis Opera . . . omnia* compiled from the work of various translators and published in 1543.

[40] It is extraordinary how this last sentence always seems to escape those who still credit the idea that some form of what is called "eclecticism" was genuinely taught as a kind of programme or system in the school of the Carracci. And yet here we have the candid opinion of one of their closest

At the time of writing, Domenichino is trying to get hold of various works *sulla pittura*. The letter is undated, but the mention of Massani coming to Rome with Agucchi's manuscript strongly suggests that it was written in the second half of 1632,[41] since Monsignor Massani, a close friend of Agucchi and the legatee of some of his manuscripts, had acted as Internuncio in Venice[42] from the time of Agucchi's death at the beginning of the year until relieved by the new Nuncio, Francesco Vitelli, in the summer or autumn; and in fact it seems very probable indeed that Massani is identical with the mysterious "Mosini" who sponsored the publication of the *Trattato* fragment.[43] If Domenichino wished to lay hands on the manuscript of the *discorso*, to address himself to Angeloni in particular for assistance in doing so would be in no way unnatural, since the latter had also been a close friend of Agucchi.[44]

A fact which emerges clearly from the letter is that the *discorso* was actually written by Agucchi at the period when they were living together,[45] and we note, for what it is worth,

pupils, not obscured (for once!) by the abstract sophisms of the world of the *letterati*. Far from having anything in the nature of an "eclectic" doctrine dinned into him in his student days, he evidently discovers for himself this expression of it in the writings of a Mannerist painter turned *letterato*, and has no hesitation in pronouncing it a fundamentally foolish idea. As is well known, Domenichino (in common with a legion of artists before and after) assimilated into his own work formal motives from that of others. But he was also a pupil of the Carracci (to whom the alleged eclectic theory has come to be popularly but wrongly attributed), with the result that the supposed coincidence between "theory" and what was after all a common practice caused the misleading expression eclectic to be attached to him, and indeed to any artists connected in some way or other with the Carracci. The complicated history of the term and the confused thinking behind its misapplication are fully discussed in Part IV below.

[41] Domenichino would therefore be writing from Naples, which would fit in with his statement that he had lost his copies of Alberti and Lomazzo *nel partir di Roma* (i.e., during the previous year).

[42] Cf. Tomasini, *Elogia*, 1644, p. 24; and cf. also note 111 of this Part.

[43] Cf. p. 145 below (note 113 of this Part), and notes 14 and 55 of Appendix 1.

[44] Cf. Tomasini, *Elogia*, 1644, p. 24; and see below, p. 144.

[45] This probably partly coincides with the years 1607-15, during which Tomasini describes Agucchi as being in retirement from public affairs and devoting himself to literary work, though the project may of course have originated before Agucchi went to Ravenna.

that there is no mention of Annibale. Some element of doubt as to the precise meaning of the second sentence seems to be unavoidable. It may refer to the advisory role which we envisaged Domenichino as playing at the time when the *Trattato* was written,[46] and indeed the classification and characterization of the *maniere* of recent times is just the sort of matter about which Agucchi would naturally have consulted Domenichino. On the other hand one could reasonably expect to find at such a juncture in the letter some explanation as to why the subject of the *discorso* had been introduced. In that event, the sentence might conceivably mean that Domenichino had set to work relatively recently to think over these matters again, but had failed[47] to make progress in the absence of any written material, and could not remember the conclusions which had been arrived at *in casa* some two decades before. Consequently he writes to Angeloni for assistance: the end of the sentence— "se la cortese diligenza di V. S. non mi aiuta, *ne dispero*"—then follows naturally.

On the whole, the evidence seems to point to the attribution of the more theoretical side of the *Trattato* primarily to Agucchi, and not to Domenichino. In taking this view we are not of course ignoring the fact that Agucchi and Domenichino must frequently have discussed artistic matters together:[48] we are

[46] The use of the past definite might suggest this. But the link in the sense between *che scrisse Monsignor Agucchi* and *mi adoperai* would then be somewhat unexplained and abrupt.

[47] *Adoperarsi* may certainly imply effort and exertion, but I am not competent to judge whether the use of this verb in the past definite would be reasonable if the situation was that the writer felt that he had been defeated by a difficult task.

[48] Agucchi must surely have concerned himself to some considerable extent with Domenichino's programmes or subject-matter. In a letter to Albani Domenichino mentions that he had corresponded with Agucchi over the *invenzione* of his *Madonna del Rosario* (cf. Malvasia, *Felsina*, 1678, II, p. 321). Elsewhere Malvasia states (*ed. cit.*, II, p. 336) that Albani had blamed Agucchi for the over-subtle *pensieri* of some of Domenichino's works, mentioning Sant'Andrea della Valle and San Carlo ai Catinari; but (since Agucchi was at Venice when Domenichino was working in those churches) it seems likely that any suggestions in connexion with the frescoes were confined to the limits imposed by the written word.

merely suggesting that Domenichino's share may well have been in the form of expressing opinions from time to time on actual works of art and relatively practical questions,[49] rather than attempting to account for those opinions with a deliberate theoretical construction in which we find something more of the professional scholar than would seem to fit in readily with

[49] As an instance of this we may quote Domenichino's view (recorded in Agucchi's letter of 31 January 1609) on *stucchi finti* in the Galleria Farnese which Annibale had painted as if broken: ". . . il Sig. Annibale, per ingannare l'occhio col verisimile ne hà finti molti pezzi rotti nella galleria, e pur sono in luogo, dove non potevano rompersi se non à posta: e tali rotture, benche fossero di stucco vero, non sarebbono da essere racconcie, per accrescere bellezza all'opera." (For an example of a *rottura* in the Galleria, cf. the right arm of the terminal figure between *Diana and Endymion* and the medallion of·*The Rape of Europa*.) The question under discussion in Agucchi's letter was whether or not the proposed memorial in S. Giacomo (cf. note 31 of this Part) should have *stucchi* in a position in which they would be likely to sustain damage in the course of time. Agucchi, the logical layman, was inclined to reject the *stucchi* on that account, and was opposed by Domenichino. The interest of the whole passage (for which cf. Malvasia, *Felsina*, 1678, II, p. 330) lies in the fact that the principle of "perfection" in the sense of the finished, of formal completeness, of the lack of irregularities (an obvious classic principle) is by no means endorsed by Domenichino, and perhaps may be taken as an indication that his mind worked empirically in such matters and not on the basis of reasoned and explicit theory; certainly his view provides a striking contrast with the opinion generally accepted among the antiquarian *dilettanti* of the time in favour of the "completion" of antique statues by the addition of missing members—a procedure which had been recorded with approval by Vasari long before, in his life of Lorenzetto (*Vite*, 1568, II, p. 134; ed. Milanesi, IV, pp. 579 f.), and which was carried out extensively during the Seicento, e.g., by Alessandro Algardi (cf. Maria Neusser, "Alessandro Algardi als Antikenrestaurator," in *Belvedere*, XIII, July-Dec. 1928, Heft 67, pp. 3-9) and by François Duquesnoy (cf. Jacob Hess, "Notes sur le sculpteur François Duquesnoy," in *La Revue de l'Art*, LXIX, Feb.-June 1936, pp. 26 ff.). Some of Domenichino's casual observations may of course have found their way into the *Trattato*. For example, I should not be altogether surprised if the following sensible passage originated from a remark by him: "E si vede ancor hoggi, che più allievi di un sol Maestro, se ben tutti cercano d'imitar lui, e si conosce dalle opere loro, che sono di quella scuola: nondimeno ciascuno vi pone certa qualità particolare, e propria à se, che da gli altri lo distingue." There is no abstract philosophy about this: it is simply the sort of commonplace practical observation which a man of the profession might make, and which could very well strike a layman as being true and worth noting.

the early accounts of our artist.[50] Certainly anything in the
nature of a bald and unqualified attribution to Domenichino
would be most misleading; yet this has unfortunately oc-
curred.[51]

<p style="text-align:center">* * *</p>

If therefore we agree to adopt what is after all the most
straightforward explanation (namely that the *Trattato* is pre-
cisely what it purports to be, a discourse by a scholarly prelate
with a considerable acquaintanceship with art, artists, and
writings on art), it is not so difficult to account for those philo-

[50] We must guard against confusion in the interpretation of what our early
sources have to tell us about Domenichino. He always figures in them as a
"serious" painter, but never, as far as I am aware, as an æsthetic theorist
of the *letterato* type; if he had any such reputation it is most unlikely that
his friend Passeri would have omitted to mention it. Actually we have a
fairly clear picture of Domenichino, who seems to have been a very
retiring little man, taking immense trouble and care over his painting; he
provided himself with light relief by means of his caricatures, and his
hobbies were architecture and music. The aroma of learning which attaches
to him is, in my opinion, mainly to be ascribed to his serious and conscien-
tious attitude towards his art; for example, his study of the *affetti*, and his
assiduous reading of histories, partly with a view to the attainment of
"historical" accuracy in the sense of *decoro*. In this latter connexion we note
that Passeri says (*op. cit.*, ed. Hess, p. 67): "Non hebbe di lettere gran notitia;
ma però godeva sommamente della lettura de' libri, però più d'Istorie, che
di Poesie . . ." We may sum up by saying that Domenichino's reputation
seems to have been that of a philosopher in painting rather than of it.

[51] Cf. Carlo Lodovico Ragghianti, "I Carracci e la critica d'arte nell'età
barocca," in *La Critica*, XXXI, 1933, pp. 65-74, 223-233, and 382-394. On
p. 70 Dott. Ragghianti quotes from Bellori's extract from the *Trattato*, but
says it is "dal discorso sulla Pittura del Domenichino;" while it may be
arguable (cf. above, p. 122) that Agucchi was influenced by conversations
with Domenichino in writing the particular passage quoted, that could
hardly justify the complete omission in this context of Agucchi's name.
Elsewhere (p. 383) Dott. Ragghianti says: "[Domenichino] sollecitato da
mons. Agucchi iniziò anche un 'Discorso sopra le varie maniere della
Pittura,' purtroppo mai compiuto"—which seems to the present writer to
be altogether too free a version of the passage in Bellori (cf. note 34 of this
Part). The disadvantage of allowing misleading statements of the kind to
get into print is that they become available for repetition by the trustful or
unwary, and indeed this tendency to beget offspring renders necessary some

sopnical and literary elements which stand behind the theory of artistic excellence which is expounded in it and of which we have already given a summary above.[52] With Agucchi we have a change from the phenomenon, which is to be found more than once during the Mannerist period, of an artist attempting to build a bridge to the learned world;[53] instead we have a *savant* trying to cross the gulf in the reverse direction. Agucchi does not produce any ideas which are strikingly new in themselves; what he does is to select, adapt, and organize certain traditional ideas which he feels to be readily applicable to the contemporary artistic situation as he sees it. In short, Agucchi's inclinations having led him to regard the pictures of the Carracci, and those of Annibale in particular, as the best of their time, he looks round for a plausible theory which will enable him to justify his taste.

Since Agucchi was a learned *letterato*, we should expect to find in his views some reflection of contemporary literary criticism, or rather, more accurately, criticism of poetry. Now, as was

comment on the whole character of Dott. Ragghianti's essay in *La Critica*. It was devastatingly refuted by Guido Lodovico Luzzatto in *L'Archiginnasio*, XXX, 1935, pp. 146-156 (cf. also Roberto Longhi's remarks on pp. 125 f. of the same), and I am bound to say that, on the facts, I substantially agree with the general tenor of these criticisms. The article was no doubt written at an early stage in Dott. Ragghianti's career, before he had had time to familiarize himself thoroughly with the material; but nevertheless it is in print, and to the reader who has not really got to grips with the problems in this field it appears to be based on normal scholarly method and procedure. It is in fact doubly misleading just because it almost light-heartedly flaunts the superficial trappings of serious research without the substance. That is why a disservice would be done to the genuine student of Seicento art by failing to give warning against the acceptance of some apparent statements of fact as if they were really as soundly documented as the true historian would wish. Dott. Ragghianti has, in good faith, allowed his fluent pen to run away with him, and the conclusions which he reaches on somewhat insecure foundations exhibit, in my opinion, as radical a misunderstanding of the subject as can well be imagined. Cf. also notes 30 and 79 of Part IV.

[52] Cf. in Part I above, pp. 62 ff.

[53] Federico Zuccaro, the author of the abstruse *L'Idea de' Pittori, Scultori, et Architetti* (Turin, 1607), is a typical example of the painter turned amateur philosopher: for Zuccaro, cf. Part III below.

pointed out by Professor Spingarn,[54] such criticism had centred during the second half of the Cinquecento to a quite extraordinary degree round a single treatise, the *Poetics* of Aristotle, which enjoyed the status of holy writ for the enquirer into the nature of poetry.[55] This almost universal acknowledgment of the authority of the *Poetics* did not however carry with it general agreement as to the interpretation of Aristotle's ideas. Quite the reverse. Indeed the treatise came to be used as a sort of quarry from which the raw materials were drawn for a considerable variety of critical edifices, often clashing with each other, and sometimes getting pretty far from Aristotle in spite of that allegiance to him which was professed by the great majority of critics and commentators.[56] Obviously a visit by Agucchi to this celebrated quarry would seem well within the bounds of probability, and he himself lends support to such a supposition by referring to Aristotle on two occasions, one of which actually turns out to be a quotation from the *Poetics*;[57] in fact, I think we can show reasonable cause for suggesting that one of the basic assumptions of his theory could very well have arisen from his reading of the bible of criticism. It will be convenient to divide our consideration of this matter into two parts, though we must bear in mind that in the last analysis these are essentially complementary to one another.

[54] J. E. Spingarn, *A History of Literary Criticism in the Renaissance*, New York, 1899, pp. 16 ff. and 136-147. The question of the connexion between criticism of poetry and criticism of painting has been very fully dealt with by Professor Rensselaer W. Lee ("*Ut Pictura Poesis :* The Humanistic Theory of Painting," in *The Art Bulletin*, XXII, 1940, pp. 197-269).

[55] Spingarn (*op. cit.*, p. 141) draws attention to the opinion of one of the most celebrated scholars of the period, Julius Caesar Scaliger : ". . . Aristoteles imperator noster, omnium bonaru[m] artium dictator perpetuus . . ." (*Poetices libri septem*, [Lyons,] 1561, p. 359).

[56] There were of course a few exceptions : for example, Francesco Patrizzi was an outspoken opponent of Aristotelian theories. Lodovico Castelvetro, who had in several respects an independent and original cast of mind, differs strongly from Aristotle (or rather from the more normal interpretation of Aristotle) on several points which particularly concern us here ; his views were published in the form of a translation of, and commentary on, the *Poetics* (*Poetica d'Aristotele vulgarizzata et sposta per Lodovico Castelvetro*, Vienna, 1570 ; second edition, Basle, 1576).

[57] Cf. note 37 of Appendix 1.

The first may be broadly summarized in the proposition that vulgarity and the highest quality are incompatible. Agucchi, as we have seen, sets up a class of artists who are characterized by the fact that they imitate imperfect nature just as she is, without selection or discrimination (this probably includes insignificant or "vulgar" subject-matter as well as the actual types or models employed), and by the fact that their work commands the applause of the mob (*il volgo, il popolo*); he then proceeds to give this purely factual description a qualitative rating by referring to a higher (which was to say, better) class of artists whose work is characterized by an ennoblement of nature, and whose aims and achievements are only appreciated at their true worth by the discerning and enlightened.[58] Now Aristotle[59] divides poets between the serious-minded (οἱ σεμνότεροι), who are concerned with noble themes, and the trivial-minded (οἱ εὐτελέστεροι), who are concerned with the affairs of the vulgar. The frontiers between moral values and æsthetic quality are not at all firmly drawn by Aristotle, who was of course mainly concerned with dramatic poetry; but this only gives a freer hand to the would-be transposer of his ideas into the realm of criticism of painting.[60] It is sufficiently clear however that the poet whose material is suitable for treatment in the grand style is *ipso facto* liable to be put by Aristotle in the higher class; it is the same tendency to regard quality as the *a priori* possession of some general group or convention

[58] Cf. also note 126 of this Part. Agucchi's association of merely natural (i.e., vulgar) models and low quality has already been pointed out in note 103 of Part I. Connected with this view is that of the hierarchy of subject-matter which is implicit in Agucchi, but which later finds explicit formulation, e.g., by André Félibien in his (unpaginated) preface to the *Conférences de l'Académie Royale de Peinture et de Sculpture, pendant l'année* 1667 (Paris, 1669); the passage is quoted by R. W. Lee, *op. cit., The Art Bulletin*, XXII, 1940, p. 213, note 78.

[59] The *Poetics*, middle of chapter IV.

[60] According to Alessandro Piccolomini's translation of this passage (1572-75), those whose spirit is "più grave, & più bello" deal with subjects akin to their nature, while the "più abbietti, & bassi d'animo" reproduce "le vili, & le indegne attioni." Obviously the scope for interpretation according to taste is considerable!

(rather than that of the individual work) which we found in Agucchi.[61] The weight Aristotle obviously attached to the type of public to whom a work of art is addressed (and by whom it is readily understood) provides another noteworthy parallel with Agucchi. The question under discussion[62] is whether tragic poetry is a higher form than epic, and the status of Tragedy is evidently held to depend largely on whether or not it can legitimately be considered vulgar. Aristotle is at pains to acquit Tragedy of this charge, but it is the criterion itself which is of interest to us: an art which imitates anything and everything without discrimination[63] is less good than one which appeals to the better (in the sense of more cultured and enlightened) public.[64]

The second Aristotelian proposition which we find reflected

[61] In the Cinquecento and later these differences became inextricably associated with social distinctions (cf. Spingarn, op. cit., pp. 62 ff. and 87), which in turn involved the ubiquitous and influential theory of decorum (decoro, convenevolezza). This theory, partly legitimized by a passage in the Poetics (beginning of Chapter XV), played an extraordinary part in literary criticism during the Cinquecento (cf. Spingarn, op. cit., pp. 85 ff.; he points out that the seeming vulgarity of some passages in Homer were considered to be a most serious blemish in the sense of a breach of decorum), and thence insinuated itself into the criticism of painting. Agucchi does not actually make use of the theory in his Trattato, but we may have little doubt that he endorsed it, and would have agreed with Mancini's and Bellori's remarks on Caravaggio (cf. Part I, notes 33 to 35): it was a breach of decorum to represent by a vulgar model some character in a religious subject for which a noble type was considered convenevole. For a discussion of decorum, cf. R. W. Lee, op. cit., The Art Bulletin, XXII, 1940, pp. 228-235; and cf. also note 74 of this Part.

[62] The Poetics, beginning of chapter XXVI.

[63] The manuscript texts and early printed versions have ἡ ἅπαντα. The suggestion that the passage should read ἡ πρὸς ἅπαντα (thus referring to the audience rather than to the play: "an art addressing any and every one") was, I believe, first made by Professor Bywater as recently as 1909; consequently we do not make use of that version here.

[64] As has already been mentioned in note 56 of this Part, Lodovico Castelvetro had definite independent opinions of his own, and cannot therefore be regarded as a typical Cinquecento interpreter of the Poetics. This matter of the public is a case in point. Castelvetro frequently repeats his strong (and, for the period, decidedly original) view that dramatic art was properly to be addressed to the common people (e.g., cf. 1570 ed., f. 16 v.

in Agucchi (an obvious counterpart to the first) is the opinion that the highest form of art involves idealized imitation, the ennoblement of the actual. Perhaps the passage which illustrates this view most suggestively is the famous one in which Aristotle says[65] that, since Tragedy is concerned with persons above the common level (μίμησις βελτιόνων), the tragic poet should follow the example of the *good* artists, who though they reproduce the distinctive features of the model, yet contrive to make them more fair without losing the likeness:

" . . . δεῖ μιμεῖσθαι τοὺς ἀγαθοὺς εἰκονογράφους· καὶ γὰρ ἐκεῖνοι ἀποδιδόντες τὴν οἰκείαν μορφὴν ὁμοίους ποιοῦντες καλλίους γράφουσιν."

Francesco Robortello, in one of the best known Cinquecento commentaries on the *Poetics*, says in a note to this passage,[66] "Huiusmodi rationem scribendi (vt alibi diximus) secutus est Xenophon in Cyro;" his fuller explanation of this remark reads:[67]

" . . . sicuti Xenophon olim in Cyro rege describendo, non qualis fuit, sed qualis esse potuit, vel debuit optimus Rex. quam rationem in suo Oratore describendo secutus est Cicero."

These passages together are certainly pretty close to Agucchi:

"Poiche se bene ad operare perfettissimamente non si dourebbe cercare, quale sia stato il volto di Alessandro, ò di Cesare, ma quale esser dourebbe quello di vn Re, e di vn Capitano magnanimo, e forte: tuttauia i più valenti Pittori, senza leuare alla somiglianza, hanno aiutata la natura con l'arte, e rappresentati i visi più belli, e riguardeuoli del vero."[68]

and 374 r.; 1576 ed., pp. 29 and 679); he has therefore to ignore, water down, or refute the implications which can very reasonably be read into Aristotle's text on this matter.

[65] The *Poetics*, towards the end of chapter XV.

[66] *Francisci Robortelli Utinensis in librum Aristotelis de Arte Poetica Explicationes*, Florence, 1548, p. 181.

[67] Robortello, *op. cit.*, 1548, p. 87.

[68] Agucchi's context (cf. p. 243 below) is of course the idealized portrait, and in this connexion it may be worth drawing attention to the fact that

As Aristotle sums it up towards the end of chapter XXV of the *Poetics*: "τὸ γὰρ παράδειγμα δεῖ ὑπερέχειν." "Hoc est," comments Robortello,[69] "oportet exemplar, quod tibi imitandum proposueris, longè excedere, pulchrioremque multò descriptionem, seu in pictura, seu in poësi effingere." Closely connected with his advocacy of idealization in the sense of the search for τὸ βέλτιον, is Aristotle's opinion[70] that the function of art is rather to express the universal than the particular. From this it can be argued that the highest form of art is that which treats the subject as it ought to be (ὡς δεῖ). Such a point of view is epitomized by, for example, Girolamo Fracastoro (died 1553); referring to Aristotle's association of poetry with the universal, Fracastoro speaks[71] of two kinds of painters, the imitators of mere nature, and those who, like the poets, do not "wish to represent this or that particular man as he is with many defects, but who, having contemplated the universal and supremely beautiful idea of his creator, make things as they ought to be."[72] Here we have the expression *idea* associated with the "ought to be," as with Agucchi, but the metaphysical context in which Fracastoro introduces it (striking a somewhat Platonic

εἰκονογράφος in our passage from the *Poetics* is now usually translated "portrait painter." This was not necessarily the case in the Cinquecento, though it struck Pietro Vettori (1560) as a possible rendering, and Agucchi (described by the editor of his *Trattato* as "persona di lettere non ordinaria") was certainly well equipped to come to such a conclusion on his own account. It should however be born in mind that in Agucchi's day τὴν ἰδίαν μορφὴν was read τὴν οἰκείαν μορφὴν; and, while οἰκεῖος and ἴδιος can be interchangeable, οἰκεῖος does lend itself more readily to misinterpretation. This is the case with Castelvetro, who also (for reasons connected with his personal opinion, cf. note 75 of this Part) says he would prefer ἀγαθῶν to ἀγαθοὺς.

[69] Robortello, *op. cit.*, 1548, p. 310.

[70] *Poetics*, beginning of chapter IX.

[71] *Hieronymi Fracastorii Naugerius sive de Poetica Dialogus*, first published on fol. 153-164 of *Hieronymi Fracastorii Opera Omnia*, Venice, 1555; the passage in which we are interested is on fol. 158 recto.

[72] The translation quoted is that by Ruth Kelso published in *University of Illinois Studies in Language and Literature*, Vol. IX, No. 3 (cf. pp. 59 f., equivalent to pp. 375 f. of the volume). No. 3 of Vol. IX is devoted to a study of Fracastoro by Murray W. Bundy, a facsimile of the original 1555 edition, and the translation; it was published in August 1924.

note[73]) is characteristically missing from Agucchi's theory, as we shall have occasion to emphasize later.

Up to the present, concerning ourselves only with literary criticism, we have found considerable similarity between certain, basic principles current in that field and those on which Agucchi's theory is based.[74] But, though parallels with painting were in several cases cited explicitly,[75] we have naturally enough discovered nothing which corresponds at all closely to Agucchi's organized application of his principles to the concrete artistic movements of his time. For this we shall have to go to the writers on painting, and, significantly, rather to the sober Leon Battista Alberti (that foreshadower in the early Renaissance of more than one classic doctrine) than to the elaborate

[73] Mr. Bundy (*University of Illinois Studies*, IX, 1924, No. 3, p. 15) points out with ample reason that Fracastoro is neither a good Aristotelian nor a good Platonist, but this does not affect our interest in this passage from the *Naugerius* as a typical example of the superficial influence of both philosophers, more in the sense of repetition of catch-phrases than of consistent thought.

[74] Perhaps before leaving the contacts between Agucchi and literary criticism we should point out that the apparent obscurity of his expression *verisimile* in connexion with painting is due to the fact that it is an importation from criticism of poetry; it was probably originally derived from Aristotle, and had been much bandied about during the previous half century (e.g., cf. H. B. Charlton, *Castelvetro's Theory of Poetry*, Manchester, 1913, pp. 42-52); the connexion between verisimilitude and decorum is dealt with by R. W. Lee, *op. cit.*, The Art Bulletin, XXII, 1940, pp. 268 f. For decorum, cf. also note 61 of this Part.

[75] Castelvetro is virtually unique in refusing to endorse these parallels between painting and poetry; indeed he digs an unbridgeable gulf between them. He rejects any theory of the painter improving nature, and asserts, e.g.: ". . . la perfettione della pittura non co[n]siste piu in fare un perfettame[n]te bello, che in fare uno perfettame[n]te brutto o mezzano, ma co[n]siste in fare che paia simile al vivo, & al naturale, & al rappresentato o bello o brutto o mezzano che si sia . . ." (*Poetica d'Aristotele*, 1570 ed., f. 190 r., misprinted 189; cf. 1576 ed., p. 342). In this view painting, in contradistinction to poetry, is the less good in so far as it deviates from strict adherence to nature and fact, with the result that (fearful heresy) he evidently prefers the portrait to the "history" painting, which he describes as "di niuna stima." However, Castelvetro, in spite of such unorthodox pronouncements, does not strike one as being sensitive to painting, and it is sometimes difficult to decide whether his independence in the matter is that of a reactionary or a revolutionary.

constructions of the Mannerist period just ending at the time.[76]
I quote from the first edition published in Italian of Alberti's
treatise on painting:[77]

"Et di tutte le parti uoglio, ch'egli ami non pure la simigli-
anza de le cose, ma sopra tutto anchora la bellezza istessa.
Percioche la bellezza ne la pittura è cosa non meno grata,
che desiderata. A quel Demetrio pittore[78] antico ui mancò

[76] It is precisely in the organization of his concepts that Agucchi marks a
break with the theoreticians of Mannerism, and can claim to be the originator
of a new departure. Naturally we find, scattered here and there in Mannerist
theory, some of the concepts he employs, but never quite in the same
context, nor co-ordinated in the same way. We may take as an example
Giovanni Battista Armenini, whose De' veri precetti della Pittura was published
at Ravenna in 1586, and re-issued in identical form the next year. He is
in many ways a transitional figure. In paying relatively little attention to
nature he is a typical Mannerist. On the other hand, his respect for the
sculptors of antiquity (originating no doubt from his artistic education at
Rome) and his view that they selected "il piu bello del natural buono"
(p. 61) directly foreshadows Agucchi. Armenini uses the expression Idea in
connexion with history painting, but in substance this boils down to a first
thought for a composition, preceding any sketches (pp. 137 f.). His approach
is often unusually practical for a Mannerist, and he avoids too much entangle-
ment in metaphysics; his precetti frequently have the character of hints for
beginners rather than that of laws of æsthetics, and in this connexion he has
some scathing remarks to make about the practical application of what
would, I suppose, be called an eclectic method (p. 67).

[77] La Pittura di Leonbattista Alberti tradotta per M. Lodovico Domenichi, Venice,
1547, fol. 39 verso f. Alberti himself completed the treatise in 1435. The
first printed edition was that published at Basle in 1540 in Latin, from which
Domenichi's translation was made. We quote from the first Italian printed
edition (rather than from the modern and more accurate publication by
Janitschek from the manuscript of Alberti's own translation into Italian)
because we are in this context only interested in Alberti in so far as his views
were readily accessible to Agucchi. In addition to the passage quoted in
the text we may draw attention to that on fol. 29 recto f.: "Racconta
Plutarcho . . . , che i pittori antichi erano usati dipingendo i Re, s'alcun
difetto era in loro, no[n] volere mostrare di lasciarlo; ma quanto piu si
poteva servata la sembianza l'emendavano. Io desidero dunque, che si
servi questa modestia, & vergogna in tutta l'historia, che le cose brutte si
lascino, o s'emendino."

[78] The artist against whom this criticism was recorded by Quintilian (cf.
note 39 of Appendix 1) seems to be identical with the bronze founder
Demetrios of Alopeke (Lucian, Φιλοψευδὴς ἢ ἀπιστῶν, §§ 18 and 20); Agucchi,
in describing him as scultore, is therefore nearer the mark than Alberti; but
Bellori's statuario (Vite, 1672, p. 201) is the most accurate.

al colmo de le sue lode, che fu piu curioso di rappresentare
la sembianza, che la bellezza. Da tutti i corpi piu belli
dunque sono da essere elette tutte le parti lodate.[79] Et percio
non s'ha da mettere ne l'ultime cose il contendere con lo
studio, & l'industria ad hauer la bellezza, conoscerla, et
rappresentarla. La qual cosa benche di gran lunga sia la piu
difficile di tutte, percioche tutte le lode de la bellezza non si
ritrouano in un loco, ma elle sono rare, & disperse, si dee
però mettere ogni fatica in cercarla, & apprenderla. Perche
colui, c'haurà imparato a conoscere, & maneggiare le cose
piu difficili, esso facilmente potrà fare le minori secondo il
desiderio suo. Ne ui è alcuna cosi difficil cosa, che tu no[n]
possa ridurre a perfettione con studio & assiduità. Ma
accioche lo studio no[n] sia uano, & speso in darno, si dee
fuggire quella usanza di molti, iquali con l'ingegno di loro
medesimi contendono ad acquistare lode ne la pittura, senza
mettersi innanzi con gli occhi, et co[n] la faccia alcuna
naturale di quella cosa.[80] Percioche costoro non imparino a
dipinger bene, ma s'auezzano ne gli errori. Perche non sanno
ritrouare gli ignoranti quella idea de la bellezza, ch'a pena
gli eccellentissimi ingegni possono discernere. Zeusi prestan-
tissimo, eccel. et dottiss. pittore sopra tutti gli altri, essendo
per fare una tauola, laquale publicame[n]te uoleua dedicare
nel tempio di Lucina appresso i Crothoniati, non confidan-
dosi temerariame[n]te nel suo proprio ingegno, si come
sogliono quasi tutti i pittori de l'età nostra, si mise a dipingere:

[79] The earliest reference to this constantly repeated concept appears in a
conversation between Socrates and the Greek painter Parrhasios, recorded
by Xenophon ('Απομνημονεύματα Σωκράτους, Bk. III, 10, § 2). It appears in
Vasari (*Vite*, 1550, p. 556; ed. Milanesi, IV, p. 8): "La maniera venne poi
la piu bella, da l'avere messo in uso il frequente ritrarre le cose piu belle;
e da quel' piu bello ò mani ò teste ò corpi ò gambe agiugnerle insieme; et
fare una figura di tutte quelle bellezze che piu si poteva . . ." But the most
frequent vehicle for its repetition and propagation was the story, which
Alberti goes on to tell, of the *Helen* painted by Zeuxis for the Crotonians
(for which cf. notes 81 and 82 of this Part).
[80] The Latin original from which the end of this sentence was translated
runs: ". . . nullam naturale[m] faciem eius rei oculis, aut mente coràm
sequentes" (*De Pictura praestantissima . . . arte libri tres*, Basle, 1540, p. 107).

ma perche egli si pensaua, che tutte le parti, lequali egli cercaua de la bellezza, di non poterle no[n] pure hauerle col proprio ingegno, ma ne anco ricercatole da la natura potersi ritrouare tutte in un corpo. Percio di tutta la giouentu di quella città, scelse cinque le piu belle vergini, per rappresentare ne la pittura quel, che in ciascuna era eccellentissimo di donnesca bellezza.[81] Veramente egli fece da sauio: percioche facilmente auuiene a i pittori, qua[n]do non è loro posto inanzi alcuno essempio da imitare, quando con l'ingegno solo si sforzano di ritrouare le lodi de bellezza, che con quella fatica guadagnano no[n] la bellezza, che deurebbono, o che cercano, ma ch'essi cadono in cattiue usanze di dipingere; lequali anchora uolendo a pena che possono lasciare. Ma colui, che si sarà auezzato a torre tutte le cose da la natura, si farà la mano tanto essercitata, che sempre ogni cosa, ch'egli tenterà, somiglierà a la natura istessa."

It seems very probable that Agucchi knew this passage and read it with contemporary artistic developments in his mind. With Alberti we have on the one hand a censure of mere copying of nature, and on the other hand a warning against

[81] The source of the story of the *Helen* painted by Zeuxis for the Crotonians, which reappears an endless number of times during the Cinquecento and Seicento, is a passage in Cicero's *De Inventione Rhetorica*, Bk. II, 1, §§ 1-3. There are some inaccurate variations. Pliny the Elder (*Historia Naturalis*, XXXV, § 64) is probably incorrect in saying that it was painted for the Agrigentines. The subject is sometimes wrongly stated to have been a *Venus* (e.g., Zuccaro, *Idea*, 1607, Bk. II, p. 10); Filippo Baldinucci, in reporting Bernini's witty and sensible criticism of too literal an interpretation of the story ("un bell'occhio d'una femmina non istà bene sopra un bel viso d'un'altra"), also speaks of the subject as a *Venus* (*Vita del Cavaliere Gio. Lorenzo Bernino*, Florence, 1682, p. 70; ed. A. Riegl, A. Burda and O. Pollak, Vienna, 1912, p. 237), but corrects himself in a later reference (*Lezione di Filippo Baldinucci*, Florence, 1692, p. 16; reprinted in *Notizie de' Professori del Disegno*, XXI, 1774, p. 124). Winckelmann, in reproving Bernini (*Geschichte der Kunst des Alterthums*, Dresden, 1764, p. 155; composite eds., Bk. IV., Ch. II, § 34) calls her a *Juno*, an error due no doubt to the fact that the picture was painted for the temple of Hera on the Lacinian Promontory (Alberti's "Lucina"); this is a few miles south-east of Crotone (the modern name of the promontory is Capo Colonne), and the worship of Hera has been replaced there by that of the *Madonna del Capo*.

too much freedom from it;[82] over all hovers the not over clearly defined concept of the *Idea della bellezza* "which the finest spirits are scarcely capable of perceiving." We know that Agucchi did not consider the mere imitation of nature as adequate and made a comparison between Demetrios and Caravaggio, and it is not unreasonable to suppose that Alberti's second point would have struck Agucchi as applicable without difficulty to the general type of picture which we now call Mannerist,[83] judging by his remarks on the corruption of the art of painting immediately before the advent of the Carracci.[84]

Moreover the venerable idea of the *judicious* imitation of nature[85] had already been associated with Agostino Carracci by the time that Agucchi began his meditations on art. In view of his friendship with the family, Agucchi must certainly have possessed the small volume, published at Bologna in 1603, of tributes paid to Agostino after his death.[86] In this was printed

[82] Lodovico Dolce (*Dialogo della Pittura*, Venice, 1557, fol. 29) takes up a similar double standpoint, which, though he does not actually use the expression *Idea*, is probably derived from Alberti. Before telling the story of Zeuxis' *Helen* Dolce says: "Deve adunque il Pittore procacciar non solo d'imitar, ma di superar la Natura." But he adds after the story: "Ilche puo anco servire per ammonitione alla temerità di coloro, che fanno tutte le lor cose di pratica."

[83] Though we are primarily concerned here with speculating as to what Agucchi would have read into Alberti's theoretical opinions (and not therefore what Alberti meant when he wrote), it may perhaps be pointed out that the general style against which Alberti's criticism was directed has something in common with post-Renaissance Mannerism.

[84] For example: ". . . maniere lontane dal vero, e dal verisimile."

[85] That is to say, an imitation of nature, but not without discreet "improvements."

[86] *Il Funerale d'Agostin Carraccio fatto in Bologna sua patria da gl'Incaminati Academici del Disegno scritto all' Ill.mo et R.mo Sig.r Cardinal Farnese*, Bologna, 1603. It consists of the description by Benedetto Morello of the funeral and decorations, the funeral oration by Lucio Faberio, and a collection of poems in praise of Agostino. This small booklet was considered to be of a certain importance in the seventeenth century: it figures in the short bibliographies of books on art published by Raphael du Fresne (in his edition of Leonardo's *Trattato*, Paris, 1651) and Luigi Scaramuccia (*Le Finezze de' Pennelli Italiani*, Pavia, 1674); Bellori (*Vite*, 1672, pp. 117 ff.) reprints Morello's description but omits Faberio's oration and all but three of the poems; Malvasia (*Felsina*, 1678, I, pp. 407 ff.) reprints both description and oration but omits all the poems.

the funeral oration composed by Lucio Faberio (a *letterato* and
a member of the Bolognese literary Academy of the Gelati[87]),
who, as a friend of the Carracci, had acted as secretary of their
Academy;[88] the relevant passage from our point of view appears
in his oration, and runs as follows:[89]

". . . vna sol cosa mi basterà per argomento del grande
ingegno del Carracci, cioè Che per essere stato nell'honorata
sua professione giudicioso imitatore delle naturali, & artifi-
ciali cose, ha meritato il nome di grande, & ammirabile
Pittore. Non senza cagione io lo chiamo giuditioso imitatore:
perch'egli considerando, che la Pittura è oggetto diletteuole
dell'occhio humano, applicaua sempre l'imitation' al meglio,
guardandosi dall'error di molti ch'amano più tosto la somi-
glianza, anco nelle parti non buone, che la bellezza libera
d'ogni emenda[90] . . . Dissimulaua, & ricopriua con arte, e
con si gentil maniera l'imperfettioni, e le mancanze della

[87] Agucchi and, later, Malvasia were both *Accademici Gelati*; Agostino
Carracci, being classed as an artist and not as a literary man, was *aggregato*
as an *Accademico di secondo ordine*.

[88] Morello (in *Il Funerale, cit.*, 1603, p. 26) describes Faberio as "persona
singolare, se si riguarda alla piena eruditione, & alla cognitione, che ha
delle belle lettere . . . ilqual' essendo di vantaggio occupato in gravissimi
affari; tuttavia per l'antico amore che porta à i Carracci, & alla Pittura s'è
compiaciuto d'esser ascritto all'Academia [i.e., *degli Incamminati del Disegno*],
anzi di servirla di Segretario." This passage is reprinted by Bellori (*loc. cit.*,
pp. 130 f.) and Malvasia (*loc. cit.*, p. 421).

[89] *Il Funerale, cit.*, 1603, pp. 36 f. (reprinted by Malvasia, *loc. cit.*, p. 429).

[90] There is a curious difficulty about the word *emenda* employed here by
Faberio. The sense from the context is quite clearly "beauty free of every
blemish," in which case the appropriate word would be *menda*=imperfection,
defect. *Emenda* means "correction," and the alternative to the more probable
explanation of a misprint would seem to be something in the nature of
"free from the need for correction of any kind," which is clumsy and some-
what far-fetched. Yet the trend of Faberio's argument is otherwise perfectly
consistent and straightforward. Incidentally, the ancient theory of the
correction and improvement of nature of which he makes use had been
reiterated on more than one occasion not long before; for example, as
Professor R. W. Lee has pointed out (*op. cit.*, *The Art Bulletin*, XXII, 1940,
pp. 204-206; cf. notes 40 and 43), by Lodovico Dolce (the references in the
original edition of the *Dialogo della Pittura*, Venice, 1557, are fol. 29 recto
and fol. 32; cf. also note 82 of this Part).

natura, sempre accrescendo le bellezze, che non si poteua desiderar meglio."

The implied criticism of painters who merely imitate nature (that is to say, without "judiciousness") cannot definitely be connected with Caravaggio, since it was written at Bologna in 1603; but at any rate it was ready to Agucchi's hand for use in support of the Carracci against *Caravaggismo*.

We have seen that some of the basic raw materials for Agucchi's edifice were available in Aristotle and his commentators, and that the general ground-plan had already been traced by Alberti. And indeed Faberio, by giving a contemporary application[91] to an important part of the theoretical

[91] Another contemporary application of previously existing theories was made by Faberio with astonishing ultimate results. For it was in Faberio's rhetoric at Agostino's funeral that we find the first association between the art of the Carracci and what eventually came to be miscalled their eclectic theory of painting. The notion that "the perfect painter" would unite the special virtues of the greatest masters had appeared in print several times during the half century before Faberio sat down to write his eulogy; it goes at any rate as far back as Paolo Pino (*Dialogo della Pittura*, Venice, 1548, f. 24), and we have had occasion to notice a characteristic example of it in a passage published by Lomazzo in 1590 (cf. note 39 of this Part). What could be more natural than that Faberio, in seeking to compose an impressive speech in honour of his departed friend, should claim that Agostino had in fact put into practice the wishful thinking of earlier theorists? Is it not the *letterato's* way of paying tribute, in the roundabout manner typical of the time, to Agostino's stature as a painter? Moreover, Faberio's enunciation of the idea has the character of a flight of literary imagination rather than that of a practical artistic doctrine; it was the best *qualities* of the great masters (*fierezza, sicurezza, morbidezza, delicatezza, gratia, maestà, vaghezza, facilità*) which he praises Agostino for bringing together (*Il Funerale, cit.*, 1603, p. 40; reprinted by Malvasia, *loc. cit.*, p. 431). In the last analysis we must read this vague, if wordily impressive, oration in its proper context and as a whole (not forgetting the occasional *oimè!*), and ask ourselves whether we really feel that it is a sound foundation stone (jointly with the notorious sonnet, for which cf. Part IV below) on which to base an assertion that the Carracci seriously advocated an eclectic system. For an instance of a similar laudatory formula, we may turn to Marco Boschini (unpaginated preface to *Le Ricche Minere della Pittura Veneziana*, Venice, 1674), who says that every *dilettante* finds even more than he expected in Palma Vecchio's *Santa Barbara*, "essendovi unite cosi in quella Idea, come in tutta la figura la grazia, la bellezza, l'artificio, la diligenza, la morbidezza, la modestia, il decoro, la simmetria e tutte l'espressioni maggiori che si può attribuire à Rafaele, à

data, may even be said to have forestalled Agucchi in commencing construction. Yet with Faberio there was no central principle around which to build, for his selection of the best and correction of faults, though relatively practical, probably seemed to Agucchi to be too tame by itself; whereas Alberti's *idea della bellezza* (an impressive designation, certainly) was too tentative and vague to satisfy either the philosopher or the artist. Consequently Agucchi, having brought up to date the Scylla of Naturalism and the Charybdis of Mannerism, and having borrowed the concept of the *idea della bellezza*, seeks to develop the latter into an imposing craft for his heroes to pilot along the middle course. It is at this point that he sees fit to make use of the "ought to be," the ὡς δεῖ implied by Aristotle. But in asserting that "le cose" should be painted "non come sono, ma come esser dourebbono" he is employing a type of phraseology which was thoroughly congenial to theorists of the Mannerist period :[92] indeed Vincenzo Danti virtually used these

Tiziano, al Correggio, & à quanti con il maggior carattere di Pittura hoggidì sono celebrati per singolari, & in fine questa può dirsi il Centro della perfezione, e l'unico dell'Arte . . ."

[92] As has already been pointed out (cf. note 76 of this Part), we can very well come across casual connexions (of no particular significance for the essence of the matter) between Agucchi and Mannerist writers. The following is an example of a potential contact of this kind. In describing the recent decline of painting Agucchi says that artists were content "di pascer gli occhi . . . con la vaghezza de' colori." It seems possible that this may be a verbal reminiscence of an expression used by Federico Zuccaro in the same context ("Arte senz'arte . . . pasce l'occhio . . . di bei colori") in his poem *Il Lamento della Pittura su l'onde Venete* (published at the end of his *Lettera a Prencipi, et Signori Amatori del Dissegno*, Mantua, 1605). This sort of lament about colour was of course nothing new; it had been made, for instance, by Vitruvius. We may quote from Daniele Barbaro's translation of a passage in Bk. VII, Ch. 5 (*I dieci libri dell'Architettura di M. Vitruvio tradutti et commentati da Monsignor Barbaro*, Venice, 1556, p. 188): ". . . quello, che affaticandosi gli antichi, e ponendovi industria tentavano di approvare con le arti, à nostri giorni si consegue con i colori, & con la vaghezza loro, e quella authorità che la sottilità dello artefice dava alle opere, hora la spesa del patrone fa, che non sia desiderata . . ." For a quotation of the passage in Zuccaro's poem, cf. note 54 of Part III ; Zuccaro himself strongly disliked the work of Tintoretto, and it may be that Agucchi shared this dislike and had the great Venetian Mannerist partly in mind when he wrote the passage in question (cf. note 21 of Appendix 1).

identical words.[93] Moreover a further step appears to have been taken towards that Neo-Platonic mysticism which is so characteristic of Mannerist theory when Agucchi says that the painters who go beyond mere naturalism "comprendono nella loro Idea l'eccellenza del bello, e del perfetto, che vorrebbe fare la natura." This is certainly perilously near (for example) to Vincenzo Danti's "si crea nella mente nostra la perfetta forma intenzionale della Natura." Dr. Panofsky quotes this passage as typical of Mannerist theory, and draws attention to the difference between it and the Renaissance point of view in the following comment: "Das Schöne in der Kunst entsteht nicht mehr durch eine blosse Synthese des zerstreuten, aber doch irgendwie gegebenen Vielen, sondern durch eine intellektuelle Schau des in der Wirklichkeit überhaupt nicht anzutreffenden εἶδος."[94]

It is the more remarkable, therefore, to find Agucchi introducing the typically Renaissance concept of the collection and synthesis of already existing natural beauties into the middle of what is ostensibly the most Neo-Platonic paragraph of his *Trattato*.[95] The best artists "non contenti d'imitare quel che veggono in vn sol soggetto, vanno raccogliendo le bellezze sparse in molti, e l'vniscono insieme con finezza di giuditio, e fanno le cose non come sono, ma come esser douebbono per essere perfettissimamente mandate ad effetto." This passage should certainly give us pause before asserting that Agucchi's *Idea* is nothing more or less than the Neo-Platonic *Idea* of the Mannerist period.[96] The fact is that Agucchi wants to make

[93] Vincenzo Danti, *Il primo libro del trattato delle perfette proporzioni*, Florence, 1567, p. 45: ". . . cercar sempre di fare le cose come dovrrebbono essere, e non in quello modo che sono." This is his distinction between *imitare* and the mere naturalism of *ritrarre*, which he compares to that between poetry and its inferior, history (cf. also pp. 59 f.). For him beauty depends on perception of *il fine* (=τέλος), but he censures "synthesis" as a method of "improvement" (p. 32, "sempre si vedrebbe qualche discordanza").

[94] Erwin Panofsky, *Idea*, Leipzig/Berlin, 1924, p. 53; for the Danti passage, see *Il primo libro del trattato . . .*, 1567, p. 58.

[95] For the whole paragraph, see Appendix 1 below, pp. 242 f.

[96] When Agucchi refers in a later passage to that *Idea* which is not to be found in nature *se non nel modo, che di sopra si diceva*, the allusion is clearly to

out an impressive case against the extreme form of naturalist painting, and finds it convenient for this purpose to graft some of the Neo-Platonic catch-phrases on to the un-metaphysical *Idea* of an Alberti. The view that he is not really borrowing the philosophical substance with the verbal formulae is supported by an examination of his attitude, closely following that of Alberti,[97] towards those who paint principally by the light of their *ingegno*, without too much reference to nature.

It is above all Agucchi's treatment of the historical position of Annibale Carracci—the modern exponent of his idealistic principles—which brings out his anti-Mannerist point of view. In Agucchi's opinion painting had declined in recent times because of insufficient attention to nature; the Mannerists, divorced "dal vero, e dal verisimile . . . si allontanauano in somma largamente dalla buona strada, che all'ottimo ne conduce." The Carracci are represented as having rescued art from the *maniere lontane dal vero* by a return to nature, and it is on this foundation that the new *Idea* is possible. First a thorough study of nature, then its ennoblement by elimination of faults, selection of the best, and synthesis "con finezza di giuditio"— "i più valenti pittori, senza leuare alla somiglianza, hanno aiutata la natura con l'arte;" translated into historico-geographical terms, Annibale is seen as crowning the naturalistic colour of the North with the idealistic refinements of Roman

his concept of the attainment of the perfect as a result of the collection and "judicious" synthesis of beauties which, though scattered, nevertheless do pre-exist in nature. The whole passage, concerning the arrival in Rome of Annibale and Agostino Carracci, is of interest in that it admirably illustrates the close relationship of Agucchi's *Idea* to concrete facts of art-history, to actual artists and works of art: "E poiche ben presto si avvidero, quale studio havesse Rafaelle fatto sopra le cose antiche, donde havea saputo formar l'Idea di quella bellezza, che nella natura non si trova, se non nel modo, che di sopra si diceva; si misero li Carracci à fare studio sopra le più celebri, e famose Statue di Roma."

[97] Since the story of Zeuxis' *Helen* has usually been regarded as the standard illustration of idealization, it is with some interest that we note that Alberti also contrives to emphasize the connexion with nature and to give the anecdote what is in effect an anti-manneristic twist; in this he seems to have been followed by Dolce (cf. note 82 of this Part).

disegno.[98] At the time when he wrote Agucchi probably assumed that there would be little dispute about the necessity of a return to nature, and that the artistic tendencies which we call Mannerist were relatively *hors de combat*. He does however seem to have felt that the issue between the so-called Classic and Naturalist groups was a live one: and so, in criticizing the Naturalists because "si fermano sù" that which they see to have been expressed by nature even though they find it extremely imperfect, he does not shrink from making use, for polemical purposes, of high-sounding Neo-Platonic language which, if taken out of its real context, would seem to open the back door to Mannerism.

It is obvious that Agucchi's theoretical point of view is markedly similar in several important respects to that expounded (about half a century later) by Bellori, of which Dr. Panofsky has given us a detailed analysis.[99] In both cases the two traditional types of *Idea* appear at first sight to be present: that which derives *a posteriori* from the contemplation of nature, and that which has an *a priori*, and therefore metaphysical, connotation. But Dr. Panofsky points out with good reason (and his view is entirely endorsed by Professor Lee[100]) that it is the more empirical *Idea*, originating from Renaissance rather than from Mannerist theory, which plays the active and essential part with Bellori:[101] in the present writer's opinion the same is true of Agucchi. Though Neo-Platonic elements in both Agucchi and Bellori can give rise to logical inconsistencies (of which the writers themselves were perhaps hardly conscious)

[98] This latter view, as we have noticed (cf. note 36 of Part I), seems to have been shared by Mancini, though he does not go into the matter in such detail as Agucchi.

[99] Panofsky, *Idea*, 1924, pp. 57-63. The present writer's debt to Dr. Panofsky's discussion of Bellori is of course considerable.

[100] In *The Art Bulletin* (XXII, 1940, pp. 207-210).

[101] Dr. Panofsky does not ignore the formidable Neo-Platonic passage with which Bellori opens his *Discorso* of 1664 (published in 1672 at the beginning of the *Vite*), but draws attention to the fact that in the outcome Bellori is especially exercised to demonstrate the natural origin of the *Idea* —a most un-Platonic view. Bellori's Neo-Platonism is in fact not integral, but (as Prof. Lee puts it) adventitious. Cf. also note 126 of this Part.

the real character of the theory is made clear in each case by its relationship to the contemporary movements in art. Bellori (whose position is of course elaborated in much greater detail than that of Agucchi) may possibly have sensed the logical difficulties of making out a sound argument in favour of the *via media* of a purified and ennobled reality between the extremes of unrestrained idealism ("fantasia") and mere nature. In any case he avoids stressing the references to the "ought to be" and the "intentions of nature" which we found in Agucchi —perhaps on the score that they could be taken to sanction a considerable loosening of the ties between art and nature.[102] Nevertheless Agucchi's objectives are clearly similar to those of Bellori, and the artists who are supposed to have sought for the true *Idea della Bellezza* (and from whose work the theory is in part rationalized) are the same in both cases: Annibale Carracci, Domenichino, and the sculptors of antiquity.[103] And

[102] It should of course be borne in mind that Bellori's reluctance to tolerate too much freedom from nature reflects the contemporary artistic situation, in which the more decorative and exuberant trends of the Full Baroque, then in vigorous life, take the place occupied in Agucchi's time by the lost cause of Mannerism; for Bellori the representative of the classic tradition in Rome during the second half of the Seicento was his close friend Carlo Maratti, under whose auspices his Discorso of 1664 was delivered, and who shared his admiration for Raphael, Annibale Carracci, and the antique (cf. note 67 of Part III). In these circumstances Bellori is cautious about jettisoning the sheet anchor of nature; it is true that he does describe the "ought to be" as "unico precetto dato da Aristotele così alli Poeti, come alli Pittori" (*Vite*, 1672, p. 5), but its position is still less important with him than it had been with Agucchi (cf. also note 125 of this Part). In this connexion we note that Agucchi's view on the feasibility of an "idealistic" style in portraiture does not reappear. This may however be partly due to Bellori's desire to refute the heretical Castelvetro, whose opinion (cf. note 75 of this Part) that art should conform strictly to nature is (we are not surprised to see) explicitly challenged on page 8 of *Le Vite*, where the suggestion is that it can only be applied to what Bellori contemptuously calls "pittori icastici, & facitori de' ritratti, li quali non serbano idea alcuna;" Bellori then proceeds to quote, in defence of his own view, our familiar passage in Aristotle's *Poetics* (cf. notes 65 and 68 of this Part), carefully translating εἰκονογράφος as painter (not portrait painter!).

[103] The opinion that there was a kinship between Annibale Carracci and classical antiquity was also held by Mancini, as the following extract from MS. it. 5571 in the Biblioteca Nazionale Marciana at Venice serves to illus-

it is as a forerunner of Bellori that the importance of Agucchi in the history of art-theory undoubtedly lies; he was in some sense, through Bellori, part originator of much of seventeenth and eighteenth century classic-idealist doctrine.[104] In view of this, our study of Agucchi may properly be concluded by a review of the evidence which exists for a connexion between him and Bellori, followed by some indication of the widespread influence of the latter.

* * *

Tomasini[105] gives a short list of Agucchi's special friends. One of these is (Monsignor) Giovanni Antonio Massani, to

trate. Mancini refers on fol. 138 verso to an antique painting "che possiede l'Ill.ma Casa Aldobrand.na trovata à S. Giuliano" and adds (fol. 139 recto) ". . . e circa questa Pittura mi par di notar una curiosità, che vi è un groppetto di figure che stanno intorno li alla sposa di alcune feminette qual gruppo quasi nel med.o modo fù dipento da Annibal Caracci Giovanetto in una decollation di S. Gio: Battã, [Mancini adds in the margin: *posseduta gia da Giulio Cesare Abbate*] che se no[n] fusse stata sotterrata q.ta Pittura [*Pittura* is struck out, apparently by Mancini] in q.el tempo si potrebbe dubitar, che l'havesse copiata, ma [*ma* is struck out by Mancini, who substitutes *et*] da q.to si puol comprender l'Ecc.za del Caracci, che in adolescenza rivo [?; corrected by Mancini to *arrivo*] li antichi et appresso, che non sempre doviam accusare di furto il Pittore, quando fà una cosa simile ad un'altro Pittore poiche li concetti son communi." The classical painting referred to is of course the celebrated *Nozze Aldobrandine*, now in the Vatican; incidentally, Zuccaro says of it (*L'Idea*, 1607, Bk. II, p. 37): ". . . & io che fui per sorte uno di quelli primi à vederla, e lavarla, e netarla di mia mano diligentemente, la viddi così ben conservata, e frescha, come se fusse fatta pur all'hora, che n'hebbi un gusto singolare, e fui causa di farla portare alla luce."

[104] We must not overlook the fact that Bellori apparently also owes a certain amount to Mancini. Bellori's three groups are present in Mancini, as we have already seen (cf. notes 32 and 36 of Part I), but there is not the same extent of polemical juxtaposition as is hinted at in Agucchi and developed by Bellori. And, though Mancini certainly applies to the Carracci the idea of the selection of the best in nature and the correction of its faults, his judgments are empirical and incidental; he does not feel any necessity to integrate them into some systematic theory of beauty intended to have universal validity. There is ample evidence that Bellori was familiar with one of the manuscripts of Part II of the long version of Mancini's *Trattato* (cf. below, pp. 316 ff.).

[105] *Iacobi Philippi Tomasini . . . Elogia Virorum Literis & Sapientia Illustrium*, Padua, 1644, pp. 24 ff.

whom (Tomasini states) Agucchi bequeathed his writings;
later Tomasini adds that other writings of Agucchi were in the
hands of Crescenzio Saccardi, but that Massani had promised
to publish them. A third friend was Francesco Angeloni: he
was in the service[106] of Cardinal Ippolito Aldobrandini, to
whom he dedicated a comedy,[107] and who was a nephew of
Agucchi's own *padrone*, Cardinal Pietro Aldobrandini. Angeloni,
who died in 1652,[108] was a well-known connoisseur and
archæologist, and regarded the Carracci as the reformers of
painting.[109] He possessed a *museo* which, according to his own
statement,[110] included a collection of six hundred drawings by
Annibale Carracci, chiefly for the Galleria Farnese. From
Angeloni's principal publication[111] we also learn that Massani
acted as temporary Nuncio (Internuncio) at Venice immedi-
ately after Agucchi's death, that (like Agucchi and Angeloni)
he was by way of being a connoisseur of painting, and that he
possessed a collection of pictures "de' Caracci specialmente e
di Domenico Zamperi." In this context Angeloni takes the
opportunity to express his own admiration for Domenichino.
We have seen that both Agucchi and Massani are mentioned in
a letter written by Domenichino to Angeloni, originally pub-
lished by Bellori,[112] and reprinted above; and we may add

[106] [Leone Allacci,] *Leonis Allatii Apes Urbanae*, Rome, 1633, p. 103.

[107] Francesco Angeloni, *L'irragionevoli amori*, Venice, 1611. A second
comedy by Angeloni (*Flora*, Padua, 1614) is dedicated to Ippolito's sister,
and one of the preliminary poems (p. 6) is by Bernardino Vannetti, who
(together with Domenichino) is mentioned by Tomasini (*Elogia*, 1644,
pp. 20 f.) as a special protégé of Agucchi.

[108] Ludovico Jacobilli, *Bibliotheca Umbriae*, Foligno, 1658, p. 112.

[109] Francesco Angeloni, *La Historia Augusta da Giulio Cesare insino à Costan-
tino il Magno, Illustrata con la verità delle Antiche Medaglie*, Rome, 1641, p. 251.

[110] *La Historia Augusta*, 1641, p. 251; Angeloni's collection of drawings by
Annibale is also mentioned by Giovanni Baglione, *Le Vite de' Pittori*, Rome,
1642, pp. 108 f., and by Malvasia, *Felsina*, 1678, I, p. 467. Cf. also note 69
of Part III.

[111] *La Historia Augusta*, 1641, pp. 260 f. (where Angeloni mentions that
Massani was at the time of writing *Maestro di Casa* to Pope Urban VIII).
Massani's tenure of the post of Internuncio in Venice in 1632 is also referred
to by Tomasini (*Elogia*, 1644, p. 24).

[112] Cf. note 35 of this Part.

that, according to Vittoria,[113] the "Mosini" who published the *Trattato* fragment in 1646 is simply a pseudonym for Massani.

How was Bellori himself connected with this group of friends of Agucchi? He prints several letters from Domenichino to Angeloni and tells us[114] that the two were great friends. Is he well informed? The answer "yes" is clearly provided by the preface he wrote to his new edition (1685) of Angeloni's *Historia Augusta*.[115] There is also good reason for believing that Angeloni was in fact Bellori's uncle.[116] Bellori, as we have seen, quotes an extract from Agucchi's *Trattato* which he says is taken from the original,[117] and elsewhere mentions[118] another manuscript of Agucchi which was in his possession. Stories which appear in the *Trattato*[119] and in "Mosini's" preface[120] are retold by Bellori. The comparison between Demetrios and Caravaggio is repeated,[121] though Bellori brings the modern Peiraïkos up

[113] Vincenzo Vittoria, *Osservazioni sopra il libro della Felsina Pittrice*, Rome, 1703, p. 93 (fifth letter, dated 27 August 1679). The internal evidence in "Mosini's" text tends to support Vittoria's identification of him with Massani; for example, "Mosini" says that he received "Machati's" manuscripts by bequest (p. 240 below; and cf. also note 55 of Appendix 1).

[114] Bellori, *Vite*, 1672, p. 342; cf. also Passeri, *op. cit.*, ed. Hess, p. 62. Bellori (*op. cit.*, p. 6) also quotes from a letter written by Reni to Massani.

[115] Angeloni, *L'Historia Augusta . . . Seconda Impressione . . . col supplimento . . . da Gio: Pietro Bellori*, Rome, 1685: "Havendo così l'Angeloni terminato i suoi giorni, io hebbi veramente à dolermi per più cagioni della sua perdita, e principalmente per essermi mancato un quasi affettuosissimo padre, appresso il quale, da teneri anni, e sin nella Corte del memorato Cardinale Hippolito, partecipe delle cure della penna, mi era educato."

[116] Cf. *Joannis Rhodii Dani Auctorum supposititiorum Catalogus . . . opusculum posthumum ex musaeo Vincentii Placcii*, p. 38 (published by Vincent Placcius as part of *De Scriptis & Scriptoribus Anonymis atque Pseudonymis Syntagma Vincentii Placcii*, Hamburg, 1674), and, in conjunction with this, Michele Giustiniani, *Gli Scrittori Liguri*, Rome, 1667, p. 219. Johannes Rhodius, or Rhode, lived at Padua from 1623 until his death in 1659, and was a friend of Tomasini.

[117] Cf. notes 34 of this Part and 19 of Appendix 1.

[118] Bellori, *Vite*, 1672, p. 78.

[119] The story of Annibale and the Laocoon (Bellori, *Vite*, 1672, p. 31); cf. pp. 253 f. below.

[120] The story of Annibale and the *vecchiarella* (Bellori, *Vite*, 1672, pp. 303 f.); cf. pp. 271 f. below.

[121] Bellori, *Vite*, 1672, p. 201. Cf. also notes 107 of Part I, 78 of this Part, and 39 of Appendix 1.

to date by the substitution of *Il Bamboccio* (Pieter van Laer)[122] for Bassano.[123] We are not at all surprised, therefore, to find distinct traces of Agucchi's concept of the *Idea della Bellezza* reflected in Bellori's theoretical standpoint, though we must of course allow that the latter has made his own contributions and adjustments, and has expanded the whole scheme into a much more elaborate system than Agucchi was ever able to do.[124] The relationship can be illustrated by a comparison between the two texts at an important point in the argument. A passage in Agucchi's *Trattato* reads:

". . . le cose dipinte, & imitate dal naturale piacciono al popolo, perche egli è solito à vederne di si fatte, e l'imitatione di quel che à pieno conosce, li diletta. Ma l'huomo intendente solleuando il pensiero all'Idea del bello, che la natura mostra di voler fare, da quello vien rapito, e come cosa diuina la contempla."

Bellori has a strikingly similar passage:[125]

[122] Bellori, *Vite*, 1672, p. 5. For the derogatory opinion held in "classic" circles of those who followed the example of Pieter van Laer ("questi Bambocianti"), cf. Andrea Sacchi's letter of 28 October 1651 to his former master Albani (published by Malvasia, *Felsina*, 1678, II, p. 267). Passeri is, as often, rather more moderate; though he deplores Bamboccio's choice of "low" subjects which caused "tanto diletto alla plebe, et a quegl' animi non sollevati in una nobile idea," Passeri seeks to avoid unfairness by adding that they were carried out "con tanto gusto di tingere, e con una imitatione cosi esatta del naturale, e con una verità così grande, che non se gli può, per giustitia, togliere il merito della lode" (Passeri, *op. cit.*, ed. Hess, p. 73).

[123] For a eulogistic view of Bassano to which Agucchi would probably have been reluctant to subscribe, cf. note 40 of Appendix 1.

[124] Bellori's theoretical lecture of 1664, which prefaces his *Vite*, is reprinted as Appendix II to Erwin Panofsky, *Idea*, 1924 (pp. 130-139); Dr. Panofsky has provided in footnotes a most thorough and useful documentation of the sources of what he with justice calls (p. 117, note 257) "das Grunddokument der klassizistischen Kunstanschauung."

[125] Bellori, *Vite*, 1672, p. 11. Bellori's only omission (the passage about the *intentions* of nature) is a significant one, since it is concerned with his feeling that the "ought to be" should not be given the prominence it had in Agucchi's theory. Cf. note 102 of this Part.

". . . gli spiriti eleuati sublimando il pensiero all'idea del bello, da questa solo vengono rapiti, e la contemplano come cosa diuina. La doue il popolo riferisce il tutto al senso dell'occhio: Loda le cose dipinte dal naturale, perche è solito vederne di si fatte . . ."[126]

We may sum up by saying that although Bellori popularized and systematized the theory which became known as "classic" *par excellence*, and his friend Poussin[127] gave authority to related tendencies in art, much preliminary clearing of the ground had already been carried out by Annibale Carracci, Domenichino,[128] and Agucchi.

[126] These two passages, in which the key word is *il popolo*, are an example of the use of high-sounding phraseology of Neo-Platonic flavour as a convenient stick to beat "popular" art and taste, preoccupied with nature in the crudest sense: they are not properly to be taken as indicating an unqualified endorsement of the real substance of the Neo-Platonic point of view because (as we have seen) the *Idea* of Agucchi and Bellori is essentially an improved derivative of nature. For a somewhat similar juxtaposition of the *Idea* as against popular art, cf. Passeri on Bamboccio (quoted in note 122 of this Part). For a reference to the connexion with the analogous "hierarchy of subject matter," cf. note 58 of this Part.

[127] For striking evidence as to Poussin's intimacy with Bellori, cf. A. de Montaiglon, *Correspondance des Directeurs de l'Académie de France à Rome*, I, Paris, 1887, p. 378.

[128] According to Bellori (*Vite*, 1672, p. 412) and Passeri (*op. cit.*, ed. Hess, p. 326), Poussin was a frequent visitor to Domenichino's *Accademia* for life studies. Though Bellori was considerably younger than Poussin, the possibility cannot be ruled out that, at the age of about 19, he also actually met Domenichino (and conceivably even had some elementary artistic tuition from him). When Domenichino fled from Naples in the summer of 1634 he took refuge at the Villa Aldobrandini at Frascati, and was received as an old protégé of the family. According to Bellori (*Vite*, 1672, p. 342) Cardinal Ippolito Aldobrandini sent his secretary Francesco Angeloni to visit Domenichino at Frascati, and Bellori actually prints (from the original then in his possession) a letter from Domenichino to Angeloni written from Frascati a day or two before. Now we have Bellori's own statement (cf. note 115 of this Part) that Angeloni had taken charge of his (Bellori's) education "da teneri anni" and indeed back to the days of Cardinal Ippolito (who died in 1638); thus it is quite possible that Bellori may have become acquainted, through his uncle, with Domenichino during the latter's stay at Frascati and subsequent months at Rome, more especially since this period of absence from Naples was spent under the aegis of the Aldobrandini. If the

Since we are underlining the affinities between these five, the present seems an appropriate moment to draw attention to another important point of contact between them; as, however, its scope is much wider than our classic-painterly contrast (being indeed one of the key notes in the seventeenth century attitude towards painting) we shall only make a passing reference to it. Bellori, in his preface to the *Vite*, says that Poussin advised him to undertake the elaborate analyses of individual pictures which were such a novel feature of his book.[129] This method is closely connected with that interest in the *affetti* which both shared with Domenichino, and which, brought into strong relief by the philosophy of Descartes,[130] became so important in France

much discussed Padre Sebastiano Resta (1635-1714) is correct in stating in a marginal note that Bellori, with whom he was well acquainted, "fu nella pittura discepolo di Domenico Zampieri," this relationship can hardly have taken place later than Domenichino's truancy from his work at Naples (the *postilla* in question is published on p. 15 of the notes to the facsimile edition of Baglione's *Vite* issued by the R. Instituto d'Archeologia e Storia dell'Arte, Rome, 1935; cf. also introduction by Valerio Mariani, p. xv). The following facts, which I have not attempted to investigate further, may or may not have some connexion with a Domenichino-Bellori association at this time: (i) Lione Pascoli (*Vite de' Pittori, Scultori, ed Architetti Moderni*, II, Rome, 1736, pp. 116 f.) records a close friendship between Bellori and Giovanni Angelo Canini at the time when the latter was a pupil of Domenichino, and adds that Bellori was doing some occasional painting at precisely the same time; (ii) Passeri tells us (*op. cit.*, ed. Hess, p. 63) that the series of caricatures which Domenichino made at Frascati in 1634 (of Passeri himself, Canini, and others) was in the possession of Bellori; (iii) Mariette says that he found a landscape engraving signed by Bellori "in" a series engraved by Canini (*Abecedario de P. J. Mariette*, I, Paris, 1851-53, pp. 113 f.).

[129] Bellori, *Vite*, 1672, preface: "Mi sono fermato sopra di alcune [opere] con più particolare osservatione; poiche havendo già descritto, l'immagini di Rafaelle nelle camere Vaticane, nell'impiegarmi dopo a scriver le vite, fù consiglio di Nicolò Pussino che io proseguissi nel modo istesso, e che oltre l'inventione universale, io sodisfacessi al concetto, e moto di ciascheduna particolar figura, & all'attioni che accompagnano gli affetti." That this method was a new departure was appreciated at the time (cf. review in *Giornale de' Letterati*, Rome, 1673, VI, 23 June; p. 78, "con modo nuovo li descrive figura per figura"), though there was of course a classical exemplar in Philostratus, as Bellori makes clear by his quotation at the beginning.

[130] Descartes' *Les Passions de l'âme* was published in 1649. I need hardly say that this digression on the subject of the *affetti* is not to be read as inferring that interest in the matter substantially originated in the seventeenth

as *l'expression des passions*. We come across it in "Mosini," both in his opening passage where he says that Annibale Carracci was often compared with the actor Il Sivello,[131] and in the story of the *vecchiarella*.[132] Though Agucchi does mention *la viva espressione degli affetti* in his exhaustive (and exhausting) catalogue of the virtues of the Galleria Farnese, this factor does not happen to receive special emphasis in the particular fragment of his *Trattato* which has come down to us. That it was of fundamental importance for Agucchi is however amply demonstrated by his lengthy analysis, printed by Malvasia,[133] of Annibale Carracci's *Sleeping Venus* then in the Palazzo Farnese and now in the Musée Condé at Chantilly.[134] This detailed description, with numerous charming touches and some passages bordering on the *risqué*, is a document of some value for the understanding of the way in which a painting could be interpreted by a *letterato* at the beginning of the Seicento, and may be regarded as the forerunner and *modello* of Bellori's analyses.[135] As we read we are left in no doubt about the importance which Agucchi

century; it did however flourish considerably during our period, and became an important feature in the pictorial language of the time. For the history of the theory of expression (in the sense of the emotions or *affetti*), cf. Prof. Lee's comprehensive study (*op. cit., The Art Bulletin*, XXII, 1940, pp. 217-226 and 265-268).

[131] Cf. notes 3 and 50 of Appendix 1.

[132] Cf. note 54 of Appendix 1.

[133] Malvasia, *Felsina*, 1678, I, pp. 503-514. His description was written, Agucchi says, when the painting was all but completed, and is strong evidence for an attribution to Annibale Carracci himself. I cannot agree with Prof. Tietze in seeing Domenichino's hand in it.

[134] Reproduced by Hermann Voss, *Die Malerei des Barock in Rom*, Berlin, 1924, p. 184.

[135] Bellori is of course more restrained than Agucchi, and is anxious not to read too much into a picture. Though he does not actually tell us that he knew this *Descrizione* before its publication by Malvasia, we may reasonably assume that the original MS. or a copy was available to him in the Angeloni-Massani circle; incidentally we note that Agucchi closes with the same quotation from Tasso (*Gerusalemme Liberata*, XVI, 2) as "Mosini" (who is probably identical with Massani) was to use towards the end of his own essay. The existence of the *Descrizione* was evidently known to Tomasini (*Elogia*, 1644, p. 27), and Malvasia refers to it (*Felsina*, 1678, I, p. 502) as "la copiosa, & elegante . . . descrizione tanto bramata al Mondo."

attaches to the rendering of the *affetti*, and he concludes by saying categorically that no painter is the equal of Annibale in expressing them.[136] Nor is it likely that Agucchi's contemporary, Mancini, would have been inclined to contest this view, since he mentions as characteristic of the school of the Carracci "espression d'affetto, proprietà e composition d'historia."[137] These three (*proprietà* being decorum) often get inextricably mixed up and are of course connected with dramatic criticism and the stage. A story such as that told by Bellori[138] of Domenichino acting the *affetti*, and Annibale praising him for doing so, fits in admirably with Aristotle's advice to the dramatic poet.[139] Bellori's anecdote was also in tune with contemporary French criticism, and is characteristically singled out for repetition by Félibien, who, in expressing the opinion (with which Bellori would have agreed) that Domenichino even surpassed the Carracci in the matter of *l'expression*, adduces the highest authority to clinch the matter.[140] We must nevertheless bear in mind that, however important the "dramatic" aspect of history painting might be for the classic group, it was by no means their monopoly. The interest it aroused during the seventeenth century was deep and widely disseminated; it was one of those general states of mind (not dissimilar from the urge in the early Renaissance to master the representation of the solid human form in space) which, by giving the artist a job which involves (from a contemporary

[136] Agucchi says: ". . . l'esprimere nientedimeno apparentemente e l'allegrezza, e la mestitia, e l'ardire, e il timore, l'ira, e la piacevolezza, e l'amore, e l'odio, ed altri tali passioni dell'animo; è una eccellenza, per mio credere, tanto propria del Sig. Annibale, che io non sò, se nel possederla altri gli vada à pari" (in Malvasia, *Felsina*, I, 1678, p. 514).

[137] Quoted from note 36 of Part I; cf. also note 178 of Appendix 2.

[138] Bellori, *Vite*, 1672, pp. 347 f.

[139] *Poetics*, beginning of chapter XVII.

[140] André Félibien, *Entretiens, seconde édition*, II, 1688, p. 265; after retelling Bellori's anecdote he says: ". . . le Poussin, dont le témoignage est d'un grand poids sur cette matiere, disoit qu'il ne connoissoit point d'autre Peintre que le Dominiquin, pour ce qui regarde les expressions." (This passage was first published in 1685.) For Félibien's knowledge of Bellori, cf. also note 144 of this Part.

standpoint) certain technical problems, also gives him the pretext and the opportunity to strike off, on occasion, a great work of art.[141] Perhaps our excuse for this digression must be that it provides support for the basis on which we attempted to compare, more or less through Seicento spectacles, Guercino's *Jacob's Blessing* (Fig. 19) with Annibale Carracci's *Three Maries* (Fig. 20).

We now turn to the fame of Bellori and the influence of his more specifically classic theories; as attention has frequently been drawn to this,[142] no more than a general indication of its scope is called for here. He received from Clement X the title of *Antiquario di Roma*.[143] His reputation spread beyond Italy, to France,[144] where the Académie Royale de Peinture et de

[141] This preoccupation with the *affetti* is of course in the abstract a purely "linguistic" matter; to deduce supposed æsthetic laws from it, either *pro* (seventeenth century) or *con* (more recently), is entirely fallacious.

[142] For example, cf. Julius Schlosser-Magnino, *La Letteratura Artistica*, Florence, 1935, p. 403: "Il più importante storiografo dell'arte non solo di Roma ma di tutta l'Italia, anzi dell'Europa, nel Seicento è l'erudito Giovan Pietro Bellori, il cui valore e il cui influsso oltrepassano di molto i limiti dello stretto campo a cui appartiene."

[143] An excellent survey of the ascertainable facts of Bellori's life has been published recently by Mr. Kenneth Donahue, who gives full bibliographical references ("The ingenious Bellori," in *Marsyas*, III, Vol. for 1943-45, pub. 1946, pp. 107-138). Mr. Donahue points out (*op. cit.*, p. 123) that there is a contemporary source in the shape of Jacques Spon for Bellori's appointment as Papal Antiquarian: the references in the original edition of Spon's book (*Voyage d'Italie . . . Fait és années* 1675. & 1676. *par Iacob Spon . . . & George Wheler*, Lyon, 1678), are pp. 44 and 390 of the first volume.

[144] A summary of the *Vite* (described as by "le Sieur Bellori fameux Antiquaire de Rome") appears in the review in *Le Journal des Sçavans*, 1676, XX, 7 December; the Carracci figure as "les restaurateurs de la Peinture", Domenichino as "le plus sçavant de tous les élèves des Carraches," while the Caravaggesques "se sont éforcez de copier la nature toute simple, telle qu'elle se présente à nos yeux, sans songer à la parer ni à l'embellir comme les autres Peintres, ce qui a rendu leurs ouvrages pauvres, d'un goût sec & rude, tout chargez d'ombres & d'obscuritez." The actual copy of the *Vite* which belonged to Bellori's French counterpart, André Félibien, *Historiographe des Bastimens du Roy*, is in the Library of the Louvre, and, as we have seen, Félibien had obtained information from Bellori in 1679 through their mutual friend the Abbé Nicaise (cf. note 7 of the Introduction, and *Archives de l'Art Français*, I, 1851-52, pp. 12 f.). In that same year Félibien published the fifth and sixth of his *Entretiens sur les vies et sur les ouvrages des plus excellens*

Sculpture made him an honorary member with the status of
Conseiller-Amateur.[145] There can be little doubt that Winckel-
mann's views on the Ideal during the mid-eighteenth-century
owed some debt to Bellori, whether indirectly (through Féli-
bien's writings) during his early years in Dresden,[146] or more
directly during his tenure of the very same post which had been
held previously by Bellori, that of *Antiquario di Roma.*[147] Dryden's
rather free quotation in English, in his preface of 1695 to his
translation of Dufresnoy's *De Arte Graphica,* of a long extract

peintres, the first since the publication of the *Vite* in 1672. In the sixth
Entretien we find the typical Bellorian verdict on Caravaggio (*seconde édition,*
II, 1688, pp. 11 ff.), including a comment on the lack of decorum, in its
French form of *bienséance,* in connexion with his *Death of the Virgin* (which,
after passing through the collections of the Duke of Mantua and Charles I,
was then in that of Louis XIV; we recall that this criticism goes right back
to Mancini, cf. Part I, notes 33 and 34). Félibien also refers in this passage
to Poussin's dislike of Caravaggio's work. Félibien's prelude to the life of
Annibale Carracci (*op. cit.,* II, 1688, pp. 58 f.) against the background of the
two opposed groups of Mannerists and Naturalists is obviously directly based
on the analogous passage in Bellori (*Vite,* 1672, pp. 20 f.), which in turn may
have been derived from the more factual and much less polemical grouping
of Mancini (cf. notes 32 and 36 of Part I, and 104 of this Part). Félibien's
debt to Bellori in the matter of facts and anecdotes is of course obvious from
the sixth *Entretien* onwards. As regards theory, perhaps the most significant
and striking passage is that in which Félibien (*op. cit.,* II, 1688, pp. 212 ff.)
explicitly adopts Bellori's verdict on Rubens (*Vite,* 1672, pp. 247 f.).

[145] This occurred in 1689; cf. *Procès-verbaux de l'Académie Royale de Peinture
et de Sculpture,* III, Paris, 1880, pp. 2 f. and 6 f., and *Archives de l'Art Français,*
I, 1851-52, p. 373. For Bellori's activities in the Roman Accademia di San
Luca and the close connexion between the latter and the Académie Royale,
see Part III below.

[146] For the influence of Félibien on Winckelmann, cf. Gottfried Bau-
mecker, *Winckelmann in seinen Dresdner Schriften,* Berlin, 1933, p. 22; Dr.
Baumecker emphasizes (p. 27) the contrast between Félibien and Winckel-
mann on the one hand, and Roger de Piles on the other.

[147] I am indebted to Dr. Ernst Gombrich for kindly drawing my attention
to a book by Curt Müller (*Die geschichtlichen Voraussetzungen des Symbolbegriffs
in Goethes Kunstanschauung,* Leipzig, 1937), in which the connexion between
Bellori and Winckelmann is assessed (cf. pp. 24 ff. and 46 ff.). Dr. Müller
points out (pp. 49 and 74) that, of the two types of *Idea* present in Bellori,
Winckelmann is favourably disposed towards the one which we have seen to
be essential (that derived *a posteriori* from nature), and tends still further to
eliminate the metaphysical, Neo-Platonic, *Idea* (cf. especially pp. 69 ff.).

from the Introduction to the *Vite* marks the arrival of Bellori's ideas in England.[148] In fact, as has been noticed with good reason, Dufresnoy's own point of view shows close kinship with that of Bellori; in view of the persistent and wide-spread popularity of *De Arte Graphica*,[149] it may be worth while to emphasize that the evidence for an association between the two rests not merely on the plausible assumption that they belonged to the same circle in Rome, but on Bellori's own statement that they discussed the poem together.[150] We may take a single point of contact as representative of many. Dufresnoy has precisely the same attitude towards nature as that which we found in Bellori, and traced through Agucchi back to Alberti: he warns against both extremes, too rigid a dependence on nature and too great a freedom from it, and counsels the painter to imitate "naturam pulchram," as the Ancients had done.[151] Sir Joshua Reynolds was of course a supporter of the theory of the Ideal,[152] but by then it had become so widely diffused that it could have reached him through many channels; he did however provide annotations to a new translation of *De Arte Graphica* which was published in 1783, and has something to say on this very passage. We may turn to Sir Joshua for a final re-statement of the re-

[148] *The Art of Painting by C. A. Du Fresnoy . . . translated . . . together with an Original Preface . . . by Mr. Dryden*, London, 1695, pp. v-xii.

[149] The poem went through innumerable editions, and was translated into French, English, Italian, German, and Dutch. For Dufresnoy, cf. also notes 50 and 80 of Part I.

[150] Bellori says in a letter of September 1670 (the publication of which in *Archives de l'Art Français*, I, 1851-52, pp. 27 f., seems to have been largely overlooked): "Alphonsus de Fresnoy Poema de Arte Graphica, ad Horatii Poetices imitationem, Romae cepit, dum hic in arte erudiendus moraretur; cum vero mihi conjunctissimus esset, quos quotidiè versus faceret, mecum conferebat. Absolvit Parisiis, et multa in eodem poemate legi venuste dicta, atque ad artis leges valde proficua." This letter is to be found in the collection of correspondence addressed to the Abbé Claude Nicaise, a well-known French antiquary (the reference in the Bibliothèque Nationale is Fonds Français, No. 9362, third letter).

[151] *De Arte Graphica*, lines 177-185.

[152] Reynolds, at once sensible and sensitive, is one of the most attractive exponents of the theory; his lengthiest treatment of it will be found in the third discourse (1770).

current dilemma which we first encountered three and a half centuries before in Leon Battista Alberti:[153]

"An individual model, copied with scrupulous exactness, makes a mean stile like the Dutch;[154] and the neglect of an actual model, and the method of proceeding solely from idea, has a tendency to make the Painter degenerate into a mannerist."

Sir Joshua then goes on to recommend to the attention of artists a version of a story already familiar to us, that told by Malvasia of Reni's idealization of an uncouth model:[155] a story in which, we remember, a second artist played the part of contrast and foil—Guercino.

[153] *The Art of Painting of Charles Alphonse Du Fresnoy, translated into English verse by William Mason, with annotations by Sir Joshua Reynolds*, York, 1783, pp. 88 f., note XXVIII. Cf. also p. 68, note III (referring to lines 37-39 of the Latin).

[154] The Dutch in general had previously been brought into the argument by Dryden in a gloss added to his translated quotation of Bellori in the Preface cited in note 148 of this Part. Bellori says (*Vite*, 1672, p. 5): ". . . in questi nostri tempi, Michel Angelo da Caravaggio fù troppo naturale, dipinse i simili, e'l Bamboccio i peggiori." But Dryden's translation reads (*op. cit.*, p. vii): "In our times Michael Angelo da Caravaggio, was esteem'd too Natural. He drew persons as they were; and Bambovio [sic], and most of the Dutch Painters have drawn the worst likeness."

[155] Cf. note 62 of Part I.

PART III

ART THEORY IN THE NEWLY-FOUNDED ACCADEMIA DI SAN LUCA, WITH SPECIAL REFERENCE TO "ACADEMIC" CRITICISM OF CARAVAGGIO

"Guercino broke like a torrent over all academic rules, and with an ungovernable itch of copying whatever lay in his way, sacrificed mind, form and costume, to effects of colour, fierceness of chiaroscuro, and intrepidity of hand."

(Henry Fuseli, R.A., 1801.)

IT seems natural to us, looking back in perspective, to use the general term "academic" to describe any criticism which tended to undervalue non-idealizing artists such as Caravaggio and the young Guercino. Consequently it might be asked why the Accademia di San Luca, that ancestress of all Academies of Art, has not figured in our consideration of the theoretic influences which Guercino might have encountered during his visit to Rome. The answer is the simple but perhaps unexpected one that the writer does not know of any evidence which would support the opinion that, in the early Seicento, the Accademia di San Luca had any material influence on art theory. The reasons for any surprise which the reader may feel at such a statement would no doubt be connected, superficially, with our rather loose common use of the adjective "academic," and with the knowledge that Federico Zuccaro, who virtually founded the Academy in 1593, was a formidable theorist; but the real reason would be that the source books relating to Zuccaro and the early years of the Academy are exceedingly scarce,[1] and that consequently it is difficult to arrive at an estimate of the relative importance of the part actually played by theory in that institution.

An instance of this is provided by some passages in an interesting essay by Miss Margot Cutter on Seicento criticism of Caravaggio.[2] The later theorists (Bellori and the rest) were of course accessible to her, but it is evident that this did not apply to several of the Zuccaro books, and in particular to the valuable chronicle of the early days of the Accademia di San Luca as

[1] It appears from the *Raccolta di Lettere sulla Pittura Scultura ed Architettura*, Vols. V (Rome, 1766, p. VII), and VI (Rome, 1768, pp. XII-XV and 199-202) that Monsignor Giovanni Bottari and Pierre-Jean Mariette had great difficulty even in the eighteenth century in finding Zuccaro's books; Bottari eventually reprinted his *L'Idea* in Vol. VI of the *Raccolta* (pp. 33-199).

[2] Margot Cutter, "Caravaggio in the Seventeenth Century," in *Marsyas*, I, 1941, pp. 89-115.

recorded by its official secretary, Romano Alberti;[3] the result
is that, in so far as she deals with the *strictly* contemporary
criticism of Caravaggio, she shows a tendency to project back
into the early Seicento that antithesis which becomes familiar
enough in later periods: the "academy" versus the "advanced"
artist. The amendment to her thesis which we are about to
suggest is doubtless just a matter of shift of emphasis, but the
whole problem of the exact nature of the relationship between
theory and practice in this period is of cardinal importance for
the interpretation (or should we say, misinterpretation?) of
Seicento art, and consequently the maximum of precision in
dealing with the question is desirable.

We may begin by drawing attention to the possibility of mis-
understandings arising if we make use, in connexion with
adverse criticisms of Caravaggio, of the expression "academic"
in too free and broad a sense, and without a clear indication as
to which of its many meanings we wish to convey. In our par-
ticular context, that of art theory, there are two main connota-
tions of the word "academic." First, it may be taken to charac-
terize the fact that any attempt at the *reasoned* interpretation in
words of the art of painting had at this time to adapt itself to a
not very flexible literary framework. It was, so to speak, a
somewhat dependant poor relation of "literature." Whether or
not it made its mark was to a certain degree contingent on the
amount of learning and erudition displayed; hence tradition and

[3] *Origine, et Progresso dell'Academia del Dissegno, De Pittori, Scultori, & Archi-
tetti di Roma. Dove si contengono molti utilissimi discorsi . . . Recitati sotto il
regimento dell'Eccellente Sig. Cavagliero Federico Zuccari, & raccolti da Romano
Alberti Secretario dell'Academia*, Pavia, 1604 (Romano Alberti's dedication to
Cardinal Federico Borromeo is dated 1599). I am not inclined to agree with
the deduction of Dr. Werner Körte in his useful work *Der Palazzo Zuccari in
Rom* (Römische Forschungen der Bibliotheca Hertziana, XII, Leipzig, 1935,
p. 88) to the effect that a passage in Zuccaro's Will of 1603 (quoted by
Körte, p. 82) refers to what could be described with any accuracy as an
earlier printed edition of this book, published in 1593; from page 15 onwards
the *Origine* deals in actual fact with the year 1594, together with a short
section on later years down to 1599. The reference in the Will may be to
a manuscript of the *Origine*, in which the rules of 1593 of course appear, or
it may be to a different book, manuscript or printed, containing those rules
alone.

precedent played a considerable part, and any new attitude is usually found to amount, at bottom, to not much more than a re-shuffling of old data to meet a changed situation. In these circumstances a reasoned and "learned" defence of an unconventional art such as that of Caravaggio was not so easily formulated.[4] If Miss Cutter is referring to the literary limitations within which art criticism had to operate when she says[5] that "to write at all was partly to identify oneself with the academic point of view," I am inclined to agree with her conclusion.

Both Federico Zuccaro (the painter playing the philosopher) and G. P. Bellori (the *letterato* and antiquary playing the connoisseur) had strong literary orientations, and in that sense may perhaps be described as "academic." But a word of caution is advisable here; though such hardy annuals as the theory of decorum and that of the superiority of "history" painting are common in various forms to both the Cinquecento and the Seicento and proved readily adaptable in an anti-Caravaggesque sense, Zuccaro's theoretical standpoint and that of Bellori are in essence about as similar as chalk to cheese, and there is some risk of overlooking this fact if they are both classified, without further qualification, as "academic." The situation is rendered still more complex in two other ways. On the one hand, the type of art to which the term "academic" could be loosely applied during and after the second half of the seventeenth century had on the whole a relatively classic tinge, thereby giving rise to the rough but long-lived equation "academic=classic"; in this later sense of the word Zuccaro and the Mannerists were of course hardly "academic." On the other hand, though the writings of Zuccaro and Bellori have an entirely different approach and are associated with opposed types of art, mannerist and classic, they were nevertheless both members of the Accademia di San Luca.

[4] Perhaps we may put it this way: the odds were much against any favourable estimate which was elaborately argued, and art theory did not produce a critic comparable to Castelvetro, who made several radical departures from tradition in literary criticism.

[5] Cutter, *op. cit.*, p. 91.

This brings us to our second main connotation of the word "academic." The historical fact of the existence of an institution called an Academy and our two writers' membership of it may tempt us to assume a continuity in theoretical matters which on closer investigation does not seem to be well founded.[6] Our sources for the early history of the Accademia are certainly not abundant or extensive in scope;[7] nevertheless sufficient material does exist, in the present writer's view, to throw considerable doubt on any suggestion that, during the first half century or so of its existence, that rather improvised and haphazard association had, *as a body*, strong opinions on theory and style, and pursued anything in the nature of a consistent artistic policy of its own in that respect. We shall now proceed to summarize such evidence as we have.

* * *

The Accademia di San Luca[8] had existed in name before 1593, but there is no doubt that the attempt to galvanize it into more than nominal existence was largely the work of one man,

[6] It is here that I feel that Miss Cutter was at a disadvantage in the matter of sources; for example, she uses the terms "academic officialdom" (*op. cit.*, p. 89) and "the academicians" (p. 90) to describe the contemporary trends critical of Caravaggio; and one must take it for granted that the reference is to the Accademia di San Luca, to which indeed Miss Cutter refers, in connexion with Zuccaro, as the "academic stronghold" (p. 100). After a reading of the *Origine* one would be inclined to avoid the implications which expressions of this kind must necessarily carry.

[7] I have unfortunately not been able to examine the Archives of the Accademia, but some idea of their scope can be obtained from Dr. G. J. Hoogewerff's second volume of *Bescheiden in Italië omtrent Nederlandsche kunstenaars en geleerden* (The Hague, 1913, pp. 1-132). This does not hold out high hopes as far as we are concerned, and the fact that the minutes of proceedings do not go back beyond 1634 supports Missirini's complaint of an *immensa lacuna* in the records (Melchior Missirini, *Memorie per servire alla storia della Romana Accademia di S. Luca*, Rome, 1823, p. 80). So we shall have to rely mainly on Romano Alberti (cf. note 3 of this Part), who is virtually a mouthpiece of Zuccaro, together with Zuccaro's own books.

[8] For a summary of the history of the Accademia in the Cinquecento and Seicento, not touching particularly on matters of theory, cf. Nikolaus Pevsner, *Academies of Art past and present*, Cambridge, Eng., 1940, pp. 60 ff. and 110 ff.

Federico Zuccaro,[9] who held office as President (*Principe*) for one year only, from November 1593 to October 1594. His two principal aims emerge clearly enough from a reading of Romano Alberti. The first was to increase the esteem felt for the arts in learned and literary circles, and as a result to enhance their "respectability" and status in society. The second (more important in its consequences for the historian of academies in general, but in my reading not necessarily more so in Zuccaro's eyes) was to give a marked educational tendency to the activities of the Accademia, in the sense of providing instruction for young beginners in the rudiments of art.[10] These two aims fit in well enough with what we know of Zuccaro's life and character. Though he is not without self-esteem, we get the impression that he was something of a disappointed man, always falling short of the highest achievements in his art in spite of the constant commissions of importance which he received. But he was cultured and urbane, and able to hold his own in the courts of princes and the discussions of the learned; Mancini

[9] Zuccaro's name has many variations: Zuccari, Zuchero, Zuccharo, Zucchero, Zucchari, etc. In his youth he even signed a letter Zuccarini! I have adopted Zuccaro because this is the form appearing most frequently in his own publications, with which we are largely concerned here.

[10] The fact that the educational side of Zuccaro's programme was an important innovation foreshadowing the practice of innumerable later academies of art is fully brought out by Dr. Pevsner (*op. cit.*, pp. 60 f.), who evidently also feels that Zuccaro himself was primarily interested in the educational aspect; I cannot quite agree with this, though I differ merely in the sense of a slight alteration of stress. It will of course be my argument here that the first part of Zuccaro's programme (bound up with his predilection for advanced theory) ended in complete fiasco. But the second, or educational, part probably survived Zuccaro's vacation of the presidency, though very likely in an attenuated form. Dr. Pevsner adduces several adequate reasons for supposing that it did survive (p. 62), but it should be pointed out that the ambitious programme of instruction which he quotes at the top of page 61 is not in fact from the rules of 1596, as he suggests, but was laid down at the second academic session of Zuccaro's presidency on 28 November 1593 (Romano Alberti, *Origine*, 1604, p. 8). The fact that this impressive scheme is *not* "post-Zuccaro" is of course important in our context. Incidentally there were only two Censori in the rules of 1596 (not twelve) and their province was "l'ordine delle scuole, e il buon costume" (Missirini, *Memorie*, 1823, p. 70).

describes him as "di nobilissimo aspetto e proceder regio," with which Baglione concurs, adding that he was universally liked—surely an exemplary president from a conventional point of view, as the latter points out. His propensity for playing the *letterato*[11] and for ambitious planning in art,[12]

[11] Zuccaro was evidently especially proud of being a member of the then flourishing literary Accademia degli Insensati at Perugia, in which he had the usual academic nickname—in his case *Il Sonnacchioso*. At the beginning of his *L'Idea* (1607) a madrigal is printed as by "Zuccaro, nell'Academia dell'Insensati detto il Sonnacchioso," and another poem appears simply with the nickname and his academic emblem (*impresa*). Another poem by *Il Sonnacchioso* appears at the beginning of Romano Alberti's *Origine* (1604), and at the end of that volume, on un-numbered sheets, there is an extract from the "Conclusioni del Rev. D. Ventura Venturi da Siena, Academico Insensato detto il Velato, disputate in publica Academia dell'Insensati in Perusa"; part of the dedication says that the author has added "alcune determinationi sopra il Dissegno, . . . per l'occasione d'una disputa incominciata nell'Academia nostra dal Sig. Federico Zucchari, Pittore famosissimo . . .", after which follow the definitions resulting from the discussion. (It would be interesting to know if this was a literary prelude to his lectures at Rome, but I have been unable to throw light on the point.) In the titles to his *Lettera a Prencipi* (advocating the foundation of art academies throughout Italy) and to his poem *Lamento della Pittura*, which were published together in 1605, he ostentatiously gives himself his literary academic designation (cf. the following footnote). Finally we learn from his *Il Passaggio per Italia, con la Dimora di Parma* (Bologna, 1608; pp. 12 ff. of the *Dimora*) that he was received in 1608 (the year before his death) by the literary Accademia degli Innominati at Parma, where he delivered a lecture on his æsthetic theories. Perhaps, as we are concerned here with Zuccaro's connexions with the world of the *letterati*, it should be pointed out that there is a potential misunderstanding in Anthony Blunt, *Artistic Theory in Italy*, Oxford, 1940, p. 147, where the inference might be drawn that the *Insensati* and *Innominati* were art academies, and even that Zuccaro was President of them; the fact that they were literary academies, and that Zuccaro never managed to establish any art academies after the Roman semi-fiasco is of course an essential part of our thesis. (Bologna is a slip for Perugia as the domicile of the *Insensati*.)

[12] Zuccaro was a member of the Accademia del Disegno at Florence in 1565 and 1575-78, and during the latter period drew up a scheme for its reform, which however was never carried out (letter published by Pevsner, *Academies of Art*, pp. 51 f.). His most ambitious piece of propaganda for the formation of art academies was a pamphlet published at Mantua in 1605 (*Lettera a Prencipi, et Signori Amatori del Dissegno, Pittura, Scultura, et Architettura: scritta dal Cavaglier Federico Zuccaro, nell'Academia Insensata detto il Sonnacchioso. Con un Lamento della Pittura*). He sees the art of painting as in decline, and advocates as a remedy the foundation of numerous academies supported by

and his preoccupation, shared by his faithful henchman Romano Alberti,[13] with the dignity and social standing of his

"the public" or the state. We give some typical quotations (the pages are not numbered); "Però per ravivare queste virtù quasi spente, vengo a proporvi, che sarebbe cosa di molto honore, et beneficio l'instituire nelle Città, ò nelle Corti de' Prencipi, ò d'altri Signori, Academie, e studij di queste professioni: poiche l'Academie assottigliano gli ingegni, & li fanno più accorti, e vivaci"; "Et che difficoltà sarebbe in alcune Città principali, come Roma, Milano, Venetia, Napoli, Fiorenza, & Genova, (per non uscir d'Italia) instituire Academie publiche, & dal publico sostentate, per queste nobilissime professioni, che sono non men necessarie, che dilettevoli, e grate?"; ". . . co'l tempo non mancarebbero virtuosi, che per accrescito dell'Academia, la favorirebbero, & farebbero delle spese, come si è veduto in molte Città [this reference may be to literary academies]; & si potrebbe talhora introdurvi alcuni discorsi, & ragionamenti intorno queste professioni, come di già n'è stata istampata una buona instruttione dall'Academia del Dissegno, de i Pittori, Scultori, & Architetti di Roma [a reference to Romano Alberti's *Origine*]." Zuccaro's open letter is followed by one purporting to be from his publisher, Francesco Osanna, dedicating Zuccaro's poem *Il Lamento della Pittura su l'onde Venete* to Girolamo Capelli of Venice, and asking him to use his influence with the Serenissima Repubblica "alla quale poco, e nulla sarebbe assegnar due stanze nella Libraria, od altrove per questi studij." The hint was not taken, and, in view of Zuccaro's not very tactful censure (in the *Lamento*) of Tintoretto as responsible for the downfall of painting, we cannot altogether be surprised! (For quotations from the poem, cf. note 54 of this Part.) Zuccaro was connected with the (largely philanthropic) Roman organization of artists known as the *Virtuosi al Pantheon*, being elected in 1572 *Reggente perpetuo*, an office which he had, however, to resign in 1584 owing to disagreements (cf. *Annales Institutorum*, II, 1929-30, p. 143); it would be interesting to know if he tried to foist one of his schemes on his fellow-members!

[13] Romano Alberti had published a work on the status of painting not long before Zuccaro's attempt to put some life in the Accademia di San Luca. The title is: *Trattato della Nobilta della Pittura. Composto ad instantia della venerabil' Compagnia di S. Luca, et nobil' Academia delli Pittori di Roma. Da Romano Alberti della citta del Borgo S. Sepolcro* (Rome, 1585). It is perhaps worth mentioning that Luigi Crespi, having found a copy of this rare volume with the title page and preliminary unnumbered sheets missing, republished it in the seventh volume which he and the Roman publisher Marco Pagliarini added in 1773 to Bottari's *Raccolta di Lettere* (unknown to the learned Monsignore himself!) In his explanatory note (pp. 144-147) Crespi suggests that the Treatise (reprinted on pp. 148-193) was the work of G. B. Paggi, and this error reappears in Stefano Ticozzi's edition of the *Raccolta* (VII, Milan, 1822, pp. 214-277), and in the reprint of the *Trattato* at the end (pp. 269-317) of Fiaccadori's edition (Parma, 1845) of Bottari's *Dialoghi*. Romano Alberti is characteristically much exercised to prove, with many

profession[14] may well have some connexion with his ill success in grasping the laurels of a really great painter: the eminence he could not reach in one way might be attained in another.

learned references to authority, that painting is a liberal, and not a mechanical, art. We may note in passing that two poems which precede the *Trattato* are by Girolamo Magagnati (cf. Erythraeus, *Pinacotheca*, 1643, p. 168), who appears to be identical with one of the laymen who are listed on the last sheet of the *Origine, et Progresso* as honorary members of the Academy.

[14] Typical manifestations of this are the references which Zuccaro makes to the high status enjoyed by painting in antiquity (cf. at the beginning of his *Lettera a Prencipi*, and in his *L'Idea*, Turin, 1607, Bk. II, p. 26); Romano Alberti has a similar reference in the *Trattato della Nobilta* (p. 18). That one of Zuccaro's objectives in bringing the Accademia di San Luca to life was the raising of the social prestige of the profession seems clear from certain passages (recorded by Romano Alberti) from his exhortations. For example: ". . . vi essorto alla frequenza di questo luogo, della quale frequenza, & essercitij virtuosi, & honorati, che vi faremo, & doveremo fare, ha da nascere grandissimo bene, & honore per noi stessi prima, & poi riputatione à tutta la professione; imperoche molti Signori, e Prelati, e gentil'huomini, pigliaranno la protettione nostra, vedendoci tutti frequenti, & bene incaminati . . ." (*Origine*, p. 3); also ". . . però dobbiamo ancora accompagnare queste honorate professioni, & questi studij co[n] un candore di bontà, & co[n] uno splendore d'honorati costumi, si come conviene, per poter saper pratticare con li gra[ndi] Principi, e Signori, & poter esser ben visto, & accarezzato" (*Origine*, p. 4). The connexion between this "prestige" aspect and the theoretical discussions proposed by Zuccaro is made clear by extracts from his speech after the rules had been agreed upon: ". . . ordiniamo alcuni ragionamenti utili per la Theorica, o per la prattica di queste nostre honoratissime professioni; & se io havrò le Signorie vostre unite, & ubidienti à quest'affare, spero che ne apporterà non solo utile, & honore à noi medesimi, ma gusto, e piacer grandissimo à molti altri, & in spetie alli amatori della nostra professione, i quali spero, che perciò ci favoriranno, e cosi accresceremo di nome, e di riputatione questo luogo, & questa nobilissima Academia, la quale non dubbito che non habbia à essere freque[n]tata da nobilissimi Signori, e bellissimi ingegni litterati, & altri, che ne daranno aiuto, favore, e reputation' insieme à tutti" (*Origine*, p. 13); and ". . . però senza la Theorica non può essere prattica d'operatione molto buona, per tanto ordiniamo, che ogni quindeci giorni in questa nostra Academia vi si facciano raggionamenti, e discorsi Theorici, circa al ben' operare, e questo è lo scopo principale di nostro affare, che se in questi si essercitaremo, daremo utili avisi à noi medesimi, e piacere, e diletto forse grandissimo à molti di fuora via, e riputatione alla professione, & à questa nascente Academia . . ." (*Origine*, p. 14). One of the *letterati* who took part in the discussions, Baldo Catanio, endorses this general view and says (*Origine*, p. 51) that he expects to see the Academy "piena di nobilissimi Signori, e gran Prelati" (for Catanio, cf. Erythraeus, *Pinacotheca*, 1643, p. 115).

Yet, to do him justice, this was by no means the whole story: he was certainly acting in what he conceived to be the best interests of art. He gave practical expression to the educational side of his programme and the philanthropic strain in his character by bequeathing to the Accademia the house he built on the Pincio, with the proviso that some rooms should be set apart as a hospice for young foreign art students. Moreover his theoretical standpoint goes somewhat deeper than what we might call intellectual snobbery. He had an inkling of the view that (to put it in modern terms) somewhere in art there is a residual factor which is not susceptible of scientific-empirical explanation. Some such feeling may be expected to come especially to the fore in periods when the limitations of an exclusively empirical view of the world become most apparent;[15] obviously the particular forms which it takes will vary according to the general spirit of the times, from simple recognition of the self-contradictory and therefore inadequate nature of the purely scientific thesis (as is partly the case now) to argued mysticism, in the sense of a wholesale transfer of the rational apparatus from an empirical to a metaphysical basis (as in the Mannerist period). Thus the form in which Zuccaro had to express this feeling necessarily involved him in the theological-philosophic jargon of his time, which not only makes unfamiliar reading for us to-day, but was largely meaningless to the majority of his fellow-artists, who were equally ill-equipped to interpret it. This latter is the point which it is necessary to emphasize. The more Zuccaro became convinced of the importance of art as a human activity, and the more he thought

[15] The modification of that faith in the scientific outlook based on observed experience which was so characteristic of the Renaissance is typified by Zuccaro's denial in a notable passage in *L'Idea de' Pittori, Scultori, et Architetti* (Turin, 1607, Book II, pp. 29-31) that art is a branch of mathematics. There is of course the usual confusion between art used as a general descriptive term and the qualitative element in art, but at the back of Zuccaro's mind is the conviction that quality cannot be obtained by recourse to mere mechanical rules, that there is something incalculable about it. Another expression of this feeling is to be found in the unfavourable reception in the Accademia of the discourse which Giovanni Coscia had induced some mathematically-minded *letterato* to write for him (*Origine*, pp. 62-65).

to substantiate this view theoretically, the further he got from the practical problems of the artist: this lack of close relationship between theory and its application in practice meant that, whatever Zuccaro's influence might be outside the profession (as a propagandist on its behalf), the direct effect of his theories among working artists was hardly likely to be great.[16] His principal object is to obtain wider recognition for the position of art as a major activity of the human spirit, and consequently he speaks rather as an abstract philosopher to the *letterati* than as an art theorist to the artists:[17] *la dignità dell'Arte*, that is his real theme.[18]

*　　　　*　　　　*

What were the fortunes of Zuccaro's brief Roman experiment, and, in particular, what sort of a reception did his interest in theory encounter from his fellow-Academicians? On this point Romano Alberti has much to tell us.

The first three meetings were spent in drawing up the rules, but at the fourth (2 January 1594) Durante Alberti and his nephew, our chronicler Romano, opened the series of lectures by one on *Disegno*, which they not unnaturally took to mean drawing, treating it from a practical point of view. But Zuccaro made it clear that he was interested in something more subtle ("più à de[n]tro nell'animo, e nello spirito"), and Cesare

[16] We must distinguish between the two roles played by Zuccaro: on the one hand the abstract philosopher whose theories had little practical relevance for the artist, and on the other the practical organizer with the belief that associations of artists would tend to raise the standards in art. The concrete application of art theory seems to have been largely overlooked between the two.

[17] A passage from the publisher's dedication in Zuccaro's *Il Passaggio per Italia* illustrates this point: "Nè si scosta come Pittore dalla Filosofia, si come si vede in alcune ben intese diffinitioni sopra il Dissegno, date da lui nell'Academia Innominata di Parma, nelle quali s'allontana da' pensieri del Volgo . . ."

[18] Zuccaro himself says towards the end of the chapter on painting in *L'Idea* (1607, Bk. II, p. 33): "E tutto questo detto habbiamo per mostrare la grandezza, e dignità dell'Arte della Pittura, e del Disegno . . ." We do not go into the details of Zuccaro's theories because we are only concerned here with establishing their general character and intention.

Nebbia was enjoined to lecture at the next meeting on this philosophical *Disegno* "intellettualmente, e come Pittore, e come Filosofo."[19] At the fifth meeting on 17 January, poor Cesare valiantly did his best, but did not meet with the approval of Zuccaro, who was begged by the company (now evidently somewhat mystified) to say what he had in mind. Zuccaro then rose, and addressing the *letterati* present, said he hoped his lack of subtlety would be excused, as he had to bear in mind the limited capacities of his brother painters![20] The ensuing exposition of his philosophical theory of Disegno seems to have stunned even the *letterati*.[21] As Zuccaro had concluded with a definition of painting the question then arose of the architects and sculptors contributing definitions of their own arts at subsequent meetings. At this suggestion considerable reluctance became evident among the potential lecturers, but eventually a promise to speak on architecture was extracted from Giacomo della Porta.[22] At the sixth meeting, however (26 January) Messer Giacomo sent word asking for postponement on the score that he was too busy,[23] and the same occurred at the seventh meeting (3 February), when his excuses were somewhat

[19] *Origine*, pp. 15 f.
[20] *Origine*, pp. 16 f.: ". . . fù sforzato il Sig. Principe à prieghi di tutti li Sig. Academici voler' egli stesso dichiarare, quello che di ciò intendeva, poi che niuno intraava [sic; for *entrava*] a penetrare il suo concetto. Così egli in prima scusandosi di pensiero tanto alto, che pochi per avve[n]tura di quelli che erano presenti inte[n]derebbero . . . & cosi voltandosi ad alcuni litterati che ivi con molti altri Accademici erano disse in si fatta maniera . . . & se bene io non saprò, ne potrò al presente à pieno discorrere con quei propri termini, e con quelle accommodate e significanti voci scolastiche, che voi altri Signori intelligenti dottamente solete nelle scuole vostre usare, doverò essere scusato in ciò perche io intendo parlare puramente con una semplice Filosofia naturale senza molto artificio, & altezza, e questo per capacità de nostri fratelli . . ."
[21] *Origine*, p. 23.
[22] *Origine*, p. 26: ". . . & se bene si volevano scusare gli Scultori, come ancora gli Architetti, & in particolare M. Giacomo della Porta, con vane, e non approvate scuse, tuttavia fù replicato tanto dal Sig. Principe, e da altri officiali, & Academici, che M. Giacomo della Porta non potè scusarsi, e promise dir qualche cosa . . ."
[23] *Origine*, p. 26.

coldly received.[24] Notwithstanding, he failed to put in an appearance at the eighth meeting (11 February), although a considerable concourse had collected to hear him.[25] Zuccaro then asked other architects who were present to step into Giacomo's shoes, but they all said they knew no better definition than that of Vitruvius; indeed one of them, foreseeing that this situation might arise, took the precaution of bringing along his own copy of Vitruvius![26] After Zuccaro had spoken impromptu suggesting his own definition in substitution for that of Vitruvius, which he thought too wide, the question arose as to who should deal with sculpture at the next meeting. Whereupon the sculptors did their best to avoid the task, one of them remarking that it was easier for him to make a couple of marble figures than a speech of that kind; eventually, however, Taddeo Landini was balloted as speaker.[27] Need we add that when the time came the usual message arrived instead of Landini,[28] and that Zuccaro stepped into the breach with an impromptu definition of sculpture?

Nevertheless lots were drawn for an extensive series of lectures lasting until August, and Romano Alberti duly affixed this

[24] *Origine*, p. 30: ". . . se bene il S. Principe, e gl'altri conobbero essere questa una dilatione, e scusa artificiosa, tutta via parve al S. Principe ametterli per allhora ancora cotal scusa, ma che no[n] se l'ametterebbe più se à quest'altra tornata non co[m]parisse, face[n]doli sapere, che à tutti darebbe gusto à uscire d'obligo, altrime[n]te perderebbe assai nell'opinion di molti, à così ma[n]care face[n]do torto à se stesso, e à questa virtuosissima Acad. . . ."

[25] *Origine*, p. 34.

[26] *Origine*, pp. 34 f.

[27] *Origine*, p. 38: ". . . gli scultori presenti si scusavano assai, e procuravano di scaricarsi di tal peso chi in una maniera, o chi in un'altra, chi co[n] dire non conoscersi buono, & atto à questa tal diffinitione, e chi con dire farebbe più facilmente un par di figure di marmo, ch'un ragionamento simile, e simil cose dicevano per scusarsi, volendo caricare tutto il peso al Sig. Principe . . ."

[28] *Origine*, p. 39: ". . . venne un suo mandato con una polliza . . . con scusarsi che per sua indispositione di male assai travaglioso, che li era sopragiunto, non era in poter suo di sperare far parte alcuna del debbito suo, nel al presente, ne per la venire . . ." At the same ninth meeting (26 February) Zuccaro had a lively debate with one of the *letterati*, Baldo Catanio.

programme to the Academy notice board;[29] but very few of the lectures actually took place as planned. Giuseppe d'Arpino excused himself and got one of the *amatori*, Camillo Ducci, to speak instead of him.[30] Cherubino Alberti actually did contrive to speak on *decoro*, according to arrangement.[31] At the subsequent meeting, however, Giovanni Battista Navarra failed to turn up, whereupon an *amatore*, Giulio Bardini, commented in reproof of conduct of this kind,[32] and Zuccaro mounted the rostrum to deliver yet another impromptu lecture. A week later Giovanni Coscia produced a discourse which was evidently not his own composition; the author of it maintained that painting was a branch of mathematics which brought a good deal of wrath down on the head of the unfortunate Coscia for being a party to the introduction of such heresies into the Academy.[33] April was to be the sculptors' month and was

[29] *Origine*, pp. 53-57.

[30] *Origine*, p. 57 (tenth meeting, 6 March).

[31] *Origine*, p. 58 (eleventh meeting, 13 March).

[32] *Origine*, pp. 58 f. (twelfth meeting, 20 March): "Toccava la seguente Domenica di discorrere à M. Gio. Battista Navarra sopra la gratia, e la bellezza della figura, il quale fù il primo che mancasse de i Pittori, à non voler fare il suo discorso, ne in voce, ne in scritto, forse per poco animo, il che fù causa che molt'altri à suo essempio mancarono, e molti più haverebbeno mancato se il Sig. Giulio Bardini gentil'huomo, e amatore della professione, che presente si trovò non faceva una reclamatione in biasimo di quei che à tal honorata Academia, e à così utili, e laudabili discorsi mancassero, e che tali discorsi erano un grand' accrescimento d'animo, di forze, e di studij, come d'honore, e di riputatione à tutti, e che niuno dovea per tanto restare per cosa alcuna di non far la parte che li toccherebbe, e chi non si conoscesse atto à trattare in voce portasse scritto il suo concetto, che ciò sarebbe anco molto utile, e giovevole à se stesso, & ad altri, e non parendoli ancora esser egli stesso atto à tanto, che non era mancamento alcuno ne vergogna in niuna maniera farsi aiutare da chi, acciò fosse atto, e buono; essendo che tutto questo che il Sig. Principe haveva prudentemente proposto, era un singular aiuto à gli studij loro, e in più maniere giovevoli al particolare, & al universale, & che questi discorsi sarebbero quelli che farebbono celebre, e copiosa d'Auditori quest'Academia, e di molt'honore, e riputatione; Apresso pregò tutti, che no[n] dovessero à niuna maniera ma[n]care, ne à se stessi, ne à tutta la professione."

[33] *Origine*, pp. 61-65 (thirteenth meeting, 27 March): " . . . fù giudicato tal discorso essere d'un Matematico, e non d'esso Pittore, il quale mostrò di no[n] intendere, ne saper quello che egli portava nell'Academia del Dis-

opened according to programme by Flaminio Vacca.[34] But Zuccaro was called away to Florence until the end of June, and in his absence everything came to a standstill, with the exception of a single architectural lecture by Francesco Volterra on 1 May.[35]

On resuming his presidential chair Zuccaro was much grieved to find that little or nothing had been done since his departure and once more appealed for support.[36] At the first meeting after his return Cristoforo Roncalli (Il Pomarancio), after an apt and interesting foreword pointing out that he was a painter and not a theorist,[37] delivered a lecture on history painting

segno, però fù notato da alcuni questo, e non mancarono di quelli che dissero che doverebbono essere molto ben' avvertiti quei, che da altri si fanno aiutare in simil negotio, & essaminar' molto bene quel tanto che in Academia si propone . . . il Coscia arrossitosi in buon modo si scusò con dire che tal cosa egli non haveva veramente osservato . . ." (p. 64).

[34] *Origine*, pp. 65 f. (fourteenth meeting, 3 April).

[35] *Origine*, pp. 66 f. Before leaving Zuccaro exhorted the Academy to carry on and left Giuseppe d'Arpino as his *luogotenente*, but "in vero si fè poco, o nulla di buona, però che passò il mese d'Aprile, e di Maggio, e parte di Giugno, che si fecero pochissime ritornate nell'Academia . . ." Romano Alberti himself was due to speak in June, but was unable to do so; at any rate we may be sure that his excuse was genuine!

[36] *Origine*, pp. 66 f.: ". . . si ramaricò assai, che in quella sua absenza, qual si fosse stata la cagione, non si erano esseguiti li buoni ordini lasciati, e pregò di nuovo tutti à non voler mancare à quanto ciascuno dovesse per utile, e honore commune, e poiche havevano incaminato così honorata Academia, non mancassero nel meglio, e promisero esser ubidienti, e far quanto per essi si potesse, e con questo il Sig. Principe si rincorò alquanto."

[37] *Origine*, pp. 67 f.: ". . . e se ben' io sò (ne punto in ciò m'inganno) che il trattare di questa, ò d'altra simile materia in Academia, non è peso dalle mie spalle, ò impresa proportionata alla debolezza dell'ingegno mio, havendo io più tosto studiato nelle mura dipingere, e nelle tavole, ò in tele colorire, che rivoltare le carte, e meditar le teoriche della nostra arte, e che io doverei lasciar' ciò far' ad altri più felici, & elevati ingegni, che non contenti delle sole prattiche d'essa, e di solamente maneggiare i penelli, ma astraendo dalle cose materiali, le immateriale [sic], e delle particolari, l'universali; con la sublimità de i loro ingegni si sollevano à i primi principij delle teoriche, & alle regole scientiali di questa nostra bellissima professione, con tutto ciò ho voluto più tosto ubedire, & discorrere come meglio sapessi . . ." I have an impression that this passage may very well reflect a widely held opinion in the Academy about Zuccaro's theories: though their learning in the literary sense is acknowledged, they are clearly recog-

which, being reasonably intelligible to all present, was well received.[38] As this lecture seems to have been the only one of any substance which was delivered by a painter other than Zuccaro,[39] it may be worth while to note its character in passing. Roncalli's method of approach is radically different from that of his president, and he is obviously quite uninfluenced by the latter. He virtually gives us a practical account of how an artist sets about a history painting. There are no abstract metaphysics: *idea* means quite simply the rough mental image of a composition before the artist starts his drawing (the word *disegno* with Roncalli means little more than drawing—certainly there is no *scintilla della divinità* about it!) Nor do we find any polemical criticism similar to that indulged in by Agucchi and Bellori. The usual accepted *clichés* of the time naturally make their appearance,[40] and Roncalli seems to consider that grace, as opposed to *crudezza*, is a valuable quality, but on the whole his discourse is strikingly free from theoretical or critical considerations. Nevertheless he had taken trouble and risen to the occasion, and the prospects for the Academy appeared to have brightened momentarily. The unjustifiable nature of this fleeting optimism was however made clear at the subsequent meeting early in July. Apparently it was the turn of the sculptors to provide a speaker, but they showed no inclination to do so, nor did they even take very kindly to Zuccaro's suggestion that they should do some work in the academy for the instruction of the

nized to be philosophical abstractions. Underlying Roncalli's remarks we may sense a conviction that painting and philosophy are quite separate, and that, while a painter may also be an explicit theorist, he need not necessarily be so.

[38] *Origine*, pp. 67-70. Alberti describes the meeting, which took place on 26 June, as the fifteenth, thus omitting Volterra's lecture on 1 May.

[39] Mr. Anthony Blunt draws attention to Zuccaro's monopoly, for all practical purposes, of the proceedings. I cannot however agree with his interpretation of this fact when he says (*Artistic Theory in Italy*, 1940, p. 139): ". . . no one but Federico Zuccaro seems to have been allowed to speak;" it will be clear from the context that I should prefer to substitute *wanted* for *been allowed*.

[40] For example, there are passages which accord a high status to history painting, and which refer to decorum and the rendering of the *affetti*.

students.[41] It was evident that there was considerable apathy and lack of enthusiasm and that Zuccaro could only count on the positive support of a few in furthering his scheme. This turned out to be the last formal meeting before Zuccaro's farewell appearance in the office of *Principe* during October,[42] and Alberti takes the opportunity to insert some general reflections on the sad decline of the Academy, making it abundantly clear that even during his presidency Zuccaro had a struggle to keep matters going, and that they deteriorated with great rapidity after he had been superseded.[43] At the meeting in October 1594, at which Zuccaro handed over the reins to Tommaso Laureti, there was much polite praise of the retiring *Principe* (who had a last opportunity to reiterate his theories), but Alberti concludes his account: ". . . e con questo si diede fine, e rese le gratie, si finì l'Academia, *& ogni buono studio.*"[44]

[41] *Origine*, p. 70 (sixteenth meeting, 3 July): "Dovevano discorrere gli Scultori, secondo l'ordine dato, ma vedendo il Sig. Principe, che poca voglia n'havevano, in cambio de' discorsi propose, che quelli tali, che havevano à ragionare, operassero alcuna cosa nell'Academia, à utilità de' giovani, e gusto proprio, e però proponessero quel che più loro piacesse di fare, ma accortosi finalmente, che poca voglia havevano gli Scultori, e meno gl'Architetti, fuor che uno, ò due di loro, di discorrere, ne di operare . . ."

[42] Romano Alberti's heading to his account of this meeting is as follows (*Origine*, p. 72): "Decima settima, & ultima Academia, la penultima Domenica d'Ottobre del 1594."

[43] *Origine*, pp. 70 f.: "Hebbe il Sig. Principe delle difficoltà ad accordare tanti cervelli, e variati humori, e tenerli insieme uniti; peroche alcuni spesse volte sono più pronti al disfare, & impedire, che all'aiutare, & operare, massime quelli che fine d'honor non hanno, tuttavia superando molte difficultà con gl'essempi, & operationi proprie, à viva forza d'essortazioni, & d'essempij, rincaminò di nuovo gli studij, e l'Academia, sino ch'egli tenne il governo, e molto sollecitamente, e con molto zelo, e frequenza; di sorte, che se havessero poi continuato, e fatto ciascuno il dover suo, se [for *si*] incaminava veramente uno studio molto utile, & un'Academia molto honorata, dove vi concorrevano continovamente, & accrescevano di molti nobili spiriti, anche fuora di professione, Gentil'huomini, Litterati, e Signori. Ma la tepidezza di molti, e la poca unione fu cagione, che la lasciassero poi cadere affatto, & in breve tempo il già incominciato essercitio, colpa di quelli che successero doppo il Zucchari; il quale mentre che fù in offitio, sustentò li studij gagliardamente con la frequenza, e diligenza sua, e con li buoni ordini, & ottimi modi . . ."

[44] *Origine*, p. 77. The word "Academia" is here used to denote a formal

Romano Alberti gives us short accounts of the ensuing five years, but, apart from a certain amount of energy expended on the revision of the rules, little seems to have been done: certainly there was no interest whatever in discussions on art theory. We may let the secretary speak for himself:[45]

"Anno secondo del 1595.

Il secondo Anno, fù retta e gouernata l'Academia da M. Tomaso Lauretti Siciliano nuouo Principe, ma ò fosse le sue occupationi, ò altri accidenti, spirò l'Anno, ne fece cosa alcuna sustantieuole per lo studio d'essa Academia, che alcuni pochi ragionamenti di Mattematica, di nulla, ò poca sustanza alli studij nostri: di maniera che da gli Academici, e studiosi no[n] parendo loro, che si essercitasse cosa di gusto, ne di susta[n]za, tralascia[n]dosi li buo[ni] ordini, e indirizzi lasciati dal S. Zucchari, à instruire i giouani, & inanimargli con le dette conferenze così vtili, e necessarie, l'Academia fù quasi abbandonata di maniera che poco, ò niente si faceua, e nel fine dell'anno si propose mutar ordini, e statuti, e nome al Principe, & altri officiali, onde ne nacquero risse, e dispareri fastidiosi; cotal fine hebbe il secondo Anno.

Anno terzo del 1596.

Fu eletto successore alla Academia M. Giovanni de Vecchi dal Borgo San Sepolchro, Pittore valent'huomo, il quale diede speranza nel suo principio ritornar in piede l'Academia, & suoi buoni studij; ma però occupato anch'egli lasciò spirar

meeting (cf. also note 42 of this Part). The words given in italics are deliberately omitted by Missirini (*Memorie*, 1823, p. 63). In this connexion a word of warning may be given on the use Missirini makes of Romano Alberti's *Origine, et Progresso*. It is not always clear from Missirini's text whether a particular passage is a quotation from Alberti, or an addition by Missirini himself. Missirini does not of course reprint anything approaching the whole of the *Origine*, and the general effect of his omissions (whether unintentional or not) is to soften the impression of failure which we get from our real source, the *Origine* itself. In short, it is necessary to turn to the latter for a reliable picture of those early days in the Accademia, and to look upon Missirini with cautious reserve.

[45] *Origine*, pp. 77-79.

l'Anno senza far cosa alcuna, saluo di far diligenza à sestare
li nuoui ordini, e statuti della Compagnia de i Pittori . . . e
vi si consumò tutto l'altr'anno seguente, e l'altro appresso.

Anno quarto del 1597.

Fu eletto suo successore nell'Academia M. Cesare Nebbia
d'Oruieto Pittore, e Poeta parimente valent'huomo, dal
quale si speraua pur vedere rimettere in piedi li studij del-
l'Academia, come haurebbe fatto, se hauesse hauuto miglior
commodità; ma occupato anch'egli passò l'Anno, e non si
fece niente, di sorte, che li buoni, & vtili studij incaminati
dal S. Zucchari bene presto mancarono. . . .

Anno quinto del 1598.

Fu eletto per successore M. Durante dal Borgo, e quello
che si farà nell'Academia si notarà qui sotto.

Domenica prima di Genaro.

Il detto M. Durante capo[46] dell'Academia, che così volsero
i Superiori, che si nom[in]asse, condusse nell'Academia per
prima sua tornata vn' Reuer. Padre della Compagnia del
Giesu, à fare vn'essortatione à tutti li fratelli Academici ad
essere auertiti al dipingere cose honeste, e laudabili, e fuggire
ogni lasciuia, e dishonestà, e sopra ciò prese soggetto di
leggere vna lettera in materia d'vna Cleopatra, vista già
figurata poco honestamente, in reprensione della quale pose
molte ragioni, & auertimenti, che furono cosa assai gustosa;
onde diede speranza di far qualche cosa, ma in resolutione
questo fù quanto egli fece, e spirò l'anno senza far mai altra
cosa di momento.

Anno sesto seguente del 1599.

Fu eletto per successore à M. Durante à reggere, e gouernar
l'Academia M. Flaminio Vacca Scultore; Ma ne anco al suo
tempo, per essere stato impedito delle proprie occupationi,
fù fatta cosa degna di memoria, che se bene si fecero quel-
l'Anno alcuni semplici discorsi, per Scultori, hebbero poco

[46] Apparently the title of *Principe* had now been definitely superseded for
the time being; Alberti records a proposal to change it in 1595.

applauso, e poco, ò nessun concorso così di quelli della professione, come anco d'altri."

There Romano Alberti's account ends, but he gives us an interesting summary of the meagre results of the theoretical experiment in his dedication of the *Origine* to Cardinal Federico Borromeo:[47]

"... ho fatto nota di quanto è successo tornata per tornata, nel tempo che gouernò il Sig. Zuccari, nel qual tempo andò molto ben ordinata, e con molto concorso, mercè li suoi buon' ordini, e buoni, & vtili ragionamenti, e discorsi, oue concorreuano con molta prontezza molti Signori, e Gentil' huomini fuori ancora della professione per il gusto, e piacere, che si cauaua di tali ragionamenti per l'vniuersale, e particolare di esse professioni. Dapoi lasciato il Sig. Zuccari l'offitio e carico al suo tempo à gl'altri suoi successori, mi dispiace sin'a l'anima non poter dire che sia seguita come doueua in continouare li buoni, & ottimi ordini dal prefato Sig. Zuccari lasciati, poiche gli altri, ò per occupationi proprie, ò per genij contrarij hanno à poco à poco dismesso l'vso buono di

[47] That Zuccaro also realized that the *ragionamenti* were not an established success "per mancamenti humani" is evident from a passage at the beginning of *L'Idea* (1607, Book I, p. 1), in which he says that the theoretical propositions which he put forward during his presidency would have been most useful to the *Studiosi* "se fosse seguitata quell'Academia, come si conveniva." In fact, I am inclined to believe that the *raison d'être* of the publication of the *Origine* is to be found in the desire that an experiment which collapsed in practice should survive in print. Zuccaro was clearly the prime mover in the matter of publication, as appears from a passage in *Il Passaggio per Italia* (pp. 10 f.), where he says: "... in questo tempo [1604] feci ancora ad instanza del Signor Cardinale [Borromeo] stampare in Pavia il mio Libro, dell'Academia . . . di Roma." Another interesting passage in *L'Idea* (Bk. I, pp. 2 f.) is that in which he observes that previous writers have met with little success in dealing with art theory: " .. per non havere quella speculatione ch'è necessaria à trattar di questo soggetto: & questo pur troppo si scoperse ne i discorsi fatti nell'Academia di Roma." The other point of view is given by Giovanni Baglione (born early in the seventies, died 1644; *Principe* of the Accademia in 1618 and on other occasions), who, though in no way antagonistic to Zuccaro, twice characterizes his theoretical writings as *bizzerrie* (*Vite*, 1642, pp. 124 f.).

essa, e fatto mancar l'animo à molti, di maniera che si può
dire annichilata del tutto, con non poco mancamento, e
danno di tutta la professione, poiche questa Academia era
vno studio singolarissimo, e di molto honore, e gloria alla
professione come di molta vtilità à giouani studiosi; ma che
marauiglia? poiche le cose buone hanno per l'ordinario
contradittioni grandissime."

Such is the gist of the evidence which survives as to the role
played by theoretical matters during the first few years of the
Academy's history. We get the impression that Zuccaro was a
flash in the pan, the exception among his fellow-members, who
were somewhat perplexed by his abstract æsthetics, and seem
to have sickened of theory for some time after the dose he gave
them. His conception was primarily philosophical and specu-
lative in character, and above all seemed to have no very direct
or close relation to the practical job of painting. It was this
unfeasibility of application in practice which rendered his
theories quite unsuitable for adoption as the doctrine or pro-
gramme of an academy of working artists.[48] All the evidence
tends to show that they were not so adopted, and indeed that
the Academy as a body had no pronounced theoretical views
of any kind. In view of these findings we may conclude that it
is highly improbable that there existed anything in the nature
of a clique of academicians who, during Caravaggio's lifetime,
functioned as a coherent and articulate opposition to him and
his new naturalistic style; this conclusion is naturally subject to
the discovery of further contemporary evidence (in the strictest
sense of the term), though the onus of producing it seems clearly
on the shoulders of any advocates of the contrary opinion.

* * *

We must not of course be taken to exclude the possibility that
Zuccaro himself as an individual showed no enthusiasm for

[48] Another case in which a literary conception (though of quite a different
type) was made by misinterpretation to masquerade as an artistic doctrine
or programme is that of the so-called "eclectic" sonnet in praise of Niccolò
dell' Abate, for which see Part IV below.

Caravaggio and *Caravaggismo*. Certainly they can have had little in common as men:[49] the one driving about Rome in a dignified manner in his carriage and pair, the other not infrequently in the hands of the police for offences ranging from physical violence to carrying a sword without a licence. We cannot imagine that Caravaggio's disreputable way of life was any recommendation to one so concerned as Zuccaro with establishing the dignity and status of the profession; and it is not unreasonable to suppose that such considerations may have become involved in the latter's estimate of Caravaggio as an artist. As far as I am aware the only more or less genuine evidence which we possess on the subject of Zuccaro's opinion of Caravaggio's work is that recorded by Baglione, who, we must bear in mind, can hardly have been favourably disposed to Caravaggio on personal grounds.[50] The story is that Baglione was present when Zuccaro paid a visit to San Luigi dei Francesi, and heard him make a comment on the *Calling of S. Matthew*: "What's all the excitement about? There's nothing so very novel here. Why, it's no advance on the sort of thing Giorgione did!" If this rather conjectural interpretation is correct,[51]

[49] Attention has already been drawn to this contrast by Dr. Werner Körte (*Der Palazzo Zuccari in Rom*, 1935, p. 46).

[50] Cf. Baglione's lawsuit against Caravaggio in 1603 (A. Bertolotti, *Artisti Lombardi a Roma*, Milan, 1881, II, pp. 51-64).

[51] Let me hasten to acknowledge that it certainly is an extremely free translation of the remark recorded by Baglione (*Vite*, 1642, p. 137: "Che rumore è questo? Io non ci vedo altro, che il pensiero di Giorgione"). I should guess that it gives the substance of what Zuccaro meant, but the precise meaning of *il pensiero di Giorgione* in this context must probably remain debatable: by substituting "what Giorgione did" for "the style of Giorgione" or "a reminiscence of Giorgione" (Cutter), the idea is conveyed, I think correctly, that Zuccaro was struck by what he felt to be the identity of method and aim (in the sense of preoccupation with nature, cf. the following footnote) between Caravaggio and the Venetians, and not primarily by an impression of concrete Venetian influence. I must emphatically disagree with Dr. Körte's view (*Der Palazzo Zuccari*, p. 46) that *pensiero* refers to some specific work of Giorgione ("Er hat also ein bestimmtes Giorgione-Vorbild im Auge"); Baglione's sentence is very badly put together, but I am convinced that the words which follow the name Giorgione ("nella tavola del Santo, quando Christo il chiamò all'Apostolato") refer to Caravaggio's picture and not to a supposed Giorgione.

Zuccaro's reaction was that, while mere haphazard imitation
of nature was well enough in its way, art could progress beyond
this to greater subtleties.[52] The impression of the encounter
which remained in Baglione's mind after many decades had
passed was probably to the effect that Zuccaro had seemed to
feel that the picture was simple and unsophisticated, which for
him meant anything but advanced. Professional jealousy apart,
it can at any rate be surmised that Zuccaro just did not under-
stand Caravaggio and consequently did not rate him high: I
do not believe there is very much more in it than that. As
regards Zuccaro's general attitude towards the imitation of
nature, I have the impression that he had relatively mild views
on the subject, along the lines of "something more is required,"
and that the positively anti-naturalistic opinions usually attri-
buted to him do not fit very comfortably into the picture. His
poem *Il Lamento*[53] provides some evidence as to this. I feel fairly
confident that Zuccaro's scathing criticism of Tintoretto (who

[52] The Venetians of the first half of the Cinquecento, for whom Giorgione
stood as a sort of generic designation, had usually passed in Roman-Tuscan
eyes for somewhat unsophisticated imitators of nature. We cannot enter
fully into this matter here, but we may refer to a characteristic passage
towards the beginning of Vasari's life of Titian (*Vite*, Florence, 1568, II,
p. 806; ed. Milanesi, VII, p. 427) where Giorgione figures as a haphazard
imitator of nature in the sense of painting directly from her (that is, without
the more considered composition which the intervention of drawings would
permit). It is in this sort of context that Zuccaro (who of course possessed
a copy of the 1568 edition) may have seen an affinity between "Giorgione"
and Caravaggio, whose habit of dispensing with drawings was sufficiently
well known to be recorded by Van Mander in the Netherlands as early as
1604 (cf. *Roma*, IX, 1931, p. 203). For a Carracci *postilla* on this same
page 806 of the 1568 edition of Vasari, cf. note 7 of Part IV. An association
between "naturalism" and "colour" was of course felt during the Cinque-
cento and Seicento, and was doubtless strengthened by the use of such
expressions as *colorire dal naturale* (cf. also note 107 of Part I). Then there
was the obvious contrast which was felt between Venetian *colore* and Roman-
Tuscan *disegno* in a general sense (e.g., cf. Raffaello Borghini, *Il Riposo*,
Florence, 1584, p. 564: ". . . si può dire che questi pittori Vinitiani grandis-
simo studio pongano nella vaghezza de' colori, molto piu che non fanno
nell'eccellenza del disegno'').
[53] *Il Lamento della Pittura su l'onde Venete* published at the end of Zuccaro's
Lettera a Prencipi, et Signori Amatori del Dissegno (Mantua, 1605); unpaginated.

seems to have more claim than Caravaggio to the title of Zuccaro's *bête noire*) is, in some part at any rate, bound up with the liberties which the great Venetian Mannerist took with "Nature," especially towards the end of his career;[54] we must not stress this, however, for Zuccaro's "nature" was very probably in some degree interchangeable with relatively sober

[54] In *Il Lamento*, addressing the artist in general, Zuccaro urges "imiti ben con l'arte la Natura," and proceeds:

> "Non faccia come quel che un Paradiso,
> Pinse presso quest'acque sì confuso,
> Che men l'intende, chi più il mira fiso.
> Ei fece i cittadini di là suso,
> Come la plebe posta in un mercato;
> Onde meritamente egli è deluso."

His criticism of Tintoretto, whom he makes responsible for the downfall of painting, runs as follows (*La Pittura* is speaking):—

> "Cadei, misera me, per un Tentore,
> Che di far cose grandi mi diè segno,
> Mentre de gli anni suoi era nel fiore.
>
>
> ma poi di bizaria
> Mi pose sottosopra tutto il regno.
> O che capriccio, ò che gran frenesia,
> O che furor; ma quel che mi sà peggio,
> È ch'altri lo seguir ne la pazzia."

Finally, here is Zuccaro's diagnosis of the sad state of painting:

> "Ohime, ch'estinte son gratia, e decoro,
> D'imitar la Natura non vi è segno,
> Nè il Salce si distingue da l'Alloro.
> Arte senz'arte, Ingegno senz'ingegno
> Pasce l'occhio, e contenta l'ignoranza
> Di bei colori, senz' alcun dissegno."

(For a possible connexion between Agucchi and the above, cf. notes 92 of Part II and 21 of Appendix 1.) When Zuccaro criticizes definitions of painting which more or less centre round the imitation of nature (e.g., Romano Alberti, *Origine*, p. 24) we must bear in mind that he is speaking as a philosopher rather than as a painter. Such definitions are clumsy and inadequate, *di poco concetto*, he is saying; a philosopher like himself can go much deeper and produce something much more subtle. This does not mean that as a practising artist he would urge a pupil to pay little attention to nature. Indeed one of the students' mottoes which he presented to the Academy on vacating the presidency runs (*Origine*, p. 74):

> "Chi imita ben il vero
> E al fin maestro intiero."

treatment and disposition (*disegno*) in the Raphaelesque tradition.

At this juncture it may be desirable to say a few words about a batch of five letters which were published for the first time by Stefano Ticozzi in 1822;[55] they purport to be written by Zuccaro, and in one of them Caravaggio is strongly condemned, with references to *stravaganza* and *novità*. For long they were regarded as authentic, and the passage relating to Caravaggio was taken to be first-hand evidence of Zuccaro's opinion of him. Attention was first drawn to the fact that they are falsifications by Professor Longhi, who gave brief but perfectly adequate reasons for his opinion.[56] My excuse for going over the same ground once again is that Longhi's remarks on the subject evidently escaped the notice of Dr. Körte, in whose important work on the Palazzo Zuccari they all unfortunately reappear as genuine.[57] The "compiler," whether Ticozzi or not, is completely at sea from the chronological point of view, and any systematic investigation of the contents of the letters reveals that they are quite valueless as a source.[58] Zuccaro's

[55] *Raccolta di Lettere sulla Pittura . . . pubblicata da M. Gio. Bottari e continuata fino ai nostri giorni da Stefano Ticozzi*, VII, Milan, 1822, pp. 509-520.

[56] *Pinacotheca*, I, 1928-29, pp. 30 and 320.

[57] Werner Körte, *Der Palazzo Zuccari in Rom*, 1935, p. 78; it may be pointed out that the Accademia degli *Innocenti* at Parma referred to on that page is a slip for *Innominati*.

[58] The "compiler" would have done the job more convincingly if a copy had been accessible to him of Zuccaro's fairly full account in his *Il Passaggio per Italia, con la Dimora di Parma* (Bologna, 1608) of how he spent the years 1603-1608. The letters all purport to have been written when Zuccaro was at work in the Collegio Borromeo at Pavia, which we know from the *Passaggio* to have taken place in the year 1604. The "compiler" was obviously not aware of this; he cautiously gives no definite years, but in the first letter he commits himself to "15 . . ." (sic). He apparently had the eighties or nineties of the Cinquecento in mind, but even if this had turned out to be correct some chronological inconsistencies would have emerged. Nor can several points in the letters be easily reconciled with what we know of Zuccaro's movements from the *Passaggio*. As far as concerns the passage relating to Caravaggio we are surprised to learn in the same letter that "i Campi" are still in vigorous activity (*op. cit.*, VII, p. 515, and cf. also p. 513), whereas by 1604 they were certainly *hors de combat*. Perhaps the most ridiculous discrepancy of all is in a letter for which the "compiler"

personal views, we may conclude, can quite possibly have been unsympathetic to Caravaggio and his work, though there is no evidence of any stronger antagonism between them.[59] But in any case we must always remember that Zuccaro's influence in the Academy was in no sense comparable to that enjoyed later in the Académie Royale by Lebrun, backed by Colbert. Nor does the fact that Baglione was a member of the Academy entitle us to assume that he was necessarily expressing the views of that body as a whole when he has a derogatory word for his old enemy Caravaggio.

Naturally such an uncompromisingly unorthodox personality as that of Caravaggio was bound to encounter opposition. But at the beginning, during his lifetime, this appears to have had a very varied basis, ranging from ecclesiastical prejudices to personal quarrels,[60] without that organized cohesion which such a term as Miss Cutter's "academic officialdom" would seem to imply. Indeed I am inclined to think that it is all too easy, as regards this very early period, to exaggerate the "opposition" which Caravaggio is often said to have encountered in specifically *artistic* circles. His importance in the eyes of his artistic contemporaries is attested, for example, by Van Mander,[61] and

selects Lodovico Carracci as an interesting recipient (*op. cit.*, VII, pp. 516 ff.) ; here "Zuccaro" is made to report a recent meeting with "certo Armenini, assai garbato giovane ed assai curioso dell'arte nostra." However, this connexion between the three is altogether too good to be true: the "compiler's" desire to be interesting has caused him to throw caution to the winds. How can Armenini, who in his *De' veri precetti* (1586, p. 65) describes himself as living in Rome as an art student in 1556, turn up at Pavia in 1604 as a young man? He was certainly at least 60, probably more!

[59] In the lawsuit of 1603 (just after Zuccaro had left Rome for good) it appears that Caravaggio regarded him as a considerable artist and had been on speaking terms with him (Bertolotti, *Artisti Lombardi*, II, pp. 58 f.).

[60] I agree with the view (expressed, e.g., by Longhi) that anyone who got too close to Caravaggio's manner was in danger of getting into his bad books. I doubt if he regarded imitation as a compliment: more likely as a theft! The stories of his quarrelsome disposition had already reached Van Mander in the Netherlands by 1604 (cf. *Roma*, IX, 1931, p. 203).

[61] Cf. *Roma*, IX, 1931, pp. 202 f. For evidence that he was regarded as an artist of importance outside the profession, cf. the description of him recorded in note 47 of Part I.

we may also observe that, apart from Rubens' enthusiasm, the *Death of the Virgin* was "tenuto per opera buona" by Pietro Facchetti,[62] who was a member of the Accademia di San Luca, and was one of those billed to speak in the list which Romano Alberti made out in March 1594.[63] Finally, judging by the general tenor of Agucchi's complaints, it might be deduced that a fairly wide-spread consensus of opinion rated Caravaggio higher than Annibale Carracci; this is to be dated towards the end of the two artists' lives. The *scoperta* of the Galleria Farnese may very well have inaugurated a general movement favourable to Annibale, and it was probably during the second decade of the century that his reputation and that of his living scholars began to catch up on that of the *Caravaggeschi*. By 1621, when Mancini wrote (and he does not strike us as prejudiced), the *Carracceschi* appear to have drawn somewhat ahead in the general estimation. What tipped the balance for Guercino in arriving in Rome at that very moment was, we may suppose, the fact that an enthusiastic and able partisan of the *Carracceschi* occupied a most influential position at the Papal Court.

*　　　　*　　　　*

It is Agucchi, and not the Accademia di San Luca, who is the *fons et origo* of the reasoned classic-idealist criticism directed against Caravaggio and consequently against strongly accentuated naturalistic tendencies in general. As we have seen, certain anti-Caravaggesque implications which we find in Bellori appear to be ultimately traceable back to Agucchi: the character of such passages is not primarily that of direct criticism, but rather of unfavourable contrast with another trend of Seicento art, the classic, or, as we would call it, the classic baroque. The *milieu* in which opinions of this kind originally passed muster may be described as that of the *letterati* with strong antiquarian interests, who found they could

[62] Ch. Ruelens, *Correspondance de Rubens*, I, Antwerp, 1887, p. 362.

[63] Romano Alberti, *Origine, et Progresso*, 1604, p. 55; Facchetti did not however get as far as actually speaking!

provide an impressive justification of their taste for a particular style, with Caravaggio as a sort of convenient negative background to set off the supposed virtues of their favourites. It was of course to be expected that they should prefer a style with a learned antiquarian flavour, and the natural corollary to that preference was an undervaluation of types of art (such as those of Caravaggio and the young Guercino) which did not possess it.[64] It was only in the second half of the century, in the time of Bellori (and, in France, of Lebrun and Colbert), that the reasoned theories originating as an interpretation, from the

[64] It is only fair to point out that Agucchi and Bellori were probably not as insensitive to Caravaggio as a bald exposition of their theoretical standpoint would seem to indicate. Agucchi describes Caravaggio as "eccellentissimo nel colorire"; and Bellori, though he is never quite able to forget the absence of such classic virtues as *nobiltà* and *grazia*, and characteristically prefers the "prima maniera dolce, e pura di colorire" to the later dark manner (*Vite*, 1672, p. 214), shows in certain incidental comments that he really had some perception of Caravaggio's real calibre. These are admissions of the truth which insisted on coming to the surface, in spite of the obligation to adhere to the strict "party line," the supremacy of Raphael and the antique. Bellori's admiration for Raphael was such that he took the trouble to deny at some length the possibility that the sight of Michelangelo's work had had a beneficial effect on his hero (G. P. Bellori, *Descrizzione delle Imagini dipinte da Rafaelle d'Urbino nelle Camere del Palazzo Apostolico Vaticano*, Rome, 1695, pp. 86-93). Though Bellori was never as biased as Malvasia in the matter of *campanilismo*, we note with some amusement that the painter Lodovico David (who, being a great enthusiast for Correggio, intended to write a book on him) was under the impression that Bellori, whom he consulted about the project in Rome *circa* 1686, was anxious to dissuade and even hinder him as much as possible: ". . . appena scoperto da essi [i.e., Bellori and other Roman writers or painters] il mio disegno d'esaltare il Correggio come merita sul soglio d'Apelle dubitando che pregiudicassi alle supreme pretensioni della scuola di Roma [i.e., the tradition of Raphael], tentarono tutte l'emulazioni e strade possibili per precipitarmi" (G. Campori, *Lettere Artistiche*, Modena, 1866, p. 521). However, David was prejudiced in the other direction, and seems to have had a feud with the Accademia (cf. Missirini, *Memorie*, p. 154), so perhaps we should not attach too much importance to his views. Even so, there can be little doubt that Bellori did have to pay some of the price of adherence to a rigid preconceived doctrine: the impairment of a balanced and tolerant judgment on merit in individual cases which did not readily fit in with it. Thus a fellow-worshipper of Raphael and the antique, though mediocre, was liable to higher rating than a better painter who followed unorthodox gods.

point of view of the *letterati*, of classic types of art, found a
sounding-board within the academic institution and made
plausible (perhaps more in theory than in practice) that rough
equation[65] "academic=classic" to which we referred above.
Zuccaro did undoubtedly make an important bequest to sub-
sequent academies: the association of the academic dignity
with educational activities. But the basic principles which were
to meet with the most general measure of acquiescence in the
art theory current in later academies did not, and indeed could
not, derive from Zuccaro's abstract *a priori* metaphysics, a
speculative philosophy far removed from any clear application
in practice. Very much more appropriate for an art academy
was a constructive idealism firmly rooted in empirical experi-
ence: a theoretical standpoint which, while having sufficient
show of subtlety to be acceptable to the learned, was neverthe-
less relatively real and understandable to the average working
artist. It was precisely this combination which the *letterati* and
dilettanti with antiquarian rather than philosophical interests
were in a position to supply.

We may take the membership of the Accademia di San Luca
of Bellori,[66] above all a scholarly antiquarian, to symbolize the
definite infiltration of these theories into the academic organiza-

[65] Certainly no such equation was yet valid in the Roman Academy during
the presidency of Pietro da Cortona (1634-38), when the Classic point of
view, represented by Sacchi (and probably Poussin) seems to have been on
the defensive as against that of the Full Baroque (cf. Missirini, *Memorie*,
p. 111 ff.).

[66] Jean Arnaud, whose work is not a model of historical accuracy, says
that "Pierre Bellori" figures in a list of members dated 1633 (*L'Académie de
Saint-Luc à Rome*, Rome, 1886, p. 35). This is rather early for Bellori, who
was probably about 18 years old at that time, and moreover Salvator Rosa
is also said to appear in it, which would be open to doubt if the character
and date of the document were precisely as stated by Arnaud ("une liste
authentique des membres qui composaient l'Académie en 1633"). Possibly
it was a register in which members entered their names, and which was in
use over a period of years; someone may have dated an entry 1633. Among
other names quoted is that of Guercino, who very likely signed on in 1621-
1623; but perhaps his name remained on the books afterwards in spite of the
fact that he was living at Cento. For the life of Bellori, cf. Mr. Kenneth
Donahue's article cited in note 143 of Part II.

tion for which (if the limitations of rational planning in art are conveniently skated over) they were not ill suited. Some events in Bellori's career may serve to illustrate this process. In 1664 he delivers his theoretical discourse on the *Idea* to the Accademia, during the presidency of his friend Carlo Maratti.[67] He is appointed secretary of the Accademia for the year 1671 and re-introduces discussions on theory.[68] In 1672 he dedicates his *Vite*, at the instigation of Charles Errard,[69] to Colbert, who since 1662 had dominated (in alliance with Lebrun) the comparatively recently founded Académie Royale at Paris, and in 1666 had entrusted Errard with the establishing in Rome of what was virtually a branch of that institution.[70] With the rise of the Parisian Académie Royale to primacy among the artistic institutions of Europe, the connexions between it and the Accademia di San Luca become closer. Errard himself was

[67] Bellori, *Vite*, 1672, p. 1. Elsewhere we have an estimate of Maratti by Bellori, and a report on his views, which are obviously identical with Bellori's own. We quote two typical passages, which sum up their joint position admirably: "Seguitò egli sempre il suo primo intento di eleggere, ed imitare la bella Natura con la scorta degl'ottimi Maestri così dell'antica, come dell'età moderna, i quali conducono per diretti sentieri, ed insegnano a noi il non errare, al qual fine più d'ogn'altro servì la Guida di Raffaele . . .;" ". . . l'elezione del Naturale, che non deve mai tralasciarsi da chi non vuoi uscir da termini d'essa Natura, e lasciarsi alla prattica" (Giovan Pietro Bellori, *Vite di Guido Reni, Andrea Sacchi e Carlo Maratti*, ed. Michelangelo Piacentini, Rome, 1942, pp. 114 f.). Cf. note 102 of Part II.

[68] This was during the presidency of Giuseppe Maria Morandi (Missirini, *Memorie*, p. 130); in 1675 Bellori was again concerned with theory in the Accademia (cf. note 87 of this Part).

[69] Cf. the end of Bellori's dedicatory epistle. The review of the *Vite* in *Le Journal des Sçavans* (1676, XX, 7 December) says: "Nous devons la publication de ce Livre aux soins de M. Errard, Directeur de l'Académie de Peinture & de Sculpture que le Roi a établie à Rome." Errard must have been acquainted with Bellori at an early date, since he made copies in his youth of some of Annibale Carracci's drawings in Angeloni's collection (cf. Vincenzo Vittoria, third letter in *Osservazioni sopra il libro della Felsina Pittrice*, Rome, 1703, p. 54).

[70] *Procès-verbaux de l'Académie Royale de Peinture et de Sculpture*, I, Paris, 1875, pp. 300 f. Cf. also A. de Montaiglon, *Correspondance des Directeurs de l'Académie de France à Rome*, I, Paris, 1887, and Henry Lapauze, *Histoire de l'Académie de France à Rome*, I, Paris, 1924.

elected *Principe* in the year 1672,[71] to be followed in 1676 and 1677 by Lebrun, with Errard as his acting deputy in Rome.[72] Almost immediately the question of a nominal amalgamation of the two Academies was mooted and agreed upon.[73] At the meeting of the Accademia in November 1677, at the end of Lebrun's term of office, the prizes munificently donated by Louis XIV were distributed, and Bellori was called upon to perform the oratorical honours. A copy of his effusive speech, culminating in the praise of Louis, Lebrun, and Colbert,[74] was duly sent to the Académie Royale by Errard, translated into French, and read with the approval of all present.[75] In 1678 Errard, after deputizing for Lebrun for the previous two years, was re-elected *Principe* in his own right.[76] As we have seen, Bellori himself was honoured by the Académie Royale in 1689, being granted the title of *Conseiller-Amateur*.[77]

These indications of the increasingly important role which

[71] Missirini, *Memorie*, pp. 130 f.; and cf. Montaiglon, *Correspondance*, I, p. 42.

[72] Missirini, *Memorie*, pp. 135 ff. (the date of Lebrun's letter on p. 136 is of course a misprint for 1676; cf. Arnaud, *L'Académie de Saint-Luc*, p. 43); *Procès-verbaux, cit.*, II, Paris, 1878, p. 68.

[73] Missirini, *Memorie*, pp. 137-142; Arnaud, *L'Académie de Saint-Luc*, pp. 45-51; *Procès-verbaux, cit.*, II, pp. 68, 77 f., 89 f., 95, and 102; *Archives de l'Art Français*, I, 1851-52, pp. 60-69; Montaiglon, *Correspondance*, I, pp. 59 ff.

[74] Bellori's speech was (rather surprisingly!) published on pp. 105-112 of his *Descrizzione delle Imagini dipinte da Rafaelle d'Urbino nelle Camere del Palazzo Apostolico Vaticano*, Rome, 1695. It bears the title: *Gli onori della Pittura, e Scoltura. Discorso di Giovan Pietro Bellori detto nell'Accademia Romana di San Luca la seconda Domenica di Novembre MDCLXXVIj. Nel concorso de' premij de' Giovani Pittori, Scultori, ed Architetti. Essendo Principe dell'Accademia il Signor Carlo Bruno.* There is no theory in the speech, which deals mainly with the esteem in which painting and sculpture were held during the course of history from antiquity to—Louis XIV. Cf. also *Le Nouveau Mercure Galant, contenant tout ce qui c'est passé de curieux au Mois de Avril de l'Année 1678* (Paris, 1678, pp. 45 ff.), in which it appears that it was Bellori who selected the subjects to be painted for the competition.

[75] *Procès-verbaux, cit.*, II, p. 131; *Nouvelles Archives de l'Art Français*, 1878, p. 283.

[76] Missirini, *Memorie*, pp. 142 f.

[77] Cf. note 145 of Part II. In 1674 Bellori received, through Errard, a gold chain from Louis XIV in acknowledgment of a dedication (Montaiglon, *Correspondance*, I, 1887, p. 50).

France played in the development of the academic institution provide us with an opportunity to emphasize some specifically French contributions which should not be projected back into the Accademia of Zuccaro's day any more than the classic-idealist theories of a Bellori or a Dufresnoy. With the alliance between Colbert and Lebrun, the state grasped the helm in matters of art.[78] The Académie was housed in Royal buildings, the Louvre and the Palais-Royal: hardly comparable to Zuccaro's barn (*fienile*)! The members received a dignified status and monopolistic privileges from the government, which offered an assured career to the artist of average talent; Bellori refers with admiration (and envy?) to the royal bounty of "quattro mila lire per ciascun anno, da doversi impiegare al pagamento delle provisioni de' Professori."[79] But in return for the security which its largesse provided the state was of course in a position to call the tune; what Colbert required was an efficient organization of the arts, centrally controlled almost in the fashion of a civil service. Accordingly something approaching a dictatorship in art was set up, as was very soon realized at the time.[80] The contrast between this formidable affair and the easy-going ways of Zuccaro's *Accademia* is obvious. We may take as a typical example the character and history of the

[78] For an excellent survey of the early history of the Académie Royale, cf. N. Pevsner, *Academies of Art*, 1940, pp. 85 ff.

[79] Extract from Bellori's speech of 1677 published at the end of his *Descrizzione delle Imagini dipinte da Rafaelle*, 1695, p. 112.

[80] For example, see the entry for 9 August 1665 in Chantelou's diary kept during Bernini's stay in France: "Lefebvre de Venise y est venu qui m'a conté plusieurs artifices dont il dit que Le Brun se sert pour se donner du crédit et l'ôter aux autres, et qu'il établit une espèce de tyrannie dans la peinture au moyen de la confiance que M. Colbert a en lui qui, au lieu de produire d'habiles gens par l'établissement de l'Académie, ne fera que des ignorants, n'y ayant aucune autre académie qui tienne l'Académie royale en émulation" (*Gazette des Beaux-Arts*, 1878, pt. 1, p. 351). Rolland Lefebvre had suddenly resigned from the Académie Royale during the previous March, shortly after his election (cf. *Procès-verbaux, cit.*, I, pp. 279 f.). Here is Colbert on discipline in the Académie de France à Rome (letter of 17 July 1671 to Charles Errard, who was in charge): ". . . mon intention est que vous ayez une autorité entière et absolue . . ." (Montaiglon, *Correspondance*, I, p. 32).

Conférences as compared with their (merely nominal) predecessors during Zuccaro's short-lived attempt to establish lectures on theory. In the Académie Royale the atmosphere is essentially practical. A specific picture is brought out for detailed analysis, the underlying assumption being that it is possible by rational methods to arrive at the fundamentals of artistic excellence, and thus to establish definite rules or *préceptes*;[81] if the principles of *la raison* and *l'ordre* are applied to art she will be compelled to relinquish her secrets.[82] The average member of the Académie Royale in Lebrun's day evidently did not relish the delivery of these discourses on theoretical matters much more than Zuccaro's colleagues had done. But (and here was the difference!) unfortunately for the Académiciens the omnipotent Colbert regarded the lectures as an important part of the system ("pour le bien du royaume," as he might have put it). He was in a position to insist on the continuation of the practice, and did so.[83] All that can be said of the result is that its lack of success was of a different order to that of Zuccaro. Both attempts have features of merit and interest, but neither achieved their ultimate object, which was the production of works of art of higher quality.

The Accademia di San Luca of Bellori's day, in spite of its relations with Paris, never had anything approaching the authoritarian atmosphere of the Académie Royale, nor could it altogether swallow that accentuation of the rational which was so characteristic in the theory of the latter. The Accademia received in 1681 a copy of Félibien's publication of the seven *Conférences* held in 1667,[84] and had a discussion on them. We are amused to see that (apart from a patriotic objection to over-praise of Poussin) they were criticized by G. M. Morandi

[81] This objective was not merely more or less implicit in the whole procedure, but was explicitly stated by Lebrun in 1670 (*Procès-verbaux, cit.*, I, p. 346).

[82] The unity of the individual work of art and the genius of the individual artist were thus largely discounted and overlooked.

[83] *Procès-verbaux, cit.*, I, pp. 342 f.; cf. also II, pp. 44 and 63.

[84] *Conférences de l'Académie Royale de Peinture et de Sculpture, pendant l'année 1667*, Paris, 1669.

(under whose presidency Bellori had been secretary in 1671) on the score that they had omitted to refer to "una parte dell'arte, ch'è forse la più bella, cioè la grazia," which was held to be an *undefinable* quality appealing to the heart rather than to the intellect.[85] Sentiments less palatable to the Académie Royale can scarcely be imagined.[86]

We may sum up by saying that though the academic name may remain constant, Academies and their influence differ widely at different periods and places, and so do the theories which from time to time find a home within them. It is true that as regards Caravaggio and naturalism the well disciplined Académie Royale during Lebrun's ascendancy would probably have agreed with the Bellori-Maratti group in the contemporary Accademia di San Luca,[87] whatever their differences on other points. We cannot perhaps be sure that the theories of this group would have been generally subscribed to by the Accademia as a whole, but their standpoint with regard to "mere" naturalism did at any rate meet with a measure of agreement.[88] The question is, however, complicated by the

[85] Cf. Missirini, *Memorie*, p. 145: "E dacchè il core non ha norme fisse come l'intelletto, quindi la grazia non s'impara, ma si sente, e traesi dalla natura: che ella è un non so che, che piace, incanta, e seduce, e l'anima a celeste giocondità dispone." Bellori was present on this occasion.

[86] Misapplied faith in the intellect and *bon sens* can occasionally border on *hubris*, so we learn without regret that the rather frigid writ (from the æsthetic point of view) of Descartes and Boileau did not run unchallenged among artists in Rome.

[87] Carlo Cesio, the painter and engraver, was probably a member of this group. During his presidency in 1675, immediately before Lebrun's election, Bellori had opportunities for speaking in the Accademia and stressing the importance of theoretical discussion and instruction (Missirini, *Memorie*, p. 132). Nearly two decades earlier Cesio's engraved plates of the Galleria Farnese, having been acquired by François Collignon, had been published by Vitale Mascardi with descriptive letterpress by Bellori (*Argomento della Galeria Farnese dipinta da Annibale Carracci disegnata & intagliata da Carlo Cesio*, Rome, 1657); the text is reprinted by Malvasia, *Felsina*, 1678, I, pp. 437-442. Some passages in Pascoli's life of Cesio seem to confirm that he was theoretically minded (Lione Pascoli, *Vite*, II, 1736, p. 175).

[88] In 1666 the then Principe, Carlo Maratti, received a manuscript from Luigi Scaramuccia which was published subsequently (Missirini, *Memorie*,

fact that the classic-idealist theory which criticized Caravaggio was also in opposition to the more extreme baroque tendencies of its own day; in this capacity it was probably in a minority,[89] though its adversaries were more concerned with the brush than with reasoned argument by means of the spoken or written word. Furthermore (as we shall have occasion to see later) theory and practice cannot necessarily be assumed to coincide;[90] lip-service did not necessarily entail an obedient brush. When all these cross-currents are borne in mind it may perhaps be

p. 121; the summary in Missirini should not be taken literally). Scaramuccia's opinions are on the whole classic. He concludes with a series of maxims (Luigi Scaramuccia, *Le Finezze de' Pennelli Italiani*, Pavia, 1674, pp. 190-210) among which occur the following (p. 200): "Rare volte, o mai sono Ideali quei Pittori, i quali del tutto stanno aviticchiati al naturale, segno certissimo, che non hanno fatto l'habito, ne studiato di proposito il bello della Natura, e l'Opere de gran Maestri;" and he describes *Ideale* as "epitetto per certo de più nobili, che dar si possano à veri Pittori." Later on he says (*Finezze*, p. 207): "Poche volte riescono ben'intese le cose, che si tengono avanti quall'hor si Dipinge." In the body of the text (*Finezze*, p. 76) there is a related passage on Caravaggio: ". . . è stato quest' Huomo un gran Soggetto, mà non Ideale, che vuol dire non saper far cosa alcuna senza il naturale avanti." In 1673 G. B. Passeri was chosen to speak in the Accademia (Missirini, *Memorie*, p. 131); as we have had occasion to note in connexion with his opinions on Guercino and Bamboccio, Passeri is an "idealist," though without such pronounced views on the subject as Bellori.

[89] Cf. notes 102 of Part II, and 2 and 3 of Part IV.

[90] Salvator Rosa is a good example of discrepancy between theory and practice in the Seicento. Who would suspect from his use of the brush (in a way so obviously suited to his temperament) that in theoretical matters he was an advocate of "erudition" among painters, that he himself aspired to fame as a monumental painter, and that he considered decorum a matter of some importance? Rosa appears to have had a low opinion of Caravaggio on the score that "non ha hauto nobiltà ed era puoco costumato nell'istoriare" (G. A. Cesareo, *Poesie e Lettere . . . di Salvator Rosa*, Naples, 1892, I, p. 113). As a report of Rosa's opinion this may very well be accurate, even though we may not feel too confident about the ultimate authorship of some of the individual *postille* supposed to have been added by Bellori to Baglione's *Vite* (from which the remark quoted by Cesareo is taken); the differentiation, in the annotated copies of Baglione, between *postille* in which Bellori expresses his own opinions, *postille* in which he simply copies material from others, and *postille* which there is reason to believe are not properly attributable to him at all, is an exceedingly difficult problem with which Dr. Jacob Hess will deal in his forthcoming critical edition of Baglione.

conceded that the use of the adjective "academic" in connexion with theoretical matters confuses rather than clarifies the issues unless its precise connotation is made abundantly clear.[91]

[91] For an instance of the loose and consequently misleading use of the adjective "academic" in connexion with the Carracci, cf. note 86 of Part IV.

PART IV

THE CONSTRUCTION OF A LEGEND:
THE ORIGINS OF THE CLASSIC AND ECLECTIC
MISINTERPRETATIONS OF THE CARRACCI

"Veramente questo è un Sonetto che ogni studente di pittura dovrebbe imparare a memoria e valersene."
(Giampietro Zanotti, 1674-1765.)

"Considered as a didactic and descriptive poem, no lover of art, who has ever read it, will cease to repeat it till he has got it by heart."
(Isaac d'Israeli, 1823.)

WE have sought to show that Agucchi's theoretical views, carrying particular though momentary weight on account of his close relationship to Papal patronage, happened to play a part in Guercino's change of style: an instance of theory influencing practice. We have seen in Part II that the essential core of the classic-idealist theory of which Agucchi was an adherent had an extraordinary vitality; it took first rank within its own field, *as a theory*. We might accordingly be inclined to assume that its influence would be widely reflected in practice. But we pointed out in Part III that, while the theory (or its implications) certainly obtained an airing in the leading Academies of Art, with their increasing concern with art education, it did so relatively late in the Seicento; and even then we did not feel much confidence in describing it as an "academic" theory, a designation which might be taken to carry the inference that the majority of Academicians subscribed to it unreservedly. What then is the precise character of the relationship between the classic-idealist theory and actual works of art?

If we were to take Zuccaro's case as a model we should have to say that the connexion between theory and practice was very indirect. For not only did his views have no sequel in their own field, but their effect on art itself, whether through the Academy or the printed word, appears to have amounted to nothing at all. In actual fact we have to turn to a much earlier period to find their most plausible parallel in paint. For they seem to express in words, not the relatively sober type of late Mannerism which Zuccaro himself affected when he formulated them, but the same kind of mysticism which his predecessors were expressing with the brush during the earlier phases of the style many years previously: in some sense they are a literary reflection of an artistic moment which was already past history. This was of course perfectly natural: during these primitive stages of its growth, art theory tends more often than not to lag a generation

or two behind the most up-to-date developments in art proper.[1]

There can be no question, however, that the relationship between the classic-idealist theories and the art with which they were concerned was a good deal closer. But which was the senior partner? In the present writer's view it is possible to exaggerate the direct influence of the theories on practice, even though their very considerable literary success is taken into account. On the whole the position they occupy is passive rather than active, a fixed pole which attracted or repelled, or could simply be ignored. Even when they assumed their most rational form and were in substance accepted by an institution (the Académie Royale) which had more power to put them into effect than any previous group of artists, we find no very clear evidence of them in paint: still less is this the case with the Accademia di San Luca. Becoming merged into the general body of European artistic teaching, they contributed much to the ground-swell beneath the surface—the "grand manner" and so forth: but they never seem to have been the driving force behind any important artistic movement. The reason for this was probably that they were basically retrospective in character, which in turn is attributable to the fact that the artists whose style more or less corresponded with them were relatively few in number[2] (for after all the painterly or baroque was the

[1] The contrast between Vasari's Mannerist paintings and the character of his writings, much more in sympathy with the Renaissance, is the most obvious example of this. It appears to the writer that there is a similar, if slighter, time lag between the theoretical atmosphere of the Académie Royale of round about 1670 (which sometimes gives one the impression of being rather a soulless post-mortem on Poussin), and the actual painting of its members, who in practice do not fight so shy of adulterating the pure springs of classicism with the alcohol of the baroque (it is a question of the less heady vintages, of course!).

[2] The principal representatives of the style in Seicento Italy were Annibale Carracci (late period), Domenichino (especially during an early phase), Reni (especially late period), Albani, Duquesnoy, Algardi, the mature Poussin, Sassoferrato, and (I suppose we must add) Guercino in his late period. Sacchi's primary allegiance is to the classic tradition, and he is usually described as classic, but perhaps he is better characterized as the least obviously baroque of the leading painters of his time in Rome (with

principal artistic language of the Seicento), and accordingly they are in a sense defensive. They should be looked upon in the light of a propagandist polemic on behalf of a minority preserving the legitimist descent:[3] an interpretation of art, therefore, rather than an active principle animating it.

How faithful was the interpretation? Preoccupation with the past was a fundamental feature of the standpoint of an Agucchi or a Bellori, and it resulted in a one-sided view of Seicento classic art, which, though favourable on a short term basis, proved most injurious in the end. At first sight Agucchi seems to provide us with an exception to the more normal time lag between art and theory; he appears to be a progressive in tune with an active contemporary movement in art. This does not however betoken quite so much originality as we might suppose on the face of it. Though, to do him justice, Agucchi did appreciate the strong naturalistic trend in Annibale Carracci's outlook, what really stirred his enthusiasm in favour of the Galleria Farnese was the presence in this particular example of modern art of elements which struck a note both familiar and sophisticated: the traditional note of classicism. Accordingly he hastened to launch an estimate the validity of which has only been questioned in comparatively recent times: this featured Annibale quite simply in the role of a postscript to Raphael and the antique, and (here was the favourable twist, or rather what passed for it) the restorer of painting.[4] Annibale almost

the exception of Poussin). Sacchi's pupil Maratti is, I suppose, the most classic Roman painter of the next generation, but even more than his master he reveals strong baroque (painterly) tendencies. In both cases what we know of their orthodox classic opinions is somewhat belied by their actual works; in this there is a certain similarity with the situation in the Académie Royale referred to in the previous note.

[3] Typical of this attitude in Bellori is the passage in which he traces Maratti's "master and pupil ancestry" through Sacchi and Albani to the Carracci; the passage following, including the attack on those who belittled Raphael, has that defensive character to which we have alluded (Giovan Pietro Bellori, *Vite di Guido Reni, Andrea Sacchi e Carlo Maratti*, ed. Michelangelo Piacentini, Rome, 1942, pp. 115 f.).

[4] Equally ill-considered distortions in the unfavourable sense have been all too common since early in the last century.

certainly regarded this sort of portrait of himself as ridiculous, and might very well have indulged in some cynical remarks about it and its manufacturers: still, it represented a generally understood, indeed almost a conventional method of praise, and its growth and repetition was hardly likely to be retarded by Annibale's cryptic sarcasms. His well-meaning admirers had their way, but their ill-judged propaganda succeeded in doing the object of their admiration a considerable disservice in the long run. By arbitrarily abstracting certain features from the complex whole of his make-up and constantly focusing disproportionate attention on them, their view of Annibale brought into being the habit of interpreting such a work as the Galleria Farnese in relation to phases of previous and subsequent art which were analogous to it in one respect alone (that of classicism), while ignoring its powerful roots in its own time.[5]

This retrospective explanation redounded to the credit of Annibale as long as the plausibility of the classic-idealist theory held good (and indeed it did so for a considerable period); but as soon as its limitations began to be perceived the rather romantic survivor of a glorious past was transformed into a prosaic reactionary out of touch with his progressive contemporaries. Both pictures are false because they tend to overemphasize the classic tradition in a semi-archæological sense and at the expense of all the other elements. We do not deny that there is a strong classic flavour about the Galleria Farnese and the late work of Annibale as a whole: indeed our contention is that this is so evident that the critic who has drawn attention to it is far too inclined to rest on his laurels, supposing that there is little more to be said. Yet in taking this view he is merely treading dutifully in the footsteps of Agucchi and Bellori, the only difference being in the qualitative connotation (favourable with them, probably relatively unfavourable with him). The disadvantage of portraying Annibale in this fashion is that it is apt to obscure the fact that, far from being a hanger-on of the

[5] The expression "in its own time" is of course intended to cover the immediate past and the immediate future: what we are advocating is an interpretation in broad cross-section rather than in depth.

past, he was in essence a breaker of new ground, a reformer rather than a restorer. For the Galleria Farnese is not a resuscitation of a dead tongue, but a re-interpretation of the broad elemental formulae of classicism into a living language which is both personal to Annibale and *en rapport* with the period—indeed, prophetic into the bargain; it has the individual inspiration, and yet it has the tang of time and place, sowing the seed for much that is to come during the ensuing century. It is significant, moreover, that in order to see Annibale in this light we have to discard the worthy Bellori's blinkers, and re-admit into our range of vision those same two extremes which they were designed to exclude, or at any rate to minimize: that close union of the real and the imaginative which is the essence of the baroque—*naturalismo e fantasia.*

At the present day it may perhaps require some effort to associate a classic style with both reform and naturalism. Nevertheless the three have gone together on occasion: we have examples in the emergence of the early Renaissance from a Gothic background and in the late eighteenth century trend in opposition to the Rococo.[6] In actual fact the fundamental interest of the Carracci in nature (which indeed ought to be obvious from any study of their work, including drawings, which goes beyond the casual) is adequately attested by contemporary sources;[7] and it should of course be seen in its proper

[6] In some of the earlier works of Jacques Louis David, for example.

[7] Perhaps the most striking evidence as to this is a marginal note by one of the Carracci (probably Agostino) to the 1568 edition of Vasari's *Vite*: "Il Signor Vasari non s'accorge che l'antichi buoni maestri hanno cavate le cose loro dal vivo, e vuol piutosto che sia buon artista dalle seconde cose che sono l'antiche, che da le prime e principalissime, che son le vive, le quale si debbono sempre imitare, ma costui non intese quest'arte." He then adds (referring to Vasari's opinion of Giorgione's method which we mentioned in note 52 of Part III): "Quasi che non si possino porre in più modi differenti su la tavola, e da questa cassarle e rifarle, come su la carta, ma mi manca luogo di provar la coglioneria di quel goffo del Vasari." These interesting *postille* were published by Dr. Bodmer in *Il Vasari, Rivista d'Arte e di Studi Cinquecenteschi* (X, 1939, pp. 89-128); the extracts quoted will be found on pp. 109 f. and the relative passage in the second volume of the 1568 edition of Vasari is on p. 806 (ed. Milanesi, VII, p. 427). If we are correct in supposing that the introduction of Giorgione's name into Zuccaro's

historical context, in direct opposition to the conventions of the
then prevalent Mannerism.[8] Agucchi, as we have noted, was
not blind to this characteristic and its contemporary signifi-
cance; unfortunately, however, he wished to differentiate
Annibale from his fellow reformer Caravaggio, and the most
obvious way in which this could be done was by over-accentua-
tion of what we may call the "archæological raiment" in which
some of Annibale's most important Roman work was dressed.
Bellori not only developed this view and popularized it, but
did the same thing for its corollary, the stressing of Caravaggio's
humble setting. Just as the classic-idealist interpretation of
Annibale caused his naturalistic tendencies to be overlooked, so
the excessive emphasis on the naturalism of Caravaggio con-
duced to the concealment of the latter's sense of structure and
plasticity, with its underlying kinship to the formal principles
of classicism.[9] Superficially, it is easy to perceive the divergences

estimate of Caravaggio would betoken agreement with the view expressed
here by Vasari (cf. notes 51 and 52 of Part III), it is instructive to find
Agostino and Caravaggio together in the same opposition camp. Though
we must guard against attaching too much weight to Lucio Faberio's
rhetoric written for Agostino's funeral (cf. notes 86, 88, and 91 of Part II),
he has a striking passage on the attention paid to nature in the Carracci
academy: "Quivi s'attendeva . . . con mirabile frequenza al disegnar persone
vive, ignude in tutto, ò in parte, armi, animali, frutti, & in somma ogni
cosa creata" (Il Funerale d'Agostin Carraccio, Bologna, 1603, p. 33; reprinted
by Malvasia, Felsina, 1678, I, p. 427).

[8] I rather doubt if the fact that the interest of the Carracci in nature
entailed a break with Mannerist traditions necessarily meant that there
was any rivalry in the sense of personal abuse (as is sometimes supposed)
between them and painters of a relatively more Mannerist type such as the
Cavaliere d'Arpino; in this matter I should prefer to rely on Mancini
(cf. note 36 of Part I) rather than on Bellori (Vite, 1672, p. 73), the interest
of whose anecdote lies primarily in Annibale's supposed reaction. I should
guess that Annibale and Agostino may well have found something to admire
in one of the Cavaliere's more lively performances, the vault of the Cappella
Olgiati in Santa Prassede, which was probably completed shortly before
their arrival in Rome.

[9] The Marchese Vincenzo Giustiniani appears to have been an exception
to this tendency to turn the two reformers almost into rivals of each other.
In his well-known letter on painting to Theodor Ameyden (undated, but not
written before the thirties), published by Bottari (Raccolta di Lettere, VI,
Rome, 1768, No. XXIV, pp. 251 f.), we find Caravaggio, Annibale Carracci,

between the two: nevertheless they have much in common if we delve beneath the surface, and not least a fundamental interest in nature, however different an external expression this may find.

It is no accident that it was a North Italian who inaugurated the process of bringing classicism down to earth from the remote fastnesses of Olympus. The spectator's imagination, captured by the many different though intertwined stages of illusive reality cunningly introduced by Annibale into the Galleria Farnese, is brought into much more intimate relationship with the decorative scheme than had previously been possible in Rome. It is almost as if it were a festival in which we ourselves are involved: we half expect to catch one of the terminal figures forgetting his part and winking, or perhaps to receive a barrage of fruit from that impudent, almost Tiepolesque, satyr perched on the right upper corner of Polyphemus' frame. This sort of atmosphere, in which the informal fascination of what are nominally accessories tends to throw the *favole* themselves into the shade, is unmistakably baroque: and the arrangement of the forms from which it emanates, involving what we may call the whittling away of the caesura, is equally so, as several modern writers (declining to swallow the traditional interpretation of undiluted classicism) have already pointed out in some detail. The truth is that the Galleria is in essence a radical metamorphosis of the classic raw materials in accordance with the new painterly outlook of the time: when compared to other forms of classicism it whole-heartedly proclaims its specifically baroque character. If we fail to perceive

and Reni classed together as imitators of natural models, but without being wholly dependent on them. No doubt we ought not to take Giustiniani's rather casual comments too literally, but there may possibly be some significance in the fact that our group is juxtaposed to a more thorough-going naturalist class, who, with the exception of a single Spaniard (Ribera, *Gris* being a misprint for *Gius.*, as Mariette pointed out), consist entirely of Netherlanders (Rubens, Honthorst, Terbrugghen?, Baburen or Rombouts?). In such a context one can understand that Caravaggio (with his firm, relatively sculptural, and thus somewhat generalized, sense of form) might have struck an Italian *dilettante* as not so radically naturalistic after all.

this, saying that we do not find in Annibale the free flow
ultimately attained as long as thirty years later by Pietro da
Cortona is his Barberini ceiling, we are asserting somewhat
cavalierly that the crop must ripen overnight: but it would
hardly be reasonable to expect such a transformation right on
the heels of Mannerism. Nevertheless many of the basic prin-
ciples of the painterly method of expression may already be
found in the Galleria, not yet pushed to their logical conclusions,
it is true, but still recognizably present in embryo for any who
might choose to read Annibale's message in that sense. I feel
confident, for example, that Rubens did so: it must surely be
evident that, allowing for the difference in medium, the lively
seething mass in motion around Silenus (on the right of the
Triumph of Bacchus and Ariadne) has in essentials very much in
common with the language of Rubens, but bears no resemblance
in any *vital* particular either to that of the Roman High Renais-
sance or to that of Mannerism. And we can hardly doubt that
Rubens contrived to see the Galleria during his Italian visit,
since it certainly ranked during his final stay in Rome (1606-08)
as the most important pictorial achievement recently completed
there.[10] Moreover the outstanding importance of the part
played in the whole by those apparent accessories the *ornamenti*
(an essentially baroque feature) was appreciated even by
Bellori and Poussin.

Annibale was without doubt profoundly affected by the

[10] As evidence of Rubens' interest in Annibale we have a splendid drawing
by the great baroque master paraphrasing part of the Galleria Farnese
(published by Dr. J. Q. van Regteren Altena in *The Burlington Magazine*,
LXXVI, Jan.-June 1940, p. 198). Whether or not Rubens' drawing is a
free variation originally derived from the fresco itself or is after some pre-
paratory study (and even though the style may suggest a later date than
1606-08), it brings out the baroque element in Annibale in a remarkable
way. Dr. F. Grossmann has pointed out to me verbally that the decorative
framing of the battle scene in Rubens' sketch of *ca.* 1628-31 (for the Galerie
Henri Quatre) in the Liechtenstein Gallery at Vienna, may, broadly speak-
ing, be derived from the analogous arrangement round the medallions in
the Galleria Farnese (e.g., compare that surrounding the *Rape of Europa*),
though Rubens' conception is naturally much more fully developed in the
baroque direction.

classical atmosphere of Rome, which led him to restrain the painterly impulsiveness of his spirited Bolognese period: yet though he may be justly claimed in his Roman phase as a powerful influence on Seicento classicism, he never surrendered to the classic spirit in the more pedantic sense. Rather is he to be credited with having infused into the antique some of the traditional warmth of the North, so much in tune with the predominant tendencies of the opening century. The fact is that even in his late works Annibale still retains a strong admixture of the baroque, sufficient indeed for him to stand midway between the two extremes: he appears baroque among thorough-going classic artists and *vice versa*,[11] and his position at the source of the two divergent streams is of considerable importance historically. The emphasis on the classic interpretation, inaugurated by Agucchi and developed by Bellori, only gave part of the story, and its frequent repetition and wide acceptance has resulted in a distorted view of Annibale's work. We may sum up by saying that the new movements in art owed both Caravaggio and Annibale a considerable debt: but, though the contribution of Caravaggio to future developments is by now universally acknowledged, that of Annibale (less obvious in any case, but also obscured by the theoretical fantasies which have attached themselves to him with limpet-like persistence) is still liable to be overlooked and underestimated.[12]

*　　　*　　　*

[11] Compared to an earlyish phase in Domenichino's career, Annibale's Roman works seem to fall short of orthodox classicism: the same impression emerges when they are contrasted with the late Poussin. Mr. John Pope-Hennessy, who has made an exhaustive study of Domenichino, tells me that he is inclined to believe that this "frozen" period in the latter's development is at any rate partly attributable to his association with Agucchi at that time.

[12] There is however general agreement in modern times that Annibale Carracci's importance as a landscapist much exceeds what we should be led to suppose from the Bellorian critical tradition. Baglione, it may be noted in passing, did appreciate Annibale's contribution in this respect (*Le Vite de' Pittori*, Rome, 1642, p. 109: ". . . diede luce al bell' operare de' paesi, onde li Fiamminghi videro la strada di ben formarli"), and Mancini mentions his example in connexion with Brill's abandonment of "quello stento fiammengo" (Marciana MS. it. 5571, fol. 88 verso). Annibale's experiments in

The central position occupied by Annibale's late works between the two poles of the classic and the baroque appears to have been understood at the time. Mancini's rationalization would have been along the lines of a union of "la maniera di Raffaello con quella di Lombardia." With this Agucchi would have agreed (he states that the aim of Annibale, after studying classic works of art in Rome, was to unite the "bellezza del colorito Lombardo" with the "disegno finissimo di Roma"), although, as we have seen, he (and, even more, Bellori) attached greater weight to the classic-idealist Roman aspect.[13] Now Annibale's modification of his remarkable early baroque style, typically North Italian, as the result of his contact with the classic tradition of Rome, is the principal *stylistic* basis on which the alleged programme of "the Carracci" must ultimately rest. It really did happen that Annibale, having been uprooted from his original artistic environment, and having settled down in another and markedly different one, bore witness in his style to this change. There is however nothing so unusual about that: indeed it has occurred to countless artists before and since without the intervention of any fancy names being required to explain it.[14] So if we wish to account for the extraordinary perpetuation of the legend of Carraccesque theory we must rather turn to its *literary* origins and history.

a new type of landscape were carried still further by Domenichino, and Poussin and Claude certainly owed some debt to them. The documentary evidence for Annibale's activities in the field of portrait caricature, which he seems to have invented, is referred to in note 43 of Appendix 1.

[13] For Mancini, cf. note 36 of Part I; for Agucchi, cf. pp. 252 and 257 below.

[14] Francesco Albani's remarks in a letter to Bellori (*Vite*, 1672, p. 80) are properly to be read along the same lines as those of Mancini and Agucchi, as an interpretation, a rationalization in words (written by Albani in middle or old age long after the event), of the position taken up by Annibale in his Roman period midway between the painterly and the classic, between North Italian colour and Roman form. Obviously an offhand view of this kind cannot be regarded as trustworthy evidence of the deliberate teaching of a *prima facie* improbable and impracticable "doctrine" many decades before; moreover Albani himself, in a not over-coherent passage published by Malvasia (*Felsina*, 1678, II, p. 251) seems to contradict implications of this kind by criticizing such statements as exaggerated eulogies likely to damage the reputation of the Carracci.

We have already seen that Domenichino, who can hardly be described as ill-informed about the teaching of the Carracci, poured scorn on a specific precept of "selection" which was written by the Mannerist theorist Lomazzo (and which may conceivably have been originally suggested by a passage in Lucian's Εἰκόνες).[15] We did find, however, that such an idea had been associated with the Carracci as early as 1603, but noted that the writer was a *letterato* and that the character of his effusion was a rhetorical oration on the occasion of Agostino's funeral:[16] we pointed out too that the author, Faberio, may very well have regarded as suitable raw material for one of his eulogistic climaxes that same passage in Lomazzo which Domenichino, as a practising artist without literary ambitions,[17] thought so absurd as a precept. It is certain that, once published, Faberio's idea had a great success as a form of somewhat over-exuberant literary eulogy of the Carracci, in the sense of a selection of good qualities.[18] We may draw attention to two Seicento examples out of many. Bernini, travelling back from Saint-Germain with Chantelou on 5 July 1665, and wishing to praise Annibale during the course of a discussion on painting, makes use of this sort of metaphor.[19] Malvasia, in a fulsome passage, tries to underline the virtues of his favourite, Lodovico, by applying such a system to the latter's frescoes in San Michele in Bosco: the effect is somewhat comic.[20] As a matter of fact,

[15] Cf. notes 39 and 40 of Part II.

[16] Cf. note 91 of Part II.

[17] The idea that Domenichino was a sort of *pittore-letterato* is questioned in note 50 of Part II.

[18] The booklet relating to Agostino's funeral was quite well known during the Seicento, and was regarded as an "art book": cf. note 86 of Part II.

[19] Cf. *Gazette des Beaux-Arts*, 1877, Pt. 1, p. 505 (Chantelou's diary). We are surprised to find Andrea Mantegna (!) as an ingredient in the stew; could the publicity he got from Lomazzo have contributed to this?

[20] Malvasia, *Felsina*, 1678, I. pp. 435 f. Cf. also for similar passages. I, pp. 358 and 388 (we must guard against crediting the ebullient Malvasia's reports of eighty-year-old conversations as if they were taken down in shorthand!). The same literary formula, with its supposedly eulogistic connotation, is employed by Malvasia in the case of other artists: for example, Giulio Cesare Procaccini (*Felsina*, 1678, I, p. 289).

however, this general type of *cliché* is not confined to the
Carracci, to the Seicento, or to Italy. Vasari, writing in
1568, says something similar about Raphael;[21] Lebrun, prais-
ing Poussin in the Académie Royale on 5 November 1667, tells
his audience that the national hero has united the good qualities
of Raphael, Titian and Veronese;[22] while as late as 1771 we
find a biographer of Rubens covering the same old ground—
except that he includes Annibale himself in the mixture.[23]
Finally, we must not omit to reiterate that the idea of selection
was in any case a commonplace of theoretical phraseology in
general: a formula of the selection of the best in art would
certainly strike a familiar note in the minds of those who had
accepted that conception of the selection of the best in nature
with which we have been so much concerned.

There is of course some trace of fire behind all this smoke.
Few works of art come into existence without the general
vehicle of expression utilized by the artist (we are not speaking
of quality) being related in some fashion or other, even by way
of opposition, to the stylistic languages of his own and previous
times; such relationship, as Dr. Walter Friedlaender has very
pertinently remarked, is no more and no less in evidence in the
case (for example) of the young Rubens than it is in that of the
Carracci. It is from the obvious fact that the work of one artist
can exhibit the influence of the work of another that this primi-

[21] Giorgio Vasari, *Vite*, Florence, 1568, II, p. 86 (ed. Milanesi, IV,
p. 377): ". . . mescolando col detto modo [i.e., that of Fra Bartolommeo]
alcuni altri scelti delle cose migliori d'altri maestri, fece di molte maniere
una sola . . ." Cf. also 1550 ed., p. 559 (ed. Milanesi, IV, pp. 11 f.).

[22] [André Félibien,] *Conférences de l'Académie Royale de Peinture et de Sculpture,
pendant l'année 1667*, Paris, 1669, p. 78. After enumerating the praiseworthy
qualities of the three Italians, Lebrun adds that he will point out "dans
l'Ouvrage du fameux M. Poussin toutes ces parties rassemblées."

[23] J. F. M. Michel, *Histoire de la Vie de P. P. Rubens*, Brussels, 1771, p. 345.
Michel suggests that the experienced judge will find the following in the
work of Rubens: "le grand coloris du Titien, le clais-obscur, & la distribu-
tion des lumières du Correggio, la noblesse des attitudes de Raphaël Urbino,
les riches vêtements de Paulo Veronese, & la grande composition & vérité
des caractères d'Annibal Carrache." Therefore, he argues, Rubens is the
greatest painter who ever lived!

tive critical fantasy ultimately originates. When we investigate the core of the matter we find that the implicit argument boils down to something in the nature of the following: (1) Artist A's work shows the influences of that of Artists B and C (this is on the whole a relatively reasonable and demonstrable proposition, being a matter of stylistic analysis not primarily concerned with quality); (2) Artists B and C are good (this is a qualitative judgment, and may or may not be agreed upon); (3) therefore Artist A must be still better than Artists B and C (needless to say, this does not follow, and we take objection to the "therefore" and the "must"); (4) consequently the general proposition is arrived at that the more good qualities (this expression is often interchangeable in actual practice with "reminiscences") of the great men of the past are perceived (or thought to be perceived) in the work of one man, the better that work can be argued to be; no further comment is required! The variations of this line of argument and inference are innumerable and vary from extreme crudity to a measure of subtlety. Sooner or later, however, the critical limitations of such pronouncements were bound to become apparent, and, when they did so, the *cliché* quietly disappeared from currency—with one exception. It was in fact only in connexion with the Carracci (later expanded from them to a majority of the Seicentisti) that this aberration of early criticism survived. Why did this occur? Two factors, which we shall now consider, played a vital part in its preservation.

The first factor is the supposition that the Carracci themselves gave credence to a theory of selection, and seriously taught and practised it as a sort of artistic nostrum: even at the present time references can be found to their system, doctrine, programme, and so forth, as if the genuineness of such a phenomenon was a proved historical fact. Now the testing of this is simply a matter of systematic historical research, of stating and weighing up the basic evidence on which the assertion must rest. And in such a task (we need hardly be reminded) we must be careful to differentiate evidence which appears to throw light on the opinions of the Carracci themselves from those

traditional literary rationalizations by now so painfully familiar to us.[24] That is the heart of the problem: what authority is there for stating that the theory of selection was in fact advocated by the actual artists as a positive principle behind their work, and was not merely a rather clumsy attempt by others to interpret that work and even (within contemporary limitations) to praise it?

Having sifted much of the material bearing on this matter, I have come to the conclusion that the main foundation of the whole edifice is the celebrated sonnet in praise of Niccolò dell'Abate first published in 1678 by Malvasia over the name of Agostino Carracci. This poem, which by constant reiteration gradually came to be regarded as a sort of *leitmotiv* for the unfortunate Carracci and their school, runs as follows:[25]

"Sonetto in lode di Nicolò Bolognese.

Chi farsi vn bon pittor cerca, e desia
 Il disegno di Roma habbia alla mano,
 La mossa, coll'ombrar Veneziano,
 E il degno colorir di Lombardia.
Di Michel'Angiol la terribil via,
 Il vero natural di Tiziano,
 Del Coreggio lo stil puro, e sourano,
 E di vn Rafel la giusta simetria.
Del Tibaldi il decoro, e il fondamento,
 Del dotto Primaticcio l'inuentare,
 E vn pò di gratia del Parmigianino.
Ma senza tanti studi, e tanto stento,
 Si ponga solo l'opre ad imitare,
 Che quì lascioci il nostro Nicolino.

Agostino Carracci."

[24] Naturally we must also be careful to retain a reasonable sense of proportion as to what constitutes reliable "contemporary" evidence. Cf. note 20 of this Part.

[25] Malvasia, *Felsina*, 1678, I, p. 159.

Hardly very convincing! And it is a fact that, though some danger exists even now of the repetition in complete innocence of the traditional *cliché* that it represents an æsthetic doctrine,[26] in recent years the majority of the more responsible writers who have dealt explicitly with the sonnet have tended not only to reject the idea that it stands for a programme, but also to regard the verses themselves with well merited suspicion. Consequently the most common, and certainly the most misleading, form in which its influence still survives is that of the casual reference to a doctrine or system without citation of any source for the assertion; but, if those who commit themselves to such statements were pressed for their authority, they would certainly be compelled to rest a substantial part of their case on the sonnet.

It is not easy to believe that Agostino Carracci, an experienced artist with full knowledge of the implications, can have been responsible in all seriousness for such a disproportionate outburst of praise for Niccolò, even though he very probably appreciated—at its true value—the latter's interesting and often delightful work; nor is the hypothesis that the sonnet is to be read as a satire by Agostino against Niccolò devoid of flaws.[27] However, a concoction of this kind could very well have been produced in deadly earnest by a *letterato*, and in my opinion Dr. von Schlosser was near the mark when he wrote:[28] ". . . il preteso sonetto di Agostino Carracci riferito dal Malvasia è sicuramente una falsificazione, in cui sono esposte non le opinioni del mondo artistico, ma quelle dei teorici e dei profani." Professor Roberto Longhi[29] takes us a stage further in the right direction with the following comment: "E chi dice che l'estetica del Malvasia sia quella implicita nelle opere dei

[26] After all, this was more or less taken for granted by Janitschek as late as 1879 (Hubert Janitschek, *Die Malerschule von Bologna*, p. 11; part of Robert Dohme's series *Kunst und Künstler*).

[27] It is difficult to conceive the slightest reason why Agostino should have wanted to raise a laugh at the expense of Niccolò, who left Bologna, after a stay of only about four years, in 1552 (before any of the Carracci were born), and settled in France until his death, *circa* 1571—in which year Agostino celebrated his fourteenth birthday.

[28] Julius Schlosser-Magnino, *La Letteratura Artistica*, 1935, p. 446.

[29] *L'Archiginnasio*, XXX, 1935, p. 126.

Carracci? Tutt'all'opposto, essa è un errato tentativo razional-
istico e meccanistico per chiarire i Carracci, tentativo anzi così
artato da aver dovuto ricorrere alla manipolazione di più di un
falso storico, in primis il famoso sonetto addebitato ad Agostino
(non sono io il primo a denunciarlo); falsi che anche il recente
eversore[30] accoglie però, come di zecca purissima."

I entirely agree with these doubts as to the genuineness of the
sonnet, and would adduce in support of them some cryptic
passages among the haphazard notes which Malvasia made
during a period of many years when collecting material for his
Felsina Pittrice. The only mention of any such poem which I
was able to find among Malvasia's papers was the statement
that a certain Carlo Abbate—an informant of Malvasia's whose
real relationship, if any, to our Niccolò of a century before is
by no means clear—remembered having seen a sonnet written
by Agostino in praise of Niccolò; the sentence in question is
preceded by some notes on the family of Carlo, whose father is
specifically stated to have been a Modenese, also called Nicolo.[31]
The obvious inference is that at the time of jotting down this
note Malvasia believed his informant Carlo (about whose
Modenese origins he clearly had no doubts) to be a member of
the same family as the painter. But when we turn to the *Felsina*
we find that the sonnet (a copy of which, it may be emphasized,
Carlo was not in a position to supply to Malvasia) is actually
introduced in support of the contention that Niccolò dell'Abate

[30] This is a reference to the article by Dott. Ragghianti commented upon
in note 51 of Part II above. Cf. also note 79 of this Part.

[31] The passage as a whole reads as follows (Biblioteca Comunale dell'Archi-
ginnasio, Bologna, MS. B16, fol. 1 verso, among the unsystematic scribblings
headed *Nicolò dell'Abbate*) :

"Il Pre di Carlo Abb.e era Modonese, e si chiamò Nicolo e faceva anch'egli
l'indoratore Carlo Sud.o e fù alliev[o] il d.o Nicolo dal Pre d'un de Rossi
pure Modonese indoratore e lavoratore di stucchi che poi gli diede in con-
sorte la figlia ond[e] il Rossi vivente e Nicolo erano cognati &[c] Carlo
sud.o [sic].

Il sud.o Carlo si raccorda aver veduto, et aver avuto in mano un sonetto
manoscritto in Lode di Nicolo dell'Abb.e fatto da Agostino Carrazzi."

On the recto of the same sheet there is a mention of the date 1667, pro-
viding a *terminus post quem*.

was properly to be regarded as Bolognese; that is to say, the weight of "Agostino's" authority is expressly invoked for (incorrectly) claiming Niccolò for Malvasia's native city.

Now, *campanilismo* was something of an obsession with Malvasia, and, as we have had occasion to observe, he was not above doctoring his sources when local prestige was deemed to be involved;[32] so perhaps we are not altogether surprised to find on the very next page of his notes some material which is quite obviously an *abbozzo* related to the passage claiming Niccolò for Bologna which precedes the sonnet in the *Felsina*[33] —in other words, Malvasia was already preparing to discount the markedly Modenese context in which he had acquired the information that some poem *in lode* by Agostino had once existed. Manipulations of this sort are not exactly an encouragement to accept his statement as to the authorship of the sonnet as he prints it—a statement which moreover plays a leading part in the campanilistic passage in which he is engaged. My own belief is that the attribution of these verses to Agostino is without real foundation, and that (whether or not Malvasia has "adapted" them from the work of some earlier *letterato*) he himself should be held substantially responsible for their present form. Nevertheless they are, it must be reiterated, the principal basis for the ascription of the theory of selection to the Carracci themselves. As a matter of fact we actually have some evidence

[32] Cf. note 38 of Part I above for Malvasia's subtle misuse of a passage from the first short version of Mancini's *Trattato*, which, being in manuscript, was inaccessible to the great majority of his readers. Mancini, in dealing with the various groups of contemporary painters, happened to begin with that of the Carracci, which he accordingly describes as *la prima*; it suited Malvasia's purposes to ignore the original context (which made it clear that no particular qualitative connotation was intended), and, by associating the expression with other eulogies of the Carracci, to convey the idea that Mancini had praised their school as the first, in the sense of the best, of modern times.

[33] In the *Felsina Pittrice* (1678, I, p. 158) Malvasia mentions the rival claims for Puccio Capanna of Florence and Assisi (Ascesi). On fol. 2 recto of MS. B16 there is a note on this subject beginning "Cosi contrastarono anticam.te frà loro i Fiorentini e que' d'Asc[esi] volendo ciascuno d'essi che Puccio Capanna fosse loro Cittadino."

as to the real opinions of the Carracci on art. If we want a less dubious starting point than a highly suspect poem, we should begin with the *postille*, probably by Agostino, to the 1568 edition of Vasari;[34] partisans of the old *cliché* will not find much comfort in them!

The authenticity of the sonnet as the work of Agostino remained unquestioned, as far as I am aware, for well over two centuries, with the result that the æsthetic opinions which it was supposed to express were transposed from the status of a conventional interpretation of already existing work to that of an authoritative doctrine preceding the taking up of the brush. When similar interpretative methods fell into disuse because their inadequacy had become clear, their particular application in connexion with the Carracci survived just because of that same transposition, and moreover the well deserved criticisms to which the so-called doctrine was subjected began, understandably but unjustifiably, to transfer themselves to the paintings of its reputed authors. This process was greatly facilitated (and the legend itself much strengthened) by a second factor, which we shall now proceed to discuss.

* * *

There are few methods of avoiding mental exertion which appeal more to the human brain than to dispose of a complicated issue by the use of one word, just as there are few more successful ways of concealing the fallacy in an argument than by contriving to embody it in an impressive slogan which lends itself readily to parrot-like repetition. It may seem almost like *lèse-majesté* to charge that distinguished eighteenth century figure the archæologist Johann Winckelmann with anything so vulgar as the propagation of a catchword. Yet that is our indictment, for it is to him that we owe the adoption into the terminology of our studies (in all innocence of its consequences, no doubt) of

[34] Enrico Bodmer, "Le note marginali di Agostino Carracci nell'Edizione del Vasari del 1568," in *Il Vasari, Rivista d'Arte e di Studi Cinquecenteschi*, X, 1939, pp. 89-128; we observe, incidentally, that there is not a single *postilla* referring to Niccolò dell'Abate. For a quotation, cf. note 7 of this Part.

that veritable masterpiece of concise meaninglessness the expression "eclectic"; and moreover in adopting it Winckelmann associates it with the Càrracci. The first reference in print (in which he simply attaches the novel designation to the traditional *cliché* about the Carracci) seems to have been in a small work published in 1763.[35] The fact that Winckelmann's employment of the term originated from his study of ancient art is made clear in his *magnum opus* on that subject published during the following year.[36] In that famous and influential work he conceives classical art as progressing stage by stage from rise to fall, and places in the penultimate stage the style of the imitators (*der Nachahmer*).[37] After drawing a parallel between the eclectic philosophers and the late classical artists (*Nachahmer*),[38] he goes on to see a similarity between this cycle of antiquity and that of "recent" art, with the Carracci playing the part of the "modern" *Nachahmer*.[39] Winckelmann's standards of quality

[35] Johann Winckelmann, *Abhandlung von der Faehigkeit der Empfindung des Schoenen in der Kunst*, Dresden, 1763, p. 26: "Beynahe funfzig Jahre nach dem Raphael fieng die Schule der Caracci an zu bluehen . . . Diese waren Eclectici, und suchten die Reinheit der Alten und des Raphaels, das Wissen des Michael Angelo, mit dem Reichthume und dem Ueberflusse der Venetianischen Schule, sonderlich des Paolo, und mit der Froehlichkeit des Lombardischen Pinsels im Correggio, zu vereinigen."

[36] Johann Winckelmann, *Geschichte der Kunst des Alterthums*, Dresden, 1764. Several translations into French and Italian appeared during the ensuing forty years.

[37] *Geschichte*, 1764, pp. 213 f.; the reference for the composite posthumous editions is Book VIII, Ch. I, § 4.

[38] *Geschichte*, 1764, p. 235 (composite eds., Bk. VIII, Ch. III, § 2): "Es wird auch der Kunst, wie der Weltweisheit, ergangen seyn, dass, so wie hier, also auch unter den Kuenstlern Eclectici oder Sammler aufstunden, die, aus Mangel eigener Kraefte, das einzelne Schoene aus Vielen in eins zu vereinigen sucheten. Aber so wie die Eclectici nur als Copisten von Weltweisen besonderer Schulen anzusehen sind, und wenig oder nichts urspruengliches hervorgebracht haben, so war auch in der Kunst, wenn man eben den Weg nahm, nicht ganzes, eigenes und uebereinstimmendes zu erwarten; und wie durch Auszuege aus grossen Schriften der Alten, diese verloren giengen, so werden durch die Werke der Sammler in der Kunst, die grossen urspruenglichen Werke vernachlaessiget worden seyn."

[39] *Geschichte*, 1764, p. 248 (composite eds., Bk. VIII, Ch. III, § 18): "Das Schicksal der Kunst ueberhaupt in neuern Zeiten ist, in Absicht der Perioden, dem in Alterthume gleich. . . . Der Stil war trocken und steif bis

in art were closely related to the degree in which the method of expression employed by the artist approximated to or deviated from the more purely classic as defined in the Wölfflinian sense. He therefore accepts the interpretation of Annibale as the heir of High Renaissance classicism[40] (this is an inheritance from Bellori), but does not consider him to be altogether successful in that role; we may guess that he regarded as impurities what we would now describe as the baroque characteristics in Annibale's work.[41] Thus we find brought together in Winckelmann several features of what was to be in future the routine estimate of the Carracci. To the label of conservative classicism was added the new and derogatory one of decadent imitation; and to their supposed selective theory was added a new, convenient, and erudite-sounding watchword, which, backed by the enormous prestige of the famous archæologist, won rapid acceptance, and was frequently repeated, particularly by German writers.[42]

The next important step in consolidating the foundations of

auf Michael Angelo und Raphael; auf diesen beyden Maennern bestehet die Hoehe der Kunst in ihrer Wiederherstellung: nach einem Zwischenraume, in welchem der ueble Geschmack regierte, kam der Stil der Nachahmer; dieses waren die Caracci und ihre Schule, mit deren Folge; und diese Periode gehet bis auf Carl Maratta."

[40] Cf. Johann Winckelmann, *Anmerkungen ueber die Geschichte der Kunst des Alterthums*, Dresden, 1767, p. 64 (composite eds., Bk. VIII, Ch. III, § 28): "Im Annibal Caracci wurde dieser Geist [i.e., that of the High Renaissance] nach langer Zeit von neuen erwecket . . ."

[41] Winckelmann characteristically omits Bernini (that leading propagator of the dreadful heresies of the baroque!) from a list of the principal sculptors of "recent" times: "Sie [i.e., die Bildhauerey] bluehete in Michael Angelo und Sansovina [sic], und endigte mit ihnen; Algardi, Fiamingo [i.e., Duquesnoy] und Rusconi kamen ueber hundert Jahre nachher" (*Geschichte*, 1764, p. 248; composite eds., Bk. VIII, Ch. III, § 18).

[42] As a comparatively early instance we may refer to Ramdohr's widely read account of works of art in Rome (Friedrich Wilhelm Basilius von Ramdohr, *Ueber Mahlerei und Bildhauerarbeit in Rom*, Leipzig, 1787, I, p. 13: "Die Carracci waren unter den Mahlern, was die Eclectiker unter den Philosophen. Sie suchten die Vorzuege der verschiedenen Schulen, alle diejenigen Vollkommenheiten in sich zu vereinigen, die man vielleicht nur in dem Ideale des Mahlers vereinigt denken kann").

the fable was carried out unconsciously by the Abate Lanzi, who in his celebrated *Storia Pittorica*[43] (which was soon translated into three other languages[44]) places the sonnet squarely in the middle of his account (written along the usual lines) of the alleged methods of the Carracci,[45] a very different matter to its introduction by Malvasia in an out-of-the-way place in connexion with Niccolò dell'Abate. Henry Fuseli, R.A. (born Johann Heinrich Füssli of Zürich) makes great play with the verses in the second of his three lectures delivered in 1801 at the Royal Academy in London. Fuseli (who was equally at home in Italian and French as in his native German or his adopted English) could very well have come across them in the *Felsina* itself, with which he was certainly familiar; but perhaps it is more likely that his attention was drawn to them by James Barry's quotation in a pamphlet which caused a considerable stir at the time and led to Barry's expulsion from the Academy. The context in which Barry introduced the sonnet was that of a plea for a permanent collection attached to the Academy; he hoped that some system or plan of art instruction in England would be facilitated by such a move, and we regret to have to

[43] Luigi Lanzi, *Storia Pittorica della Italia*, Bassano, 1795-96. The original first volume (*Italia inferiore* only) was published at Florence in 1792. It was re-issued at Bassano in 1795-96, when the second volume (divided into two parts with separate pagination) was added, thus completing the work. I can find no evidence for the existence of an edition sometimes alleged in bibliographies to have been published at Bassano in 1789.

[44] French, 1824; English, 1828; German, 1830-33.

[45] *Storia Pittorica*, 1795-96, II, Parte Seconda, p. 78. Lanzi prefaces his quotation of the sonnet as follows: "E il bizzarro Agostino emulando gli antichi legislatori, che il corpo delle lor leggi chiudevano in pochi versi, compose quel sonetto, pittoresco veramente più che poetico, che avendo per oggetto l'elogio di Niccolino Abati, spiega nonpertanto la massima della sua scuola di corre il più bel fior di ogni stile. Eccolo quale il Malvasia ce lo ha tramandato nella vita del Primaticcio." Lanzi then quotes the sonnet; his version, apart from variants in spelling, substitutes *brama* for *cerca* in line 1, and *vera* for *giusta* in line 8. Whenever this version is quoted, therefore, we are justified in supposing that the writer concerned was more familiar with the sonnet in its Lanzi context than in its original Malvasia context, which is, as we have seen, a matter of importance; for an example of this, cf. note 79 of this Part.

record that he spoke highly of the poem in that connexion.[46] It was Fuseli, Barry's successor as Professor of Painting at the Academy, who appears to have been the first to wax sarcastic about the absurdity of the sonnet as a practical programme, and, though he may possibly have been influenced by the opportunity afforded of taking an oblique tilt at Barry, it must be admitted that he was in any event on sensible ground in attacking it as such. Now, Fuseli was familiar with the writings of Winckelmann (he had translated one of them into English in 1765) and seems to have been responsible for introducing Winckelmann's expression "eclectic" into English, in direct connexion, moreover, with the supposed theory of the Carracci as set out in the sonnet.[47] He is careful to differentiate between the fatuity of the "doctrine" itself and the quality of the works of its reputed devotees.[48] Nevertheless Fuseli's general tone was decidedly critical by contrast with the traditional view, though perhaps more in relation to their followers than to the Carracci

[46] James Barry, R.A., *A Letter to the Dilettanti Society*, London, 1798, p. 25: ". . . the manly plan of art pursued by the Carraches, and their school at Bologna, in uniting the perfections of all the other schools, of which there remains a masterly, elegant record, in a beautiful little poem of Agostino" [which he quotes in Italian].

[47] Henry Fuseli, *Lectures on Painting, delivered at the Royal Academy, March 1801*, London, 1801, pp. 80 ff. (second lecture), where Fuseli refers to the foundation at Bologna of "that ecclectic school which by selecting the beauties, correcting the faults, supplying the defects and avoiding the extremes of the different styles, attempted to form a perfect system. But as the mechanic part was their only object, they did not perceive that the projected union was incompatible with the leading principle of each master. Let us hear this plan from Agostino Carracci himself, as it is laid down in his sonnet [quoted in Italian in a footnote] on the ingredients required to form a perfect painter, if that may be called a sonnet, which has more the air of a medical prescription." After translating it, he comments: "Who ever imagined that a multitude of dissimilar threads could compose a uniform texture, that dissemination of spots would make masses, or a little of many things produce a legitimate whole? Indiscriminate imitation must end in the extinction of character, and that in mediocrity—the cypher of art."

[48] Fuseli, *Lectures*, 1801, p. 82: ". . . separate the precept from the practice, the artist from the teacher; and the Carracci are in possession of my submissive homage."

themselves;[49] and we have evidence that his remarks were in fact read in this critical sense not so long after.[50] Before leaving Fuseli we may point out that the accessibility of his first three lectures was not restricted to those who could read English.[51] So far, we have been concerned with the existence of critical material which was readily available for use in a sense derogatory to the Carracci: but some extra impulse was required to transform a more or less passive accumulation of material into a positive standpoint unfavourable to them. This was soon forthcoming.

During the course of the eighteenth century there had been signs of awakening interest in the works of the "primitives," by which is meant in our context works produced before the High Renaissance. This revision of taste had assumed formidable dimensions by the end of the century and it was natural (though not logical) that the fascination of the discovery of a new artistic language should ultimately entail a revulsion against that which had held the field for so long. As we are concerned with the loss of esteem which later art tended to suffer by contrast with the enthusiasm which the primitives evoked, and not with the actual rediscovery of the latter (a vast subject outside our terms

[49] Fuseli, *Lectures*, 1801, p. 84: "The heterogeneous principle of the ecclectic school soon operated its own dissolution . . ." We need hardly say that from now onwards Guercino (who never met Annibale and Agostino, and whose acquaintance with Lodovico cannot have amounted to much more than a visit of courtesy at the end of the latter's life) is duly enrolled in "the eclectic school." Not only that, but (as a consequence of supposed Caravaggesque influence) he even achieved the unenviable distinction of being dubbed a "double eclectic"—whatever such a verbal gymnastic may mean!

[50] Isaac d'Israeli, *A second series of Curiosities of Literature*, London, 1823, I, p. 44: "The curious reader of taste may refer to Mr. Fuseli's Second Lecture for a *diatribe* against what he calls 'the Eclectic School . . .'" Incidentally, this passage seems to confirm the novelty in English at this time of the expression "eclectic" as applied to the Carracci.

[51] A German translation as *Vorlesungen über die Malerei* was published at Brunswick in 1803; an Italian translation as *Discorsi tre sulla Pittura* was published at Rome in 1804; and I believe there was a French translation, of which I have not however succeeded in tracing particulars.

of reference), perhaps a single example may suffice to characterize the new atmosphere. In 1823 Friedrich von Schlegel published the notes on painting which he had made on a visit in 1802-04 to Paris (then full of Napoleonic loot), the Low Countries, and the Lower Rhine.[52] His allegiance to the "old style" is manifest from the start: he prefers a few figures with firm distinct outlines and clear colours to a confused heap of human beings half concealed by effects of chiaroscuro.[53] He launches the idea, so wide-spread during the nineteenth century, that "art" ended with the High Renaissance, and makes some deprecatory remarks about "the learned imitators and eclectic painters of the school of the Carracci."[54] Here we find yet another misleading ingredient added to the potentially unfavourable portrait previously sketched out by Winckelmann: the false idea that "the Carracci" were learned, which of course led to the inference that they were pedantically theory-ridden.[55] To lay down a sweeping *a priori* qualitative veto against all art after the High Renaissance was of course as unsound as the reversed opinion previously current, and was bound to lead to some curious misjudgments: we are amused, for example, to find the opposed baroque and classic trends of the Seicento (represented by Rubens and Reni) receiving an equal share of

[52] *Gemäldebeschreibungen aus Paris und den Niederlanden in den Jahren 1802-1804,* in Friedrich Schlegel, *Sämmtliche Werke,* VI, Vienna, 1823.

[53] Cf. the passage beginning "Ich habe vorzüglich nur Sinn für den alten Styl in der christlichen Mahlerey; nur diese verstehe ich und begreife ich . . ." in F. Schlegel, *Werke,* VI, 1823, pp. 8-10.

[54] F. Schlegel, *Werke,* VI, 1823, p. 75: "Mit den genannten Mahlern, mit Julio Romano, Titian und Corregio geht die grosse Kunstepoche der erfinderischen Genies zu Ende; die gelehrten Nachahmer und eklektischen Mahler aus der Schule der Carraccis und der andern gleichzeitigen, sind den gelehrten Arbeiten der alexandrinischen Dichter zu vergleichen, welche in ähnlicher Art die alte Poesie mit Nachbildungen und Blumenlesen beschliessen."

[55] There may be some measure of truth in this as regards the voluble Agostino, who was certainly the most cultured of the trio, but was also the least important artistically: it is however really going too far to bestow the laurels of learning on the taciturn Annibale, an instinctive painter who pretty clearly regarded rationalized theory as silly nonsense and waste of time.

censure.[56] But the confusion between general artistic language and particular artistic quality was deep rooted, and we cannot blame Schlegel for not perceiving it: rather is he entitled to our admiration (and indeed our envy) at the "discovery" of such a figure as Giambellino.

The final stage in the establishment of our legend was of course the bringing together of all the different threads and their summarization in a popular form. This function was performed with great efficiency by Franz Kugler in his celebrated standard work, first published in 1837.[57] Though the author himself did not claim that it was more than a compilation composed in some haste, it filled a very definite public want and was an instant success; an English translation of the portion dealing with the Italian Schools was published in 1842, embellished with notes by (Sir) Charles Eastlake, R.A. Kugler, following in the footsteps of Rumohr, was of course genuinely and sincerely interested in the early periods; but the corollary to this was a complete absence of understanding for the Seicento. That can be seen at first glance from the headings, so important and influential in a popular book of the kind. The last chapter is entitled "Restauration[58] und neuer Verfall," and the artists dealt with are quite simply divided into two general types, the Eclectics (the term is now honoured with a capital letter in the English translation) and the Naturalists. Moreover we are astonished to read in the introduction to this chapter that the greater part (sic!) of the Italian artists of the end of the Cinquecento and the first half of the Seicento are commonly described as Eclectics. Kugler thereupon treats us to a brief definition of the supposed eclectic theory and does not neglect to draw attention to its contradictory character.[59] The school of the

[56] F. Schlegel, *Werke*, VI, 1823, p. 192: "Man sieht hier gleichsam die beyden Extreme des verirrten Talents, des falschen Kunststrebens, beysammen: Rubens und Guido, manierirte Wirkung und das leere kalte Ideal."

[57] Franz Kugler, *Handbuch der Geschichte der Malerei*, Berlin, 1837.

[58] Shades of Bellori!

[59] Kugler, *Handbuch*, 1837, I, p. 331: "Man benennt den grössten Theil der Künstler dieser Zeit, am Ende des sechzehnten und in der ersten Hälfte des siebzehnten Jahrhunderts gewöhnlich mit dem Namen der Eklektiker

Carracci is of course given pride of place among the Eclectic Schools (sic !),[60] just as the sonnet is made the kernel of Kugler's exposition and criticism of their alleged principles,[61] and, by implication, of their paintings; this, as we should expect by now, is most unfavourable.[62] Other supposed eclectic schools are specifically named, those of the Campi at Cremona and the Procaccini at Milan.[63] We are surprised to learn that a new

(Auswähler), insofern sie nemlich aus den Werken der einzelnen grossen Meister ihre vorzüglichsten Eigenschaften herauszuziehen und zu einem Ganzen zu vereinigen suchten (ohne dabei jedoch das Studium der Natur aus den Augen zu setzen). Natürlich liegt in dieser eklektischen Richtung, wenn sie auf die Spitze getrieben wird, ein grosser Missverstand der eigent-lichen künstlerischen Conception und Ausübung, indem jene älteren Meister gerade in ihren besonderen Eigenthümlichkeiten gross waren, und innerlich Verschiedenartiges zu vereinen, schon an sich ein Widerspruch ist."

[60] Kugler, *Handbuch*, 1837, I, p. 332: "Die bedeutendste unter den eklektischen Schulen ist diejenige, welche zu Bologna, durch die Familie der Caracci gegründet ward."

[61] Kugler, *Handbuch*, 1837, I, p. 333: "Naturbeobachtung und Nachah-mung der grossen Meister waren die Grundsätze dieser Schule. Letztere geschah so, dass sie entweder die einzelnen Vorzüge jener Meister in Einen Gesammtvorzug zu verschmelzen suchten, oder (auf etwas rohere Weise) dass sie die einzelnen Figuren ihrer Gemälde, je nach deren besonderem Charakter, in der Weise des einen oder des anderen Meisters malten. Es giebt ein Sonett vom Agostino Caracci, in welchem er den Grundsatz der Schule dahin ausspricht " [a translation of it then follows].

[62] Immediately after his translation of the sonnet, Kugler comments (I, pp. 333 f.): "Ich habe schon vorhin bemerkt, dass aus solchen heterogenen Theilen kein wahrhaftes Ganze entstehen kann. Das Zusammentragen der technischen Vorzüge jener Meister, die das Ergebniss lebendiger und eigenthümlicher Kunstanschauung gewesen waren, konnte—im besseren Falle—wohl zur Regelrichtigkeit und technischen Tüchtigkeit führen, aber kein geistig belebtes Produkt erzeugen. Aeussere Regelrichtigkeit ist der Gesammtcharakter dieser ganzen Schule, und darin besteht allerdings ein grosses Verdienst im Verhältniss zu der nächst vorhergehenden Periode; aber selten findet man in ihr Werke, welche den Stempel eines unbefangenen, wahrhaft erfreulichen Sinnes tragen."

[63] Kugler, *Handbuch*, 1837: "Gleichzeitig mit der Schule der Caracci traten in Italien noch andre eklektische Schulen auf. So die Schule der Campi zu Cremona . . ." (I, p. 345); "Eine dritte eklektische Schule ist die der Procaccini zu Mailand . . ." (I, p. 346). The idea about the Campi is adumbrated by Lanzi in one or two passages, though of course without use of the expression "eclectic"; and as we have seen (cf. note 20 of this Part), Giulio Cesare Procaccini had already been the recipient of a mixed bouquet at the hands of Malvasia!

manneristic movement gained the upper hand over the Eclectic Schools during the course of the Seicento, and the arch-conspirator in founding this pernicious style ("Der Hauptgründer dieser verderblichen Richtung") was—Pietro da Cortona.[64] Here we find the traditional classic interpretation of Annibale becoming almost equated with "eclecticism," and the full baroque with "mannerism." This classic accent is even more evident when we read of a further revival of "eclecticism" in the persons of Mengs and Battoni.[65] The truth is that the expression "eclectic" had come to have no clear meaning in practice except to share with other expressions (such as "mannerist") in the conveyance of a general censure of post-Renaissance art. This sort of implied condemnation in bulk of an enormous number of varied artistic personalities is of course a sure sign that the critic in question has little intimate understanding of the material concerned; or, to be more precise, that he has not had the inclination to penetrate beneath a general artistic language with a view to distinction between what is poetry and what is not in terms of that language. Nowadays it would seem incredible that a survey of Italian painting of 360 pages should not devote more than three words to Giambattista Tiepolo: yet that is the result of Kugler's preoccupation (admirable by itself) with the earlier periods, and his consequent complete lack of comprehension for the later ones.[66]

It is pleasant to be able to record that that great art-historian, Jacob Burckhardt, who was entrusted by Kugler with the greater part of the revision for the second German edition of 1847,[67] characteristically did not lose his head in this orgy of superficial misinterpretation. Considerable amendments were

[64] Kugler, *Handbuch*, 1837, I, p. 350.
[65] Kugler, *Handbuch*, 1837, I, pp. 358 f.
[66] Kugler, *Handbuch*, 1837, I, p. 358. Tiepolo is simply described as "ein abentheuerlicher Phantast," no more and no less.
[67] *D. Franz Kugler's Handbuch der Geschichte der Malerei. Zweite Auflage unter Mitwirkung des Verfassers umgearbeitet und vermehrt von Dr. Jacob Burckhardt*, Berlin, 1847.

made to the chapter dealing with the Seicento; these tend to introduce a sense of proportion into Kugler's exaggeratedly tendentious thesis, and unmistakably carry the stamp of Burckhardt's mind. For example, the passage in which Kugler indulges in his most extreme criticism of the Carracci is scrapped,[68] and Burckhardt inserts in its stead an estimate which, bearing in mind the circumstances of the time, is quite remarkably sensible and balanced.[69] He clearly could not bring himself to believe that the mythical "system" was really put into effect, and introduces a couple of sentences at the end of Kugler's preliminary remarks on eclecticism which have the effect of undermining the whole argument.[70] Possessing a more than offhand knowledge of the actual works of art concerned, he naturally found great difficulty in reconciling the usual *clichés* with them: it is unfortunate, though understandable, that he did not carry his suspicions still further and question, not only the opinion that the "doctrine" was applied, but also the fact that it was ever advocated by the Carracci at all. As matters stood, in spite of Burckhardt's instinctive qualifications (and those of many who came after him), the influence of the popular headlines, the succinct chapter headings, won the day: the attractions of a simple classification and a convenient term with a slight flavour of learned abracadabra about it (seeming to dispose of the necessity for deeper consideration) proved irresistible to the nineteenth century mind in general. It must be admitted with regret that all this sorry stuff had, quite literally, a *succès fou* in England. So much so indeed that the translator into English of the revised German edition thought fit to doctor Burckhardt's very reasonable amendments. Thus the passage in which the latter states his disbelief in the rigid

[68] The passage in question, omitted from the revised edition, is that quoted in note 62 of this Part.

[69] Kugler-Burckhardt, *Handbuch*, 1847, II, p. 356.

[70] Kugler-Burckhardt, *Handbuch*, 1847, II, p. 354: "Wäre diese Theorie wirklich in der Praxis streng festgehalten worden, so brauchten wir mit diesen Künstlern nicht vielen Raum zu verlieren. Glücklicher Weise verhielt es sich anders." This follows immediately after the passage quoted in note 59 of this Part.

application of the theory is entirely omitted :[71] it was evidently felt to be inconsistent with the chapter heading itself ("Eclectic Schools"), and this would never have done! The expression "eclectic" rapidly became a sort of specialists' commonplace in England,[72] and the great popularity and numerous editions of Kugler's book (with the same chapter headings constantly re-appearing) must have done much to keep it so.[73] From France,

[71] *Kugler's Handbook of Painting. The Schools of Painting in Italy. Edited, with notes, by Sir Charles L. Eastlake, P.R.A., F.R.S. Second edition, thoroughly revised, with much additional matter,* London, 1851. The passage omitted from its proper context (II, p. 478) is that quoted in our previous footnote.

[72] Cf. John Ruskin's (anonymous) review of Lord Lindsay's *Sketches of the History of Christian Art,* in *The Quarterly Review,* LXXXI, June-Sept. 1847, p. 24: "This [an interpretation by Lindsay of Niccolò Pisano] is mere Bolognese eclecticism in other terms, and those terms incorrect. We are amazed to find a writer usually thoughtful, if not accurate, thus indolently adopting the worn-out falsities of our weakest writers on Taste." That the misuse of the actual expression "Bolognese eclecticism" implied critical indolence on no small scale was largely overlooked during the nineteenth century!

[73] English editions were published in the following years: 1842, 1851, and 1855 (all edited by Eastlake); 1874 (edited by Lady Eastlake); 1887 and 1891 (both edited by A. H. Layard). As an example of the popularization of the term "eclectic" in England we may refer to Ralph N. Wornum's *Descriptive and Historical Catalogue of the Pictures in the National Gallery, with Biographical Notices of the Painters,* London, 1847. In this (p. 48) Lodovico Carracci is described as "founder of the eclectic school of Bologna," a translation of the sonnet is given in a footnote, and the comment is offered: "This sonnet sufficiently explains the principles of the eclectic school, and at the same time, shows their mere technical tendency." For a typical nineteenth century classification of the Italian Schools we may turn to the 1863 catalogue of the Hermitage by Baron B. de Koehne (*Ermitage Impérial, Catalogue de la Galerie des Tableaux,* Saint Petersburg, 1863). Beginning with the *époque de la formation* (Quattrocento) and the *époque la plus florissante de l'art* (High Renaissance), we reach the *époque du déclin de l'art* (this includes Bronzino, Barocci, the Cavaliere d'Arpino, Tintoretto, Veronese, Bassano). Next we have the *seconde époque de la fleur de l'art,* subdivided into *les Éclectiques, les Naturalistes,* and various local schools; the Eclectics include the Carracci, Domenichino, Reni, Tiarini, Albani, Mola, and Sacchi, while the Naturalists consist of Caravaggio, Strozzi, Salvator Rosa, Fetti, and Guercino. Finally we have the *époque de la décadence,* which includes Pietro da Cortona, Castiglione, Giordano, Maratti, Crespi, Tiepolo, Canaletto and Solimena. In the second edition (1869) the *déclin* idea has to be abandoned, doubtless owing to the presence of Tintoretto and Veronese, and this particular stage becomes refreshingly factual as *Peintres de la fin du XVIe et du commencement du XVIIe siècle!*

we need hardly say, epigrammatic renderings were soon forth-
coming, pithy, lively, and ostensibly significant—but after all
not really relevant.[74]

The subject of the Carracci was so frequently treated after
this fashion in the mid-nineteenth century that it became only
too easy to write plausibly on them by means of no more
strenuous a method than providing fancy variations on the
literature of the previous few decades—that is, without allow-
ing oneself to be troubled to any great extent by serious study
of the works of art or by paying too scrupulous an attention to
the evidence from the original sources. A typical example of
this sort of concoction was provided by Charles Blanc in the
Histoire des Peintres edited by him, essentially a popular publica-
tion in imposing form. For smooth platitudinous handling,
with no trace of a serious background, his remarks (published
in 1874[75]) would be hard to beat. He is, however, bold enough
to load one further burden on the donkey. Francia now be-
comes involved in the *éclectisme lumineux* (whatever that may
mean) which is pronounced to be characteristic of Bologna.
Blanc modestly admits that in introducing the term eclecticism
into the interpretation of Bolognese art he is not the first in the
field, adding, "et comment ne pas le remarquer, puisqu'il a été
hautement avoué . . . par les Carrache?" The latter, we are
now given to understand, did nothing but to erect "en système
l'éclectisme qui avait distingué les maîtres antérieurs."[76] Blanc
says he will only concern himself in his Introduction with their
"théories publiquement enseignées."[77] He then characterizes

[74] For example, Théophile Thoré, writing under the pseudonym of W.
Bürger: "A bien dire même, ils [les Carrache] descendent de tout le monde.
Ce sont des bâtards issus de la promiscuité;" and "Quand un art commence,
c'est la nature qui l'inspire; quand un art finit, il ne s'inspire plus de la vie:
il pastiche les morts" (W. Bürger, *Trésors d'art exposés à Manchester en 1857*,
Paris, 1857, pp. 97 and 99).

[75] *Histoire des Peintres de toutes les écoles, École bolonaise*, Paris, 1874. The
Introduction, with which we are concerned, was written by Charles Blanc.

[76] Blanc, *École bolonaise*, 1874, p. XIII.

[77] Blanc, *École bolonaise*, 1874, p. XIV. Cf. also p. XVII: "Les principes
enseignés par les Carrache étaient, nous l'avons assez [!] dit, ceux de
l'éclectisme."

these alleged theories in the usual way (e.g., "les ordonnances de celui-ci, les effets de celui-là"). Though he remarks with truth that we have some difficulty in understanding in modern times that "une semblable philosophie de l'art soit entrée dans la tête d'un artiste, d'ailleurs éminent et éclairé,"[78] it does not occur to him to draw the obvious conclusion from this; quite the reverse! Though he exhibits traces of uneasiness on the sonnet,[79] he is quite prepared to accept it as a pretext for the rhetorical passages expected of him on the absurdity of the doctrine it is supposed to represent.[80] He senses something odd about the presence of Niccolò dell'Abate in it, but does not venture to suggest any constructive deductions on the subject.[81]

[78] Blanc, *École bolonaise*, 1874, p. XIV.

[79] Blanc, *École bolonaise*, 1874, p. XVII: "Sans prendre au pied de la lettre le sonnet si connu d'Augustin, dans lequel il avait prétendu résumer les doctrines de l'école, et en tenant compte des altérations qu'a pu subir la pensée du peintre par l'insuffisance du poëte ou les nécessités de la rime, on peut considérer ce sonnet comme le programme des idées qui avaient cours et crédit dans l'école des Carrache." Blanc then quotes it in Italian, and it is characteristic of his second-hand methods that his quotation is derived from the Lanzi version rather than the original Malvasia version: *branca* (line 1) is a misprint for Lanzi's *brama*, and he uses Lanzi's *vera* in line 8 (for these variants introduced by Lanzi, cf. note 45 of this Part). Blanc was puzzled by the role of Niccolò in the poem (cf. note 81 of this Part); but obviously an understanding of this was hardly facilitated by ignoring the original context! C. L. Ragghianti (*La Critica*, XXXI, 1933, pp. 226 f.) quotes the Lanzi version, and by a slip omits the not entirely insignificant last three lines; this is the article referred to in note 51 of Part II and note 30 of this Part.

[80] Blanc, *École bolonaise*, 1874, p. XVII: "Avons-nous besoin de faire ressortir ce qu'il y aurait d'incohérent et de monstrueux dans un tel amal-game de qualités absolument contraires? Avons-nous besoin de dire combien il serait absurde de tenter la conciliation d'éléments aussi inconciliables?" Etc., etc. Later on (p. XVIII), he lays down the general principle: "En peinture, comme en philosophie, l'éclectisme est une doctrine stérile qui ne saurait produire que des œuvres sans caractère, sans harmonie, sans portée." Then he attempts to qualify it: "Cependant, ce serait une erreur de croire que les leçons des Carrache ont pu étouffer les originalités natives . . ." Etc., etc.

[81] Blanc, *École bolonaise*, 1874, p. XVIII: "Mais le sonnet d'Augustin doit être pris, après tout, pour ce qu'il est, un jeu d'esprit, ou si l'on veut, une formule pour signaler aux jeunes gens les artistes suprêmes de la Renaissance, parmi lequels il est inconvenant, soit dit entre parenthèses, de placer Niccolino, quand on oublie le sublime Léonard."

Nevertheless we must be grateful to him for an appropriately farcical note on which to conclude our account of this strange fantasy:[82]

"Les rapins de nos ateliers ont fait une amusante parodie du sonnet d'Augustin Carrache, en disant: 'Le peintre parfait doit réunir la composition de Raphaël, le dessin del Michel-Ange, le coloris de Rubens, la grâce du Corrège, et le clair-obscur de Rembrandt, avec le paysage de Claude Lorrain, les lointains de Weirotter et les fabriques de Boissieu.' Quelques-uns ajoutent à cet heureux mélange: 'le croquis de Meissonier.' "

* * *

A few words about the wider implications of our study of the history of a particular interpretative formula. The justification of the time we have spent on it must be that the formula stood between us and the perception of the one thing which really matters, the qualitative element in the individual work of art. A tradition of this kind, heavy with the accretions of centuries, surreptitiously conditions the eyes, so that one can fail to see the work of art freshly—that is, as nearly as possible as its maker saw it; and yet until the art-historian realizes his obligation to attempt this, he is as the blind leading the blind. In the case of Seicento art, his task is impeded by the traditional theoretical smoke-screen which still lingers between the artists' work and the modern spectator, a formidable obstacle to understanding even now. Our investigation is offered in the hope that a more detailed knowledge of the precise character and origins of that legacy of misconception will contribute to its disappearance, and that consequently a more genuine and more sensitive relationship with the works of art themselves will be facilitated. We must bear in mind, however, that we shall not completely free ourselves from its deceptive influence unless we firmly resolve to reform our terminology. There is no need to stress one of the most striking lessons which the history of art

[82] Blanc, *École bolonaise*, 1874, p. XVII.

theory has to teach us, namely that some of the greatest critical fallacies of the past derive from confusion between what appertains to the factual on the one hand and the æsthetic on the other: confusion, that is to say, between those innumerable factors by means of which any work of art is related to the rest of the world through the operation of the law of cause and effect (for example, the general methods of expression which are "given" *a priori* to such and such an artist at such and such a time and place), and those qualitative elements in a particular work of art which render it unique.

Though it is essential in the interests of clear thinking and clear exposition that these two categories, descriptively-analytical and qualitative, should be kept recognizably apart, the use of the term "eclectic" has precisely the reverse effect. Nowadays the descriptive facet of the expression is uppermost; it has contrived to retain its position in the terminology of art-history by passing itself off as a convenient means of indicating the borrowing of formal motives.[83] But even the pseudo-scientific mantle under which it conceals its nakedness begins to resemble Hans Andersen's *The Emperor's New Clothes* if one gets past the superficially impressive façade and starts to call the bluff. By asking how many influences constitute "eclecticism," how simultaneous these must be to qualify, and such-like questions (logically legitimate, however ridiculous in effect), we soon reach a *reductio ad absurdum*.[84] It is not in fact the business-like expression it may at first sight appear to be, but rather a standing invitation to the art-historian to be vague just where definition is required: an altogether too convenient device to enable him to dispense with saying exactly what he

[83] Certain formal motives in a fine picture at Gothenburg of *Amarillis and Mirtillo* derive from Titian. If the artist had been remotely connected with the Carracci or with Bologna, instead of being Van Dyck, such a process of reinterpretation would inevitably have been called "eclecticism." (For the pictorial raw materials of the Gothenburg painting, cf. Carl Nordenfalk, "Ein wiedergefundenes Gemälde des van Dyck," in *Jahrbuch der preuszischen Kunstsammlungen*, LIX, 1938, pp. 36-48.)

[84] We almost begin to approach that regrettable blemish on the excellent record of Roger de Piles, the notorious *Balance des peintres*!

means.[85] The fact that "eclectic" (unlike, for instance, the
Wölfflinian "baroque") has nothing very definite to describe is
no recommendation for its transformation into a purely descrip-
tive term. There is no general style or school (Kugler not-
withstanding!) to which it can reasonably and usefully be
attached, especially in view of the probability that it was never
explicitly professed by any group of artists as a serious theoretical
doctrine for the fully fledged master. Moreover even when we
employ it in particular cases for purposes of style analysis it is
unable to divest itself of its inherent qualitative connotation
(which entails the confusing injection of æsthetic judgment into
the argument): because of its obvious etymological origin and
subsequent history it does not lend itself, as Gothic and Baroque
have done, to gradual metamorphosis into qualitative neutrality.
If we wish to convey the descriptive fact that an artist's style
is derived in such and such a manner from previously existing
styles we should be able to do so without falling back on a
rather esoteric expression found appropriate in the eighteenth
century by Winckelmann to express his own æsthetic ideas in
relation to ancient art.

To sum up, we ought on principle to avoid as much as
possible, in the interests of clarity, portmanteau terms which,
while ostensibly having a factual basis, nevertheless also carry
a qualitative implication.[86] Those days when it was thought

[85] Far greater genuine precision is attained in these matters by employing
a couple of dozen words than by making use of one word with half a dozen
potential meanings.

[86] "Academic" is another instance of a misleading portmanteau term of
this kind, and one which incidentally has also contrived to attach itself to
the unfortunate Carracci; for example, Ralph N. Wornum (*The Epochs of
Painting characterized*, London, 1847, p. 378) has a chapter on the followers of
the Carracci entitled "The Carracceschi: Academic Style." It is a fact that
the Carracci had a very flourishing joint workshop at Bologna, frequented
by numerous pupils and amateur admirers, and this (probably at the
suggestion of the would-be *letterato* Agostino) assumed the impressive name
of *Accademia* and aped certain of the outward forms of the literary academies
then prevalent. On no account however can a private association of this
kind properly be equated with a state-supported institution for the education
of artists in the sense of a nineteenth century *École des Beaux-Arts*. The true
character of the Carracci Academy has been convincingly shown by Dr.

possible to assert *a priori* that a particular vehicle of artistic expression would semi-automatically produce a good or bad picture have passed away.[87] It is equally absurd to lay it down in the abstract that a certain number of influences in a picture are consistent with high quality, and that another number are not. The proof of the pudding is in the eating: let us see the picture and then judge the result.[88] The expression "eclectic," we may conclude, should be given a well-earned rest, on the score that it confuses more than it interprets: and certainly we ought to think twice before we assert that a mere word is of no account.

Bodmer (Enrico Bodmer, "L'Accademia dei Carracci," in the periodical *Bologna*, 1935, fasc. 8, August), who incidentally launches a strong attack on the supposition that the Carracci either advocated or followed an eclectic programme. As we have had occasion to see in Part III, references to an academic theory or style during the Seicento, even in connexion with a public body like the Accademia di San Luca, are not very easy to justify.

[87] Michelangelo did not understand the language of the Flemish painters and so rated them low qualitatively; German visitors to Cinquecento Venice were apt to think that the local painting fell short of its reputation because it appeared unfinished by their own standards; for a Bellori the classic style became nearly equivalent to a guarantee of quality; for a Friedrich von Schlegel his beloved "primitives" spoke the truest tongue. Yet all these groups produced good and bad works: it was of course not the general language which counted, but the individual artist. The fact was that, outside the range of their linguistic predilections and limitations, the supposed æsthetic judgments of many critics were actually nothing of the kind: as they had an inadequate understanding of the language they could hardly be expected to appreciate the poetry.

[88] As Professor Longhi very reasonably asks apropos the Carracci: "Ma è da far questione sul numero dei componenti o non piuttosto da giudicar la resultante?"

APPENDIX I

AGUCCHI'S *TRATTATO*

(ANNOTATED REPRINT OF
MOSINI'S PREFACE[1] OF 1646
CONTAINING
THE SURVIVING FRAGMENT OF THE TREATISE)

[1] This Preface, here reproduced in its entirety, appears only in the original edition of 1646 of Simon Guillain the younger's eighty etchings after the Carracci drawings of Bolognese artisans, craftsmen, tradesmen, and so forth. Malvasia was familiar with it and quotes from it on several occasions; the references to his quotations will be given in footnotes, as it may be of use to know which passages had the wider publicity which *Felsina Pittrice* afforded. Whenever slight textual differences appear between Malvasia's quotations referred to here and Mosini's original version, it may be assumed that they are due to faulty transcription by Malvasia; these small variations are usually quite unimportant. A manuscript of the Preface exists in the Biblioteca Universitaria at Bologna (the first item in MS. 245, which is from the Marsili Library). It seemed very probable from the entry in the printed inventory (Sorbelli and Mazzatinti, XVII, p. 67, No. 305) that this was a copy (from the text printed in 1646 by Grignani) made on behalf of Count Luigi Ferdinando Marsili (1658-1730, the soldier and man of learning who was the moving spirit behind the foundation of the Accademia Clementina in 1709) as part of the material collected by him in connexion with a projected work on Bolognese painting. However, I wrote to Prof. D. Fava, Director of the Biblioteca, to enquire if there was any reason to suppose that it was the author's original manuscript, and he very kindly confirmed that it is clearly only a copy after the printed text—an opinion which I was later able to endorse myself after having had an opportunity to examine the manuscript; it covers fol. 1-31 of the codex, has no corrections or *postille*, and is followed by a list of the *Figure*, but not by the drawings themselves. When Dr. Juynboll says "Het handschrift van Mosini vonden wij op de Universiteits-bibliotheek te Bologna (M.S. 89)" he is presumably referring to this manuscript, and the implicit attribution to Mosini's own hand is no doubt due to the fact that he apparently did not know the text printed by Grignani (Willem Rudolf Juynboll, *Het komische genre in de Italiaansche schilderkunst gedurende de zeventiende en de achttiende eeuw*, Leiden, 1934, p. 103, note 3). I am much indebted to Dr. Rudolf Wittkower for drawing my attention to a second manuscript which he found in the Gabinetto dei Disegni in the Uffizi at Florence. On the sheet preceding the Preface is the following note on the provenance of this volume: "Questo libro fù mandato alla R.le Galleria il dì 2. Luglio 1771. d'ordine di S. A. R.le quando piacque all'Altezza Sua di levare dal palazzo de' Pitti la Biblioteca Palatina." The history of the original book of drawings, summarized from Mosini's text, is then given in a different hand, and the writer concludes that the Florentine volume "è stato malamente copiato, e creduto per molto tempo essere il vero originale d'Annibale Caracci." The drawings which follow the text (Inv. Nos. 3063 to 3143) are in fact merely copies after Guillain's etchings, and the manuscript itself, which is without corrections or *postille*, has not the character of an author's MS. as supplied to the printer: the probability that, like the Bolognese manuscript, it was simply copied from the text printed by Grignani is supported, e.g., by the fact that the misprint *isquitezza* (for *isquisitezza*, see the following page) is faithfully copied in the Florentine manuscript (page 1).

[*Title page :*]

DIVERSE FIGVRE / Al numero di ottanta, Disegnate di penna / Nell'hore di ricreatione / DA / ANNIBALE CARRACCI / INTAGLIATE IN RAME, / E cauate dagli Originali / DA SIMONE GVILINO PARIGINO. / *DEDI-CATE* / A TVTTI I VIRTVOSI, / Et Intendenti della Professione della / Pittura, e del Disegno. / IN ROMA, / Nella Stamperia di Lodouico Grignani. / MDCXLVI. / *CON LICENZA DE' SUPERIORI.*

[*The Preface begins as follows on page 3 :*]

A TVTTI COLORO, / Che della professione ingegnosissima del Disegno / si dilettano. / GIOVANNI ATANASIO MOSINI[2] / Salute.

ANNIBALE Carracci Pittore de nostri tempi dell'eccellenza, che à voi (amatori di così bello artificio) può esser manifesta, fù riputato da coloro, che in vita lo conobbero, esser dotato di vna felicità d'ingegno marauigliosa; con la quale, accompagnando egli con suo gran gusto lo studio, e la fatica, arriuò ad hauere così pronta, & vbbidiente la mano ad esprimer col disegno gli oggetti, che vedeua, e s'imaginaua; che non si pose mai à far cosa, che felicemente non gli riuscisse, e che, per picciola che ella si fosse, non venisse da gl'intendenti oltremodo stimata. E quanto all'isqui[*si*]tezza dell'imitatione, fine principale del Pittore, la quale à lui ottimamente sempre riusciua, alcuni lo paragonauano à que' tali, che, per grande habilità

[2] For the identification of "Mosini" as a pseudonym for Monsignor Giovanni Antonio Massani, *Maestro di Casa* to Pope Urban VIII, cf. notes 113 of Part II, and 14 and 55 of this Appendix. He appears, from his own contributions to this Preface, to have been somewhat less of a thorough classicist than Agucchi or Bellori.

naturale, e per istudio particolare, essendo attissimi ad imitare i linguaggi, la voce, li gesti, & altre singolari, e proprie qualità di alcuno, fanno credere, che ascoltando, ò veggendo essi, si ascoltino, ò veggano que' medesimi, che da loro vengono imitati. E perche al tempo di Annibale viueua il valentissimo Siuello,[3] il quale superò forse gli antichi Histrioni celebrati per brauissimi, e marauigliosi dagli Scrittori, & era amico de' medesimi Carracci; quindi è, che, in riguardo dell'ottima imitatione, specialmente à lui veniua Annibale paragonato. Percioche tra l'altre cose molte, che'l Siuello mirabilmente imitaua, egli da per se solo rappresentaua vn congresso di sei persone differenti di linguaggio, di voce, di età, e di conditione. Egli si poneua in luogo, doue da niuno potesse esser veduto, ma ascoltato benissimo da molti: e fingendo, che le sei persone cominciassero à ragionare fra loro di cose piaceuoli, e curiose; dipoi, proponendo di giuocare à carte, risolueuano tre di loro di fare vna primiera, e gli altri di starsene à vedere. Principiato il giuoco, e per alquanto continuato pacificamente, nasceua [*Page 4*] poi fra essi contesa, come suole accadere tra i giuocatori; e dicendo il lor parere li tre altri, che à vedere se ne stauano, s'interponeuano ancora per acchetarli, mentre dalle contese, alle parole mordaci, & indi alle mani anco finalmente veniuano. Rappresentaua il Siuello tutto ciò da per se solo, imitando isquisitame[n]te la diuersità de' linguaggi, e della voce, appropriandoui le parole, i motti, facendo sentire alcuno strepito, & altre circostanze proprijssime à quel congresso, & all'attione, che imitar voleua; di modo, che da persone di grandissimo sapere, e giuditio, che l'hanno vdito, io hò sentito affermare, che in quel genere d'imitatione era quell'huomo arriuato al colmo, e certamente non si potea far più. e ben'e

[3] For Giovanni Gabrielli, known as Il Sivello, cf. Luigi Rasi, *I Comici Italiani*, Florence, 1897, I, pp. 953 ff. Quadrio (writing in 1744, quoted by Rasi, *loc. cit.*) guesses that he was born about 1588. This is clearly far too late, since Agostino Carracci (who died in February 1602) engraved his portrait (cf. note 50 of this Appendix), and two works of his were published at Bologna in 1601 (*Villanelle Nuove Composte per Giovanni Gabrielli detto il Sivello*) and 1602 (*Il Studio, Comedia Nova, Composta per Giovanni Gabrielli da Modona, detto il Sivello*).

[*sic*] spesso auuenne, che molti tale attione per finta non credettero, sinche ancora col vedere non se ne resero sicuri. Annibale similmente in vece di fingere con le parole, ò con la voce, ò co' gesti, imaginandosi i lineamenti, e tutto quello, che appare alla veduta in qual si voglia corpo, ò oggetto visibile, & imitabile, l'hà rappresentato in modo col disegnare, e col dipingere; che, applicando mirabilmente à ciò che faceua, le particolari, e proprijssime qualità di contorni, di lumi, & ombre, e colori, secondo che à ciascuna cosa più conuiene, hà in tutte le sue opere chiaramente mostrato, quanto possa la mutola fauella della mano esprimere all'humano intelletto, col mezzo della facoltà visiua. e perciò assai acconciamente si adattaua la comparatione di Annibale al Siuello: perche si come questi ingannaua l'vditore, che non vedeua, così quegli ingannò più volte il riguardante, che non toccaua.

E perche dal felice operare, & imitare di questo maestro nasceua ancora grandissimo diletto in altri, e in se medesimo; poiche quanto più l'imitatione al vero si accosta, tanto più diletta, e piace à i riguardanti, & all'Operante istesso:[4] da ciò nasceua, che occupato[5a] Annibale nelle opere più grandi di molto studio, e fatica, egli prendeua il suo riposo, e ricreatione dall'istesso operare della sua professione, disegnando, ò dipingendo qualche cosa, come per ischerzo: e tra le molte, che in tale maniera operò, postosi à disegnare con la penna l'effigie del volto, e di tutta la persona de gli Artisti, e che per la Città di Bologna, patria di lui, vanno vendendo, ò facendo varie cose, egli arriuò à disegnarne sino al numero di settantacinque figure intere, in modo che ne fù formato vn libro, il quale, per alcun tempo, che il maestro se lo tenne appresso di sè, fù riputato da' suoi Discepoli vn'esemplare ripieno d'insegnamenti dell'arte vtilissimi per loro, e del continuo diligentemente di approfit-

[4] This is an example of the sort of statement by Mosini to which Agucchi and Bellori would have found it difficult to subscribe. But cf. also note 12 of this Appendix.

[5a] to [5b] The passage between 5a and 5b is quoted by Malvasia (*Felsina*, 1678, I, pp. 469-470). In this context the expression *Artisti* naturally means artisans, craftsmen, tradesmen, etc.

tarsene si studiarono. Dapoi peruenuto il libro alle mani di vn
Signore di viuace ingegno, che diuentò poi anche gran Per-
sonaggio, egli lo tenne per lungo tempo tra le cose à lui più
care, compiacendosi con gran dilettatione di farlo vedere à
gl'intendenti, & amatori della professione. nè s'indusse mai à
priuarsene per qual si sia richiesta di altri Personaggi, che lo
desiderauano ò in dono, ò in vendita, ò con ricompensa di altre
cose belle, e curiose. Ma poi per sola liberalità, e grandezza
d'animo, volle farne dono ad vn virtuoso suo amico, il quale
delle cose più belle della natura, e del- [*Page 5*] l'arte, dilettan-
dosi, fece del libro la stima, che meritaua, e come doueua fù
sempre ricordeuole della cortese dimostratione di quel Signore.
Fù il libro donato dal Signor Cardinale Ludouico Ludouisio[6]
al Signor Lelio Guidiccioni,[7] gentilhuomo Luchese assai noto
alla Corte di Roma per le virtù, e qualità sue molto degne, e

[6] Ludovico Ludovisi (1595-1632), *Cardinal Nipote* during the pontificate of
Gregory XV (1621-23), was appointed Archbishop of Bologna (1621),
Camerlengo di Santa Chiesa (1621), and Vicecancelliere di Santa Chiesa
(1623).

[7] Lelio Guidiccioni was a *letterato*, *dilettante*, and poet, first in the entourage
of Cardinal Scipione Borghese and then in that of Cardinal Antonio
Barberini; judging by several passages in his *Rime* (Rome, 1637) he was a
friend of the brothers Sacchetti (Cardinal Giulio, and Marcello), the patrons
of the young Pietro da Cortona. Giovanni Vittorio Rossi, alias Erythraeus,
gives us a short biography of him (*Iani Nicii Erythraei Pinacotheca Altera*,
Cologne, 1645, pp. 127-130, No. XL). Rossi's biographies caused consider-
able amusement to his contemporaries (Urban VIII, when reading the first
Pinacotheca, is said to have had to remove his spectacles frequently for fear
that mirth would cause them to fall off his nose), so perhaps we may be ex-
cused for inserting the following quotation of the sad story of how Guidiccioni
was struck dumb when deputed by Cardinal Scipione to conduct the Grand
Duke of Tuscany and his brother round the works of art in the Villa
Borghese: "Verum cum anno MDCXXX, magnus Etruriae Dux, una cum
Io. Carolo fratre, Romam, pietatis ac religionis ergo venisset, ac magnifi-
centissimam eam villam, quam Cardinalis extra portam Salariam extruxerat,
invisurus esset, missus est illuc Laelius, ut Principes illos, plena eloquentiae
atque observantiae oratione, exciperet, eisque signa ac tabulas pictas, quibus
ea villa referta est, & artificum nomina, demonstraret. sed vir, ita in-
geniosus, ita eloquens, ad solum Principum illorum aspectum, obstupuit,
obmutuit, nec verbum ullum, ineptum saltem, proloqui potuit; ac, nisi
magnus Dux, qui eum exanimatum videbat, prior loqui occupasset, perpetuo,
in eo stupore & taciturnitate, haesisset" (*Pinacotheca Altera*, 1645, pp. 127 f.).

laudeuoli. E gloriandosi egli di hauer cosa nel suo Museo,[8] che particolarmente eccitaua la curiosità de' virtuosi di andarla à vedere; godè per molti anni dell'applauso, ch'egli medesimo ne riportaua; [*sic*] delle lodi, che se ne dauano all'Autore; e della continua ricordanza della magnanimità del Donatore. Venuto à morte[9] il Guidiccioni, e passando il libro alle mani d'altri con pericolo di essere trasportato in parte, donde non se ne sapesse mai più altro; peruenne finalmente alle mie col mezzo della diligenza del Virtuoso Leonardo Agostini,[10] il quale

[8] Pompilio Totti (*Ritratto di Roma Moderna*, Rome, 1638, p. 336) mentions Guidiccioni's collection: "... quì [Piazza di Spagna] il Sig. Lelio Guidiccione ha dottissima libraria, e bellissimi quadri." Rossi gives us a sly little vignette of Guidiccioni as a collector (*Pinacotheca Altera*, 1645, p. 129): "Incredibili tabularum studio & cupiditate flagrabat; adeo ut, in illis comparandis, nulli neque labori neque sumtui parceret; ex iisque insignem domi suae Pinacothecam instruxerat, in quam, summa ambitione, omnes, sive cives sive hospites, introducebat; ipse erat uniuscujusque demonstrator, ipse laudator, ipse memoria, omnium eorum artificum nomina repetens, quorum eas manu depictas ajebat; atque, has Michaeli Angelo Bonarotae, has Raphaeli Sancio Urbinati, has Perino Vago, aliisque, qui longe omnibus, pingendi arte, praestiterunt, tribuebat. In quo, ut insignem quendam pictorem dicere audivi, qui saepius eas attente consideraverat, mire se decipiebat, vel ab aliis, qui eas illi carissime divenditas obtruserant, deceptus, errabat. quo in errore, usque ad extremum vitae, permansit."

[9] Guidiccioni was alive in 1641 (Jacobus Gaddius, *De Scriptoribus non ecclesiasticis*, Florence, 1648, I, p. 210), but Rossi in a letter of October 1643 to Monsignor Fabio Chigi (afterwards Alexander VII) mentions him as dead (*Iani Nicii Erythraei Epistolae ad Tyrrhenum*, Cologne, 1645, p. 119).

[10] Leonardo Agostini, an antiquary of Sienese birth, was in the entourage of Cardinal Francesco Barberini and was later appointed *Antiquario Pontificio* and *Commissario delle Antichità di Roma e del Lazio* by Alexander VII (1655-1667). Bellori, in his anonymous *Nota delli Musei, Librerie, Galerie . . . di Roma* (Rome, 1664), mentions (pp. 5 f.) Agostini's "museo vario di statue, e marmi antichi," which was in the Via della Madonna di Costantinopoli. Most of our information with regard to Agostini is derived from casual references in his own books. These were: (i) a revised edition, issued in 1649 (by the same Roman publisher, Lodovico Grignani, and with the same type, as our *Diverse Figure* of 1646) of *La Sicilia di Filippo Paruta descritta con medaglie* originally published in 1612; (ii) *Le Gemme antiche figurate di Leonardo Agostini Senese* (Part I, Rome, 1657, with a portrait of the author *d'anni 63*; Part II, Rome, 1669); (iii) a *Seconda Impressione* of No. ii, revised after the death of Agostini by G. P. Bellori (who was one of his executors) and published at Rome in 1686. From these it appears that Agostini was a friend of

hauendo buon gusto delle cose antiche, belle, e curiose, vien'
anche amato da coloro, che se ne dilettano.

Ma io non hebbi così prestamente in mio potere il libro, che
molti di Voi (Signori miei) correste curiosamente à vederlo, e
mi poneste in consideratione, che l'Autore meritaua di essere
maggiormente conosciuto al mondo anche col mezzo di questa
piaceuole fatica; e che gli amatori, e desiderosi di queste virtù,
meritauan parimente di esserne fatti partecipi; persuadendoui,
che, anche in vna tal opera fatta per ischerzo, potrebbon
riconoscere gl'intendenti quanto vi sia di sapere, e ritrarne non
pochi ammaestramenti gioueuoli dell'arte.[5b] Perciò, (seguendo
io il vostro consiglio) hauendo deliberato di fare intagliar le
figure in rame all'acqua forte, per imitare più facilmente i tratti
della penna; hò procurato sopra tutto, che i contorni sieno per
appunto conformi à gli Originali: e mi è venuto fatto di farlo
condurre à segno da potersi publicare, essendoui anche aggiunte
cinque altre figure dell'istesso Autore, di grandezza vguale alle
altre, e nel medesimo modo disegnate, le quali dalla cortesia di
amici virtuosi mi sono state imprestate, per vnirle à tutte l'altre
in fine del libro, poiche mostrano medesimamente il valor
grande di quel Maestro, e sodisfanno come l'altre à gli occhi de'
riguardanti. Ma mentre si è messo all'impresa dell'intaglio

Poussin's patron, the Cavaliere Cassiano dal Pozzo, of Andrea Sacchi
("degno Pittore, fra moderni, delle lodi de gl'antichi"), and naturally of
Bellori himself, who seems to have done much of the work for the original
issues of Le Gemme antiche as well as taking charge of the revised posthumous
edition. In describing Guidiccioni and Agostini as virtuosi Mosini was
following the normal practice at this period, since the expression was used
broadly, without any differentiation, for letterati, scienziati, and artists. The
connoisseur, in the sense of the discriminating layman who collected works
of art, was beginning to flourish during the Seicento, but he had not quite
fixed upon his future designation when Mosini wrote. A term was required
which suggested more knowledge than dilettante and amatore. Virtuoso was
too general, and the two most promising aspirants were intendente and
conoscitore, both of which Mosini uses, but without any very firm dividing
line between artist and layman; however, his buoni conoscitori towards the
end (p. 273 below) does seem to suggest that use of the term which was
ultimately to establish itself, via France. For an instance of Agucchi employ-
ing the expression, cf. note 26 of this Appendix.

Simone Guilino[11] Francese, giouine studioso, e diligente, egli
per condur meglio à fine il suo lauoro, si è accostato à chi
potesse à lui somministrare conforme al bisogno, gli auuerti-
menti. e come che in altre sue occorre[n]ze glie ne fossero stati
dati per prima de' gioueuoli dall'Algardi Scultore, ad esso egli
fece ricorso; e paragonando sempre l'intaglio con l'originale,
hà col parere di lui, e con questa diligenza, di mano in mano
ogni figura perfettionata. E quando è stato in fine di tutte,
desiderando di più il Francese d'intagliar ancora il ritratto di
Annibale da porre per frontispitio del libro, hà riceuuto
dall'Algardi questo seruitio di più, che di sua mano gli hà
disegnato quel ritratto con vn'accompagnamento, che per
frontispitio possa acconciamente seruire. E benche ciò sia
vna picciol cosa; coloro però, che il buono conoscono, non
lasceranno (quasi ex vngue leonem) di scorgerui per entro, da
qual fonte di sapere, e [*Page 6*] di buon gusto ella deriui. e voi
medesimi, a' quali il libro è dedicato, ne farete più sano
giuditio; sicome io sò, che molti di voi non vi s[i]ete ingannati,
quando più volte vi hò vdito affermare, che essendo l'Algardi
della medesima patria de' Carracci, egli è parimente buon
conoscitore del gran valore di essi, e con l'opere medesime sà
egregiamente imitarli nell'hauer sempre la mira al bello, e fare
elettione del meglio.[12]

Rimane, ch'io vi soggiunga (Curiosi di questa professione),
che molti anni addietro, vn tale Gratiadio Machati,[13] persona

[11] Simon Guillain the younger, born in Paris in 1618; cf. Thieme-Becker,
Künstlerlexikon, XV, 1922, p. 296.

[12] This last statement would have met with the warm approval of Agucchi
and Bellori, and serves to illustrate Mosini's somewhat uncertain position
between classic-idealist theory and mere imitation of nature (cf. note 4 of
this Appendix). The Bolognese Alessandro Algardi (1602-54) was, like
Duquesnoy, one of the more classically-minded of Seicento sculptors, and
provides something of a contrast to Bernini. Bellori tells us (*Vite*, 1672,
pp. 388 ff.) that he received some instruction as a youth in the school of
Lodovico Carracci, and that on reaching Rome in 1625 he became friendly
with Domenichino, who gave him some advice "nelle cose dell'arte;"
according to Passeri, however (*op. cit.*, ed. Hess, pp. 196 f.), Algardi and
Domenichino eventually became estranged.

[13] For the identification of Gratiadio Machati (otherwise Graziadio

di lettere non ordinaria, mi lasciò alla sua morte alcuni de'
suoi manoscritti,[14] nelli quali trouandosi diuerse annotationi, e
discorsi intorno alla professione della Pittura, & à gli Operarij
di essa così antichi, come moderni; è paruto non meno à molti
de' miei amici, che à me, non essere fuor di proposito il
ma[n]dar in luce alcuna cosa di quegli scritti in compagnia
delle Figure; poiche quell'Autore fà vna particolar mentione
della scuola de' Carracci, e più specialmente di Annibale si è
posto à ragionare. Ma perche egli pensò di trattare diffusa-
mente dell'arte della Pittura, e con qualche lunghezza entrò
ad inuestigarne filosoficamente la sua vera definitione; potrebbe
forse pareroi, che troppo lunga occupatione io vi apportassi qui,
dandoui da leggere tutta la materia nel modo, che egli l'hà
lasciata, che ne meno (come forse egli volea) è interamente
perfettionata. E perciò, posto da parte per hora quel che egli
hà considerato come Filosofo, vi apporterò qui ciò, che può più
appartenere alla presente opportunità per fare al libro delle
Figure non disdiceuole accompagnamento. e voi ancora ricor-
dateui, che pur mi hauete persuaso di aggiugnere alle Figure
del libro alcuna particolarità, che io hauessi, intorno alla vita
di Annibal Carracci, & alla medesima sua professione.

Dice dunque quell'Autore,

[*From here onwards until further notice the original is printed in
italics, to denote that we are concerned with the writings of Machati,
otherwise Agucchi.*]

Maccati, etc.) as a pseudonym of Monsignor Giovanni Battista Agucchi
(1570-1632), cf. notes 13 and 14 of Part II. Malvasia was well aware of
this fact (e.g., cf. *Felsina*, 1678, II, p. 504; and *Le Pitture di Bologna . . . Il
Passeggiere disingannato ed instrutto dell'Ascoso Accademico Gelato* [i.e., Malvasia],
Bologna, 1686, p. 24).

[14] "Mosini's" statement in this passage tends to confirm that he is really
Monsignor Massani, since Tomasini tells us (*Iacobi Philippi Tomasini . . .
Elogia Virorum Literis & Sapientia Illustrium*, Padua, 1644, p. 24) that Agucchi
did in fact bequeath many of his manuscripts to Massani. Moreover
Domenichino (in his letter to Angeloni, cf. above, p. 119) obviously con-
sidered Massani to be the obvious person to approach in order to lay his
hands on the manuscript of the *Trattato*.

Esser cosa molto verisimile, che all'arte ingegnosissima della Pittura auuenisse nel suo nascimento quel ch'è successo à tutte l'arti, cioè di esser nata con semplicissimi, & imperfettissimi principij; e che non arriuasse al colmo della perfettione se non con lunghezza di tempo, e moltiplicità di Operarij, che vno doppo l'altro aggiugnendo alle cose inuentate da gli antecessori, sono in fine arriuati à perfettionarla. E si può tener per vero quel che dicono tutti gli Autori, che il primo principio fosse insegnato dall'istessa natura, con l'ombre de' corpi riceue[n]do il lume; e che si sia cominciato à delineare i dintorni dell'ombre di essi, & indi à distinguere le membra, e poi le parti illuminate dall'ombreggiate: e si può dire, che (secondo afferma Plinio)[15] la prima sorte di Pittura fusse la lineare, ritrouata (com'egli dice) da Cleante Corinthio; e che Ardice Corinthio, e Telefane Sicionio, fossero i primi ad esercitarla senza colori, spargendo solamente delle linee entro le figure per finger l'ombre: e che Cleofante Corinthio fusse il primo, che la colorò di vn sol colore: & Eumaro Ateniese cominciò à distinguere il maschio dalla femina, & ad imitare ogni sorte di figure: e Cimone Cleoneo trouò il modo di variare gli atti del volto, e fù inuentore de gli scorci, e distinse le membra con le giunture, & imitò le vene, e le pieghe delle vesti. Polignoto poi, Aglaofante, Apollodoro Ateniese, e Timagora, e Protegene, e Zeusi, e Parrasio, e Timante, & Aristide [*Page 7*] Tebano, le aggiunsero l'vn doppo l'altro molte parti, che le mancauano; fin tanto che l'arte si fe perfetta, massimamente da Apelle, che più da per se solo, che tutti gli altri la guernì di bellezze. Laonde si rende chiarissimo quello si diceua, che l'arte non è nata da vn solo, ma da molti, & in lunghezza di tempo.

In oltre sarà ancora facil cosa, che gl'intendenti di questo artificiosissimo operare, concedano, che mentre l'vn maestro doppo l'altro è andato aggiugnendo, e perfettionando l'arte, sia anche stata non poca la diuersità delle maniere tra l'vno e l'altro, non solo quanto all'operare più, ò meno eccellentemente, ma secondo la diuersità de' genij, ò dispositioni, ò gusti, hab-

[15] Cf. Pliny the Elder (Gaius Plinius Secundus), *Historia Naturalis*, XXXV, §§ 16 and 56 ff.

biano assai diuersamente le loro opere eseguite, ancorche ad vna medesima meta habbiano tutti hauuta l'istessa intentione, e quando anche sia stata vguale la qualità de' loro ingegni. E si vede ancor hoggi, che più allieui di vn sol Maestro, se ben tutti cercano d'imitar lui, e si conosce dalle opere loro, che sono di quella scuola: nondimeno ciascuno vi pone certa qualità particolare, e propria à se, che da gli altri lo distingue.

Di più, vn'altra differenza si truoua tra gli artefici di questa professione: & è, che se bene ella è vn'arte imitatrice, che può imitare tutto quello, che appare alla veduta; e certamente non dee chiamarsi eccellente Pittore colui, che tutte le cose visibili non sà perfettamente imitare; con tutto ciò molti artefici, studiandosi d'imitare vn sol genere di cose, à quello si sono del tutto appigliati, lasciando stare tutte l'altre, come all'arte loro non appartenga l'imitarle.

In vn'altra cosa più importante sono stati sempre differenti tra di loro li Pittori, cioè intorno all'inuestigare più ò meno la perfettione del bello:[16] poiche alcuni, imitando vno, ò più generi di cose, datisi solamente ad imitare quel che alla facoltà visiua è solito di apparire, hanno posto il fine loro nell'imitàre il naturale perfettamente, come all'occhio appare, senza cercar niente di più. Ma altri s'inalzano più in alto con l'intendimento, e comprendono nella loro Idea l'eccellenza del bello, e del perfetto, che vorrebbe fare la natura, ancorche ella non l'eseguisca in vn sol soggetto, per le molte circostanze, che impediscono, del tempo, della materia, e d'altre dispositioni: e come valorosi artefici, conoscendo, che se essa non perfettiona del tutto vn'individuo, si studia almeno di farlo diuisamente in molti, facendo vna parte perfetta in questo, vn'altra in quello separatamente; eglino non contenti d'imitare quel che veggono in vn sol soggetto, vanno raccogliendo le bellezze sparse in molti, e l'vniscono insieme con finezza di giuditio, e fanno le cose non come sono, ma come esser douebbono per essere perfettissimamente mandate ad effetto. Da che intenderassi

[16] For a discussion of this paragraph, in which Neo-Platonic verbal formulae are made, for polemical reasons, to serve the purposes of a theory which is at bottom Neo-Renaissance in character, cf. above, pp. 139 ff.

ageuolmente quanto meritino di lode li Pittori, che imitano solamente le cose, come nella natura le truouano, e si debba farne la stima, che ne fà il volgo: perche essi non arriuando à conoscer quella bellezza, che esprimer vorrebbe la natura, si fermano sù quel che veggono espresso, ancorche lo truouino oltremodo imperfetto. Da questo ancora nasce, che le cose dipinte, & imitate dal naturale piacciono al popolo, perche egli è solito à vederne di si fatte, e l'imitatione di quel che à pieno conosce, li diletta. Ma l'huomo intendente, solleuando il pensiero all'Idea del bello, che la natura mostra di voler fare, da quello vien rapito, e come cosa diuina la contempla.[17]

[*Page 8*] Nè si creda perciò, che qui non si voglia dare la meritata lode à que' Pittori, che fanno ottimamente vn ritratto. Poiche se bene ad operare perfettissimamente non si dourebbe cercare, quale sia stato il volto di Alessandro, ò di Cesare, ma quale esser dourebbe quello di vn Re, e di vn Capitano magnanimo, e forte: tuttauia i più valenti Pittori, senza leuare alla somiglianza, hanno aiutata la natura con l'arte,[18] e rappresentati i visi più belli, e riguardeuoli del vero, dando segno (anche in questa sorte di lauoro) di conoscere quel più di bello, che in quel particolare soggetto la natura haurebbe voluto fare per interamente perfettionarlo.

Segue appresso, che si consideri, che se gli artefici passati hanno hauuta vna maniera loro particolare, sicome di sopra si è accennato; non perciò si deono costituire tante maniere di dipingere, quanti sono stati gli Operarij: ma che vna sol maniera si possa reputare quella, che da molti vien seguitata; i quali nell'imitare il vero, il verisimile, o'l sol

[17] For the similarity of the end of this paragraph to a passage in Bellori's lecture of 1664, cf. above, pp. 146 f., and notes 125 and 126 of Part II.

[18] For this passage, cf. above, p. 129; for Bellori's rejection of the idealized *portrait*, cf. end of note 102 of Part II. Agucchi's conception of the best type of portraiture was of course classic-idealist in so far as it advocated going beyond "mere" natural appearance. In the outcome it was not necessarily anti-baroque, however. A close combination of idealistic generalization with naturalistic movement and liveliness is of course to be found in some baroque portraits (e.g., certain busts by Bernini); but this was an entirely new, and characteristically baroque, contribution, which had not yet developed when Agucchi wrote.

naturale, o'l più bello della natura, caminano per vn'istessa strada, & hanno vna medesima intentione, ancorche ciascuno habbia le sue particolari, & indiuiduali differenze. Onde benche gli antichi hauessero moltitudine di Pittori; trouamo però, che appresso[19a] i Greci furono prima due le sorti della

[19a to 19b] A passage corresponding to that between 19a and 19b is printed by Bellori, whose version (which was taken, he tells us, "dal suo [i.e., Agucchi's] originale, benche inserto, e commutato da altri sotto oscuro nome") varies to a certain extent from that of Mosini. The section relating to the various Greek schools at the beginning of the passage originates from Pliny the Elder, *Historia Naturalis*, XXXV, § 75; the Mosini version distorts, and the Bellori version preserves, the sense of the passage in Pliny. It will be noted that at the end of Bellori's version some material is introduced which does not appear at all in that of Mosini (particularly the passage relating to Michelangelo). We now quote *in extenso* Bellori's extract from the Treatise (Giovanni Pietro Bellori, *Le Vite de' Pittori*, Rome, 1672, pp. 316-317): "Appresso li Greci furono prima due le sorti della pittura; l'Ellanica, overo Greca, e l'Asiatica. Da poi la Greca si divise in due sorti, Attica e Sicionia, per l'autorità di Eupompo che fù Sicionio; e crebbero tre sorti di pittura, Attica, Sicionia, & Asiatica. Li Romani imitarono i Greci, ma hebbero anch'essi la loro maniera, e perciò quattro furono le maniere de gli Antichi. A tempi moderni, dopo essere stata la pittura per molti secoli sepolta, hà havuto mestieri quasi di rinascere, e nemeno sarebbe così presto rinata a perfettione, se gli Artefici moderni non havessero havuto avanti gli occhi il lume delle statue antiche conservate sino a tempi nostri, dalle quali come anche dall'opere di architettura hanno potuto apprendere quella finezza di disegno che tanto hà aperto la strada alla perfettione. E quantunque si habbia da recare molta lode a tutti coloro che cominciarono a trar fuori questa professione dalle tenebre oscurissime de' barbari tempi, e rendendo à lei la vita, e lo spirito, l'hanno portata à chiarissima luce, e si potrebbono nominare molti eccellenti maestri Italiani, e di altre nationi che ingegnosamente, e con valore hanno operato, con tuttociò essendo già state toccate da altri simili particolarità, con haver anche descritto le loro vite, ci ristringeremo a quei soli soggetti che per commun consentimento de gli intendenti sono stati riputati maestri di prima classe, e capi della scuola loro particolare. E per dividere la pittura de' tempi nostri in quella guisa che fecero li sopranominati Antichi, si può affermare che la scuola Romana, della quale sono stati li primi Rafaelle, e Michel Angelo, hà seguitato la bellezza delle statue, e si è avvicinata all'artificio de gli antichi. Ma li Pittori Venetiani, e della Marca Trivigiana, il cui capo è Tiziano, hanno più tosto imitato la bellezza della natura, che si hà avanti gli occhi. Antonio da Correggio il primo de' Lombardi è stato imitatore della natura quasi maggiore, perche l'hà seguitata in un modo tenero, facile, & ugualmente nobile, e si è fatta la sua maniera da per se. Li Toscani sono stati autori di una maniera diversa dalle già dette, perche hà del minuto alquanto, e del

Pittura, l'Hellanica, ouer Greca, e l'Asiatica. Dapoi l'Hellanica si diuise nella Ionica, e nella Sicionica, e tre diuentarono. I Romani imitarono i Greci, ma hebbero nondimeno ancor essi la maniera differente; e perciò furono quattro le maniere degli antichi.

A' tempi moderni, dopo d'essere stata la Pittura per molti secoli come sepolta, e perduta, hà hauuto mestieri quasi di rinascere da que' primi rozzi, & imperfetti principij dell'antico suo nascimento: e ne meno sarebbe così prestamente rinata, e perfettionata, come le è successo, se non hauessero gli artefici moderni hauuto auanti gli occhi il lume delle Statue antiche conseruate sino à i tempi nostri; dalle quali, si come anche dall'opere di Architettura, hanno potuto apprendere quella finezza di disegno, che tanto hà aperta la strada alla perfettione.

diligente, discopre l'artificio: frà essi eccellentissimi sono Leonardo da Vinci, & Andrea del Sarto Fiorentino. Possono dunque osservarsi quattro spetie di pittura in Italia, la Romana, la Venetiana, la Lombarda, e la Toscana, e l'altre sono accessorie à queste, e dipendenti. La maniera Romana autorizzata da Michel Angelo hà dato l'esempio dello stile grande ricercato di contorni, per lo studio fatto da esso sopra il torso, o tronco della statua di Hercole in Belvedere di mano di Apollonio Ateniese, sopra questa statua Michele formò l'idea delle sue megliori figure: però li suoi corpi hanno le proportioni e lineamenti forti, muscolosi & herculei, come si riconosce nella volta della Cappella di Sisto IV. in Vaticano, per la formatione de gl'ingnudi, e particolarmente nella figura di Aman Crocifisso che è stupenda, con l'altra di Giona; se bene questa rappresenta più tosto un gigante che un Profeta.'' The employment of the literary term *stile* as a virtual synonym for *maniera* (Agucchi repeats it below, p. 256) is relatively rare until almost the end of the Seicento. There are of course earlier instances (e.g., G. P. Lomazzo, *Trattato dell'Arte della Pittura*, Milan, 1584, p. 237), but it is remarkable that Filippo Baldinucci does not refer to it either in its own right or in elucidation of *maniera* in his *Vocabolario Toscano dell'Arte del Disegno* published as late as 1681. On the other hand Félibien, while not according it an independent status of its own, does refer to it in connexion with *manière* (*Des Principes de l'Architecture, de la Sculpture, de la Peinture, . . . avec un Dictionnaire des Termes*, Paris, 1676, p. 646, s.v. *manière*: "Comme l'on reconnoist le style d'un Auteur, ou l'écriture d'une personne dont on reçoit souvent des lettres, on reconnoist de mesme les ouvrages d'un Peintre dont on a veu souvent des Tableaux; & on appelle cela *connoistre sa manière*''). Passeri uses the expression *stile* freely, as we have had occasion to observe (cf. notes 44, 60, 133 and 145 of Part I), and it comes into common use for the Fine Arts during the eighteenth century.

E quantunque si habbia da recare molta lode à tutti coloro, che cominciarono à trar fuori questa professione dalle tenebre oscurissime de' barbari tempi, e rendendo à lei la vita, e lo spirito, l'hanno portata à chiarissima luce; e si potrebbon nominare molti eccellenti Maestri Italiani, e di altre nationi, che ingegnosamente, e con valore hanno operato : con tutto ciò, essendo già state toccate da altri, simili particolarità, con hauer ancor descritta la vita degli stessi artefici; ci restrigneremo qui à que' soli Soggetti, che per comun consentime[n]to de gl'intendenti sono stati reputati Maestri di prima Classe, e capi della scuola loro particolare, e ne faremo quella breue mentione, che all'opportunità presente può appartenere.

E per diuidere la Pittura de' tempi nostri in quella guisa, che fecero li sopranominati antichi; si può affermare, che la Scuola Romana, della quale sono stati li primi Rafaelle, e Michelangelo, hà seguitata la bellezza delle statue, e si è auuicinata all'artifitio degli antichi. Ma i Pittori Vinitiani, e della Marca Triuigiana, il cui capo è Titiano, hanno più tosto imitata la bellezza della natura, che si hà innanzi à gli occhi. Antonio da Correggio il primo de' Lombardi è stato imitatore della natura quasi maggiore, perche l'hà seguitata in vn modo tenero, facile, & [Page 9] egualmente nobile, e si è fatta la sua maniera da per se. I Toscani sono stati autori di vna maniera diuersa dalle gia dette, perche hà del minuto alquanto, e del diligente, e discuopre assai l'artifitio. Tengono il primo luogo Leonardo da Vinci, & Andrea del Sarto tra' Fiorentini; perche Michelangelo quanto alla maniera, non si mostrò troppo Fiorentino: e Mecarino, e Baldassare tra' Sanesi.[20]

Possonsi dunque costituire quattro spetie di Pittura in Italia, la Romana, la Vinitiana, la Lombarda, e la Toscana. Fuori d'Italia Alberto Duro formò la Scuola sua, & è meriteuole della lode, che al mondo è nota: e la Germania, e la Fiandra, e la Francia hanno hauuti molti altri valorosi artefici, c'hanno hauuto fama, e nominanza.[19b]

[20] Mecarino (Mecherino) and Mecuccio were nicknames of Domenico Beccafumi (ca. 1486-1551); the other Sienese artist is of course Baldassare Peruzzi (1481-1536).

Hora si come egli è vero, che li sopranominati Maestri, e tanti altri valent'huomini, che dietro alle vestigia di quelli si sono incaminati alla perfettione dell'arte, hanno recata la gloria a' nostri secoli da vgguagliarsi à quello dell'antichità, quando gli Apelli, e i Zeusi con opere di marauigliosa bellezza eccittarono le lingue, e le penne à celebrare i loro pennelli: così noi potremo affermare quel che à persone di sano intendimento non sarà nascosto; cioè, che dapoi che fiorirono i capi delle Scuole, ò maniere sopradette del secol nostro, e tutti gli altri, che con buon gusto, e sapere d'imitar quelli si studiarono: auuenne[21a] poi alla Pittura di declinare in modo da quel colmo, ou'era peruenuta, che se non sarebbe caduta di nuouo nelle tenebre oscure della barbarie di prima, si rendeua almeno in modo alterata, e corrotta, e smarrita la vera via, che si perdeua quasi affatto il conoscimento del buono: e sorgeuano nuoue, e diuerse maniere lontane dal vero, e dal verisimile, e più appoggiate all'apparenza, che alla sostanza, contentandosi gli artefici di pascer gli occhi del popolo con la vaghezza de' colori, e con gli addobbi delle vestimenta, e valendosi di cose di là e di quà leuate con pouertà di contorni, e di rado bene insieme congionte, e chi per altri notabili errori vagando, si allontanauano in somma largamente dalla buona strada, che all'ottimo ne conduce.

Ma mentre in tal modo s'infettaua (per dir così) di tante heresie dell'arte questa bella professione, e staua in pericolo di smarrirsi affatto; si videro nella Città di Bologna sorgere tre

[21a] to [21b] This passage is quoted in Malvasia's *Felsina Pittrice* (1678, I, pp. 449 f.), and, beginning at "che si perdeva quasi affatto," in his *Le Pitture di Bologna* (1686, pp. 24 f.). It is not impossible that Agucchi may have had Zuccaro's strictures of Tintoretto (in *Il Lamento* of 1605, cf. notes 92 of Part II and 54 of Part III) fresh in his mind when writing the first half of this passage, that concerned with the decline of art. We can hardly imagine that Agucchi was very favourably disposed to a "Tintorettesque" manner, and in this connexion certain late Cinquecento Venetian elements in Guercino's early style may perhaps have struck Agucchi as somewhat infected with the heresy against which he inveighs! (For a suggestion of the present writer that Scarsellino played a part in passing on Venetian influences to Guercino in his very early days, cf. *The Burlington Magazine*, LXX, Jan.-June 1937, pp. 177 ff.).

soggetti, i quali essendo strettamente congionti di sangue, furono tra loro non meno concordi, & vniti col proponimento di abbracciare ogni studio, e fatica, per giugnere alla maggiore perfettione dell'arte.

Furono quegli, Ludouico, Agostino, & Annibale Carracci Bolognesi; de' quali il primo era Cugino degli altri due, che erano Fratelli carnali: e come che quegli fosse maggiore di età, fù anche il primo, che si diede alla professione della Pittura, e da lui riceuerono gli altri due i primi ammaestramenti dell'arte. E perche tutti tre erano felicemente dotati di quel dono di naturale habilità, che tanto à quest'arte assai difficile si richiede; ben presto si auuidero, che conueniua riparare al cadente stato di essa per la corruttione sopradetta.[21b] Laonde mentre nella Città di Bologna poteron riuolger l'animo ad alcune opere di Titiano, e del Correggio, sopra quelle fecero il primo studio loro.[22] E ben considerando con quanto intendimento, e buon gusto hauessero que' due gran Maestri imitata la natura, si posero con esattissima diligenza à studiare sopra il naturale con quella stessa [*Page 10*] intentione, che da quell'opere si raccoglieua hauer hauuto gli stessi Correggio, e Titiano. Appresso non contenti di contemplare quelle sole opere di quei Maestri, che erano in quella Città, si trasferirono à bello studio à Venetia, & ad altri luoghi della Lombardia, doue n'erano in gran copia, non solo di que' due gran soggetti, ma de' loro megliori seguaci in buon numero. Perciò datisi li Carracci ad imitare mirabilmente quelle maniere, giunsero ben presto à vn segno, che coll'vtile, ne riportarono no[n] poco credito, e nominanza. Onde dopo d'hauer fatte diuerse opere per quelle Città, tornati à Bologna, doue costuma quella nobiltà di conoscere, stimare, & amare la virtù, fù da que' Signori auualorato in modo l'animo di que' tre valorosi Giouani co[n] proportionate occasioni di lor vtile, e soddisfattione; che me[n]tre si veniua ad arricchire la Città di molte opere di lor mano, eressero

[22] It seems that Agucchi may have been romancing here; at any rate I know of no record of any "public" pictures by Titian or Correggio having been at Bologna at this time.

ancora vn'Academia del Disegno:[23] nella quale studiando del continuo sopra il naturale non solo viuo, ma spesse volte de' Cadaueri hauuti dalla Giustitia, per apprendere quel vero rilassamento, che fanno i corpi; essi si alzarono sempre più à gradi di maggior eccellenza; e furon cagione, che molti della giouentù s'inuaghirono di così bell'arte, e bella maniera di que' Maestri; e dandosi alla medesima professione, ne sono poi riusciti li soggetti, che parimente con gran valore si sono resi al mondo famosi.

Mentre[24a] di sopra si è accennato, che Ludouico era maggiore di età, e fù il maestro degli altri, e si soggiunge qui, che Annibale era più giouane di Agostino; conuien qui dire quel che fù verissimo, cioè, che in breue tempo arriuarono tutti ad vn segno, che hauendo occasione di operare in luogo, doue quasi in vn volger di occhi si vedean l'opere di tuttitre insieme, si riconosceua bene qualche cosa particolare, e propria di ciascun d'essi; ma quanto all'eccellenza dell'opere non sapeuano gl'intendenti fare vna minima differenza tra l'vna, e l'altra; & in gran numero furono le opere da lor fatte in Bologna con tale vguaglianza, & egualmente lodate, acquistando tutti insieme il credito, e'l nome di valentissimi Maestri.[24b] Ben' è vero, che crescendo Annibale in età, daua[25a] sempre segni grandi di maggior viuezza di spirito, e di esser più degli altri due della natura aiutato.[25b] Ma Agostino attendeua ancora all'intaglio del Bolino, nel cui genere di operare non si sà forse chi à lui sia andato innanzi, e congiungesse insieme così perfettamente (com'egli fece) con la peritia dell'intaglio la vera maniera del ben disegnare; si come la moltitudine delle carte, che si veggono

[23] For the Accademia degli Incamminati, cf. Dr. Heinrich Bodmer's study in the periodical *Bologna* (Enrico Bodmer, "L'Accademia dei Carracci," Bologna, 1935, fasc. 8, August). Cf. also note 86 of Part IV.

[24a] to [24b] This passage is quoted by Malvasia (*Felsina*, 1678, I, p. 489). Lodovico was born in 1555, Agostino in 1557 and Annibale in 1560 (cf. *Memorie Originali Italiane risguardanti le Belle Arti*, ed. Michelangelo Gualandi, I, Bologna, 1840, pp. 52 f.) The reference to the work carried out by all three together is presumably to such undertakings as the decorations in the Palazzi Fava, Magnani and Sampieri at Bologna.

[25a] to [25b] This fragment is quoted by Malvasia (*Felsina*, 1678, I, p. 489).

da lui intagliate, ne fà certissima testimonianza. E parendo, che Ludouico si fermasse in quel grado di eccellenza, ou'era peruenuto, cominciò Annibale ad[26a] apparire superiore à gli altri, e traeua gli occhi degli intendenti à rimirare le sue opere con vna più particolare curiosità, e delettatione. E quanto all'imitare Titiano, e'l Correggio, arriuò egli tant'oltre, che i migliori conoscitori dell'arte riputauano le opere di lui, essere di mano di que' medesimi Maestri.[26b] & à tale proposito non si lascerà qui di far mentione, che vn Signore principale, à cui Annibale dipinse alcuni quadri, l'auuertì, che[27a] egli si pregiudicaua troppo nello stare così intento all'imitatione delle maniere di que' due Maestri, perche i riguardanti, troppo ingannati dal credersi di mirare l'opere di mano degli stessi Correggio, e Titiano, ne dauano ad essi la lode,[27b] & egli, che n'era il vero autore, ne rimaneua priuo. Ma Annibale [*Page 11*] gli rispose, che non pregiuditio, ma guadagno grande si riputerebbe, se le sue opere partorissero veramente quell'inganno, perche il Pittore non hà da far altro, che ingannar gli occhi de' riguardanti, facendo lor apparire come vero quello, che solamente è finto: e soggiunse à quel Signore, che douea ben' egli stare auuertito, che que' riguardanti non fossero più tosto ingannatori, che ingannati; mentre che lodando troppo quelle pitture, non volessero forse ingannare più tosto il padrone di esse, & il Pittore insieme; dicendo Annibale quel che solea dire spesso; perche infinita era la schiera degli adulatori, che meglio del Pittore sanno fingere, dar ad intendere, & ingannare.[28]

[26a] to [26b] This fragment is quoted by Malvasia (*Felsina*, 1678, I, pp. 488 f.). We observe that Agucchi uses the expression *conoscitore* (cf. note 10 of this Appendix).

[27a] to [27b] This fragment is quoted by Malvàsia (*Felsina*, 1678, I, p. 491).

[28] We may quote an anecdote, told by Mancini, which illustrates Annibale's good-humoured irony and scepticism in much the same way (Biblioteca Nazionale Marciana, Venice, MS. it. 5571, fol. 162 recto f.): ". . . Anibal Caracci nel princ.o che venne à Roma, condusse in una tela nuova adornata d'un ornam.to vecchio un χρο [Cristo] flagellato e tirato p[er] i capelli da i manigoldi di maniera di Frà Bastiano [del Piombo], lo fece veder appiccato al muro da quel suo poco benevole quale lo lodò, e soggiunse, che di quei mastri se n'era persa la forma; all'hora Annibale che era presente sorridendo disse Mons.r Ill.mo p[er] Iddio gratia vivo, ne hò

Crescendo intanto il credito di quell'Academia, vi concorreuano non solo coloro, che la Pittura si eleggeuano per lor professione, ma molti di que' Signori, e diuersi altri forestieri, che per l'occasione dello studio colà si trouauano, spessissime volte per lor diletto la frequentauano. Et era così efficace il lume, che apportaua il veder operare que' Maestri; e così ben fondata era la maniera già introdotta; che oltre alli molti allieui professori, che diuentarono valorosissimi soggetti, vi furono ancora non pochi di que' Gentilhuomini, e Caualieri, che per sola delettatione si resero atti à far delle cose degne di esser vedute, e stimate da coloro, che maggiormente le conoscono.

Non essendo poi il nostro proponimento di far qui mentione di tutte l'opere de' Carracci da lor fatte in Bologna, e in Lombardia; basterà accennare, che moltissime ne fecero, e ne riportarono di tutte applauso, e commendatione. Ma seguiteremo bene à dire, che essendosi essi perfettionati in quelle maniere di bellissimo colorito tenero, facile, e naturale, entrarono poi in[29a] gran desiderio, e curiosità di vedere le Statue di Roma, che vdiuano oltre modo celebrare da coloro, che vedute l'haueuano.[29b] E perche quando essi andaron per la Lombardia, si fermaron alcun tempo in Parma per fare studio nella gran Cuppola del Correggio; & Agostino, & Annibale in particolare hebber occasione di farui dell'opere[30a] per quel Serenissimo con molto gusto di Sua Altezza, ciò aperse loro l'adito di poter venir poi à Roma, appoggiati alla protettione del Sig. Cardinale Odoardo Farnese.[30b] Laonde restando

voglia di morire all'hora staccato il quadro e vedutolo In tela nuova soggiunse p[er] una scusa, che no[n] havea visto che fusse in tela, et che era stato ingannato da quell'ornamento; Alche soggionse Annibal con i suoi sali e motti che la pittura si faceva p[er] essere guardata d'avanti e no[n] di dietro, e che p[er] non buttar quell'ornamento c'haveva incassato quel quadro, et appresso, che la sua maniera ordinaria gli pareva meglio di quella, e per tanto [Mancini adds: *per*] operar meglio e nel presente, e nell'avenire haverebbe operato nel suo modo consueto e naturale . . ."
 29a to 29b and 30a to 30b These two fragments are quoted by Malvasia (*Felsina*, 1678, I, p. 403). *Sua Altezza* is Ranuccio I, Duke of Parma (1569-1622), who had succeeded his father Alessandro Farnese, Philip II's governor-

Ludouico à Bologna, doue hebbe sempre occasioni importanti,
e principali di lauorare, con sua grandissima lode, e soddis-
fattione; Agostino, & Annibale à Roma se ne vennero, e dal
Cardinale sopradetto, che del valor loro hauea notitia, furono
volontieri accolti, e prestamente al suo seruitio destinati.[31]

Subito che viddero le Statue di Roma, e le Pitture di Rafaelle,
e Michelangelo, e contemplando specialmente quelle di
Rafaelle; confessarono ritrouarsi per entro più alto intendi-
mento, e maggior finezza di disegno, che nell'opere di Lom-
bardia: e giudicarono, che per costituire vna maniera d'vna
sourana perfettione, conuerrebbe col disegno finissimo di Roma
vnire la bellezza del colorito Lombardo.[32] E poiche ben presto
si auuidero, quale studio hauesse Rafaelle fatto sopra le cose
antiche, donde hauea saputo formar l'Idea di quella bellezza,
che nella natura non si troua, se non nel modo, che di sopra si
diceua; si misero li Carracci à fare studio sopra le più celebri,
e famose Statue di Roma; e come che fosser già gran maestri,
in breue tempo dieder segno di essersene grandemente appro-
fittati.

[*Page 12*] Soggiugneremo qui ancora non fuori del nostro
proposito, che Agostino oltre l'eccellenza sua nell'arte del
Disegno, della Pittura, e dell'Intaglio, haueua ancora vna

general in the Netherlands, at the end of 1592. Prof. Hans Tietze points
out ("Annibale Carraccis Galerie im Palazzo Farnese und seine römische
Werkstätte," in *Jahrbuch der kunsthistorischen Sammlungen des allerhöchsten
Kaiserhauses*, XXVI, 1906-07, p. 63, note 2) that Lodovico Carracci had
received payments on 11 May and 12 June 1593 for work in connexion with
the funeral of Alessandro. Odoardo Farnese (1574-1626), the younger son
of Alessandro, was created Cardinal as a youth in 1591.

[31] The precise date and circumstances of the arrival of Annibale and
Agostino Carracci in Rome to work for Cardinal Odoardo Farnese are not
finally established. The question is dealt with by Tietze (*op. cit.*, Vienna
Jahrbuch, XXVI, 1906-07, pp. 54 and 57); it seems possible that they both
came to Rome for the first time towards the end of 1594, that they were
both back in Bologna during the course of the next year, that Annibale had
returned to Rome by the end of 1595, and that Agostino followed him there
later on.

[32] For this characterization, which Agucchi repeats later (p. 257 below),
and which was evidently shared by Mancini (cf. note 36 of Part I), see
p. 204 above.

particolare habilità al ben discorrere d'ogni cosa, e della professione sua specialmente, apportando gran diletto à coloro, che l'vdiuano; onde ciò era cagione, che non solo per vedere le opere di lui, e di Annibale, concorreuano in quel principio alla loro habitatione molti Gentilhuomini del Cardinale, & altri virtuosi, ma per vdir li discorsi di Agostino ancor volentieri vi andauano. e raccontaremo, che tra l'altre volte, ritrouandosi nelle loro stanze vna mano di galant'huomini; e discorrendo Agostino, del gran sapere mostrato dagli antichi nelle Statue; e fermatosi à celebrare specialmente il Laoconte veduto da lor di fresco; egli haurebbe voluto, che Annibale ancora alcuna cosa n'hauesse detta: ma questi, che assai diuerso dal Fratello era di genio, e di gusto, quanto al compiacersi di ragionare; poiche amaua più la ritiratezza, a fuggiua à bello studio le occorrenze de' discorsi, e sol taluolta con gran viuezza di spirito rispondeua breuemente, pareua quasi, che pochissimo conto egli facesse di quel ragionamento del Fratello; onde Agostino se ne mostrò offeso, e con risentimento motteggiò alcuna cosa contro Annibale, come mostrasse di non apprezzare quello studio, che si erano proposti di fare sopra le Statue antiche, e sopra quella in particolare, di cui egli parlaua, che era di tanta isquisita eccellenza; della quale come poco curante pareua quasi, che Annibale si fosse dimenticato, ò non l'hauesse veduta. E proseguendo poi Agostino i suoi ragionamenti, che con attentione, e gusto erano da quegli altri ascoltati, mostraua sempre più Annibale di dargli poco orecchie: e mentre egli vedeua il Fratello più inferuorato nel celebrare quell'antica Scoltura, e gli altri più che mai attenti ad vdirlo, si accostò al muro della stanza, e senza che niuno se n'auuedesse, vi disegnò con vn carbone la figura del Laoconte, e gli venne così felicemente espressa, come hauesse hauuto dinanzi à gli occhi l'originale, per farne vn'aggiustatissimo contorno. Della qual cosa accortisi poi tutti, rimasero oltre modo ammirati, & Agostino confessò, che con la marauiglia, in se stesso si sentì non poco mortificato: poiche, essendosi per prima quasi creduto, che il Fratello non hauesse più il pensiero à quella Statua; si auuide poi, che meglio di lui l'haueua Annibale impressa nella fantasia, e

saputala in modo disegnare, che à lui certamente non daua l'animo di arriuarui. e dicendo egli sopra di ciò varie cose, e lodando il valor grande del Fratello: & approuandosi il tutto da i circostanti, stauano pur attenti se Annibale alcuna cosa dicesse. e finalmente, mostrando egli di volere da loro partirsi, disse ridendo: Noi altri Dipintori habbiamo da parlare con le mani. E così lasciando tutti pieni di marauiglia non meno per cagion del disegno, che delle parole poche, ma à proposito, e significanti, dalla stanza da per se solo se ne vscì.[33]

Non istette questo auuenimento senza essere particolarmente notato, e stimato degno di essere raccontato à chi dell'opere ingegnose si diletta. e peruenutane la notitia al medesimo Cardinale, si compiacque di andar à veder subito quel Disegno, e grandemente lo lodò; si come fecero molti altri, che à bella posta, per vederlo, à quella stanza con grande curiosità si trasferirono.

Accortosi per tanto Annibale del compiacimento, che per questa sua poca cosa [*Page 13*] molti si prendeuano; e come fosse piaciuta all'istesso Cardinale, si pose à fare diligentemente vn Disegno in carta; d'vn'altro Laoconte di sua propria inuentione, tutto diuerso da quello antico di marmo: & eseguì vn pensiero tanto eleuato, & in ogni parte ottimamente inteso, considerato, e finito; che da i più intendenti fù riputato vn parto di felicissimo ingegno, e di sapere di sodissimo fondamento. Onde il Cardinale, che ben presto hebbe il Disegno nelle mani, se lo tenne carissimo, e come cosa di molta bellezza la mostraua con suo gran gusto à coloro, che l'altre sue belle cose, e singolari, spesse volte à vedere se n'andauano.

Ritrouandosi dunque il Cardinale appresso di se que' due gran Maestri, deliberò di arricchire il suo Palazzo anche con le opere di lor mano: & oltre à diuersi quadri à olio, si posero à dipignere à fresco alcune picciole Camere, & vna Galleria assai grande dalla parte del Palazzo verso'l Teuere. E con tutto che cominciassero li due Fratelli que' lauori, come hauesser da toccare ad amendue insieme, senza veruna distintione; e nel

[33] This story is retold more briefly by Bellori (*Vite*, 1672, p. 31), and is referred to, under Mosini's name, by Malvasia (*Felsina*, 1678, I, p. 480).

vero vi si veggono delle cose degne di gran lode tanto dell'vno, quanto dell'altro; ad ogni modo, à lungo andare, nascendo[34a] tra loro de' dispareri per cagione d'alcuno, che amaua di vederli disuniti, Agostino pensò di leuar l'occasione de' disgusti, e di lasciar al Fratello tutto il peso di que' lauori, e della Galleria in particolare,[34b] della quale restaua à farne la maggior parte; e diceua liberamente, ch'egli si conosceua di esser non poco superato da Annibale nel felicemente operare, e che perciò conueniua di lasciar à lui il pensiero di condurre il tutto à. fine. Laonde se ne tornò Agostino à Bologna, & indi andato di nuouo à Parma per seruire il Duca,[35] alcun tempo vi si trattenne col dipignere varie cose, conforme al suo valore; sinche iui terminò i suoi giorni, mentre che à quell'istesso seruitio era impiegato.[36]

Rimas[t]o solo Annibale ad operare pe'l Cardinale, continuò molti anni, e diede fine alla Galleria con diuerse altre opere, che li furon da quel Signore ordinate; sicome diuerse ne fece anche per altri, che tutte meriterebbono d'essere particolarmente commendate. Ma se si hauessero da descriuere qui solamente le cose da lui fatte in quel magnifico Palazzo, e ponderare i gradi di sapere, e d'eccellenza, a' quali in esse egli dà à diuedere di essere arriuato; troppo lungo sarebbe il diuisarne à bastanza intorno ad vna sola piccola parte, arriuando anche solamente ad accostarsi al vero.

Ma poiche di sopra si fece mentione de' Pittori antichi, e moderni, e delle loro maniere, e differenze tra essi; aggiugneremo qui alcun'altra poca cosa, dalla quale, insieme col rimanente, più chiaro apparirà essersi poi il tutto non fuori di proposito diuisato.

Considerando Aristotile, che necessariamente si doueuano

[34a] to [34b] This fragment is quoted by Malvasia (*Felsina*, 1678, I, pp. 403 f.).

[35] Tietze (*op. cit.*, Vienna *Jahrbuch*, XXVI, 1906-07, p. 127, note 4) records a payment to Agostino at Parma on 5 November 1600, to cover the period from 1 July of that year.

[36] Tietze (*op. cit.*, p. 130, note 5) quotes a document at Parma as authority for 23 February 1602 as the date of Agostino's death. Bellori's date of 22 March 1602 (which is frequently repeated, e.g., in Thieme-Becker, VI, 1912, p. 53) is thus incorrect.

dalla Poesia imitare persone di qualità, ò migliori di quelle del
suo tempo, ò peggiori, ò simiglianti : lo prouò con l'esempio della
Pittura ; perche Polignoto imitò i migliori, Pausone i peggiori,
e Dionisio i simiglianti.[37] E non è dubbio, che frà gli antichi,
altri molti non vsassero gli stili medesimi : poiche gli Apelli, i
Zeusi, i Timanti, i Parrasij, & altri diuersi imitarono i migliori.
E Plinio[38] racconta, che Pierico conseguì somma gloria nell'
imitare cose basse ; come delle botteghe de' Barbieri, e de'
Calzolai, e degli [*Page 14*] asinelli, e delle robbe da mangiare,
e simili. E Callicle pure imitò cose piccole : e Calare dipinse
tauolette d'argomenti comici : & Amulio Romano fù stimato
nella Pittura di cose humili. Ma Antifolo imitò egualmente i
migliori, e i peggiori : e Quintiliano[39] afferma, che Demetrio,
benche questi fosse Scultore, andò tanto dietro alla simiglianza,
che alla bellezza non hebbe riguardo. Ma a' nostri tempi Rafaelle,
e la Scuola Romana di quel secolo, come di sopra si è detto,
seguendo le maniere delle Statue antiche, hanno sopra gli altri
imitati i migliori : & il Bassano è stato vn Pierico nel rassomi-
gliare i peggiori :[40] & vna gran parte de' moderni, hà figurati gli

[37] Aristotle, The *Poetics*, beginning of Ch. II : "Πολύγνωτος μὲν γὰρ κρείττους,
Παύσων δὲ χείρους, Διονύσιος δὲ ὁμοίους εἴκαζεν."
[38] Pliny the Elder, *Historia Naturalis*, Book XXXV : for Peiraïkos, § 112 ;
for Kallikles, Kalates (="Calare") and Antiphilos (="Antifolo"), § 114 ;
for Famulus (="Amulio") § 120, though Pliny does not mention that he
was noted for painting subjects of humble type.
[39] Quintilian, *Institutio Oratoria*, XII, 10, § 9 : "Ad veritatem Lysippum
ac Praxitilen accessisse optime adfirmant. Nam Demetrius tanquam nimius
in ea reprehenditur et fuit similitudinis quam pulchritudinis amantior."
Cf. note 78 of Part II.
[40] By way of corrective to Agucchi's inference that Bassano is to be rated
as an artist of minor consequence we may quote a remarkable passage by
Marco Boschini, which provides a complete contrast in approach and treat-
ment to the classic-idealist point of view. This characteristic example of
intuitive painterly appreciation is from the unpaginated preface to Le Ricche
Minere della Pittura Veneziana (Venice, 1674) and runs as follows : "Questo
gran Classico [Bassano !] dunque è stato di cosi fiero colpo di pennello, che
certo in simile maneggio non hà havuto pari, & à differenza d'ogn'altro,
sprezzando la diligenza, e la finitezza, con un Caos (per cosi dire) de colori
indistinti, e miscugli di confusione, che da vicino, e sotto l'occhio rassem-
brano più tosto un sconcerto, che un perfetto artificio, e pure quello è
un'inganno cosi Virtuoso, che non confondendosi sul fatto, ma scostandosi

eguali; e fra questi il Carauaggio eccellentissimo nel colorire si dee comparare à Demetrio, perche hà lasciato indietro l'Idea della bellezza, disposto di seguire del tutto la similitudine.[41]

Hor hauendoci portato il proposito à parlare della Scuola de' Carracci, e di Annibale più in particolare; rimane, che alcuna comparatione di lui si faccia con li sopranominati Pittori, così antichi, come moderni. Onde diremo, che qua[n]to all'esser egli stato imitatore di coloro, che la più rara bellezza di esprimere si studiarono, hauendo egli conseguito quel fine, che nel suo primo arriuar a Roma si propose, di congiugnere insieme la finezza del Disegno della Scuola Romana, con la vaghezza del colorito di quelle di Lombardia; si può affermare, che in questo genere di oprare, che la più sourana bellezza ricerca, egli sia arriuato ad vn grado eminentissimo. Poiche se più all'indiuiduo in tutte le sue opere, e specialmente in quella Galleria di sopra nominata, si mira alla dispositione del tutto, alla rara inuentione di ciascuna parte, al componimento, al disegno, & isquisitezza de' contorni, alla vaghezza, e morbidezza del colorito, alle proportioni, alla bellezza, alla maestà, alla grauità, alla gratia, alla leggiadria, alla nobiltà de' soggetti, al decoro, alla viuacità, & allo spirito delle Figure, à gl'ignudi, a' panneggiamenti, à gli scorci, alla viua espressione degli affetti, & à tutti gli altri accompagnamenti, e qualità, e circostanze, che negli oggetti visibili si ponno vedere, ò imaginare; può certamente vn'intelletto eleuato, e delle belle arti ben capace, rinuenirui per entro quell'Idea del perfetto Pittore, che si forma Aristotile dell' ottimo Poeta, e Cicerone dell'Oratore.

Ma doppo d'hauere di questo Artefice sin qui breveme[n]te

in debita distanza l'occhio, e l'or[e]cchio dell'Intelletto restano paghi, e godono la più soave armonia, che render possa un ben accordato istrumento, tocco da maestra mano, e la più simpatica unione trà l'Arte, e la Natura, che possi formare concerto humano. Questo singolarissimo Pittore ha sempre applicato il suo genio in rappresentare la pura humiltà . . . hà dimostrato, che tanto rende ammirazione il raffigurare le humili figure quanto le rappresentanti gli Rè, e gli Monarchi Mondani pomposamente vestiti . . ." It may be added that Agostino Carracci had a high opinion of Bassano (cf. note 53 of this Appendix).

[41] Cf. note 107 of Part I.

diuisato, lasceremo, che quanto à gli altri generi d'imitare, e'l ponderarne per ogni verso maggiormente, rimanga al sano giuditio di coloro, i quali dal conoscimento illuminati, il bello, e'l vero, & il buono discernono, e danno nel lor concetto alla virtù quel luogo, che in altri, priui di quel lume, vien' occupato dalla vana voce del volgo, dall'aura fauoreuole della fortuna, ò dalla forza della lingua di tal vno, che più vale nell'adoperar questa, che la mano: e bene spesso poi n'auuiene, che il vero Virtuoso di queste professioni sia lasciato da parte, & i Principi defraudati di quella gloria, che à tempo loro, e per sempre potrebbon ageuolmente conseguire.[42]

[*Here the italics cease in the original, denoting the end of the extract from the writings of Machati, otherwise Agucchi.*]

Sino à questo segno (ò benigni, e virtuosi Lettori) mi è paruto à proposito di farui parte delle osseruationi di quello Scrittore. E poiche egli hà lasciato di considerare, ò di esprimere in particolare, se il Carracci fosse anche imitator valente degli oggetti simili al vero, & à quelli, che inferiori, ò [*Page 15*] più vili, ò difettosi si trouano; perche forse à lui è paruto assai basteuole il mostrare, che ottimo imitatore sia stato della bellezza, che solo dall'alto intendimento viene compresa: io hò giudicato di doueruene aggiugnere alcuna cosa da per me; e massimamente, che l'istesso libro delle Figure, che à Voi vien dedicato, ne porge opportuna occasione da osseruare, se Annibale Carracci

[42] The guess might be hazarded that this passage could partly be connected with the patronage of the Cavaliere d'Arpino by Clement VIII and the Aldobrandini family (at a time when Agucchi himself was a rather junior member of their entourage). Agucchi may well have regretted that his friend Annibale was not given any large and important commissions by the Pope and may have laid the blame for this on the misguided influence of "altri, privi di quel lume," together with the forceful language of the Cavaliere, who, Bellori tells us in a *postilla* to Baglione's *Vite* (facsimile ed., pub. in 1935 by the R. Istituto d'Archeologia e Storia dell'Arte, p. 374), was "astuto, et sapeva dar martello, et vendere la sua mercanzia." Agucchi's insertion of the *vana voce del volgo* as an element detrimental to enlightened judgment may perhaps have some connexion with Caravaggio, though it could of course have none with the Aldobrandini.

si possa paragonare à Dionisio, à Demetrio, & ad altri, che gli
oggetti imitauano, come nel naturale li ritrouauano. poiche il
maggior argomento, che di ciò io sia per apportarui, sarà il
porui auanti à gli occhi le medesime figure: le quali, se somi-
gliantissime fossero à quelle stesse persone, che al tempo di Anni-
bale per la Città di Bologna andauano attorno; oltre che lo
potrete sentir affermare da que' medesimi, che le han conosciute,
e raccontare da altri, come cosa, che è stata notissima; io mi
persuado, che'l vostro proprio giuditio ve ne. renderà intera-
mente certi: perche considerando tanta diuersità d'effigie di
volti, di età, di contorni, degli habiti, delle attitudine [*sic*], e
posamenti, & altre particolari qualità à simili sorte di persone
proprie, e proportionate; comprenderete, dico, che da quel
valoroso Artefice sono stati gli oggetti come appunto nel
naturale gli hà trouati, mirabilmente imitati.

Quanto[43] poi all'imitatione degli altri oggetti peggiori del

[43] This paragraph is of considerable interest as a document in the early
history of caricature. The portrait caricature (in the strict sense of the
term, as the comic distortion of a particular individual) seems to have
been the invention of Annibale Carracci, as has been frequently pointed
out (e.g., E. H. Gombrich and E. Kris, *Caricature*, Harmondsworth,
1940, p. 10). Unfortunately (as Dr. Gombrich tells me) we are not yet
on completely sure ground as regards the definite attribution of exist-
ing caricatures to Annibale; but the evidence in the written sources
pointing to him as the inventor of the *genre* is certainly weighty. We may
add to Mosini's remarks a quotation from Mancini (Biblioteca Nazionale
Marciana, Venice, MS. it. 5571, fol. 163 recto): ". . . per esprimer la
similtud.ne col disegno fù singolar Anibal Caracci, perche alle volte p[er]
scherzo haverebbe visto qualched'uno in luogo contrasegnato, che haveva
qualche cosa da vender di suo gusto tornato à casa lo faceva con doi linee
lo dava à qualched'uno de suoi Giovani ordinandoli che andasser' [sic] à
comprar q[ue]lla tal cosa da quel tal ritratto[,] per tralasciar quei ritratti
ridicoli d'augumento [i.e., *aumento*, in the sense of emphatic stressing] di
difetto na[tura]le scherzi proprij di q.ta scola nel q.le escede [i.e., *eccede*] il
S.r Domenico detto Domenichino . . ." Mancini's *doi linee* is interesting in
that it singles out at a very early date one of the most important charac-
teristics of modern caricature. Bellori refers (*Vite*, 1672, p. 75) to Annibale's
practice of writing facetious verses and *motti* on his caricatures, and Mancini
says something similar of Agostino's "composition[i] facete accompagnate
con terzetti e madrigali, che si son [Mancini adds: *viste*] in più occasioni di
sue Pitture redicole che un gentilhuomo di studio ne hà un libretto"
(Marciana MS. it. 5571, fol. 5 recto).

vero, ò più vili, ò difettosi, che fù seguitata da Pierico, e da
altri; io vi soggiugnerò vna particolarità, che à molti di voi io
sò non essere nascosta; ma forse non considerata da tutti per
quel verso, che la considerò, chi di essa n'vdì parlare l'istesso
Carracci. Io dico, che intorno à questa sorte d'imitatione
soleua dire Annibale, che[44a] sicome noi veggiamo, che lo
scherzare, e'l giuocolare, è cosa molto propria non solo à gli
huomini, ma etiandio à gli animali, tra' quali ve ne sono, che
à pena nati à scherzare incominciando, danno segno di non
hauer il maggior instinto naturale, che al nutrirsi, & al trastul-
larsi; (diceua egli) che la Natura nell'alterare alcun' oggetto,
facendo vn grosso naso, vna gran bocca, ò la gobba, ò in altra
maniera alcuna parte deformando, ella n'accenna vn modo di
lei di prendersi piacere, e scherzo intorno à quell'oggetto, e di
sì fatta deformità, ò sproportione, ridersi ancor' essa per sua
ricreatione. E così piaceuolmente soggiugneua Annibale, che
quando l'artefice questi tali oggetti imita, non può far dimeno
di non co[m]piacersene ancor esso, e darne egualmente diletto
ad altri; poiche le cose in tale maniera dalla natura prodotte,
hauendo per se stesse del ridicolo, riescono poi, quando sono
ben' imitate, doppiamente diletteuoli: perche il riguardante
gran piacere si pre[n]de dalla qualità, che muoue à riso; e gode
dell'imitatione, che per se stessa è cosa diletteuolissima. Ma
quando l'artefice imita questa sorte d'oggetti, non solo come
sono, ma senza leuare alla similitudine, li rappresenta maggior-
me[n]te alterati, e difettosi: e nella Scuola de' Carracci hebber
nome di Ritrattini carichi; s'aggiugneua (diceua Annibale) la
terza cagione del diletto, cioè la caricatura;[45] la quale quando

[44a] to [44b] The passage between 44a and 44b is quoted by Malvasia (*Felsina*,
1678, I, pp. 379 f.; for a passage on caricatures by Malvasia himself, cf. I,
pp. 468 f.); though when making the quotation he mentions Mosini as the
author, he erroneously attributes it to "Monsig. Agucchi, sotto nome di
Graziadio Macchati" in his index (*Felsina*, 1678, II, p. 534). Dr. Juynboll,
who apparently did not know the Preface as printed by Grignani in 1646
(that is to say, with the Agucchi section in different type from that of
Mosini), did however suspect that the author of this passage was Mosini and
not Agucchi (W. R. Juynboll, *Het komische genre*, 1934, p. 103).

[45] It seems probable that the actual word caricature, as used in its modern
sense, was invented by Annibale, and it is quite possible that this is its first

era fatta bene, eccitaua maggiormente il riguardante al ridere. Ma con più alto intendimento, e con gusto, egli tal lauoro in [*Page 16*] questo modò consideraua, dicendo, che quando il valente Pittore fà bene vn ritrattino carico, imita Rafaelle, e gli

appearance in print. The expression also appears in print two years later in connexion with one of the greatest practitioners of the art, Gianlorenzo Bernini (1598-1680), in an anonymous poem entitled *Parallelo tra la città e la villa* (Bracciano, 1648) of which an extract is quoted by Prof. Antonio Muñoz (*Roma Barocca*, 2 ed., Milan/Rome, 1928, pp. 441 f.), who says it is by Paolo Giordano II Orsini, sixth Duke of Bracciano. Bellori describes Annibale's caricatures as "ritratti burleschi, overo caricati" (*Vite*, 1672, p. 75), and the term soon found its way into general usage in Italy. It is defined as follows in 1681 (Filippo Baldinucci, *Vocabolario Toscano dell'Arte del Disegno*, Florence, 1681, p. 29): "E caricare dicesi anche da' Pittori o Scultori, un modo tenuto da essi in far ritratti, quanto si può somiglianti al tutto della persona ritratta; ma per giuoco, e talora per ischerno, aggravando o crescendo i difetti delle parti imitate sproporzionatamente, talmente che nel tutto appariscano essere essi, e nelle parti sieno variati." Mancini's *augumento di difetto* (cf. note 43 of this Appendix) is of course similar to Baldinucci's *crescimento*, and naturally involves the idea of giving more weight (*carico*) or emphasis to the defects and thus exaggerating them, but Mancini himself does not, as far as I am aware, make use of the expression *caricatura* itself. *Caricare* could also carry the meaning of to load or to charge, in the sense of a firearm, and though this was probably not the original connotation of our use of the term, it was eminently suitable for something which came to have a sting in it. As Drs. Heinrich Brauer and Rudolf Wittkower have pointed out (*Die Zeichnungen des Gianlorenzo Bernini*, Berlin, 1931, p. 182), Bernini seems to have introduced the term into France while at work on his bust of Louis XIV. M. de Chantelou had to make an impromptu translation for the benefit of the King, and describes the incident (which occurred on 19 August 1665) as follows in his diary (pub. in *Gazette des Beaux-Arts*, 1879, pt. 1, p. 294): "M. de Créqui s'étant avancé pour parler au roi à l'oreille, le Cavalier [Bernini] a dit en riant: 'Ces messieurs-ci [the courtiers] ont le roi à leur gré toute la journée et ne veulent pas me le laisser seulement une demie-heure; je suis tenté d'en faire de quelqu'un le portrait chargé.' Personne n'entendait cela; j'ai dit au roi que c'étaient des portraits que l'on faisait ressembler dans le laid et le ridicule. L'abbé Butti a pris la parole et a dit que le Cavalier était admirable dans ces sortes de portraits, qu'il faudrait en faire voir quelqu'un à Sa Majesté, et comme l'on a parlé de quelqu'un de femme, le Cavalier a dit que *Non bisognava caricar le donne che da notte*." Chantelou's literal translation *portrait chargé* appears in print only eleven years later in Félibien's *Des Principes de l'Architecture, de la Sculpture, de la Peinture, . . . avec un Dictionnaire des Termes* (Paris, 1676, p. 520), where the fact that they can be carried out *avec trois ou quatre coups de crayon* is mentioned. The term *caricatura* appears in England in two posthumously published works of Sir Thomas Browne

altri buoni autori, che non contenti della bellezza del naturale, la vanno raccogliendo da più oggetti, ò dalle Statue più perfette, per fare vn'opera in ogni parte perfettissima: percioche il fare vn ritrattino carico, non era altro, che essere ottimo conoscitore dell'intentione[46] della natura nel fare quel grosso naso, ò larga bocca, à fine di far vna bella deformità in quell'oggetto. ma no[n] essendo ella arriuata ad alterare quel naso, e quella bocca, ò altra parte, al segno che richiederebbe la bellezza della deformità; il valoroso artefice, che sà alla natura porgere aiuto, rappresenta quell'alteratione assai più espressamente, e pone auanti à gli occhi de' riguardanti il ritrattino carico alla misura, che alla perfetta deformità più si co[n]uiene. Et in tal modo piaceuolmente discorreua Annibale di questa sorte di operare.[47]

(1605-82): *A Letter to a Friend* (London, 1690, p. 5) and *Christian Morals* (Cambridge, 1716, p. 98, Part III, § 14). Other early examples in print are in a letter from John Hughes to the *Spectator* (No. 537, 15 November 1712) and in Jonathan Richardson's *An Essay on the Theory of Painting* (London, 1715, p. 198).

[46] Malvasia (*Felsina*, 1678, I, p. 380) omits the not unimportant words *dell'intentione*.

[47] This passage, which is in any case a spirited defence of the activity of the caricaturist, might be taken at its face value as a corollary to the classic-idealist theory of beauty, and as a contribution to the theory of caricature put forward with serious intent. But, in the opinion of the present writer, to read it narrowly *alla lettera* and leave it at that would be a mistake. In spite of its show of theoretical logic, it is essentially anti-theoretic, subversive rather than constructive. There is of course a vein of oblique truth running through it, as with many of Annibale's aphoristic pronouncements, and it is precisely this substratum of good sense which could make it unsettling for the *a priori* theorist. Are we not to regard it as a *reductio ad absurdum*, a burlesque, or—why not use Annibale's own word?—a caricature of the conventional classic-idealist theories of artistic excellence? For the doctrinaire classic theorist the comparison between Raphael and a caricaturist was something like *lèse-majesté*, the conception of nature intentionally playing the part of a jester (instead of always striving for the best) had a heretical flavour, and the application of the adjectives *bella* and *perfetta* to *deformità* was a contradiction in terms. In short, though—or rather, because—the method of argument employed is recognizably similar, the logical foundations of the classic-idealist theory in so far as it claimed to be the only true gospel of beauty are being subtly yet plausibly undermined. We are surely hearing the shocking and deflating voice of the *enfant terrible*, a role which fits in admirably with what we know of Annibale's character; indeed Mancini refers to his good-humoured verbal pungencies in direct connexion

Ma nella sua Scuola si pose tanto in vso questo fare i ritrattini carichi, che gran piacere apportò sempre à tutti di essa, & à

with his caricatures: ". . . fù di costume piacevole, ma ritirato[,] acuto nel parlare e mordace con piacevolezza come ancor nel ritraher con deformità qualche d'uno di singolariss.º gusto, come si vede in molti ritratti . . ." (Marciana MS. it. 5571, fol. 56 verso). Mosini himself, who (as we have suggested in note 4 of this Appendix) was apparently by no means such a thorough-going classicist as Agucchi or Bellori, seems to have been in two minds as to whether Annibale really meant his theory to be read *alla lettera* and treated seriously: the expression *alto intendimento* (true enough, if not taken too literally) is weakened by the twice repeated statement that Annibale spoke *piacevolmente*, with his tongue in his cheek (and cf. note 56 of this Appendix for a third repetition). The worthy Baldinucci however finds the *concetto* so intriguingly subtle that he cannot resist embroidering it: he associates it with the celebrated story of Zeuxis' *Helen* (cf. note 81 of Part II), and makes great play with the view that the artist produces both *bellezza* and *bruttezza* by means of a process of *caricando* and *scaricando* (*Lezione di Filippo Baldinucci*, Florence, 1692, pp. 16 ff., reprinted in *Notizie de' Professori del Disegno*, XXI, 1774, pp. 124 ff.; his rejection of Annibale's title to be the inventor of the portrait caricature is strongly tainted with *campanilismo*). Baldinucci commendably keeps his own opinions in the background when writing his life of Bernini, and his account of the latter's views on art is of some interest (*Vita del Cavaliere Gio. Lorenzo Bernino . . . scritta da Filippo Baldinucci*, Florence, 1682, pp. 69 ff.; ed. Riegl, Burda, and Pollak, Vienna, 1912, pp. 237 f.). Though Bernini considers the Zeuxis story *una favola*, his theoretical standpoint may seem at first to amount to an extremely mild idealism (with a characteristic touch, however, about the desirability of his subjects talking and moving while he was at work). Nevertheless he explicitly draws the sort of conclusion which we felt only implicitly in Annibale's disquisition on caricatures, namely that artistic excellence is not necessarily to be associated with "perfect" bodily beauty. "Soleva dire," says Baldinucci of Bernini (*Vita, cit.*, 1682, p. 71), "che nell'imitazione è tutto il diletto de' sensi nostri, e davane per esemplo [sic] il gran gusto, che apporta il vedere ben dipinta una rancida, e schifosa Vecchia, che viva, e vera ci apporterebbe nausea, e ci offenderebbe." The doctrinaire classic theorists would have had their doubts about stressing a conception of this kind. Similar passages in the life of Bernini by his son Domenico (*Vita del Cavalier Gio. Lorenzo Bernino, descritta da Domenico Bernino suo figlio*, Rome, 1713, p. 30) are obviously based on Baldinucci, but the fact that the son does include this material may perhaps be taken to indicate that he regarded it as a reasonably accurate reflection of his father's views. Domenico has an interesting passage on caricatures, describing the art as "Inventione rare volte pratticata da altri Artefici, non essendo giuoco da tutti, ricavare *il bello dal deforme*, e dalla sproporzione le simetria" (*Vita, cit.*, 1713, p. 28; my italics).

gli altri, che la frequentauano; & era ben riputato il più atto,
anche nelle opere d'importanza, colui che gli altri auuanzaua
nel caricar bene i ritrattini. E certamente da coloro ne furon
fatti li più diletteuoli, e più belli, che i maggiori soggetti della
Scuola sono poi riusciti, secondo il parere de' più intendenti.[48]
& Annibale istesso, che ne fù il principale Autore, e Maestro,
ne hà fatto in grandissimo numero, e tutti stimatissimi da
coloro, che gli hanno veduti, ò potuto hauere: E massimamente
di quelli, che furon da lui fatti in riguardo di quel che dicono
i Fisionomisti, de' costumi di quelle persone, che alcuna somi-
glianza hanno in alcuna parte co' gli animali irragioneuoli:[49]

[48] Domenichino was noted as a caricaturist. Mancini says of him: "Si
dilettò anch'esso di quei ritratti ridicoli, et in essi [Mancini substitutes *vi*]
hebbe grand.^mo eccesso, facendo in essi alcune cose part.^ri, che nel vederle
dan meraviglia [Mancini adds *et*] eccita[no] riso" (Marciana MS. it. 5571,
fol. 74 verso); cf. also Passeri, *op. cit.*, ed. Hess, p. 63. Guercino was a prac-
titioner of the art: a large volume containing 195 of his caricatures was
recorded in 1719 in the possession of his heirs. He can have been introduced
to the idea by almost anyone in the Bolognese orbit, including Domenichino;
he does however seem to have been familiar at a particularly early stage of
his career with the drawings of Pietro Faccini (cf. evidence to this effect
adduced by the present writer in *The Burlington Magazine*, LXX, Jan.-June,
1937, p. 118 and note 27), and it may be worth noting that Malvasia tells
an anecdote about Faccini as a caricaturist (*Felsina*, 1678, I, p. 564).
Guercino cannot of course have known him personally, as there is no reason
to doubt Malvasia's statement (*Felsina*, 1678, I, p. 567) that Faccini died
in 1602 "in assai fresca età." This remark of Malvasia appears, by the way,
to be the only early indication we have as to the approximate date of
Faccini's birth. That of 1562, which figures in most of the modern reference
books, has not (as far as I am aware) any firmer foundation than a pure
conjecture of Johann Rudolf Fuessli in his *Künstler-Lexicon* (Zürich, 1763,
p. 177); moreover the qualificatory *um* of this first edition disappears from
the revised editions of 1779 and 1810 (p. 224 in each case), where Faccini
is stated to have died in 1602 at the age of 40. Bartsch (1818) simply says
that he was born in 1562, and this was repeated by Nagler (1837), Bolognini-
Amorini (1843), and the majority of subsequent writers.

[49] This idea appears at a very early date in the treatise τὰ φυσιογνωμονικά
which passed under Aristotle's name. As Drs. Kris and Gombrich have
pointed out (*The British Journal of Medical Psychology*, XVII, Pts. 3 and 4,
1938, pp. 334 f.), the writings of Giovanni Battista della Porta, with en-
gravings of human and animal heads compared together on the same plate,
must have helped to diffuse it widely: the first edition of Della Porta's
physiognomical work was published in 1586 (*Io: Baptistae Portae Neapolitani
De Humana Physiognomonia Libri III*).

poiche egli disegnò solamente ò vn Cane, ò vn Bue, ò altro
animale; e nondimeno benissimo si comprendeua essere il
ritratto di colui, i cui costumi, e l'effigie haueua voluto l'artefice
rappresentare.[44b]

Ma poiche di cose piaceuoli intorno all'arte della Pittura io
sono entrato à parlare; alcun'altra simile io ve n'aggiugnerò,
perche l'occasione di accompagnare il tutto al libro delle Figure,
che per diletto e ricreatione furono dal Carracci disegnate, ce
le farà cadere à proposito; e Voi (Signori miei Virtuosi) potrete
parimente valeruene per passatempo nelle hore, che alle opere
di maggior cura si tolgono; desiderando io, che da ogni cosa
voi riconosciate il mio desiderio di seruirui, e compiacerui, con-
forme al merito grande, ch'io stimo in tutti voi; e vorrei, che la
vostra virtù fusse così conosciuta, & adoprata, & egualmente
premiata, come voi col vostro ingegnoso oprare molto ben
sapreste meritare. Può essere à tutti voi notissimo, che non
poco è stata sempre stimata la lode data dagli Scrittori à que'
Pittori antichi, che arriuarono à fare delle pitture, che dagli
occhi de' riguardanti furono reputate cose vere, e non finte; e
ne rimasero ingannati non solo gli animali irragioneuoli, ma
gli huomini, e finalmente i medesimi artefici. Laonde se io vi
racconterò alcun simil caso accaduto nelle opere dalla mano
d'Annibale vscite; ne darete à lui la lode, che merita, e parerà
al vostro saggio conoscimento. Ben io vi dico, che alla fama,
che già del valor di lui, fà da per [*Page 17*] tutto sentirne il
grido, & al vostro intendimento non è di mestieri altro argo-
mento da persuadere l'eccellenza di quell'artefice: ma io vi
replico, che il tutto serua per piaceuolezza, e galanteria, sicome
la ricreatione è stata cagione del nascimento delle Figure del
libro.

Io dico dunque, che tra l'opere del Carracci sono state
osseruate molte, e diuerse cose dipinte, le quali ingannano
l'occhio nel modo sopradetto. e per breuità faremo qui mentione
solamente di alcuni lauori finti di stucco nel Palazzo di Farnese,
che sono in modo imitati per ragion di prospettiua, e degli
effetti del lume, e dell'ombre; che l'occhio di chi li mira, ne
rimane del tutto ingannato. Onde accade benespesso, che come

cose non finte, ma vere reputate, non vi facciano i riguardanti altra riflessione, nè si accorgano di quell'artificio. Per la qual cosa coloro di quel Palazzo, a' quali spetta di mostrar a' curiosi le pitture, e l'altre belle cose, che in abbondanza vi sono, hanno alle volte stimato, che si defraudi troppo alla riputatione di quel Prencipe, e del medesimo Maestro, non facendo conoscere a' riguardanti la bellezza di quel'artificio, coll'auuertirgli, che quegli stucchi siano finti, e no[n] veri. Ma è ben più volte accaduto, che ne meno habbiano alcuni voluto crederlo, sinche col tatto delle mani, ò d'altra cosa non si sono accertati co[n] gran lor marauiglia, essere quelle superficie piane senza punto di rilieuo, & esser al sicuro vn mero inganno dell'occhio. Ma qui può cader in proposito il ricordarsi di quel che di sopra si disse del brauissimo Siuello: che la di lui attione mirabilmente rappresentata al solo senso dell'Vdito, non veniua da molti creduta per finta, sin tanto che col vedere non ne veniuano accertati. E qui vi accennerò ancora, che, quando vi verrà per le mani quel bel ritratto intagliato da Agostino, di colui, che tiene vna Maschera in mano; lo riconosciate per l'istesso Siuello, che in tal modo fù effigiato, per denotare la sua eccellenza nell'imitare.[50]

[50] This engraving (Bartsch, XVIII, pp. 120 f., No. 153) is reproduced by Luigi Rasi, *I Comici Italiani*, Florence, 1897, I, p. 955; though it bears no date, Quadrio (writing in 1744, quoted by Rasi) contrives to date it 1633, over 30 years after the artist's death! For Giovanni Gabrielli, known as Il Sivello, cf. also note 3 of this Appendix. It is possible, but perhaps not absolutely certain, that Annibale Carracci's portrait of the lute-player at Dresden represents Gabrielli. Malvasia (*Felsina*, 1678, I, p. 502) simply describes the portrait, then in the Modena Gallery, as of Annibale's intimate friend *il sonatore Mascheroni*, and this designation is preserved in all the early Dresden catalogues, beginning with that of 1765 (p. 198). The specific identification with Gabrielli which appears in recent catalogues is thus not an old tradition, but a plausible hypothesis of relatively recent date. It seems to have originated in the catalogues of Julius Hübner, possibly in the first edition of 1856 (which I have not seen); in any case it appears in the second edition of 1862 (p. 171), and the spelling *Siello* suggests that Hübner was connecting Bellori's description of the engraving (*Vite*, 1672, p. 116) with the picture. The two portraits, engraved and painted, could very well represent the same man; but it is curious that Malvasia, who describes the subject of the engraving correctly (*Felsina*, 1678, I, pp. 96 f.),

Dirò ancora, che hauendo Annibale dipinto in Roma vn Quadro grande à olio, il quale doueua esser mandato in parte lontana, fù esposto al Sole in vn' horto contiguo alla sua casa, accioche i colori si asciuttassero, e si potesse la tela auuoltare senza patimento della pittura. e perche vi haueua finta vna scala di pietra, auuenne, che vn suo Cane anzi grande, che piccolo, veduti da lontano que' scalini, che veramente all'occhio appariuano veri, e di rilieuo, datosi[51a] à correre à quella volta, e nell'auuicinarsi, spiccando il salto con impeto per salirui sopra, vrtò in modo nel quadro con le zampe, e con la testa, che non solo imbrattò quella parte che toccò, per la freschezza de' colori, ma ruppe anche la tela.[51b] Onde il padrone del quadro, che da vn lato sentì disgusto per la tardanza di hauerlo, che da ciò ne seguì; dall'altro si pregiava poi d'hauer fatta fare vn'opera, che per quell'auuenimento ancora pareua se ne douesse fare maggiore stima.

Mentre[52a] dipigneua nella propria Casa vna tauola per vn Signor grande, questi, quando l'opera fù à buon termine vi andaua spesso à vederla. Ma ad Annibale pareua, che quel Signore non si mettesse à guardare, & attenta- [*Page 18*] mente

should not refer to either Gabrielli or Sivello on three occasions when he mentions Mascheroni (*Felsina*, 1678, I, pp. 471 and 502, and *Le Pitture di Bologna*, 1686, p. 241). The putative identification of the portrait of a man with a mask by Domenico Fetti in the Hermitage at Leningrad (repr. in *Dedalo*, III, 1922/23, p. 780, and cf. p. 792) as that of Gabrielli was probably the offspring of the Dresden identification; the Hermitage catalogues of 1869 and previously are silent on the subject, and the name of Gabrielli first appears as a result of the revision by Brüiningk and Somoff (cf. *Ermitage Impérial, Catalogue de la Galerie des Tableaux; premier volume, les écoles d'Italie et d'Espagne; troisième édition, revue, augmentée et remaniée par le bar. E. Brüiningk et A. Somoff;* Saint Petersburg, 1891, p. 71). The identification of the copy in the Accademia at Venice occurs still later. We may record its Odyssey in the catalogues: G. Botti, 1891, (and other earlier catalogues), unidentified portrait by an unknown artist of the Neapolitan School; Pietro Paoletti fu Osvaldo, 1903, unidentified portrait by Fetti; Luigi Serra, 1914, unidentified portrait after Fetti; catalogue of 1924, portrait of Gabrielli, probably a copy of the original Fetti in the Hermitage.

51a to 51b This fragment is quoted by Malvasia (*Felsina*, 1678, I, p. 473).
52a to 52b The passage between 52a and 52b is quoted by Malvasia (*Felsina*, 1678, I, pp. 471-473).

considerare la pittura della tauola, come la qualità dell'opera meritaua; e che con maggiore applicatione si fermasse à co[n]sigliarsi con vno specchio, che da vna parte della stanza era al muro attaccato. Onde pensò Annibale di vendicarsene: e quando vn'altro giorno giudicò, che quegli potesse à lui tornare, leuò quello specchio, e nell'istesso luogo ne dipinse vno su'l muro à quello somigliante, ma vi finse sopra vna coperta, la quale, lasciando solamente vedere vna picciol parte del cristallo, impediua lo specchiarsi, e'l vedersi tutto il volto intero. Essendo poi dinuouo tornato il Personaggio alla Casa del Carracci, fermatosi non molto con gli occhi volti alla pittura, che per lui si dipigneua, verso lo specchio secondo il suo solito, prestamente se n'andò: e veggendo l'impedimento di quella coperta, che non finta, ma vera, era dall'occhio giudicata, vi pose incontinente la mano sopra, per tirarla da parte, e discuoprire tutto'l cristallo: ma sentendo di toccar la piana superficie del muro, e ben presto accorgendosi dell'inganno, ritirò la mano à se con quella prestezza, e celerità, che si suol fare quando auuiene di toccar vna cosa, che non si crede essere calda, e poi si sente esser cocente. E nel medesimo tempo più nascosamente, che egli potè, voltò gli occhi verso Annibale, & alcun 'altro, che iui era, per vedere, se, di quel che à lui era successo, si fossero auueduti: poiche gli corse subito all'animo di celarlo, se poteua, per ischiuare la vergogna, che lo stimolò in quel punto pensando alle risa altrui, che potean farsi di quell'inganno. Ma Annibale, che attentissimamente l'osseruò, del tutto ben si accorse, & altrettanto seppe far finta di non essersene auueduto, per osseruar prima ciò che ne seguiua. Ma vn'altro di coloro, che vi si trouò, e lo vide, e che non era informato di quell'inganno da Annibale à bello studio premeditato, fermò lo sguardo verso quel Signore, e con curiosità ancora se gli accostò, per intendere quale cosa gli hauesse cagionato quel subitaneo ritiramento di mano, dubitando forse no[n] l'hauesse morsicato ò punto vno Scorpione, ò altro animaletto velenoso. Onde poiche il Personaggio fù certo, che il fatto non si potea celare, deposta la vergogna, riputò subito se stesso anzi di lode meriteuolissimo, se, confessando lietamente l'inganno, in che egli era incorso,

ne commendasse molto, come fece, l'ingegno dell'inuentore: e
così parimente tutti gli altri, che vi fur[ono] presenti, se ne
presero piacer grande, e discorsero eruditamente di simili casi
celebrati dagli Scrittori in lode de' Pittori antichi più famosi.[53]

Ma doppo le molte parole degli altri, Annibale si voltò à
quel Signore, e gli disse: (se vi foste Signor mio fermato à
guardare questa tauola, che per voi dipingo, non sareste stato
ingannato.) e stette vn poco, senza dir altro, godendo in se
medesimo di hauerli detto così apertamente donde hauea
hauuto origine l'inganno dello Specchio. Ma poi volendo pur
variare, ò moderare il senso di quelle parole, soggiunse: (non
vi sareste ingannato, perche qui non arriuo à farui parer per
vere le cose, che io vi fingo.) il che da tutti gli altri fù inteso
per vn detto ingegnoso, e modesto, che meritasse parimente di
essere non poco commendato. ma il vero senso fù ben inteso
da chi del- [Page 19] l'altre circostanze fù benissimo informato.

Vn'altra simil beffa fece Annibale ad vno di coloro, che
appresso di lui dimorauano per apprender l'arte; il quale era
vn giouine, che se alcuna cosa fatta di propria mano mostraua,
si studiaua con le parole farla apparir più assai di quel che era;
e se dell'opere altrui parlaua, più intendente che egli no[n] era,
di apparire procuraua. Onde veniua chiamato communemente
il Saccente della Scuola. Parendo perciò ad Annibale, che
molto bene si adattasse alcuna beffa à quella tanta saccenteria;
pensò di fargliela in modo, che se n'hauesse à ricordar per
sempre.

Soleua colui per suo passatempo trastullarsi con vna di quelle
balestre da palla, che vsano i giouanetti, e da vna fenestra della

[53] Probably the closest story to this was the often repeated one of Zeuxis
and Parrhasios told by Pliny the Elder, *Historia Naturalis*, XXXV, § 65:
Zeuxis painted some grapes which deceived the birds, but Parrhasios painted
a picture of a curtain which Zeuxis attempted to pull. For other stories of
the same type, cf. Ernst Kris and Otto Kurz, *Die Legende vom Künstler, ein
geschichtlicher Versuch*, Vienna, 1934, pp. 70 ff. In the Carracci marginal
notes to the 1568 edition of Vasari's *Vite*, the writer (who is usually thought
to be Agostino) praises Bassano by alleging that he himself was deceived in
Bassano's studio by a painted book (cf. *Il Vasari, Rivista d'Arte e di Studi
Cinquecenteschi*, X, 1939, pp. 115 f.); Bellori (*Vite*, 1672, p. 23) gives this
extract with slight variations and with an attribution to Annibale.

medesima stanza, doue si dipigneua, verso vn albero, che gli
era incontro, tiraua de' colpi à gli vccelletti, e gli pareua di far
cosa di molta lode, se alcuno ne colpiua. Hor qua[n]do parue
ad Annibale di poter far ciò, che nel pensiero gli era venuto;
senza che altri lo vedessero, nascose quella balestra; e preso vn
pezzo di legno della grandezza del manico di essa, lo pose là
doue soleua starsene la balestra, appoggiando l'vn capo del
legno al muro, & l'altro posando in terra, e dipinse nella super-
ficie del muro l'arco, e la corda, vnendo insieme ingegnosamente
il finto col vero con la forza delle linee, dell'ombre, e de' lumi;
sichè pareua appunto all'occhio del riguarda[n]te, che la
balestra in quella guisa che solea se ne stesse in quel luogo
appoggiata al muro. Venuta poi l'occasione di adoprarla; che
anche in ciò Annibale vi vsò l'industria per farla opportuna-
me[n]te nascere senza che altri dell'artificio si auuedesse; il
Saccente Giouine presa alcuna palla, e desideroso di tirare
alcun colpo, s'inuiò alla volta della balestra per pre[n]derla; e
dato di piglio al manico, si vide d'hauer in mano quel sol pezzo
di legno senza l'arco, e la corda; che in quel subito restò
stordito, e gli parue vna fantasma da non leggermente spauen-
tarsi. Ma accortosi poi dell'inganno, in che egli così facilmente
era caduto, se l'arrecò à non poca vergogna, me[n]tre che
essendo egli dell'arte, e dell'intendime[n]to, che pretendea di
essere, haurebbe voluto, che più ad ogn' altro, che à lui fusse
vna tal cosa succeduta. ma quanto gli altri se ne prendessero
piacere, egli è facile da imaginarselo. basti dir sol questo, che
il caso diede poi occasione à tutti della Scuola di motteggiare
del continuo con facetie, & argute punture, per mortificare la
Saccenteria di colui solennissimamente.[52b]
 Diuerse altre simili galanterie (Signori Virtuosi) vi sarebbono
da raccontare, tanto di opere della mano, quanto di parole, e
sentenze acutissime, e piene di spirito, che tutte sono inditio
della finezza dell'ingegno del Carracci: ma alla presente oppor-
tunità può esser basteuol quello, che se n'è già toccato. e vi
aggiugnerò solamente vn modo da lui tenuto, per lodare più
vno, che vn'altro di due suoi Scolari intorno à due opere fatte
da loro, delle quali, senza che io vi dia più aperta notitia di

quel che farò, mi persuado, che ne saprete da per voi stessi ritrouare il luogo, e riconoscerle, e vi riuscirà forse di gusto il sapere, che giuditio il Carracci medesimo ne facesse; e voi col vostro [*Page* 20] ben purgato, comprenderete ancora (senza che io ve ne spieghi il nome) quale delli due Discepoli venisse dal Maestro più laudato.[54] Vn letterato de' primi di quel tempo, domandò ad Annibale, chi si fosse portato meglio di due Pittori della sua Scuola in vn lauoro, che insieme fecero per vn Cardinale, cioè vn'Historia grande per ciascuno della vita di vn medesimo Santo, dipinte à fresco in Roma dentro vna Chiesa nelle due lati, l'vn'inco[n]tro all'altro. Al quale quesito Annibale rispose, che quelle due Historie erano state cagione, che egli si era conosciuto se stesso per vn grandissimo balordo: perche non haueua mai saputo comprendere, quale di esse meritasse d'esser più lodata; sintanto che egli non imparò à conoscerlo da vna Vecchiarella; la quale hauendo per mano vna Fanciulla, si fermò vn giorno à guardare l'vna e l'altra di quelle Historie; & egli l'osseruò; che me[n]tre ella ad vna fissò lo sguardo, andò voltando l'occhio da ogni parte per mirarla tutta, ma non disse mai vna parola, nè diede altro segno d'alcun affetto, che in lei hauesse cagionato il guardar quella Pittura. ma poi all'altra Historia voltatasi, cominciò à dire alla

[54] Mosini is making a quite unnecessary mystery about this anecdote, which refers to the Oratory of S. Andrew (restored by Cardinal Scipione Borghese in 1608) at S. Gregorio Magno, Rome; according to the story Annibale preferred Domenichino's *Flagellation of S. Andrew* to Reni's *S. Andrew led to martyrdom*. Mosini is the original source of a story which was retold, discussed, and abused many times in later literature; Bellori (*Vite*, 1672, pp. 303 f.), Malvasia (*Felsina*, 1678, II, pp. 17 and 319), Passeri, Vittoria, Zanotti and Pascoli all refer to it. Interest in the *affetti* (for which cf. above, pp. 148 ff.) becomes especially important in French theory: we may note that a review of Bellori's *Vite* in *Le Journal des Sçavans* (1676, XX, 7 December) makes a special mention of this particular comparison between Reni and Domenichino, and of the fact that the latter receives praise for his rendering of *l'expression*. Félibien tells us (and is supported by stylistic evidence) that in Poussin's early days in Rome he studied Domenichino's fresco in preference to that of Reni, and adds that Poussin "regardoit le Dominiquin comme le meilleur de l'école des Caraches pour la correction du dessein, & pour les fortes expressions" (*Entretiens, seconde édition*, 1688, II, pp. 320 f.).

Fanciulla: Vedi vedi figlia quell'huomo, che fà la tal cosa; e
col dito gli accennaua la Figura, che quell'attione, ch'ella
diceua, rappresentaua: e così di mano in mano mirando l'altre
Figure, le additaua, e ne dichiaraua con gusto le attioni alla
Fanciulla, la quale ancora pareua che se ne prendesse diletto.
Hor vedete (disse Annibale al Letterato) com'io hò imparato à
conoscere, quale delli nostri due Dipintori habbia più viuamente
espressi gli affetti, e più chiaramente la sua Historia dichiarata.
E questo bastò per chiarissima risposta à quel quesito.

Nell'vltimo luogo parerebbe forse à proposito l'entrare in
alcun'altra particolarità della persona d'Annibal Carracci,
mentre egli è Autore del Libro delle Figure, donde è nata
l'occasione di toccar di lui, come di sopra si è fatto. Ma essen-
dosi già altri messi à questa impresa, coll'hauer descritta dis-
tesamente la Vita, come hanno fatto di altri Pittori ancora; io
non aggiugnerò altro particolare: e tanto più, che io sò, che da
persona d'ingegno, e sano conoscimento si pensa di aggiugner
anco delle cose rileua[n]ti alle Vite già descritte di molti Pittori,
e de' Carracci specialmente, parendole, che troppe cose sieno
state lasciate indietro, le quali di tanta virtù, e valore, si
doueuano più ampiamente spiegare.[55]

Ma in quest'vltimo io farò ben'vna consideratione, che nasce
dall'istesso discorso d'Annibale, che di sopra fù accennato.
Io dico, che chi volesse applicare quel che egli piaceuolmente[56]
discorreua degli oggetti della Natura, co[n] qualche spropor-
tione da lei deformati; si potrebbe dire, che nella persona di lui

[55] This is, in the writer's opinion, almost certainly a reference to Bellori,
who was dissatisfied with the lack of discrimination in Baglione's *Vite*, pub-
lished four years previously. Evidence that Bellori was thinking of his own
Vite even at this early date has been adduced by Mr. Kenneth Donahue,
who points out ("The ingenious Bellori," *Marsyas*, III, Vol. for 1943-45,
pub. 1946, p. 115 and note 34 on p. 132) that Bellori was in fact obtaining
material for his life of Van Dyck at just about this time from Sir Kenelm
Digby, during the latter's comparatively brief residence in Rome as the repre-
sentative of Queen Henrietta Maria. Knowledge of Bellori's intentions fits
in excellently with the identification of "Mosini" with Monsignor Giovanni
Antonio Massani (cf. notes 113 of Part II, and 14 of this Appendix).

[56] Once again we note that Annibale is stated to have discoursed *piace-
volmente* about the theory of the caricature (cf. note 47 of this Appendix).

habbia voluto la Fortuna essere imitatrice della Natura in quel
genere di adoprare. Poiche essendogli stata sempre anzi con-
traria, che fauoreuole, si può dire, che egli fusse vno di quegli
oggetti della Fortuna, da lei no[n] poco alterati, ò deformati.
perche se la prosperità è veramente vna bella cosa, assai
aggiustatamente si può adattare il titolo di deforme all'infelice,
e disauuenturato: e certamente egli appare poco bello colui,
che dalla Fortuna [*Page 21*] venga così malamente trattato;
come auuenne ad Annibale;[57] che nel vero non si potrebbe
esprimere à bastanza, quanto copiosamente ella caricasse
adosso à lui delle disgratie, e forse co[n] gran piacere di lei,
me[n]tre che tutta della sua mano veniua quest'opera riconos-
ciuta; sicome all'incontro niente ad essa, ma il tutto alla virtù,
& al merito ne sarebbe stato attribuito, se si fosse voltata à
fauorirlo. Et in tal maniera la Fortuna imitando la Natura nel
deformare gli oggetti più meriteuoli, e portar in alto chi à lei
più piace, ella dee ancora ridersi con gusto grande delle arcate
delle ciglia, e delle esclamationi di que' più saggi, quando si
belle deformità si pongono à contemplare.

Ma se il Carracci è stato dal potere della fortuna tenuto
sempre al basso, in riguardo di quello, che più il volgo apprezza;
per conseguir però quella gloria, che i più sublimi ingegni per
meta si propongono, ella non valse ad impedirgli, che non
gettasse saldissimi fondamenti. Percioche sicome egli è stato
grande imitatore di Rafaelle, e degli altri valorosi di sopra
nominati; così è accaduto di lui quel che di que' medesimi è
auuenuto: io dico, che quanto più il tempo si è andato, e si và
allungando doppo la morte dell'Artefice, e moltiplica il numero
de' buoni conoscitori; tanto più si rende cospicua la virtù di
lui, e maggiormente ne viene il suo nome celebrato: ilche suc-
ceder non potea, quando sù le saldissime basi del vero, del
bello, e dell'ottimo, pia[n]tati non fossero i fondamenti del suo
sapere. anzi, se quel credito, che pur in vita egli si acquistò, si

[57] Mosini may have had particularly in mind the way in which Annibale
was treated in the matter of payment for the Galleria Farnese; cf. also
note 28 of Part II. This passage on the ill fortune of Annibale is referred
to by Malvasia (*Felsina*, 1678, I, p. 487).

fosse posato più sù l'aura fauoreuole della fortuna, e più sù la vana opinione del volgo, che nella verità del valor di lui; l'haurebbe forse egli medesimo, prima di morire, veduto come appunto vn'aura fumante onninamente suanire. E se intorno al vero sapere, e felice operare di esso, io hauessi da recare qui alcun altro testimonio; non mi volterei ad altro, che al purgatissimo giuditio vostro (Signori Virtuosi;) riducendoui à memoria, che nell'opere di lui, Voi hauete ben compreso, e spesse volte affermato, che egli lascia à i riguardanti più da intendere, che da vedere; e vince l'arte medesima con l'acutezza dell'ingegno, & esprime, ne' bellissimi corpi, gli animi in guisa viuaci, che da voi medesimi gli è stata pur data questa insigne commendatione: Che in essi per certo

Manca il parlar; di viuo altro non chiedi;
Nè manca questo ancor, s'à gli occhi credi.[58]

E nell'vltimo luogo io debbo dirui, che molti di voi vi hauete à ricordare di hauermi efficacemente persuaso à mandar alla luce il Libro delle Figure di Annibal Carracci, insieme con alcuna cosa, che io potessi aggiugnerui della vita, e professione sua: e perciò, mentre io vi hò vbbidito, hauete ancora da riconoscerne l'effetto per vn pensiero di Voi medesimi, eseguito da me per la stima, ch'io hò fatta del giuditio, e consiglio vostro, e pe'l desiderio, che hò hauuto, e tengo tuttauia di seruirui.

E dal dedicare, ch'io fò à Voi stessi le Figure, e'l rimanente, hauete da comprendere di più non solamente la conuenienza, che così, e non altri- [*Page 22*] menti mi hà inuitato à fare; ma che le Figure, la breue scrittura, & io, non ricerchiamo altra protettione, che quella dell'affetto, e dell'ingegno vostro; accioche ne prendiate opportunamente la difesa, quando alcun di coloro, che della vostra Classe non sono, si mettesse in tutto, ò in parte, troppo rigidamente à contrariare me, e le cose à Voi

[58] Torquato Tasso, *Gerusalemme Liberata*, Canto XVI, 2.

medesimi dedicate. E qui di nuouo vi saluto, desideroso, che la vostra virtù sia sempre largamente premiata.

In Roma li 8. di Giugno 1646.

Vostro affettionatissimo Seruitore
Il medesimo Giouanni Atanasio Mosini.

[*On the next (unnumbered) page is a list of the subjects of the etchings, entitled:* "NOMI DEGLI ARTISTI DELLA CITTA DI BOLOGNA FIGVRATI DA ANNIBALE CARRACCI." *This is followed by the frontispiece designed by Alessandro Algardi and containing the portrait of Annibale Carracci; it is signed* "A. Del." *and* "S G", *and is inscribed* "ANNIBALI CARRACCIO BONON. AETATIS SVAE ANN. XLIX Romae. MDCXLVI." *The eighty etchings by Simon Guillain the younger then conclude the volume.*]

APPENDIX 2

NOTES ON THE MANUSCRIPTS
OF MANCINI'S *TRATTATO*

THE writings of Giulio Mancini (1558-1630) possess a certain value for the student of early Seicento painting,[1] and a complete publication, with a critical commentary, of all the manuscript material—by no means an easy task if the necessary standards of scholarship are aimed at—is much to be desired. An undertaking of this kind has been worked over by a group of Viennese scholars for nearly half a century, but it is not known whether its completion is still to be expected, and, if so, when the present difficulties in making the material available in print can be surmounted. Meanwhile art-historians must continue to have recourse to the actual manuscripts.[2]

It is obviously impracticable that the rigorous sifting of the

[1] For an appreciation of Mancini's work, and extensive particulars of the relevant literature, cf. Julius Schlosser-Magnino, *La Letteratura Artistica*, Florence, 1935, pp. 402 f., 533 f., and 541 (bibliography). Mancini, a native of Siena who had settled in Rome in the late Cinquecento, was by profession a physician of sufficient distinction to have become, in 1623, *Medico intimo* to Pope Urban VIII. For particulars of Mancini's life, cf. pp. 8 ff. of Dr. Schudt's introduction to his edition of Mancini's guide book of the pictures of Rome (*Giulio Mancini, Viaggio per Roma, herausgegeben von Ludwig Schudt*, Römische Forschungen der Bibliotheca Hertziana, IV, Leipzig, 1923). This is the most important modern work dealing with Mancini, and contains much interesting material; the presence of occasional slips and inaccuracies and the fact that no attempt is made to undertake a more than fleeting investigation of some of the incidental questions which present themselves are doubtless due to the conditions prevailing when the book was written, which (judging by the date of publication) can hardly have been very favourable.

[2] POSTSCRIPT. Since this Appendix was written, and indeed during the actual process of printing, the fact has come to my knowledge that a critical edition of Mancini is being prepared by Dott. Sergio Samek Ludovici. I need hardly say that if I had been aware of such a project earlier my own treatment of Mancini would have been very much more cursory. In the circumstances, however, I have to let the text stand, with a request to the reader to bear in mind that, as written, it was intended for those proposing to make use of the MSS. In the meantime, while expressing the hope that Dott. Samek Ludovici may find something of value in my own researches, I must wish him every success in his formidable undertaking, which will be most welcome to all art-historians concerned with the period.

material proper to a critical edition should be required of any
art-historian who wishes to make incidental use of an important
source which exists in a number of different MSS. On the
other hand, it is equally obvious that the complete ignoring of
all textual problems, and the consequent presentation of the
material to the reader from a manuscript selected by mere
chance or convenience, is hardly desirable. Indeed such a
procedure can be positively misleading, for it may perpetuate
the errors of a faulty transcription; once a fragment of text is
published it is usually quoted again and again, and the likeli-
hood of the manuscript background being re-investigated is
diminished.

This was the dilemma which confronted the present writer in
the course of making use of Mancini for his own rather limited
purposes. The textual problems had to be taken into account
to some extent, but the investigation of them had also, not un-
reasonably, to be kept more or less within the bounds suggested
by relevance to the subject-matter under consideration. The
notes published in this Appendix are therefore necessarily of a
fragmentary nature, and are merely published as a contribution
towards a complete and thorough edition of Mancini.[3] It is
true that Dr. Ludwig Schudt has already provided us with a
useful starting-point in the list of the MSS. which he published
as an Appendix to his edition of Mancini's *Viaggio per Roma*;[4]
but, apart from the fact that his account of the manuscripts

[3] There are innumerable problems in Mancini of which I am aware, but
which (in the absence of any solutions which are both rapid and convincing)
I have not attempted to tackle. Moreover no one is entitled to lay down
the law about Mancini unless he has seen all the existing manuscripts—and
this I myself have not done. There is however some reason for believing
that the MSS. dealt with here are generally speaking the most important;
but even so, my examination has been decidedly cursory in certain cases,
particularly Nos. II and IV.

[4] Beilage I: "Bibliographie der Codices Manciniani" (pp. 109-113 of the
second work cited in note 1 of this Appendix). Dr. Otto Kurz mentions in
his *Appendice* (Florence, 1937, p. 36) to Julius Schlosser-Magnino, *La Lettera-
tura Artistica* (Florence, 1935) a Mancini MS. in the Biblioteca Estense at
Modena which is not listed by Dr. Schudt; for others, cf. notes 6 and 11 of
this Appendix.

requires revision in certain particulars, Dr. Schudt did not really tackle the question of the chronology and development of the different versions of the Treatise from Mancini's point of view, with its not inconsiderable bearing on the character of the relationship between the various manuscripts.[5] Accordingly the present writer hopes that, as a result of making his findings available, some at any rate of the time and trouble which he had to expend in investigating the manuscripts may be saved to subsequent students, who, in view of the increasing interest in Seicento source material, are likely to find themselves turning frequently to Mancini.

[5] Theodor Schreiber, to whom credit must be given for being the first scholar in relatively modern times to deal with Mancini in any detail, was unfamiliar with several of the more important manuscripts and consequently had a somewhat confused idea of the whole work (Theodor Schreiber, *Über die Kunsttraktate des Giulio Mancini* on pp. 103-110 of *Gesammelte Studien zur Kunstgeschichte, eine Festgabe . . . für Anton Springer*, Leipzig, 1885). He does however just touch upon these questions of dating and sequence (cf. pp. 106 and 110). The instance he points out (p. 106) of 1575 being given as the approximate date of birth of the Cavaliere d'Arpino (cf. f. 100 v. of MS. No. VB, which was one of the MSS. consulted by Schreiber) is not one of the most straightforward clues, both because the date shows an alteration to 1565 in MS. No. III (f. 69 r.), and because the age of the Cavaliere at the time of writing is vaguely stated to be "assai frescha sopra però di 50. anni." Another not very precise clue indicated by Schreiber is that of the restorations in S. Crisogono (MS. No. III, f. 15 r.; MS. No. VB, f. 33 v.), which he rather arbitrarily dates 1624; in point of fact this sort of work was normally spread over several years, and there is evidence that it was already in progress in 1620 (cf. note 131 of Part I above). Though he notices that "Fulminetto" is stated to have died two years previously, he does not identify that artist with Martin Fréminet (for this, cf. *The Burlington Magazine*, LXXXVIII, 1946, p. 42, note 17), and so is unable to draw any conclusion about the dating. Schreiber (p. 109) seems to have had some second-hand information to the effect that Part I of the *Trattato* (and moreover the "best" copy of this Part) was to be found in the Chigi Codex G. III, 66 (now in the Vatican); this is not correct (it actually contains a copy of Part II derived from MS. No. VB). Not long after Schreiber's publication some further (but by no means exhaustive) details of several of the MSS. were given by Eugène Müntz in the periodical of the École Française de Rome (*Mélanges d'archéologie et d'histoire*, VIII, 1888, pp. 99-101; there are some slight errors of description and fact).

* * *

I. Short Version

I know the earliest and shortest version of Mancini's Treatise principally through an incomplete manuscript at Siena and extracts published by Gualandi in 1841.[6]

(a) Siena, Biblioteca Comunale degli Intronati, Cod. L. V. 13; only 12 fol., closely written in a not very easily legible hand. I cannot agree with Dr. Schudt[7] that this hand is identical with that of the *postillatore* of MSS. Nos. III, IV and Vв below:[8] and the internal evidence to the effect that the latter is in fact the author himself is very weighty. I could find nothing in Cod. L. V. 13 itself to indicate that it is Mancini's original, as Dr. Schudt believed, and think it should rather be regarded as an early copy.[9] It may be added that a comparison with Gualandi's publication shows that it is only a fragment without the final

[6] The usefulness of Gualandi's partial publication is very limited. It is to be hoped that the short version—complete, and based on a more satisfactory MS.—will not be omitted if and when an edition of Mancini should be published. The other MSS. of the short version listed by Dr. Schudt (*op. cit.*, pp. 111 f.) are: (1) Florence, Biblioteca Marucelliana, Cod. C. 345; (2) Bologna, Biblioteca Universitaria, fol. 1-88 of MS. No. 1698 (*Inventari*, XXI, 1914, p. 129, No. 1062); (3) Rome, Biblioteca Apostolica Vaticana, Cod. Capp. 230, fol. 157-209 (for this MS., which lacks material at the beginning, cf. note 12 of this Appendix); (4) Rome, Biblioteca Apostolica Vaticana, Cod. Vat. Lat. 8080 (two copies, fol. 1-50 and 51-74). To these may be added two MSS. in the Biblioteca Nazionale Centrale at Florence: (5) Cod. Gino Capponi 211, fol. 212-261 (the MS. from which Gualandi's text was derived, cf. note 11 of this Appendix); (6) Second item, $22\frac{1}{4}$ unnumbered pp. in Cod. II-190, which passed from the Nelli collection to the Magliabechiana in 1822 (catalogued by G. Mazzatinti, *Inventari*, VII, 1897, p. 239; the MS. is a fragment, lacking considerable material at the end and breaking off abruptly at the word *eminentissimi*—compare bottom of p. 60 of Gualandi's publication). I have looked over the above six MSS. very cursorily; none are autograph, and I did not come across any *postille* by Mancini in them.

[7] Ludwig Schudt, *op. cit.*, p. 111.

[8] E.g., compare their versions of capital R, capital M, and *che*.

[9] Though it does not appear to be the work of a professional scribe, it may be doubted whether the copyist was a *dilettante* familiar with the material (e.g., cf. note 130 of this Appendix).

section. On fol. 6 verso is a passage throwing some light on the dating: "La Prima [i.e., variety of modern painting] diremo ch[e] sia quella de Caracci, e la poniamo p[er] la prima, poich[e] è già morto Annibal, et Agostino, et Lodovico ancorch[e] operi con la sua solita eccellenza nondimeno è molto vecchio." There are no remarks characterizing the works of the family and school, and, after a short list of paintings, including otherwise unspecified ones in San Girolamo della Carità (i.e., Domenichino's altarpiece of 1614, cf. note 124 of Part I) and *nella pace* (i.e., Albani's frescoes in Santa Maria della Pace, probably of the same year), Mancini goes on to deal with the second *varietà*, that of Caravaggio.

(b) Incomplete extracts published in the second volume of the *Memorie Originali Italiane risguardanti le Belle Arti* (edited by Michelangelo Gualandi, Bologna, 1841, pp. 55-78) from a manuscript then in the possession of the Marchese Gino Capponi at Florence (the passage quoted above will be found on p. 56 of the *Memorie*). At the time of publication the name of the author of the treatise was unknown, but he was identified as Mancini in Vol. III of the *Memorie* (1842, pp. 156 f.) by Carlo Milanesi, who observed: "Nella sanese Biblioteca, è copia di questo Discorso, probabilmente di mano dello stesso Mancini; è mancante di tutto quello che nel nostro documento si legge dalla pag. 69 [i.e., of Vol. II of the *Memorie*] sino alla fine."[10] Milanesi was shortly afterwards given the task of cataloguing the Capponi manuscripts, and duly records the rather defective copy used for the publication in the *Memorie*.[11] This Capponi copy should not be confused with another copy of the short version (lacking material at the beginning) which passed to the

[10] Cod. L. V. 13 does in fact lack just this section. Milanesi seems to have launched the questionable idea that the handwriting is that of Mancini, and was followed by Lorenzo Ilari (*La Biblioteca Pubblica di Siena*, VII, Siena, 1848, p. 120), who describes it as *codice autografo*.

[11] Carlo Milanesi, *Catalogo dei manoscritti posseduti dal marchese Gino Capponi*, Florence, 1845, p. 244, No. 2068. The same Library contained a copy of Mancini's *Breve Ragguaglio delle cose di Siena* (*Catalogo, cit.*, p. 189, No. 1598). These MSS. are now in the Biblioteca Nazionale Centrale at Florence (Cod. Gino Capponi 211 and 290 respectively).

Vatican in 1746 as part of the Library bequeathed by the
Marchese Alessandro Gregorio Capponi.[12]

II. Long Version, First Edition

A manuscript in Florence (Biblioteca Nazionale Centrale,
Cod. Palat. 597; former numberings, 20 and E, 5, 5, 46), is
quite distinct from No. I, though in a sense originating from
it.[13] No. II is a fully-grown Treatise and embodies a mass of
new material, which is to be found again in No. III rearranged
and split into two Parts; owing to this rearrangement it is
difficult without much expenditure of time[14] to check the precise
relationship with No. III, which—having undergone a certain
amount of revision and containing still more material[15]—un-
doubtedly represents a slightly later phase than No. II in the
composition of the *Trattato*. No. II is written by at least four
Seicento hands, and has received attention from two *postillatori*;
none of these hands is that of Mancini himself. The text
of the *Trattato* concludes as follows on the fifth page from
the end of the manuscript: "E q[ue]sto basti p[er] adesso
d[e]lla Pitt.ra, rimettendomi sempre à miglior giudizio;" this
corresponds with the end of Part I of the *Trattato* in MS.
No. III and the manuscripts derived from it. The last four

[12] A note by Dr. Schudt (*op. cit.*, p. 5, note 4) requires correction on this
point. For the Capponi manuscript in the Vatican, cf. Giuseppe Salvo
Cozzo, *I Codici Capponiani della Biblioteca Vaticana*, Rome, 1897, p. 297
(second part of Cod. Capp. 230).

[13] A catalogue entry relating to Cod. Palat. 597 will be found in Luigi
Gentile, *I Codici Palatini*, II, Rome, 1890-99, pp. 168 f. (*Cataloghi dei mano-
scritti della R. Biblioteca Nazionale Centrale di Firenze*). The MS. was previously
in the collection of Gaetano Poggiali, who died in 1814.

[14] My own remarks on this manuscript are limited by the fact that I have
only been able to spend a few hours examining it.

[15] For example, the last biography of the series in MS. No. II is that on
p. 167 of a Milanese painter described as "Antonio Francesco" (he is really
Pier Francesco Morazzone—a typical slip by Mancini over the Christian
name). In MS. No. III several further *Vite* follow, the next after Morazzone
being the revised version of Guercino (cf. pp. 310 f. below, and note 40 of
Part I above).

pages of the codex are in the handwriting of one of the two *postillatori*, and consist of some haphazard notes on various artists; among these is an interesting reference to Caravaggio's pictures at Naples.[16] As regards dating, Lodovico Carracci's

[16] Cod. Palat. 597, third page from the end of the manuscript. This passage is substantially the same as that published by Professor Roberto Longhi (*Proporzioni*, I, 1943, pp. 36 f., note 23) as from "Vat. Barber. Lat., 4315, f. 145 v." (sic); but the section of Cod. Barb. Lat. 4315 (i.e., MS. No. VB below) which is devoted to the *Trattato* only covers fol. 21-128, and this passage does not appear in it, while f. 145 v. happens to have nothing whatever to do with art. The question therefore arises whether the quotation derives from the Florentine MS., or from some other MS. known to Prof. Longhi but not to the present writer. There are slight variations in Prof. Longhi's version; for example, *la medexima* is certainly incorrect for Cod. Palat. 597 (I should suggest *limatissima*, though this is perhaps a somewhat unexpected adjective for Caravaggio's *maniera*), and *di suo* should precede "vi sono più tavole" towards the end. However, in the absence of any further enlightenment on the subject, I do not think we can exclude the possibility of a rather hasty transcription from Cod. Palat. 597. If this should prove to be the case I must join issue with Prof. Longhi as to the strict accuracy of his description of the information quoted as "dato nel 1620 dal Mancini in un'aggiunta alle Vite." In his article he assumes "1620" as the standard date for "Mancini." That date is of course perfectly adequate as a rough generalization, but it can mislead if one is studying some question of that very period, since Mancini actually began to write before Lodovico Carracci's death in 1619, and his additions to MS. No. III below continued until 1627 at least. Then there is the fact that everything in a "Mancini" manuscript is not necessarily Mancini; in the case of No. III, for example, there are *postille* which clearly date from after 1650. Moreover the Caravaggio material added to No. II does not reappear in No. III, to which information acquired later was in fact added by the author himself over a period of several years (nor, incidentally, does it reappear in No. VA); conversely, the same hand which added the four final pages to our Florentine codex was also responsible for several *postille* which on internal evidence cannot derive from Mancini—though the writer certainly seems to have been active at a relatively early date (e.g., cf. note 155 of this Appendix). Finally there is a less concrete argument against Mancini's authorship (though real enough if one regards this type of source not as information in the abstract, but rather as information conveyed by an individual personality) in the fact that the passage exhibits an attitude towards Caravaggio which is slightly more favourable than usual with Mancini (e.g., compare his views on Caravaggesque lighting published in *Memorie Originali Italiane*, ed. M. Gualandi, II, 1841, p. 74). It may be added that the name of the annotator's informant in the matter of Caravaggio's pictures at Naples, published by Prof. Longhi as *Gallarini*, appears in Cod. Palat. 597

death is recorded as having occurred *quest'anno 1619*,[17] and the years 1620 (pp. 55 and 233) and 1621 (p. 41) are mentioned as *ora, adesso,* and so on.

III. Long Version, Second Edition

The most interesting manuscript for Mancini studies known to the writer is MS. it. 5571 in the Biblioteca Nazionale Marciana at Venice.[18] The volume contains two works on art by Mancini, the *Trattato* in a revised version (rearranged, retouched, and expanded in relation to No. II), and the *Viaggio*

as *Gallaccini* (". . . si vede in Napoli secondo la relatione datami dal S.r D.r Gallaccini nel ritorno dà Napoli q[ua]le dice cosi . . ."). This is not without interest, as it enables us to establish the fact that the information was provided by the Sienese scholar Teofilo Gallaccini (1564-1641), among whose attainments Isidoro Ugurgieri Azzolini includes that of *antiquario perfettissimo* (*Le Pompe Sanesi*, Pistoia, 1649, I, p. 676), and whose work *Trattato di Teofilo Gallaccini sopra gli errori degli Architetti* (published posthumously at Venice in 1767 accompanied by a biographical note on the author) was dedicated to Mancini himself (for Gallaccini, cf. also Angelo Comolli, *Bibliografia Storico-Critica dell'Architettura*, IV, Rome, 1792, pp. 252-258).

[17] The text of Cod. Palat. 597 (p. 120) reads *quest'Anno 1619 à dj 14 aple*, whereas in MS. No. III (f. 54 v.) *quest'anno* is dropped and the month is given as *9m̃bre*, which is repeated in MSS. Nos. Va (f. 195 v.) and Vb (f. 85 v.). The scribes of Cod. Palat. 597 are not particularly accurate (e.g., the passage quoted above in note 30 of Part II appears on p. 150, but *Maestro Annibale* is substituted for *Mons.r Agucchia*!), and I think we can reasonably assume that the month is a copyist's error, while allowing *quest'Anno 1619* to stand as being what Mancini actually intended to appear in the original of this first edition of the long version of his *Trattato*. The title, with its reference to the appearance of the date 1620 in the MS. (cf. Schudt, *op. cit.*, p. 111), is in the hand of the *postillatore* who added the last four pages.

[18] For a full catalogue entry, cf. Carlo Frati and A. Segarizzi, *Catalogo dei Codici Marciani Italiani*, II, Modena, 1911, pp. 34 f. (No. It., IV, 47). The MS. came to the Marciana in 1797 from the Nani Library, in which it had previously been catalogued by Jacopo Morelli (*I codici manoscritti volgari della Libreria Naniana*, Venice, 1776, pp. 25-30); a decidedly free copy of this MS. (which was made by Daniele Farsetti round about 1800, and which was in the possession of Morelli) is now also in the Biblioteca Marciana (MS. it. 5576; Frati and Segarizzi, *op. cit.*, II, p. 125, No. It., IV, 195). I am greatly indebted to the authorities of the Biblioteca Marciana for their co-operation, particularly in the matter of having photographs made.

per Roma (which is however in reality a kind of supplement to the *Trattato*).[19] The arrangement is as follows. The *Trattato* is divided into two Parts,[20] the first of which is bound first, but is numbered[21] fol. 92-177. The *Parte Seconda* is bound after, though it is numbered fol. 4-90; it contains the *Vite*. At the end (fol. 178-195) is the *Viaggio*, being the text used by Dr. Schudt as the basis for his edition. Five hands are distinguishable. The main text of the *Trattato* is written by one professional scribe and that of the *Viaggio* by another.[22] There are three annotators; two of these were active after Mancini's death

[19] Dr. Schudt (op. cit., p. 14) is inclined to regard the *Viaggio* as an introduction, a view with which I am unable to concur. It is true that in Cod. Barb. Lat. 4315 in the Vatican Library (a codex containing numerous Mancini MSS.) the second part of the *Trattato* (MS. No. VB below, titled *Parte seconda*) happens to follow the MS. of the *Viaggio*, but there is no indication in the title of the latter that it should precede the *Trattato* and I do not believe that such an arrangement represents the author's intentions. Though it appears to me that the *Viaggio* was conceived by Mancini rather as a supplement to his *Trattato*, the two are certainly extremely closely connected. So much so that it would be a mistake to omit the *Viaggio* (the text of which is, after all, relatively short) from any future publication of the *Trattato*; moreover its inclusion would provide an opportunity to revise Dr. Schudt's transcription (which sometimes transposes into what purports to be the Marciana text the uninformed attempts at decipherment of the scribe of Cod. Barb. Lat. 4315—e.g., in the passage on Schudt's p. 64* *Mannesco* is in fact the guess of the copyist of Cod. Barb. at *Marcello*, sc. Venusti, in the original), and also to add various facts which have come to light since his useful but not entirely exhaustive commentary was written.

[20] Part I is not so described in this particular MS., Dr. Schudt's *Libro primo* being an error (*op. cit.*, p. 12); the title on f. 92 r. reads as follows: "Alcune considerationi appartenenti alla Pittura, come di diletto di un gentil'huomo nobile, e come introduttione à quello si deve dire." Part II, which begins on f. 4 r., is headed *PARTE SECONDA* (probably in Mancini's handwriting), and the title reads: "Alcune considerationi Intorno à quello, che hanno scritto alcuni Autori in materia della Pittura se habbin scritto bene, ò male, et appresso alcuni agiognimenti d'alcune Pitture, e Pittori, che non han potuto osservare quelli che han scritto per avanti."

[21] We are making use of this old numbering throughout and not that referred to by Frati and Segarizzi, *loc. cit.* We may note that there is evidence in the MS. itself to the effect that the old numbering was established at a relatively early date (cf. cross references by an early *postillatore* on fol. 11 r. and 30 v.).

[22] Neither of these hands reappears in MS. No. IV, and we are concerned with yet another scribe in No. V.

and we need not concern ourselves further with them.[23]
The third annotator appears very frequently indeed, and the

[23] I noted traces of the more frequent of the two later annotators in the
following places in the *Trattato*: Part I, fol. 122 v., 131 v., 176 v. ("Pietro"),
177 r.; Part II, fol. 15 r., 16 r., 18 v., 21 v., 71 r. He is more active in the
Viaggio, in which he has added throughout in the margin the names of the
churches, palaces and other buildings referred to in the text. He is also
responsible for the following four *postille*. (i) fol. 189 v. (cf. Schudt, p. 90*):
"Nella volta della sagrestia della Chiesa nova ultimamente terminata hà
dipinto Pietro da Cortona" (this was painted in 1633). (ii) fol. 190 r. (cf.
Schudt, p. 91*, but *levate* rather than *guaste*). (iii) f. 188 r. (cf. Schudt,
p. 84**). (iv) fol. 178 r. This is the *postilla* quoted on p. 51*** by Dr.
Schudt, whose notes on the subject seem to have got mixed. It is not in
fact at the top of f. 178 v., but at the bottom of f. 178 r., and its non-appear-
ance in the early copy (Cod. Barb. Lat. 4315) is not due to the fact that it
was on the double page omitted by the copyist (as one would assume from
the printed edition) but is rather to be accounted for on the basis of having
been added after the copy was made. I cannot in any case agree with
Dr. Schudt's ascription of this note to Mancini himself (the hand I propose
to identify as Mancini's is much in evidence throughout the *Viaggio* and is
in my opinion quite distinct from this), and would further suggest that the
information therein may possibly be derived from a book published after
Mancini's death (*Memoria fatta dal Signor Gaspare Celio . . . delli nomi dell' Arte-
fici delle Pitture . . . di Roma*, Naples, 1638, p. 103). Clues as to the dating of
this later *postillatore* are provided by the reference to the Cavaliere
d'Arpino's death in 1640 (f. 71 r.), and by the mention on f. 177 r. of two
works by Pietro da Cortona, the *S. Paul* in the Cappuccini (S. Maria della
Concezione; before 1638) and the sacristy ceiling in the Chiesa Nuova
(S. Maria in Vallicella; 1633). The existence of the latter is also recorded,
as we have seen, on f. 189 v., where there is an addition "come anco la
Cupola e la Tribuna." This must of course be later than the reference to
the sacristy ceiling (cupola, 1647-51; tribuna, 1655-60), but I am not clear
whether it is in the same handwriting or in that of the other annotator, to
whose rare appearances we now turn. The principal *postilla* of the second
annotator is on f. 188 r. and includes the date 1667 (Dr. Schudt's 1661 on
p. 85*** being a misprint). A *postilla* on f. 190 v. (not transcribed by Dr.
Schudt) is probably in the same hand, refers to S. Maria del Popolo, and
reads: "la Cupola del Cav.r Raffaello Vanni come anco [sic]." The pay-
ments for Vanni's frescoes in the cupola and pendentives were in fact made
between 13 June 1656 and 4 January 1658 (cf. *Archivio della Società Romana
di Storia Patria*, VI, 1883, pp. 529, 532-4, 536). It is just possible that the
abrupt breaking off of our *postilla* is due to the fact that the writer was using
Filippo Titi (*Studio di Pittura*, Rome, 1674, pp. 422 f.), who says: "La
Cuppola della Chiesa la dipinse ultimamente il Caval. Vanni, come anche
li quattro Angioli [sic];" the misprint *Angioli* is duly corrected to *angoli* in

character of his operations is such that I have no doubt that we are dealing with Mancini himself. Obviously the grounds for a conclusion of this kind, based on a mass of cumulative internal evidence, are best demonstrated in a complete edition of the text in question; but in the absence of that a brief résumé of the annotator's activities may be given.

In the first place our annotator (I shall call him Mancini in future) corrects the scribe's small *storpiature*, the nature of several of which tends to suggest that the text may, in part at any rate, have been dictated rather than copied.[24] There are numerous corrections of grammatical errors, and examples of the re-phrasing of parts of sentences. Sometimes an entirely new word is inserted, with a sense which is in some respects quite different

the next edition of Titi's guide-book (*Ammaestramento*, Rome, 1686, p. 360). Finally, the same hand may perhaps also be responsible—I do not feel at all certain about this—for the cross references on fol. 11 r. and 30 v. (cf. note 21 of this Appendix). I have made no further progress with my tentative suggestion (in *The Burlington Magazine*, LXXXVIII, 1946, p. 19, note 41) that these *postille* might be by the brothers Dal Pozzo, and do not now regard it as more than a possibility which could be checked (and very likely eliminated) as a matter of routine; for the existence of a Mancini manuscript in the Dal Pozzo library, cf. below, p. 316. There is a slight, but probably fortuitous, resemblance between certain words in the second group of *postille* and the writer of the Siena MS. of the short version of the *Trattato* (Cod. L. V. 13), but no certainty seems possible owing to the exiguousness of the available data.

[24] We may give some typical examples of this. Perhaps the most amusing is the transmogrification of poor Praxiteles, who appears (f. 104 v.) as "frà Zitelle" (duly corrected by Mancini to *Prasitele*). Other instances of single words are "Menozzo" (corrected to *Benozzo*, f. 123 v.); "mandato" (corrected to *ma nato*, f. 133 r.); "fluitione" (f. 154 r.) and "fintione" (f. 155 v.), both corrected to *fruitione*; "profani" (corrected to *populani*, f. 37 v.); "podigre" (sic, corrected to *pudiche*, f. 61 r.). As a more elaborate instance of misunderstanding we may cite "collationi ancor'erroice" (f. 44 v., corrected to *co[n] le attioni ancor'eroiche*). Names are often stumbling blocks; so are learned or technical terms, as with the details of Lodovico Carracci's illness (f. 54 v.). Occasionally such errors may have escaped correction by Mancini, e.g., in such a passage as the following on the framing of pictures (f. 171 v.): "Crederei che in alcune cose picciole di color molto vivace, et che non han tempo rilievo, com'è la maniera del Baroccio, [the frames] fussero molto meglio di color nero che dorate." *Tempo* turns out to be *troppo* when this passage is collated with its fellow on p. 282 of MS. No. II, which might well provide an explanation for other puzzling passages in No. III.

from that which it supersedes (very much of an author's correction, this).[25] There are occasions when one-word errors on a point of fact are corrected,[26] or when a name has been ascertained after the text was written and is inserted in the space left for the purpose.[27] Short sentences are added in the middle of the text, where the space available permits—perhaps at the end of the *Vita* of an artist, recording some further details which had come to Mancini's notice (we shall refer to some of these later in connexion with the dating). Sentences in the scribe's text are struck out altogether, and there are copious notes in the margin ranging from a word or two to continuous passages covering the complete margin of a page, or even more. Sometimes these marginal notes have a very personal flavour;[28] they are however free of the critical and even abusive tone which is so often to be found in the splutterings of the independent *postillatore*.[29] They very frequently, though not invariably, have insertion marks indicating precisely how they are to be introduced into the text. Of a different type are the notes beginning with such expressions as *qui va* (usually indicating where an artist's *Vita* is to appear) and *qui pone*; these certainly have the character of the memoranda of an author.

[25] An example will be found on f. 142 v., where *subsequente* [i.e., subsequent to the High Renaissance] is substituted for *declinante* in "del secol n[ost]ro declinante."

[26] We may indicate a single instance (f. 127 r.), where the text refers to "la Cappella delli SS.ri Caetani in S. Prassede di Giuseppe [i.e., Cesari d'Arpino]," and Mancini correctly substitutes *Olgiati* for *Caetani*.

[27] As with Antonio Carracci's friend "Dionisio " on f. 57 r.; Mancini inserts *Buonavia* in the space.

[28] For example, the two words "come credo" on f. 100 r., or the longish passage on f. 40 r. reading "et io ho conosciuto un vecchio in mia fanciullezza di eta di 70 anni che diceva haverlo [the reference is to the Sienese painter Capanna] conosciuto che cosi potea [il Capanna] esser stato amico di Baldassare [Peruzzi] ma di maggior eta."

[29] Mancini dearly loves a striking anecdote, but on a single occasion feels impelled to scribble that one which he has allowed to appear in the text is too far-fetched ("Questo fuor d'ogni credenza," f. 86 r.); this apparently refers to the story about a picture by Terenzio Terenzi (who seems to have had a reputation for faking Raphaels) having found its way into the possession of the King of Spain under Raphael's name.

Finally we have complete *Vite* written in by Mancini himself. He both inserts a *Vita* in a space left on purpose by the scribe,[30] and adds several after the handwriting of the latter ceases. The last *Vita* written by the scribe is that (on fol. 87 verso) of an anonymous Fleming who had worked in San Pietro in Montorio. Mancini himself then adds a few lines at the bottom of the page on his companion in that work, also a Fleming.[31] The *Vite* on the ensuing fol. 88-90 are all in Mancini's handwriting. On fol. 88 recto are *Tobia* (probably Tobias van Haecht or Verhaecht) and *Broglo* (Jan Bruegel); *Pavol Brillo* (Paul Brill) begins at the bottom of fol. 88 recto and continues until the top of fol. 89 recto,[32] the rest of which is occupied by *Moñ* [i.e., "Monsieur"] *Bordino*,[33] who is very probably Louis Brandin.[34] On fol. 89 verso is the note on *Monsu Possino* published by the present writer.[35] Fol. 90 recto and verso complete Part II with

[30] Fol. 77 recto (the Procaccini).

[31] These two *Vite* (or rather *notizie*) were published from MS. No. VB by Dr. J. A. F. Orbaan (*Bescheiden in Itali" omtrent Nederlandsche kunstenaars en geleerden*, I, The Hague, 1911, pp. 351 f.). The identity of the artists concerned was established by Dr. T. H. Fokker ("Twee Nederlandsche navolgers van Caravaggio te Rome," in *Oud Holland*, XLIV, 1927, pp. 131-137) as Dirk (Theodoor) van Baburen and David de Haen; cf. also Arthur von Schneider, *Caravaggio und die Niederländer*, Marburg/Lahn, 1933, pp. 39 ff., esp. pp. 43-44. Mancini is evidently in error in saying that they had both returned "in Fiandra," since David de Haen died in Rome in August 1622.

[32] This *Vita* was also published by Orbaan (*op. cit.*, p. 352) from MS. No. VB.

[33] The name is spelt *Bordino* in Nos. III and VB (f. 128 r.), and in Eugène Müntz' publication of the *Vita* from Cod. Capp. 231 in the Vatican (*Nouvelles Archives de l'Art Français*, Vol. for 1876, pp. 296 f.); *Bardino* only appears in No. VA (f. 242 r.). The reference to his birthplace was added by Mancini in the margin of f. 89 r. of No. III; he first wrote "nato in Francia vicino a Parigi" and then substituted "in Borgognia" for the last three words.

[34] For this identification, cf. *The Burlington Magazine*, LXXXVIII, 1946, p. 16, note 11.

[35] Denis Mahon, "Nicolas Poussin and Venetian Painting: a new connexion," in *The Burlington Magazine*, LXXXVIII, 1946, pp. 15-20 and 37-43; Mancini's short account of Poussin will be found on p. 17. Perhaps I may add here that, since my article was published, Dr. Jacob Hess kindly informs me that in endeavouring to decipher the last few words he has come to the conclusion that they should read: ". . . per poterla poi come fa felicem[ente] esprimerla co[n] il pennello." I think this is certainly correct.

an account of Pietro da Cortona.[36] At the end of Part I, however, there are several *Vite* in Mancini's handwriting which
have obviously got out of place; they cover fol. 175 verso, 176
and 177. Fol. 175 verso begins with a short note on an unnamed
painter,[37] and ends with the *Vita* of Prospero Fontana. Fol. 176
recto is devoted to *Ottavian Mascarini* (Mascherino), and a
second *Vita* of Pietro da Cortona (probably slightly earlier than
the one mentioned above) occupies fol. 176 verso and 177
recto.[38] The final page (fol. 177 verso), which immediately
precedes the beginning of the *Parte Seconda*, contains the life of
an anonymous *religioso* who painted perspectives.[39] So much for
the scope of Mancini's own operations in this copy of the *Trattato*.

We now turn to the question of dating.[40] On two occasions
the date 1621 appears in the handwriting of the scribe,[41] and

[36] The *postilla* on Pietro da Cortona added by a later hand does not appear
at the end of this *Vita* on f. 90 v. (as stated by me in *The Burlington Magazine*,
loc. cit., p. 16), but at the end of Pietro's other *Vita* on f. 177 r. Though the
fact does not appear to be of any particular importance, I regret this inaccuracy, which was due to a misunderstanding of my notes.

[37] The note, which begins "Opero a Corneto per il Cardinal Rombaglietto," seems to refer to Mateo Pérez de Alesio (otherwise Matteo da
Lecce), a longer account of whom will be found on fol. 58 of the Marciana
manuscript; for further details of this identification, cf. note 122 of this
Appendix.

[38] For the dating of the two accounts of Pietro da Cortona, cf. notes 46 to
48 of this Appendix. In the interests of strict accuracy I should like to take
this opportunity of revising my readings from the earlier of the two *Vite*
quoted in *The Burlington Magazine, op. cit.*, p. 16: *16 in 18 anni* (f. 176 v.),
amicizia rather than *servizio* (f. 176 v.) and *d'eta* (f. 177 r.).

[39] He can probably be identified (through Mancini's mention of his
activities "come si vede nella Chiesa di S. Silvestro") as the Theatine Father
Matteo Zaccolini(o) or Zoccolini(o), for whom cf. also note 50 of this
Appendix. For San Silvestro sul Quirinale, also known as *a Monte Cavallo*,
cf. Filippo Titi, *Studio di Pittura*, Rome, 1674, pp. 322 f.

[40] The manuscript contains a very fair quantity of evidence—of varying
weight—with regard to the dating. I propose to indicate only a selection of
the more straightforward examples.

[41] They are:

(i) f. 17 r.: "... fin hora 1621 ..."

(ii) f. 106 v.: "L'epoca dunq[ue] di Christo à noi piu nota, et che communem.^{te} vien usata in Europa è di mille seicento vintun'anno ..."

In MS. No. II above the year in the case of the first passage is given as
620 (p. 55), and in that of the second as *1621* (p. 41).

I think it can reasonably be assumed that his task was completed in that year, most probably during the first half. Some of Mancini's *postille*, presumably added the next time he turned to his treatise after receipt of the information, refer to events which occurred in 1620 or early in 1621.[42] It seems clear that he continued to add small items to this manuscript for some time after the scribe's part in it was finished. As an example of an addition which was probably made a good deal later we may cite Mancini's note in the margin of the *Vita* of Lanfranco, which includes the statement that the latter was working *adesso* for San Paolo fuori le Mura;[43] and Baglione tells us that the chapel there for which Lanfranco provided the paintings was

[42] We may quote four examples.

(i) The scribe ends the *Vita* of *Carlo Veneziano* [i.e., Saraceni] on f. 83 r. as follows: "E stato chiam.to ultim.te à Venetia dove no[n] si dubita che sodisfarà." Immediately after this Mancini adds a longish note beginning "Vien detto esser morto . . ." In fact, Saraceni had died at Venice on 16 June 1620 (for documentary evidence, cf. *Rivista Mensile della Città di Venezia*, VII, 1928, p. 395).

(ii) The scribe had written of *Gerardo* the Fleming [i.e., Honthorst] on f. 86 v.: "Vive hoggi in Roma . . ." Mancini strikes out the first three words, and substitutes "Parti q.o anno di." Honthorst appears to have left Rome in 1620 (cf. Arthur von Schneider, *Caravaggio und die Niederländer*, Marburg/Lahn, 1933, pp. 21 f.).

(iii) The scribe had written (f. 87 r.) in the biography of *Anton Francesco* [a Milanese painter who is really Pier Francesco Morazzone] that "ultim.te si è visto di sua mano una Juditta di maniera assai fiera e risentita che hà il Padre R.mo Comm.rio del S.to offitio." Mancini has written in the margin, immediately after the word *offitio*, "hoggi Cardinal Scaglia." Desiderio Scaglia, Commissary General of the Roman Inquisition, was one of the Cardinals in Paul V's last creation, which took place on 11 January 1621.

(iv) The scribe writes that *Filippo* of Naples [Filippo d'Angeli] is in the service of the Grand Duke of Tuscany (f. 83 v.). Mancini adds at the end of the *Vita*: "Doppo la morte di q.ell Altezza s'aspetta in Roma." Cosimo II died on 28 February 1621.

[43] Mancini's addition (f. 77 r.) reads: "have[n]do fatto molte cose qui in Roma come in S. Agostino alla Chiesa nuova et adesso p[er] S. Pauolo co[n] molte cose private." Mancini adds a note "La Cappella di Giovanni Lanfranchi" to the account of S. Paolo in his *Viaggio* (f. 182 v.; ed. Schudt, p. 66).

built for the Anno Santo 1625.[44] But perhaps the clearest
evidence of late dating to be found among these *postille* is that
in which Mancini records the death of an infant son of Antonio
Carracci as having occurred in 1624.[45] Finally there are three
complete *Vite* which were undoubtedly added still later. They
are the two accounts of Pietro da Cortona, in which his work
in Santa Bibiana in 1624-26[46] is (in one case) described as in

[44] Attention was drawn to this information in Baglione's *Nove Chiese*
(Rome, 1639, p. 64) by Dr. Jacob Hess in his notes to Passeri (*op. cit.*,
p. 146, note 2).

[45] The scribe writes (f. 57 v.) : "[Antonio Carracci] lasciò [at his death
in 1618] un figl[i]o d'8. mesi, che lo pigliò il S.ʳ Lud.ᶜᵒ Caracci, et adesso
il fr[at]ello, faccia Iddio, che possa essere educato nella p[ro]fessione, che
possa i semi imp[re]ssali [Mancini crosses out from *nella* to *impssali*, and
substitutes *da poter i semi impressili*] dal p[ad]re dedurà [sic; apparently for
dedurre a] p[er]fettione, che in q.º modo non si deve dubitar, che sia p[er]
far riuscita grande poiche q.ⁱ Caracci sono pittori grandi p[er] heredità."
Mancini then adds, in the space at the end of the paragraph, immediately
after *heredità*: "Q.º putto morse nel 1624." The scribe continues with "un
giovanetto di med.ᵐᵃ fameg.ᵃ . . . che d'età di 21. in 22. anni in Bologna
fa cose da mastro che con q.º e co[n] q⁰ᵉˡ fanciulletto d'Antonio si deve
sperar [great things]," and it may be noted that in MS. No. II above
(p. 126) the age of the young man is given as 20, thus supporting our con-
tention that the version preserved in Cod. Palat. 597 dates from a year or
so before No. III. The young man is presumably Franceschino Carracci,
and it is curious that, if Malvasia is correct in saying (*Felsina*, 1678, I, p. 524)
that he died in the Ospedale di Santo Spirito (Mancini's own hospital!) on
3 June 1622 at the age of 27, Mancini did not insert a note about his death
also. However, apart from the fact that Malvasia's final *2* in the year might
be an error or a misreading (for 7?), Mancini's warmest admirer would
hardly claim that he was a model of thoroughness in such matters, and so
(in the absence of further evidence) the question is probably best left un-
settled.

[46] For the date, cf. the documents transcribed by Oskar Pollak (*Die
Kunsttätigkeit unter Urban VIII*, I, Vienna, 1928, pp. 23 and 29). The Pope's
instructions with regard to commencing the restoration and embellishment
of the Church are dated 17 August 1624, and documents relating to five
payments to Pietro are dated between 5 December 1624 and 20 July 1626,
by which latter date his frescoes appear to have been finished, leaving an
altarpiece on canvas as the only work outstanding. In November 1626 the
body of the Saint (the finding of which was the pretext for the restoration)
was taken to the Church and the Pope celebrated Mass there; thus the
work may be assumed to have been almost, if not quite, completed by the
end of 1626.

progress[47] and (in the other case) referred to as though recently completed;[48] and the note on *Monsu Possino*, which has a *terminus post* in the shàpe of Nicolas Poussin's arrival in Rome (placed by both Bellori and Passeri in the spring of 1624), and may perhaps have been written between the summer of 1627 and that of 1628.[49] To these (since it is on the back of the second page of the earlier life of Pietro) can plausibly be added the *Vita* of the *prospettivista* Padre Matteo Zaccolini,[50] who died in the same month as Mancini himself,[51] August 1630.

IV. *Partial Revision of Part I of No. III*

A manuscript of Part I[52] in Siena (Biblioteca Comunale degli Intronati, Cod. L. V. 11) is undoubtedly slightly later than Part I of MS. No. III. It is the work of a scribe (different from those in No. III and No. V), but contains corrections and *postille* which, though not as copious as those which we have

[47] Fol. 177 recto: "Opera adesso in S. Bibiana."

[48] Fol. 90 recto: ". . . ultima[mente] in S. Bibiana dove si vede la natura acco[m]pagniata dal studio, et il buon gusto . . ." Mancini has also added a *postilla* in the *Viaggio* about this work (f. 185 v.): "Quivi va S. Bibiana, dove vi sono . . . pitture moderne del Cortonese et Ciampelli" (cf. Schudt, *ed. cit.*, p. 76).

[49] For a discussion of this, cf. *The Burlington Magazine*, LXXXVIII, 1946, pp. 19 f.

[50] For Zaccolini, cf. note 39 of this Appendix and Baglione (*Le Vite de' Pittori*, Rome, 1642, pp. 316 f.), who says that he died on 19 August 1630. Mancini writes of him as alive (f. 177 v.): "Non opera fuor della Religione et in q.ª anche seco[n]do il furore. Ma pero se S. B. [i.e., presumably Urban VIII] si risolvesse a far qᵃlche cosa dove vi haveva luogo la prospettiva no[n] è da dubbitare che operasse."

[51] Dr. Schudt (*op. cit.*, p. 11, note 4) publishes an *avviso* of 24 August 1630 in Cod. Urb. Lat. 1100, f. 507, recording Mancini's death *giovedì notte*.

[52] The title (as given by Schudt, *op. cit.*, p. 110) is the same as that of the first part of MS. No. III (cf. note 20 of this Appendix), with the exception that the words *Parte prima* are added. Dr. Schudt lists as copies of MS. No. IV: (1) Florence, Biblioteca Laurenziana, Cod. Med. Palat. 50 (cf. note 59 of this Appendix, and quotations by Schreiber, *op. cit.*, p. 110); (2) Siena, Biblioteca Comunale degli Intronati, Cod. C .IV. 18, fol. 75-119.

found reason to believe are Mancini's own in MS. No. III, are
unmistakably written by the same hand. When I saw this
manuscript nearly ten years ago I was chiefly interested in
what Mancini had to say about contemporary artists (most of
the material concerning which is in any case in the *Parte
Seconda* of his treatise), and so did not spend much time in
examining it after I had ascertained that there were no very
substantial additions relating to Mancini's own period. How-
ever, some more or less fragmentary evidence which seems to
throw light on the relationship of this MS. to No. III and the
first part of No. VA may be worth recording.

To start with a rather trifling instance, Passignano's name is
so written in No. III (f. 146 r.) that a copyist who did not know
what to expect could easily misread it *Bassignano*. This mis-
reading does in fact occur in No. IV (f. 58 v.) and is duly
corrected.[53] A rather more elaborate example is provided by
Mancini's reference to Caravaggio's painting of *The Fortune-
Teller*. On fol. 145 recto of No. III the scribe writes in the text
". . . et di q.ta [i.e., Caravaggesque] scuola non credo forsi che
si sia visto cosa con [Mancini writes in *piu*] gratia et affetto che
q[ue]lla Zingara, che da la bonav.ra à q.el giovenotto mano del
Caravaggio, che possiede il S.r Aless.ro Vittrice gentilhuo[mo]
qui di Roma." Mancini then makes an insertion mark and
adds the following in the margin: "che anchor che sia per q.a
strada no[n] dimeno la Zingara mostra la sua furbaria co[n]
un riso finto nel levar l'anello al Giovanotto et q.o la sua
se[m]plicita et affetto di libidin[e] verso la vagezza della
Zingaretta che le da la ve[n]tura et le leva l'anello." This
whole passage, both the section written by the scribe of No. III
and the *postilla* added by Mancini, is copied by the scribe of
No. IV (f. 58 r.). Disregarding the usual slight variations in

[53] Mancini was, incidentally, a personal acquaintance of Domenico
Passignano (cf. Passignano's letter of 22 December 1629 published by
Michelangelo Gualandi in *Nuova Raccolta di Lettere sulla Pittura*, II, Bologna,
1845, p. 76). As an example of a passage which, being deleted in No. III,
does not reappear in No. IV, we may cite a sentence on Baglione which
followed shortly after the mention of Passignano.

spelling, the latter's version is faithful enough. There are however three exceptions, which (significantly) are all in Mancini's rather trying handwriting in No. III (the unfortunate copyist has my sincere sympathy!); he reads *sua* for *strada*, apparently *vagara* for *vagezza*, and *teneva* for *leva*, and one can, I think, see in the original how this occurred. Mancini corrects all three errors in No. IV, even giving *vaghezza* the *h* which is apparently missing in No. III, though the word is split on the edge of the page.[54] Further extracts from this MS. can be more conveniently discussed in connexion with No. Va, but before passing on we may note that a useful hint as to dating is provided by an addition in the margin referring to the restoration of the Triclinium of Leo III, which was one of the few surviving portions of the old Lateran Palace.[55] Mancini's *postilla* reads (fol. 32 recto): "Queste pitture [he uses the term for mosaics also] hoggi per pieta χρña et liberalita di Principe sono resarcite et ornate dall Illmo Cardinal Barberino."[56] The latter is Francesco Barberini, who was created Cardinal in October 1623; and the restoration of the Triclinium, carried out under his auspices, is commemorated by an elaborate dissertation (by

[54] A similar split is probably the cause of the *strada* misunderstanding; *stra* looks like *sua*, and the copyist has ignored the *da* on the next line.

[55] The relative text in the scribe's handwriting on f. 32 r. of MS. No. IV (corresponding with that on f. 116 r. of No. III) makes the identification clear enough: "Il Musaico della Capella Leonina a S. Gio: Laterano hoggi della Penetentiaria [No. III has *Penitentiaria*] di Leon 3. al tempo che Carlo magno venne a Roma come si vede da questa Pittura dove è S. Pietro in mezzo a man destra Leone et alla sinistra Carlo che p[er] le mani di Leon piglia da S. Pietro lo stendardo, le teste di Carlo e Leone hanno la diadema quadrata in segno di vita che queste pitture furono fatte vivente Leone e Carlo Magno . . ." For the proximity of the Triclinium to the Hospice of the Franciscan *Padri Penitentieri* of the Lateran Basilica, cf. Giovanni Baglione, *Le Nove Chiese di Roma*, Rome, 1639, pp. 127 f.

[56] This information does not in fact appear in the corresponding place in MS. No. III. Though I am not altogether confident of my reading, it seems possible that Mancini has noted in the Margin of No. III (f. 139 v.), near another reference to this mosaic: "dove comincia la decrepita et Ruina." This does not reappear in MS. No. Va (f. 77 v.), but I have no note as to whether it is crossed out in No. IV or merely not included.

Niccolò Alemanni, the *Custode* of the Vatican Library) which
was published in 1625.[57]

V. *Early Copies of Nos. III and IV*

We now turn to two early copies, the work of the same scribe:
one contains the whole of the *Trattato*, while the other consists
only of the *Parte Seconda*. The first, to which we shall refer as
No. VA, is Harleian MS. 1672 in the British Museum; the
second, to be described as No. VB, covers fol. 21 to 128 of Cod.
Barb. Lat. 4315 (formerly No. XLVIII, 83) in the Vatican
Library.

No. VA is straightforward as a manuscript. It is written
throughout by a single hand which makes only three small
additions in the margin; it is divided into *Parte Prima* and *Parte
Seconda*,[58] and is preceded by an undated dedicatory letter to a

[57] *De Lateranensibus parietinis ab . . . D. Francisco Card. Barberino restitutis
dissertatio historica Nicolai Alemanni*, Rome, 1625; for an engraving of the
mosaic described, not too accurately, by Mancini, cf. p. 70. For the question
of the significance of the rectangular haloes, cf. note 67 of this Appendix.
It appears that instructions had been given for the work of restoration
before Cardinal Francesco Barberini left Rome in March 1625 on his lega-
tion to France. The news had evidently reached the celebrated French
savant Nicolas-Claude Fabri de Peiresc at Aix-en-Provence by 6 February
1625, as he writes on that day to his friend the Cardinal's Secretary, Girolamo
Aleandro, "Ho caro d'intendere che si repari il mosaico della Basilica
Leoniana," showing also in the same letter that he had been informed of
Alemanni's forthcoming publication (cf. *Revue Archéologique*, Troisième Série,
III, Jan.-June 1884, p. 6, note 1; and *Revue critique d'histoire et de littérature*, IX,
1875, Pt. II, p. 109, note 2). The Cardinal, accompanied by Aleandro, met
Peiresc during the subsequent April, and Aleandro spent several days with
him.

[58] Cf. *A Catalogue of the Harleian Collection of Manuscripts . . . preserved in the
British Museum*, London, 1759, I, No. 1672 (1808 edition, II, p. 170). The
titles are as follows. Part I (f. 2 r.; the Part ends on f. 123 r.): "Alcune
considerationi, appartenenti alla Pittura, come diletto d'un' Gentilhuomo
nobile, e come introduttione à quello, si deve dire. Parte Prima." Part II
(f. 124 r.): "Parte Seconda. Alcune considerationi intorno à quello che hà
scritto qualche Autore, in materia della Pittura, con altre considerationi di
Pittura, e Pittori, che non sono potute esser osservate, ne sapute da quelli,
che hanno scritto ava[n]ti questo tempo." The Part and MS. conclude on

personage whose name is not given.[59] A cursory examination establishes the fact that it was written later than the main text of No. III, since many of Mancini's additions to that MS. are embodied in the present copy. We should naturally expect that there should be omissions where the copyist could not read Mancini's writing or when the insertion of the *postille* into the text was awkward; and this is true throughout both Parts of No. VA. Nevertheless certain discrepancies between Nos. III and VA cannot be accounted for on that basis alone. As far as the *Parte Prima* is concerned there are additions which insist on the intervention of an intermediate MS., whereas on the other hand certain omissions in the *Parte Seconda* suggest that this section of No. VA was copied from the second part of No. III before Mancini had finished adding to it.

In the case of Part I, with which we shall begin, there seems to be a strong *prima facie* case for supposing that No. VA was in fact copied from No. IV. As has already been explained, I only made a rather brief acquaintance with No. IV, but some of my notes seem to point quite clearly to that conclusion. For instance, there is a passage in No. III where a blank is left for two names;[60] this blank is repeated by the copyist of No. IV, but filled in by Mancini,[61] while in No. VA the names simply

fol. 242 verso: "E di costume affabile, piacevole, et allegro" (i.e., end of the life of "Bardino" [=Bordino=Louis Brandin]). No. VB (f. 128 v.) concludes with the same words.

[59] The letter (fol. 1 r. and v.) ends with Mancini's name. There are also dedicatory letters in Nos. II and IV, neither of which I have copied. I observe however that the quotation given by Bandini of the beginning of such a letter in Cod. Med. Palat. 50 in the Biblioteca Laurenziana at Florence corresponds with that in No. VA, with the exception that the latter substitutes *Ecc.mo* for *Reverendiss.* in the style of the person addressed (for Cod. Med. Palat. 50, stated by Dr. Schudt to be a copy of No. IV, cf. Angelo Maria Bandini, *Bibliotheca Leopoldina Laurentiana*, III, Florence, 1793, col. 196 f.).

[60] In describing the third group or school, that of the Cavaliere d'Arpino, in his classification of modern painters, Mancini says (No. III, f. 145 v., handwriting of the scribe): "Vi sono molti di q.a scuola come è il fr[at]ello del Cav.re Franzese . . ."

[61] In No. IV (f. 58 v.) Mancini himself fills in this gap "d.o Bernard.o Fulminetto," which, being interpreted, signifies Bernardino Cesari (brother of the Cavaliere d'Arpino) and the French painter Martin Fréminet.

appear as part of the text.[62] An excellent example of corrections running right through is furnished by a passage on *Ferraù da Faenza* (Ferraù Fenzoni).[63] Further striking witness to the intervention of No. IV between Nos. III and Vᴀ seems to be provided by a passage on Cristofano Allori, described by Mancini as *Bronzin giovane*.[64] Finally, the passage inserted by Mancini in the margin of No. IV relating to the restoration of the Triclinium of Leo III referred to above (page 297) is copied by the scribe of No. Vᴀ as one of his three marginal notes in that MS.,[65] but he very understandably failed to decipher a small insertion indicated by Mancini in No. IV in connexion with the description of the mosaic.[66] Mancini apparently wished to add an adjective to his description of the *diadema*

[62] On fol. 84 verso. Incidentally, the copyist of No. IV leaves out the *è*, which is likewise missing from No. Vᴀ.

[63] No. III (f. 146 v., handwriting of the scribe): ". . . come si vede dalle cose sue che fà adesso in Faenza sua patria che danno nel maestro grande, e no[n] hanno paura d'alcuno che nel domo li sono incontro" [and Mancini himself adds] "le cose dei Dossi et le sue no[n] so[n] mute." This passage is copied complete into No. IV (f. 59 r.), but Mancini does not like the look of it, substituting *vi* for *li* and inserting *pur* in front of *le sue*; these corrections are duly embodied in No. Vᴀ (f. 85 v. f.). For another instance of alterations running right through, compare f. 100 r. (top) of No. III with f. 11 v. (middle) of No. IV and f. 17 v. (top) of No. Vᴀ.

[64] No. III (f. 146 r. and v., handwriting of the scribe) reads: "Si vede quì in Roma In Casa dell'Ill.ᵐⁱ Orsini una giuditta di esquisitiss.ᵃ bellezza [,] molti dicono, che sia di maniera stentata ma dican' quello che vogliono l'opera fatta è bellissima." In No. IV (f. 59 r.) Mancini inserts "alla Vigna dell'Ill.ᵐᵒ Borghese un San Fran.ᶜᵒ" after *bellezza*, and strikes out *voglion*[o], substituting what appears to be *le piace*. The copyist of No. Vᴀ (f. 85 v.) takes account of the insertion, and reads *le piace*. Prof. Roberto Longhi, in quoting the above passage from the Venice MS. (No. III) in *Proporzioni* (I, 1943, p 53, note 68) says that the quotation is from the Vatican MS., "Barb. Lat. 4615" (sic); this is of course a misprint which has eluded him.

[65] The *postilla* with regard to the restoration of the Triclinium mosaics is on f. 46 r. of No. Vᴀ; for the other two marginal notes in this MS., cf. note 69 of this Appendix. We observe that the faulty spelling *Penetentiaria* employed by the scribe of No. IV (cf. note 55 of this Appendix) reappears in the text of No. Vᴀ (f. 46 r.).

[66] The passage is that quoted in note 55 of this Appendix.

quadrata and inserts *et* followed by an illegible word ;[67] the scribe of No. VA copies the *et* and then leaves a blank.[68]

On the whole it seems probable that where there is a discrepancy between the first part of No. III and that of No. VA, its origins will usually be found in No. IV.[69] Among various

[67] Mancini has written the word so badly in No. IV (f. 32 r.) that no certainty is possible in deciphering it. The sense may very well be *blue*, for that was the abnormal characteristic of these rectangular haloes. My guess is *celeste*, an adjective which Mancini uses elsewhere (No. III, f. 139 v.) in this context and indeed in referring to this particular mosaic (cf. also fol. 116 recto of No. III for a reference to a *diadema quadrata turchina*). After *in segno di vita* Mancini adds *et santita*, which words are incorporated in No. VA. It may be suggested that this latter addition may have been due to a perusal of Niccolò Alemanni's *De Lateranensibus parietinis* fresh from the press in 1625. There were originally two mosaics flanking the apse. When Mancini's main text was written only the mosaic representing S. Peter, Leo III and Charlemagne still existed; the other (with Christ, S. Silvester and Constantine) was reconstructed later, allegedly from drawings which had been made of the lost originals some seventy years previously (cf. Alemanni, *op. cit.*, pp. 55 ff.; his plates II and III show the Triclinium before and after restoration). Now the awkward fact for the *segno di vita* theory which emerged from the just completed reconstruction was that the figure of Constantine (based on drawings the genuine existence of which has since been questioned, and which were at any rate unknown to Mancini when he first wrote) also had a rectangular halo, despite the fact that Constantine was very obviously not alive at the time when the original mosaics were made. Alemanni naturally discusses this discrepancy (*op. cit.*, pp. 63 ff.), and comes to the conclusion that the popularly-held *segno di vita* theory does not always hold good, and that the rectangular halo is a sign of outstandingly good qualities : hence, we may suppose, Mancini's *santità*, though *virtù* would have been more appropriate.

[68] There are two other alterations by Mancini on f. 32 r. of No. IV which reappear as part of the text on f. 46 r. of No. VA. But some not very easily intelligible words preceded by *qui pone* (as in No. III), and a longish *postilla* with a pen stroke through it are both ignored by the scribe of the British Museum MS.

[69] As we have seen (cf. note 65 of this Appendix), this was the case with one of the marginal notes in No. VA, and may possibly prove to be so with the other two, both of which appear on f. 61 v. Their context is a list of pictures in Rome which were painted between 1550 and 1600. In the margin opposite "in S. Agostino la Cap.ª della Croce di Daniello [i.e., Ricciarelli da Volterra]" is the note "Quelle di Daniello son intorno al 1550" (a remark presumably based on Vasari). And opposite "In S. Caterina de funari . . . abbasso alla porta grande d'Anibal Caracci" is the comment "Mà doppo il 1600." If this comment proves to be actually in

small instances which I have not checked in No. IV are the
insertion of Fréminet in the long *ruolo* of painters' names,[70] and
the statement (in the list of recent paintings in Rome) that
Lanfranco had painted a chapel for the Sacchetti family.[71]
The most extensive variation (which I have also not been able
to collate with No. IV) seems to be between a section on ancient
painting in No. III and its fellow in No. VA;[72] the considerable

Mancini's handwriting, the discrepancy between its improbability (if taken
literally) and the statement, much more plausible from the stylistic point of
view, in his *Vita* of Annibale that this picture (*S. Margaret*) was painted in
Bologna (i.e., some considerable time before 1600) may perhaps be accounted
for in the following way. What Mancini is trying to convey is, we suggest,
that a picture by Annibale should (for the purpose of the context) be re-
ferred to later, grouped with his other works and those of his followers.
Actually the mention of the Church of Santa Caterina dei Funari in con-
nexion with the paintings there of stylistically earlier artists had led Mancini
on to mention that of Annibale; the *postilla* may express his subsequent
feeling that its insertion here is out of place.

[70] On fol. 72 r. of No. VA: "Fulminetto Pittore della Maestà del Rè di
francia." As we have seen (notes 60 and 61 of this Appendix) Mancini
evidently had some difficulty in putting a name to Fréminet. It may be
suggested that his memory was jogged by having come across "Fulminetto"
in Giovanni Battista Marino's *La Galeria*, in which the name appears twice;
the Cavaliere Marino's verses were first published in 1619 (second impression,
1620).

[71] Cf. f. 63 r. of No. VA: "In S. Gio: Fiorentini . . . pitture del Tempesta,
e del Ligozza, di Cherubin dal Borgo, et in questi tempi seguenti nel Vaticano
la Sala Clementina, e la Cappella de Sig.ri Sacchetti di Gio: Lanfranchi."
The passage would appear to be an example of the way in which a copyist's
misreading can lead us astray. In this case however we know the facts,
which are that the references to Tempesta, Ligozzi and the Sacchetti chapel
by Lanfranco are all intended to apply to San Giovanni dei Fiorentini,
whereas Cherubino [Alberti] dal Borgo worked in the Sala Clementina in
the Vatican. I should guess that what has occurred is that two *postille*
(namely "di Cherubin dal Borgo" and "e la Cappella de Sig.ri Sacchetti di
Gio: Lanfranchi") appear in MS. No. IV, perhaps in opposite margins and
perhaps without contrasting insertion marks; in any case the copyist has
found it possible to transpose them, inserting the one in the position intended
for the other, and thus creating a Lanfranco chapel in the Vatican! The
work in this chapel in San Giovanni dei Fiorentini was clearly very recent, as
it is also the subject of a *postilla* which Mancini himself added to the *Viaggio*
(f. 189 v.; ed. Schudt, p. 89).

[72] The passage begins *Trà le pitture*; it covers fol. 107 r.-111 r. of No. III,
and fol. 30 r.-37 v. of No. VA.

additions, rearrangements and omissions are sufficient to make a new fair copy necessary, and may perhaps be the *raison d'être* of No. IV.

Before turning to Part II of the *Trattato* as rendered in the second half of No. VA and by No. VB, it may be well to say a word or two about the latter.[73] No. VB covers a part (fol. 21-128) of Cod. Barb. Lat. 4315 in the Vatican Library, and is preceded (fol. 1-20) by a manuscript of the *Viaggio per Roma*; both are in the handwriting of the same scribe as No. VA. Fifteen other works by Mancini then follow, written by a single hand different from the foregoing; there is nothing among these to interest the art-historian, with the exception of a brief discourse entitled *Che cosa sia Disegno, e di quali Professioni sia et à chi appartenga* (fol. 147-155), some short passages in the *Breve Ragguaglio delle cose di Siena* (which covers fol. 292-375), and a section at the end of *Del Origin et Nobiltà del Ballo* (fol. 157-208; painting is discussed from f. 190 v. onwards). Scattered throughout this codex are occasional notes by a hand which is certainly the same as that which we have identified as Mancini's own in MSS. Nos. III and IV above. Though there are substantial *postille* in the *Viaggio* and in the various works which follow the *Trattato*,[74] those in the latter itself are intrinsically unimportant and exceedingly few in number. Apart from the insertion of one omitted word[75] and the introduction of two artists' names in the margin with a view to drawing attention to the passages concerning them,[76] Mancini's very fleeting activities were con-

[73] I should like to place on record my gratitude to Prof. Volbach and Dr. Hess, who most kindly facilitated my researches at a time when I did not think I should be able to study the original codex.

[74] The most extensive *postille* in the *Viaggio* are those on fol. 13 r. and v. (Dr. Schudt's handling of them is not without inaccuracies). There is an interesting *postilla* on fol. 375 verso, at the end of the *Breve Ragguaglio*, which begins "Questa scrittura ha bisognio d'esser rivista," remarks "Ma fu fatta in fretta," and concludes "Però a suo tempo se si havera ozio si ridurra in meglior forma." Surely an author's note?

[75] On f. 22 r. the word *tempi* in "che in tempi nostri;" compare f. 5 r. of No. III.

[76] "Michelangelo Anselmi detto in Parma Michelangelo da Siena" on f. 65 r., and "Il Giannella Milanese" on f. 68 v.

fined to the *Vita* of Sodoma.[77] In view of the many glaring
errors of transcription which remain uncorrected throughout
No. VB, it must be assumed that Mancini glanced casually at
one or two passages but never sat down to the systematic correc-
tion of this copy; nevertheless the fact that the manuscript was
in his hands is useful supporting evidence for the view that both
No. VB and No. VA (since the latter is in the same handwriting)
are extremely early copies.

We may now consider the relationship of both No. VB and
the second half of No. VA to the *Parte Seconda* as rendered in
MS. No. III. The majority of Mancini's alterations and addi-
tions to No. III have been embodied in the two later manu-
scripts, including those *postille* connected with more or less

[77] They consist of the following.

(i) The insertion of "Di Giovan Ant.º da Vercelli detto il Soddoma" in
the margin at the beginning of the *Vita* (f. 59 v.).

(ii) The insertion of a reference to Fracastoro in line 3 of f. 60 v. The
context is that (in the absence of models) the memory is apt to weaken with
the passing of time. Mancini adds in the margin of No. III (f. 36 r.) "delche
a longo il m[aest]ro [?] Fracastoro nel lib.ro Intellectione" (this latter being
a reference to *Turrius, sive De Intellectione Dialogus*, published on fol. 165 r.-
206 v. of *Hieronymi Fracastorii Opera Omnia*, Venice, 1555; Fracastoro deals
with the memory on fol. 172 r. ff.). No. VA (f. 168 v.) ignores this *postilla*
entirely, but No. VB (f. 60 v.) copies *delche à longo il* and apparently reads
nostro for the next word, which has however been scored over. The copyist
then abandons the attempt, leaving a gap in which Mancini inserts
"Fracastoro in q.º sto [for *studio*?]." At the bottom of this same f. 60 v. the
insertion of a *no*[n] may be attributable to Mancini. The Fracastoro passage
is quoted by Padre Guglielmo della Valle (*Lettere Sanesi*, III, 1786, p. 242),
who reads *il nostro Fracastoro*, but leaves a gap where *in q.º sto* should have
followed.

(iii) The insertion of "et il stoico riformato" and the correction of a word
on f. 61 v. (the *co*[n] with which this page begins may also have been added
by Mancini). The context is that, in dealing with the life of Sodoma, Vasari
quite unnecessarily assumes the pose of "il stoico riformato, et come dicon'
in Fiorenza, il Bacchettone, il Catagrafaio [corrected by Mancini, perhaps
to *Catafaggiaio*?], e finimondone." This passage underwent corrections by
Mancini in No. III (f. 36 v.). When copying No. VB the scribe could not
decipher *et il stoico riformato* and left the space which Mancini afterwards
filled; when copying No. VA, however (f. 170 r.), he did manage to read it
correctly, but in both cases the Florentine expression (which I am unable
to elucidate) defeated him.

datable events to which we have previously referred.[78] In particular the two relatively late passages concerning Lanfranco's activities "at present" for San Paolo and the death of Antonio Carracci's child in 1624 both reappear.[79] When marginal notes in No. III are not reproduced in the two later manuscripts, the omission can often be accounted for on the score of illegibility,[80] or on that of the absence of an insertion mark in the text.[81] There can be little doubt, however, that Mancini also continued to add to No. III after the copies with which we are concerned had been made from it. While this is difficult to demonstrate in the case of alterations to a previously existing text, there appears to be no clear reason why the copyist should in each case have concluded with the life of "Bordino" (Brandin) unless the *Vite* of Nicolas Poussin and Pietro da Cortona which immediately follow it on fol. 89 verso and 90 of No. III did not in fact then exist in that manuscript.[82] Moreover internal evidence in pre-

[78] The references in the later MSS. to the four passages referred to in note 42 of this Appendix are as follows. (i) VA, f. 234 v.; VB, f. 121 r. (ii) VA, f. 239 r.; VB, f. 125 r. (iii) VA, f. 239 v.; VB, f. 126 r. (iv) VA, f. 235 v.; VB, f. 122 r.

[79] (i) *Adesso per S. Pauolo*: VA, f. 226 v.; VB, f. 113 r. (ii) *Questo putto morse nel 1624*: VA, f. 199 v.; VB, f. 89 r.

[80] Perhaps the most tantalizing case of poor legibility is that of the long note on Caravaggio on f. 59 v. and f. 60 r. of MS. No. III.

[81] As an example of this we may cite the *postilla* on Manfredi on f. 80 v. of No. III: "In Siena vi è uno Sdegnio in casa del Sigor Cavalier Chigi la meglior cosa che forse habbia fatto, co[n] inve[n]zione fine[?] et verita." To take another instance, the difficulty of fitting the long marginal note on Scarsellino (f. 75 r. of No. III) into the text can be easily understood.

[82] The situation is less straightforward when we come to consider the *Vite* in Mancini's handwriting which appear on fol. 175 verso to 177 verso of No. III, and which, as we have pointed out, are entirely out of place at the end of Part I. That of Ottaviano Mascherino on f. 176 r. reappears in both VA and VB in positions which, though differing as between VA and VB, nevertheless do appear to take account of certain indications in No. III (cf. the subsequent footnote). A longer *Vita* of Matteo da Lecce figures elsewhere in Nos III, VA and VB, and presumably the short comments on him at the top of f. 175 v. were ignored on that account. The *Vita* of Prospero Fontana in the lower half of f. 175 v. of No. III (thus preceding Mascherino) does not reappear in Nos. VA and VB, but I should guess that the reason for the omission in this instance is not its non-existence when the copies

cisely these two final *Vite* suggests that they were written slightly later than the year which seems most probable for the activities of the copyist—1625.

Both copies appear to have been made direct from No. III; that is to say, one of them cannot be a copy of the other. Indeed, in view of the considerable differences in reading there can be little doubt that the first copy was not available to the copyist for reference when he was at work on the second.[83] The two copies must be very close to each other in time, and it is difficult and of small consequence to establish which was made first. It is worth noting, however, that No. Vb (from which several of the later copies are evidently derived, whether directly or indirectly[84]) is on the whole the more careless[85] and

were made, but rather the absence of any indications elsewhere in No. III for its eventual insertion; it has consequently been overlooked. There remain the *Vite* of Pietro da Cortona and Matteo Zaccolini on fol. 176 v. to 177 v. (i.e., following Mascherino). In these two cases it seems to me probable, though perhaps not absolutely certain, that we are concerned with material added by Mancini to No. III after the copies had been made from it (for the dating of Pietro da Cortona's work in Santa Bibiana, mentioned on f. 177 r. as being in progress, cf. note 46 of this Appendix).

[83] As an example of evidence bearing upon this we may cite the *Vita* of Ottaviano Mascherino. In No. III this appears on one of the odd sheets at the end of Part I (cf. the previous footnote). In No. Va the *Vita* is placed on f. 201 v. and 202 r. after Raffaellino da Reggio and before Caravaggio, in a position where Mancini notes in No. III (f. 59 r.) "Ottaviano Mascharini vedi abasso;" while in No. Vb (f. 93 v. and 94 r.) it appears after Caravaggio and before "Fulminetto" (Fréminet), corresponding to a note by Mancini in No. III (f. 61 r.) "Di Ottaviano Mascharini vede doppo." (The presence of yet another note by Mancini on f. 66 r. of No. III—"Qui va Ottaviano Mascarini"—is however ignored!) This difference in arrangement in the two copies would not be easy to account for on the basis of No. Va being simply a copy of No. Vb or *vice versa*; still less the fact that No. Va omits the final few words of the *Vita* (which are certainly difficult to read in No. III), whereas on the other hand No. Vb includes them, but leaves a gap a line or two higher, corresponding to a few poorly written words of which No. Va had attempted a rendering.

[84] Cod. Chis G. III, 66a in the Vatican Library contains the *Viaggio* (pp. 1-32), Part II of the *Trattato* (pp. 33-203), a note on Mancini added on the verso of p. 203 by a *postillatore*—mentioning Erythraeus' biography (published in 1645), a transcript of the Carracci *postille* to Vasari's *Vite* (pp. 204-207), and a note on the cleaning of the Sistine Chapel by a certain

unintelligent[86] copy of the two, with more frequent failures to

Simone Laghi in the time of Urban VIII (p. 208). In so far as the *Viaggio* and Part II of the *Trattato* are concerned it is abundantly clear that we are dealing with an early copy of fol. 1-128 of Cod. Barb. Lat. 4315. Numerous variants in the *Viaggio* peculiar to the Barberini codex reappear in the Chigi codex; this will be apparent in Dr. Schudt's edition, though it is unfortunate that a veil of confusion has been drawn over one of the most striking sequences of variants as between No. III (f. 189 r.), Cod. Barb. (f. 13) and Cod. Chis. (p. 21). As regards the *Trattato* we may mention as examples that the variants of No. VB discussed in notes 83, 85, 86, 88 ("Urbino"), 89 (ii), 89 (iii), 121 and 122 of this Appendix are reflected in Cod. Chis. (pp. 146, 73, 202, 195, 158, 181, 153 and 139 respectively), and that the *Vita* of Guercino (revised version) on p. 199 of Cod. Chis. reproduces the variants of the text of No. VB published below (pp. 312 f.). Two mid-Seicento *postillatori* are active in the Chigi codex, and their presence enables us to establish that Cod. Capp. 231 in the Vatican—which contains precisely the same works and in the same order—is copied from it (and not, *pace* Dr. Schudt, direct from Cod. Barb. Lat. 4315); the greater part of the additions of both *postillatori* to the Chigi codex reappear in the handwriting of the scribe of the Capponi codex, both in the margin and in the main body of the text. I have not seen the other two MSS. of Part II, which are both in the Biblioteca Comunale at Siena and which are stated by Dr. Schudt to be derived from Cod. Capp. 231. They are No. L. V. 12 and part of No. C. IV. 28, and both bear the name of the Abbate Giuseppe Ciaccheri (who was a Sienese scholar of the second half of the eighteenth century and a friend of Padre Guglielmo della Valle); it seems possible that these copies were specially made by or for him, and based on Cod. Capp. 231, the existence of which in the Vatican had received publicity from Monsignor Bottari in 1759.

[85] As an example of carelessness we may cite a passage on Pietro Cavallini. No. III (f. 27 r.) reads: "Ne voglio lasciar d'avvertir quello, che dice il Vasari, che le pitt.re di S. Fran.co di Ripa e di S. Cecilia sieno di q.o Cavallini perche nell'un' e nell'altra s'inganna poiche l'un e l'altra pittura e fatta molto prima, ne q[ue]lla di S. Fran.co e dell'istessa maniera di q[ue]lla di S. Cecilia." No. VB (f. 48 v. and 49 r.) omits the whole sentence between the two mentions of *S. Fran.co*: ". . . quello, che dice il Vasari, che le pitture di S. Fran.co è dell'istessa maniera di quella di S. Cecilia." No. VA (f. 156 r.) gives the entire passage correctly.

[86] In No. VB the copyist is often extremely unintelligent in the matter of guessing, from the general context, the meaning of an illegible word. As an instance of this we take a passage on Paul Brill in Mancini's handwriting in No. III (f. 88 v.). Brill, Mancini writes, "ha nelle figure fatto assai passaggio et nel paesaggio lasciato quello stento fiammengo accostandosi piu al vero . . ." No. VB reads (f. 127 v.): ". . . hà nelle figure fatto assai passagio, et nel paesaggio lasciarò [sic] quello Remo [sic] fiammengo, accostan-

tackle Mancini's marginal notes;[87] indeed the suggestion might be advanced that the author, being displeased with it, had a further copy of Part II (that in No. VA) made direct from the original after giving the copyist due warning on the subject of his inefficiency.[88] At any rate, though there are instances of both readings being defective when collated with No. III,[89]

dosi più al vero . . ." Now the fact is that *lasciato* and *stento* do look like *lasciaro* and *Remo* in No. III (mainly owing to Mancini's typical ill-formed *t*); that such a reading conveys nothing at all does not worry the copyist. This sort of passage is nevertheless apt to be awkward for the art-historian. For example, Professor Longhi, in quoting this passage from No. VB (*Proporzioni*, I, 1943, p. 45, note 31), very understandably amends *lasciarò* to *lasciò*, but is naturally completely defeated by the baffling *Remo* which stands out clearly and inexplicably in the text; he is driven to making a complete surmise—*vecchio* in brackets and with a question mark. Another conjectural solution—*stremo*—was suggested by Dr. Orbaan, who also used No. VB (*Bescheiden in Italië*, I, 1911, p. 352). That the mysterious word is how-ever really *stento* is supported by the reading of this passage in No. VA (f. 241 v.), and by the readings in both No. VA (f. 241 v.) and No. VB (f. 128 r.) of a repetition lower down on f. 88 v. of No. III in the phrase "condotti a frescho co[n] grandissima fine et senza stento." As a matter of fact No. VA itself indulges in one or two wild guesses in the life of Brill (for instance, *lasciano* for *lasciato*, *pomo* for *porto*) but generally speaking it is rather less prone to this sort of lapse than No. VB.

[87] Two examples. (i) *Postilla* in the life of Caravaggio (No. III, f. 59 r.): "poiche il Padre fu m[aest]ro di Casa et Architetto del Marchese di Cara-vaggio;" this is copied in No. VA (f. 202 v.), but not in No. VB (f. 91 r.). (ii) *Postilla* in the life of the Cavaliere d'Arpino (No. III, f. 70 r.): "la Canonizatione di S. Fran.co di Pauola [i.e., SS. Trinità dei Monti];" this is copied in No. VA (f. 213 v.), but not in No. VB (f. 101 r.).

[88] It is possible that it was at this juncture that the wording of the title of the *Parte Seconda* got changed. The title in No. VB (f. 21 r.) is a copy, with but the slightest variations in spelling, of that in No. III (f. 4 r.; cf. note 20 of this Appendix); but No. VA boasts a new, re-phrased, title (f. 124 r.; cf. note 58 of this Appendix). It may be noted that the *Vita* of Terenzio Terenzi in No. III (f. 85 v.) begins, in the handwriting of the scribe, "Terentio nacque in Urbino," and Mancini inserts *Pesaro* above *Urbino*. In No. VB (f. 124 r.) the town given is Urbino, and in No. VA (f. 237 v.) it is Pesaro. It might be argued that Mancini's alteration could only have been made in the interval between the two copies; but I doubt if we are entitled to rule out mere inattention when No. VB was being copied, as the scribe's *Urbino* in No. III is much clearer than Mancini's *Pesaro*.

[89] The following are examples in which both copies are defective.
 (i) No. VB (f. 88 v.) fails to read the surname of Antonio Carracci's friend

an improvement is often, though not invariably, to be noted in No. VA as compared with No. VB.[90]

<div align="center">* * *</div>

The findings in an investigation of this kind are invariably tedious to read, since (unless one is satisfied with the ever-

Dionisio Buonavia which is inserted by Mancini on f. 57 r. of No. III (cf. note 27 of this Appendix), and leaves a gap after *Dionisio*; No. VA (f. 199 r.) succeeds in reading *Buonavia*, but spoils this good effect by giving the Christian name as *Dionatio*.

(ii) The scribe in No. III writes at the beginning of the life of the Cavaliere d'Arpino (f. 69 r.): "Onde Giovanetto disegnando le cose di Raffaello nel Vaticano . . ." Mancini crosses out *nel Vaticano*, and inserts these two words, very poorly written, after *disegnando*. No. VA (f. 212 v.) reads *nell'unire*, while No. VB (f. 100 v.) has *nell'universale*. On neither occasion has the copyist observed that all Mancini wanted to do was to change the position in the sentence of the words *nel Vaticano*; thus the unexpected result of the process has been the omission of any mention of the Vatican at all!

(iii) Mancini himself adds to No. III (f. 78 r.) at the end of his *Vita* of Giovanni da San Giovanni (Giovanni Mannozzi): "Stette in Roma et ivi opero molte cose et in particolare nel palazzo del Card. Bentivogli et nella Chiesa di S. 4.ro Coronati la Tribuna s'aspetta gran progresso." No. VA (f. 228 r.) does not get beyond the word *Coronati*, while No. VB (f. 115 r.) transcribes the whole passage, but substitutes *e d'esso* for *la Tribuna* (which indeed would be hardly legible if we had no idea what to expect). Actually the passage is of interest from the point of view of dating, since Professor Muñoz discovered the signature and date on the tribuna fresco (concealed from the ground by the cornice) in the Santi Quattro Coronati (Antonio Muñoz, *Il restauro della Chiesa e del Chiostro dei SS. Quattro Coronati*, Rome, 1914, p. 80: "Gio. de S.o Gioni Toschano fecit 1623"). Perhaps we may be permitted to draw attention in passing to the not inconsiderable importance for the development of the Full Baroque of Giovanni da San Giovanni's *conca*; the artist's short stay in Rome—no one would think of him as belonging to the Roman *ambiente*—may account for the fact that the historical significance of this work (coming two years before Lanfranco began work on the cupola of Sant'Andrea della Valle) is very frequently overlooked.

[90] A slightly comic instance may be cited of an alteration by Mancini which is transcribed in No. VB but not in No. VA. In No. III (f. 52 r.) a description of *sbirri* and *spioni* as *persone dishoneste* appears in the handwriting of the scribe, but Mancini evidently repented of this and modified his censure by crossing out *dishoneste* and writing in "per pocho ben formata oppenion delli huomini no[n] son reputate honeste." This alteration is introduced into the text in No. VB (f. 82 v.), but the copyist apparently could not be bothered with it in No. VA and allowed *dishoneste* to stand (f. 192 r.).

flourishing art of making unsupported statements) chapter and verse must to some extent be given for the conclusions drawn. Nor is the actual task of accumulating the evidence any less tedious: quite the reverse! The fact is, however, that a source such as that provided by Mancini cannot be judiciously used unless some attempt is made to assess the relative value of the different manuscripts in which it is preserved. There are two opposed extremes of naïvety which art-historians endeavour to avoid with varying success. One is that of swallowing an attribution which is without an adequate source foundation, whether direct or indirect; the other is that of treating a contemporary "document" as if it were necessarily an unblurred authoritative voice, speaking distinctly from the past without need of interpretation. The justification for our researches must be that the Mancini manuscripts provide rich pastures for those who are inclined to succumb to the second type of misconception; as our previous examples have not been specifically chosen to illustrate the extent to which the most curious "facts" can be "established" by a copyist,[91] we may point the moral with two characteristic conjuring tricks of our versatile scribe.

In this connexion the opportunity can be taken to transcribe *in extenso* the brief revised *Vita* of Guercino which Mancini introduces into MS. No. III (fol. 87 recto); the main text is in the handwriting of the scribe, but the *Vita* is embellished with *postille* by Mancini himself which we shall indicate in italics.

> "*Di* [blank] *detto Il Guercino da Cento*
> In Cento luogo del Ferrarese nacque e vive hoggi [blank] communem.te d.o Il Guercin da Cento q.le havendo studiato in Bolog.a [Mancini underlines the last two words and writes in the margin near them *e hoggi in Roma*] p[er] la strada de i Caracci [insertion mark] *in una tavola che e a Cento di Lodovico et doppo essendo stato a Bologna* ha fatto tal progresso che senza dubio puol esser messo nella p.ma Classe de i viventi. Qui in

[91] We were inclined to attribute the inaccuracy of a passage quoted in note 71 of this Appendix to a copyist's misreading, but were not in a position to verify this view in the actual passage from which the error originated.

Roma si son viste di suo alcune cose private di gran disegno colorito e forza, che han dato gra[n] gusto. Nel parlar col s.ʳ Lud.ᶜᵒ Caracci conobbi che lo reputava molto. Adesso è nel colmo del suo bel [*n* is written over *l*] operare che venendoli occasione [*sic*] grandi non è da dubitare che si sia p[er] acquistar durabil gloria. *dico*[no] *esser apresso al Serenis⁰ di Mã̃tova.* [The following note was also added by Mancini in the margin:] *Pone qui qᵉlle di S. P. et del Car Ludovisi.*"

The sequence in which the various items of information came into Mancini's possession seems reasonably clear from the appearance of the manuscript. Mancini had a conversation with Lodovico Carracci[92] which opened his eyes to the fact that in his previous account of Guercino he was labouring under a complete misapprehension as to the latter's identity; in consequence Mancini remembered to arrange for the scribe of MS. No. III to insert a revised *Vita* which had not appeared in MS. No. II.[93] He then heard, probably early in 1621, the rumour

[92] For another repetition by Mancini of Lodovico Carracci's high opinion of Guercino, cf. note 40 of Part I (where the possibility is raised of a brief visit having been made by Lodovico, not long before his death, to Rome, where he could have met Mancini). Two extracts from letters written by Lodovico in 1617 may be quoted in confirmation of Mancini's report of his admiration for the young artist (whose work, it appears, was then something of a novelty to Lodovico himself). The first letter is dated from Bologna on 19 July 1617, and the passage in question reads: ". . . e pur gionto un ms Gio Francesco da Cento e qua per fare certi quadri al S.ᵒʳ Cardinale arcivescovo [i.e., Alessandro Ludovisi, afterwards Gregory XV] e si porta eroicamente . . ." (quoted from the facsimile reproduction in A. W. Thibaudeau, *Catalogue of the Collection of Autograph Letters and Historical Documents formed . . . by Alfred Morrison*, I, [London], 1883, Plate 36, opp. p. 167; first published by Giovanni Bottari, *Raccolta di Lettere sulla Pittura*, I, Rome, 1754, pp. 209 and 198 in the two printings). The second letter, published by Monsignor Bottari (*Raccolta di Lettere*, I, 1754, pp. 210 and 199 in the two printings) is dated from Bologna on 25 October 1617 and contains the following passage: "Quà vi è un giovane di patria di Cento, che dipinge con somma felicità d'invenzione. È gran disegnatore, e felicissimo coloritore: è mostro di natura, e miracolo di far stupire chi vede le sue opere. Non dico nulla: ei fa rimaner stupidi li primi pittori: basta il vedrà al suo ritorno." (Bottari says both letters were written to Don Ferrante Carlo.)

[93] Unfortunately Mancini forgot to dispose of the false *Vita*, which accordingly went on being re-copied! Cf. note 40 of Part I.

that Guercino had paid a visit to Mantua,[94] and added it in the
space at the end of the scribe's text. Guercino however arrived
in Rome during that summer, and Mancini, hearing the news
in due course, scribbled *e hoggi in Roma* in the margin. He also
became aware, subsequently to the writing of the main text,
that one of the principal influences on Guercino even before he
went to Bologna was a painting by Lodovico in his native town
of Cento.[95] It is tempting to hazard a guess that this informa-
tion was added as a result of a conversation with Guercino him-
self, who was evidently very ready to acknowledge his debt to
Lodovico's picture.[96] In any case Mancini indicated that the
original sequence should be altered by eliminating the words
in Bolog.a (the underlining evidently stands for this) and re-
phrasing the sentence so as to refer to the visit to Bologna after
the mention of Lodovico's picture at Cento. Finally he added
a reminder—presumably intended for himself in the event of
another revision of Guercino's *Vita*—to insert the paintings *di
S. P.*[97] *et del Car Ludovisi.*[98]

The obvious possibilities for misunderstanding in such an
account, with new material added unsystematically from time
to time, have borne fruit in the hands of the copyist of No. VB
to the extent of falsifying the course of Guercino's career; the
Vita in that manuscript reads (fol. 126 recto):

"Di [blank] detto, il Guercin da Cento.
In Cento luogo del ferrarese, nacque, e vive hoggi [blank]
comunem[ente] detto Il Guercin da Cento quale havendo

[94] For Guercino's Mantuan visit, which must have occurred in 1620 or at
latest in the first months of 1621, cf. note 113 of Part I. Mancini seems to
have written *e apresso* first, but then obliterated the *e* by means of an insertion
mark, adding *dico*[no] *esser* above.

[95] That is to say, Fig. 12.

[96] Cf. note 57 of Part I.

[97] Whether the letters *S. P.* stand for *San Pietro* (which seems to me more
probable) or for *Santa Petronilla*, the reference is surely to Fig. 29, which was
to be seen in San Pietro in Vaticano in the spring of 1623 (for the *Santa
Petronilla*, cf. note 137 of Part I).

[98] That is to say the frescoes in the Casino Ludovisi, among which are
Figs. 9 and 15.

studiato in Roma[99] per la strada de i Caracci in una tavola che è[100] [blank] e doppo essendo andato[101] à Bologna, hà fatto tal progresso, che senza dubbio puol esser messo nella prima Classe dei viventi. Qui in Roma si sono viste di suo alcune cose private, di gran disegno colorito, e forza, che han' dato gran' gusto. Nel parlar col[102] Sig.ʳ Lodovico Caracci, conobbi che lo reputava molto. Adesso è nel colmo del suo ben[103] [fol. 126 verso] operare, che venendoli occasioni grandi, non è da dubitare, che sia[104] per acquistare durabil gloria. Dicono[105] esser app.º il Ser.ᵐᵒ di Mantova."

If we were to read the text of No. Vʙ without knowledge of its original state in No. III, and without information from other sources as to Guercino's movements, we should obtain an apparently clear, but actually entirely erroneous, account of his early career.[106] The inference in MS. No. Vʙ is that in his student days Guercino went straight to Rome from his native town of Cento, that he only went to Bologna after this, and was at the time of writing back at Cento ("In Cento . . . nacque, e *vive hoggi*"), though rumour said—this has the appearance of being the latest information—that he had gone to Mantua in the service of the Duke. The most misleading part of the concoction is the copyist's misinterpretation of the marginal note *e hoggi in Roma*: what he has done is to omit the important words *e hoggi* altogether and substitute the words *in Roma* for *in Bolog.ᵃ*, which (as we have seen) Mancini intended in actual fact to be merely deleted—a deletion related to the other *postilla*, in which

[99] No. Vᴀ omits *in Roma* and reads (f. 239 v.) : ". . . quale havendo studiato [f. 240 r.] per la strada dei Caracci . . ."

[100] No. Vᴀ reads ". . . che è al [blank] e doppo . . ." The *C* of Cento is attached to the *a* in Mancini's original, and could be taken for *l*.

[101] No. Vᴀ also reads "andato," instead of Mancini's "stato."

[102] No. Vᴀ reads "con il."

[103] No. Vᴀ reads "del suo bell'operare."

[104] No. Vᴀ reads "che si sia," as in No. III.

[105] No. Vᴀ (f. 240 r.) reads "Dicano."

[106] It seems likely, moreover, that No. Vʙ's reading was the most widely disseminated, since (according to Dr. Schudt) most of the later copies of the *Parte Seconda* are derived directly or indirectly from it.

Bologna is mentioned a few words later on. One can under-
stand that the reminder in the margin about Guercino's Roman
works could have been awkward to interpret and to insert in
the text, but its absence from No. Vв supports by default the
impression given there that Guercino's Roman visit had taken
place a fair time previously. The discrepancy about the "present
whereabouts" of Guercino (Cento or Rome), a solution of which
is suggested by the two hands in MS. No. III, is neatly avoided
in No. Vв, and the artist is by implication sent back to Cento,
with the suggestion that some last minute news has arrived to
the effect that he has gone to Mantua. If we were not only to
accept this account, but also to relate it to the false date of 1618
which Malvasia supplies for the Mantuan visit,[107] our concep-
tion of the dating of Guercino's movements in these formative
years would indeed be wide of the mark.

Our second example of the sort of transformation which can
be brought about by a copyist is less complicated and relates to
the creation of a decidedly odd work of art: it is the story of
how Domenichino came to design an obelisk in San Pietro in
Vincoli. In his *Vita* of Domenichino Mancini says (MS. No. III,
fol. 74 verso, handwriting of the scribe): "Si diletta d'Archi-
tett.ra et in essa hà studiato molto tempo e fattovi progresso,
come si vede nel tumolo del Card.¹ Sega in S. Honofrio, e
d'Agucchia in S. Pietro in Vincola, et altre cose . . ."[108] How-
ever, Mancini evidently came to doubt that Domenichino had
anything to do with the designing of the inscription in Sant'
Onofrio in memory of Cardinal Sega, and accordingly struck
it out; but in doing so his pen ran through the greater part of
the word *tumolo*. As a result the relative passage on fol. 223
recto of No. Vа reads "come si vede nell'Aguglia in S. Pietro
in Vincola et altre cose."[109] Since there can be no question
that at this period both *aguglia* and *guglia* were common

[107] Cf. note 113 of Part I.

[108] This passage had appeared previously in MS. No. II (p. 150). For
the monuments referred to, cf. also note 31 of Part II.

[109] No. Vв reads (f. 110 r.): "come si vede nell'Aguccia in S. Pietro in
Vincola, et altre cose."

synonyms for *obelisco* (indeed there chances to be evidence to this effect elsewhere in the *Trattato* itself[110]), the fact that Domenichino was responsible for the monument to Cardinal Agucchi is obscured, and a mysterious obelisk designed by him makes its appearance in a source apparently sanctified by contemporaneity. As a matter of fact, few art-historians familiar with the Seicento would in this instance fail to suspect a faulty text and to draw the conclusion that the original reference must actually have been to the monument of Cardinal Agucchi. But this would be because we happen to have evidence from other sources, because the monument still exists,[111] and so on; in the absence of such evidence only knowledge of the manuscript background could avert acceptance of a defective reading. And, though our example is a minor one, chosen—it must be admitted—on account of its neatness as an illustration, the principle applies throughout, and may have its bearing on the understanding and interpretation of more important passages.

* * *

Were Mancini's writings on art available to his successors in that field?[112] One manuscript at any rate is recorded which

[110] MS. No. III, f. 17 v.: "l'oblisco o Aguglia" (cf. No. VA, f. 142 v., and No. VB, f. 37 r.). Curiously enough, the words *o Aguglia* in No. III happen to be written in by Mancini himself. All three words *aguglia*, *guglia*, and *obelisco* are given as synonyms by Baldinucci (*Vocabolario*, 1681, pp. 6, 72 and 108).

[111] It seems to attract errors of description; Alinari's photograph (No. 27854) ascribes the design to Guercino!

[112] We may refer to one example of Mancini's work being used by a writer not primarily concerned with artistic matters. The Abate Secondo Lancellotti (1583-1643) gives a long list of painters in the second part of his *Hoggidì* (first edition possibly in 1636?); the copy I have used was published at Venice in 1646 (*L'Hoggidì overo Gl'ingegni non inferiori à' passati. Parte Seconda*), and a comparison between the list of painters on pp. 302-306 and that on fol. 130 verso-135 recto of MS. No. III leaves no doubt that it is derived from Mancini's *Ruolo* (such variations as exist are relatively slight). Lancellotti was in Rome in the late twenties and could have copied Mancini's MS. then; he makes no acknowledgment of his source, however.

can very well have been accessible in Rome during the middle
and late Seicento to those who were seriously interested in such
matters. This copy, Prospero Mandosio tells us,[113] was in the
possession of Carlo Antonio dal Pozzo, who had inherited in
1657 the extensive library of his elder brother, the celebrated
dilettante Cassiano dal Pozzo; it may reasonably be supposed
that the Mancini manuscript was originally part of the collec-
tion of Cassiano, who must almost certainly have been ac-
quainted with the author towards the end of the latter's life.[114]
Mandosio's rendering of the title—*Trattato delle Pitture di Roma*—
suggests that it began (precisely as is the case with Cod. Barb.
Lat. 4315) with the *Viaggio per Roma*;[115] this Dal Pozzo copy
has however not been identified.[116]

In the circumstances we cannot ascertain whether or not
Giovanni Pietro Bellori actually made use of the Dal Pozzo
copy, though he must certainly have been a welcome visitor
to the brothers' library. There can however be no question of
the later writer's knowledge of Mancini's work,[117] and it seems

[113] θέατρον *in quo Maximorum . . . Pontificum Archiatros Prosper Mandosius
. . . spectandos exhibet*, Rome, 1696, p. 142: "[Mancini] Picturae fuit intelli-
gentissimus, scripsitque volumen, cujus titulus *Trattato delle Pitture di Roma*,
quod ms. exstabat in Bibliotheca . . . amici mei . . . Equitis Caroli Antonij
a Puteo."

[114] For the close connexion of both Mancini and the Cavaliere Cassiano
dal Pozzo with the Papal Court after the election of Urban VIII in 1623,
cf. *The Burlington Magazine*, LXXXVIII, 1946, pp. 18 f. It may be noted
that Mancini refers to "alchune . . . cose cha il Sig.or Cavalier del Pozzo"
in one of the *Vite* of Pietro da Cortona in MS. No. III (f. 177 r.).

[115] Cassiano dal Pozzo, as Secretary and *famigliare intimo* of Cardinal
Francesco Barberini, would of course have been in a position to have a
copy made of Cod. Barb. Lat. 4315 if the latter MS. was at that early date
already in the possession of the Barberini family—which indeed seems quite
possible in view of Mancini's connexion with them as Papal physician.

[116] Theodor Schreiber suggested (*op. cit.* in note 5 of this Appendix, p. 109)
that it could have gone to the Biblioteca Nazionale at Naples, but Dr.
Schudt says (*op. cit.*, p. 109) that he could find no Mancini manuscript there.
I have not come across any supporting evidence since making my own very
tentative suggestion referred to in note 23 of this Appendix, and do not now
regard it as more than a very faint possibility.

[117] Although (if my recollection is accurate) there is no specific mention
of Mancini's name in Bellori's publications.

very probable that the version with which he was familiar was that originating in No. VB—as opposed to Nos. III and VA. Abundant evidence that Bellori had a Mancini manuscript in his hands is to be found in the *postille* which he added to a copy of Baglione's *Vite* ;[118] facts and stories from Mancini's *Parte Seconda*[119] are to be found in many of these, and in several instances Mancini's text is virtually reproduced verbatim by Bellori.[120] The probability that the latter used MS. No. VB, or a copy derived from it, seems to be indicated by *postille* in which he transcribes variants which do not exist in MSS. Nos. III and VA. Perhaps the most convincing is a note on Niccolò Circignani (Pomarancio, or dalle Pomarance), in which Bellori copies the statement, peculiar to No. VB, that his paintings in Santo Stefano Rotondo were completed *in un mese*, whereas what

[118] This annotated copy of Giovanni Baglione's *Le Vite de' Pittori Scultori et Architetti* (Rome, 1642) is preserved in the library of the Accademia dei Lincei at Rome (No. 31—E—15), and was published in facsimile by the R. Istituto d'Archeologia e Storia dell'Arte (Rome, 1935) in the series *Opere inedite o rare di Storia dell'Arte.*

[119] We have already noticed (cf. note 104 of Part II) that Bellori's "three groups" seem to be derived from those of Mancini. If this hypothesis should be correct, Bellori must also have seen a version of the *Parte Prima.*

[120] Apart from the examples referred to in notes 121, 122 and 124 of this Appendix, the following may be cited from the facsimile copy of Baglione's *Vite.* Upper *postilla* on p. 49, Girolamo Muziano (partly verbatim) ; upper *postilla* on p. 121, Federico Zuccaro (partly verbatim) ; *postilla* at top of p. 133, Cherubino Alberti (derived, partly verbatim, from a passage in Mancini's *Vita* of "Fulminetto," otherwise Fréminet) ; upper *postille* on pp. 153-154, Lodovico Cigoli (partly verbatim) ; lowest *postilla* on p. 154, Giovanni "Bellinert" (Biliverti, statement probably derived from Mancini's "Belivelt") ; *postilla* on p. 159, Bartolomeo Manfredi (freely based on Mancini) ; *postilla* on pp. 188-189 (288-289), Cristofano Roncalli (partly verbatim) ; *postilla* on p. 192 (292), Cristofano Roncalli (facts probably derived from Mancini) ; *postilla* on p. 193 (293), Antiveduto Grammatica (facts probably derived from Mancini) ; *postilla* on p. 199 (299), Baldassare Croce (derived, partly verbatim, from Mancini's "Baldassarre da Bologna") ; upper *postilla* on p. 213 (313), Giovanni da San Giovanni (verbatim from No. VB, which has *perche è nato*—as opposed to Nos. III and VA, which omit the *è*) ; *postilla* on p. 362, Rubens (wording closely related to that of Mancini) ; *postilla* on p. 384, Domenichino (facts possibly derived from Mancini) ; upper *postilla* on p. 385, Domenichino (partly verbatim).

Mancini actually wrote was *in un estate*.[121] Another example is the appearance of a mysterious Cardinal "Bamboglietti" in Bellori's note on Matteo da Lecce; the *B* with which the name begins is an error of transcription confined to No. V$_B$, the personage referred to by Mancini being intended (as Dr. Jacob Hess has pointed out to me) for the Cardinal de Rambouillet.[122] In concluding our note on Bellori's familiarity with Mancini's writings we may cite an instance of an anecdote published by Bellori in his *Vite* which is traceable back through one of his *postille* in Baglione to Mancini's *Trattato*. It is the story of Annibale Carracci's purchase of a landscape painted by the young Domenichino, in which a child was depicted as having overturned a bottle of wine into some water; though Mancini gives the subject as a river landscape with washerwomen[123]

[121] In No. III (f. 63 v.) the scribe wrote *in un ostate*, which Mancini corrected by writing *estate* above it. No. V$_A$ (f. 208 v.) copies *estate* accurately, but No. V$_B$ (f. 97 r.) has *mese*. Bellori's *postilla*, on p. 41 of the facsimile edition of Baglione's *Vite*, reproduces sufficient of the wording of Mancini's account of Circignani to make its general origin perfectly clear, but reads *mese* (end of the *postilla*) instead of *estate*.

[122] Mancini says (MS. No. III, f. 58 r.) that Matteo da Lecce (i.e., Mateo Pérez de Alesio) worked at Corneto for this Cardinal, whose name is given (*loc. cit.*, handwriting of the scribe) as "Rambglietti." This information enables us (i) to identify Mancini's short account of an unnamed painter on f. 175 v. of No. III (cf. note 37 of this Appendix; Mancini here twice writes the name "Rombaglietto") as being that of Matteo da Lecce, and (ii) to identify the Cardinal as Charles d'Angennes de Rambouillet, generally known as the Cardinal de Rambouillet, who was appointed governor of Corneto by Sixtus V, and died there in 1587. In No. V$_A$ (f. 200 r.) the name of the Cardinal is given as "Ramobglietti;" in No. V$_B$, however, it is quite clearly written "Bamboglietti" f. 89 v.) and reappears in this form in Bellori's *postilla* on p. 31 of the facsimile edition of Baglione's *Vite*.

[123] MS. No. III (f. 74 r., beginning with the handwriting of the scribe): "[Domenichino] nel medesimo tempo [i.e., in his early years in Rome, when working in S. Onofrio] fece in Casa [i.e., presumably in that of Monsignor Agucchi] alcuni paesaggi à olio di gran vaghezza e perfettione, che in simil sorte di pittura veram.te eccedeva [a long insertion in Mancini's handwriting then follows] che vene[n]do alle mani del Sig Anibal un suo paesaggio dove era un fiume nel qal alchune donne vi lavavano i panni co[n] un putto che haveva dato la volta ad un fiasco di vin negro che tengeva qel acqua Il tutto co[n] tanta grazia che il Sig.or Aniballe lo co[m]pro dicendo apresso che no[n] haveva pagato qel pezzo di acqua tenta dal vin negro."

(and this is duly copied by Bellori in his *postilla*[124]), the relevant passage in the latter's *Vite* omits the river and the washerwomen, substituting a spring.[125]

Before we leave Roman circles, the opinion[126] of Dr. Jacob Hess should be placed on record that traces of Mancini are to be found in more than one instance in the printed text of Baglione's *Vite*. The question will of course be discussed in detail by Dr. Hess in his critical edition, so I shall content myself here with a single example of the evidence, to which Dr. Hess has kindly drawn my attention. It seems clear that several sentences in the account of Antonio Tempesta in Baglione's *Vite*—usually regarded as the basic source for that artist[127]—are so closely related to what was written on the subject some two decades earlier by Mancini as to eliminate the possibility of coincidence.[128]

This passage is copied in MSS. Nos. VA (f. 222 v.) and VB (f. 109 v.) ; No. VA has variants which do not appear in Bellori's *postilla*, e.g., (i) "un fiume, *dove* alcune donne" (instead of *nel quale*), and (ii) "*senza il* vin nero" at the end (instead of No. III's *tenta dal*, No. VB's *tento dal*, or Bellori's *tenta di*).

[124] Bellori's *postilla*, which appears at the bottom of p. 383 of the facsimile edition of Baglione's *Vite*, keeps pretty close to Mancini. However, he first wrote "un fiasco di vino *rosso*" and then substituted *nero* for *rosso*, and later on wrote "quel *poco* di acqua" instead of "quel *pezzo* di acqua;" for the latter variant, cf. the following footnote.

[125] G. P. Bellori, *Le Vite de' Pittori*, Rome, 1672, p. 357: ". . . un . . . fanciullo, che piange, versatosi un fiasco di vino in una fonte, rosseggiando l'acqua tinta nel vino. Piacque tanto ad Annibale Carracci, che volle comperar questo quadretto, e comperatolo, disse: non hò pagato ne meno quel poco d'acqua tinta."

[126] Expressed verbally to the writer.

[127] Cf. Thieme-Becker, *Künstlerlexikon*, XXXII, 1938, pp. 516 f.

[128] Quotation from MS. No. III of the first part of Mancini's *Vita* for comparison with Baglione's *Vita* (*op. cit.*, 1642, pp. 314 f.): [Fol. 81 verso] "Di Anton Tempesta. Si diede Anton Tempesta al disegno, et alla pitt.ra in Fiorenza sua Patria nel tempo che lo Stradano dipengeva quelle battaglie nel Palazzo vecchio che fù suo scolare e riconosciuto ancor giovanetto p[er] suggetto, di far riuscita p[er] la sua gran natura che dimostrava nella sua fanciulezza. Et di q.a sua opinione se vivesse hoggi lo Stradano non si vedrebbe ingannato, p[er]che venuto à Roma sotto Greg.o 13. et operando nelle loggie mostrò in quelle figurine della Traslat.e del corpo di S. Greg.o Nazianzeno spirito vivacita e movenza con buon disegno, et attitudini [,] à fresco hà operato molte cose in part.r due battaglie una terrestre l'altra

On passing to Bologna, we find that Malvasia has done much to facilitate our task. He refers to Mancini by name on several occasions, and, as we have already had occasion to note,[129] he appears to have been familiar with the earliest version of the *Trattato*. There are three further clues which seem to settle the matter. Mancini protests in a passage in No. I (which we quote from the copy in the Biblioteca Comunale at Siena, Cod. L. V. 13) against Vasari's claim that Cimabue revived the art of painting:

[Fol. 4 verso] "Dove dicono costoro, come [fol. 5 recto] il Vasari, et altri ch[e] non han cosi ben visto, e considerate le pitture, et in particolare quelle di Roma, ch[e] rinascesse la pittura, e ch[e] il suo Padre, e Genitore, fusse Giabuè[130] di Fiorenza, come si raccoglie del d.º di Dante.[131] Credette Giabuè d'haver il vanto nella pittura, ma s'inganno, p[er]ch[e] in Constantinopoli vi erano pitture, e mastri molto megli[o] di quelle di Giabuè, anzi in Toscana istessa come in Siena nel altare de Cappuccini,[132] et in Roma tante pitture . . ."

navale nel Palazzo dell'Ill.ᵐᵒ marchese S.ᵗᵃ Croce sotto Campidoglio, et ultim.ᵗᵉ la cavalcata del Papa e quella del G. Turco p[er] l'Ill.ᵐᵒ Borg.ˢᵉ che se [fol. 82 recto] non havesse dipento altro gli bastarebber quest'opere sole p[er] renderlo p[er] molti secoli famoso. Ma aggiungendovi tanti disegni e tagli di varie materie in acqua forte, come fin adesso l'han fatto conoscere p[er] tutt'Europa dove è arrivato il diletto della pitt.ʳᵃ così i med.ᵐⁱ lo terranno vivo e famoso finche havrà esser la stampa e q.º diletto. Vive hoggi in Roma . . ." The references to the above passage in other MSS. are: No. Vᴀ, f. 232 v. f.; No. Vʙ, f. 119 r. f.

[129] Cf. note 38 of Part I above.

[130] There is a flourish between *Gia* and *buè* which gives the impression that *Giambuè* or possibly *Gimabuè* were intended; the *G* is perfectly clear. This awkward rendering of Cimabue's name, the spelling of which had been standardized by Vasari, suggests that the writer of this particular MS. was not only not Mancini himself, but can hardly have been a knowledgeable *dilettante* who was *au fait* with the subject.

[131] Dante, *Purgatorio*, Canto XI, 94 f.: "Credette Cimabue nella pintura/ Tener lo campo . . ."

[132] *Cappuccini* is almost certainly a copyist's error for *Capacci*. In MS. No. III Mancini makes use of Guido da Siena's much discussed *Madonna* as an argument against Vasari's pro-Cimabue thesis, and describes it (f.

Malvasia's quotation under Mancini's name in *Felsina Pittrice*[133] certainly seems to be a paraphrase of this; two passages in manuscript No. III in which Mancini puts forward the same argument are quite different.[134] Our second clue is provided by Malvasia's list of early paintings in Rome;[135] though he does not mention his indebtedness to Mancini in this instance, it seems clear that the material is simply rearranged from a passage in No. I.[136] The most striking confirmation of this is afforded by Malvasia's quotation of an inscription in San Crisogono, of which we have more accurate versions in the 1677 edition of Chacon,[137] and in Forcella's great work.[138] Mancini has made numerous errors in copying this out, including a misreading of the date[139] and the omission of eight consecutive words;[140] these errors reappear in *Felsina Pittrice*. Mancini has

15 r.) as "una sua pittura fatta in Siena nella Chiesa di S. Domenico, che già servì p[er] altar della Cappella de Capacci et hora è sopra la porta di d.ª Chiesa . . ." Cf. also *Breve Ragguaglio . . . di Siena* (Cod. Barb. Lat. 4315, f. 349 v., *Cappuccini* corrected to *Capocci*; Cod. Gino Capponi 290, p. 137, *Capacci*; G. della Valle, *Lettere Sanesi*, I, 1782, p. 238, *Capacci*).

[133] Malvasia, *Felsina*, 1678, I, p. 10.

[134] The references in MS. No. III are as follows. (i) Fol. 15 recto f. (immediately after the mention of the *Madonna* by Guido da Siena referred to in note 132 of this Appendix; partial quotations from fol. 34 recto f. [sic] of No. Vʙ are to be found in Ernst Benkard, *Das literarische Porträt des Giovanni Cimabue*, Munich, 1917, bottom of p. 127 and note 2 on p. 134; a German translation of the whole passage from Cod. Capp. 231 is in Josef Strzygowski, *Cimabue und Rom*, Vienna, 1888, pp. 2 f.). (ii) Fol. 18 recto f. (quoted from fol. 37 verso of No. Vʙ by Benkard, *op. cit.*, note 1 on p. 129; cf. also Strzygowski, *op. cit.*, p. 3).

[135] Malvasia, *Felsina*, 1678, I, pp. 9 f.

[136] Cf. fol. 4 recto f. of Cod. L. V. 13 in the Biblioteca Comunale at Siena. Some phrases are reproduced verbatim; there is nothing so close in MS. No. III.

[137] *Vitae, et res gestae Pontificum Romanorum et S. R. E. Cardinalium . . . Alphonsi Ciaconii . . . operâ descriptae . . . Ab Augustino Oldoino . . . recognitae*, Rome, 1677, I, col. 919 f.

[138] Vincenzo Forcella, *Iscrizioni delle Chiese e d'altri Edificii di Roma*, II, Rome, 1873, p. 169, No. 487.

[139] The date is M.C.XXVIIII, as opposed to Mancini's 1128.

[140] The words omitted are between *vestimentis* and *possessionibus*; according to Forcella this passage should read: VESTIMTIS ORNAV. EDIFICIIS INTVS & FORIS DECORAV. LIBRIS ARMV. POSSESSIONIBVS.

also completely failed to read the part of the inscription refer-
ring to Cardinal Giovanni da Crema's parentage (IOHES DE
CREM PATRE OLRICO MTRE RATILDI NATVS);
his version in No. I reads *Ioannes de Crema* [blank] *vel curoso mare
Bauldi natus*,[141] which appears to be the basis of the mysterious
rendering of Malvasia, who has added still further distortions.[142]
The supposition that Malvasia's source was not MS. No. III or
any manuscript derived from it is strongly suggested by the fact
that he describes the paintings in S. Crisogono as actually in
existence, just as Mancini did in the first version of the *Trat-
tato*;[143] but in MS. No. III Mancini repeatedly refers to them
as having previously existed there,[144] and this for the good and
sufficient reason that the paintings had been recently destroyed
in the alterations to the Church under the auspices of Cardinal
Scipione Borghese.[145] The third piece of evidence pointing to
Malvasia's use of the short version of the *Trattato* is his quota-
tion[146] under Mancini's name of some ridiculously extravagant
praise of poor Agostino Tassi which is to be found in it;[147] when

[141] Cod. L. V. 13, *cit.*, f. 4 r. In No. II (p. 205) we have *vel Euroto Matre
Raveldi natus* after the blank space, and in No. III (f. 118 r.) *vel Euroso Mre
Raveldinatus* (similarly in No. VA, f. 48 v.).

[142] *Felsina*, 1678, I, p. 10: *Ioannes de Crema . . . vel Coroso mare Balduinatus.*

[143] Cod. L. V. 13, *cit.*, fol. 4 recto: ". . . le Pitture in S. Grisogono dove è
[sic] la navigatione della transportatione del braccio di S. Giacomo nella
pariete della porta d'onde di chiesa si va nel monasterio." As a further small
instance of disagreement between (a) Malvasia and No. I, and (b) No. II,
No. III and the derivatives of No. III, we may note that in (a) *à fundamentis*
precedes *hanc Basilicam*, whereas in (b) this order is reversed.

[144] Cf. MS. No. III, f. 117 v.: "Ne voglio lasciar q[ue]lle che erano [sic]
In S. Grisogono nella pariete verso Il monasterio dove era [sic] dipenta la
translation del braccio di S. Jacomo, dove vi era [sic] la navigation con
molti Prelati . . ." The past tense is also employed in the relative passage
in MS. No. II (p. 204).

[145] Elsewhere in No. III (f. 15 r.) Mancini specifically states that *adesso*
this particular painting *è andato à male* as a result of the embellishment of the
Church undertaken by Cardinal Borghese (similarly in No. II, p. 51). This
work was commemorated by an inscription dated 1623, but was apparently
already in progress in 1620 (cf. note 131 of Part I).

[146] Malvasia, *Felsina*, 1678, II, p. 100.

[147] Cod. L. V. 13, *cit.*, bottom of fol. 7 verso. This version of the passage
surprisingly has *S.ta Cecilia* instead of Malvasia's (obviously correct) *S. Elena*,
but in other respects is substantially the same as Malvasia's quotation.

re-writing Mancini evidently realized the absurdity of this passage and so deleted it.

The Florentine Filippo Baldinucci (*ca.* 1623-1696), whose massive *Notizie de' Professori del Disegno* was published between 1681 and 1728,[148] evidently had access to a manuscript of the *Trattato*, and explicitly mentions Mancini on several occasions;[149] but (as we should expect) Baldinucci does not care for the Sienese writer's criticisms of Vasari.[150] A passage in Baldinucci's life of Sodoma provides a clue as to the version which he used. He refers to a note "by Mancini" to the effect that Sodoma's birthplace was recorded as "Rivatero" in a facetious *Denunzia* which Sodoma is supposed to have made of his possessions to the authorities at Siena[151]—a farcical document which,

[148] Since the particulars of the original issue of the *Notizie de' Professori del Disegno da Cimabue in qua* are somewhat complicated, it may be useful to recapitulate them here (none of the volumes are actually numbered on the title page, but it is convenient to give them consecutive numbers in accordance with the sequence of the periods dealt with in each case). All six volumes were printed at Florence, though the publishers vary. Vol. I, covering 1260-1300, appeared in 1681 (Santi Franchi); Vol. II, covering 1300-1400, appeared in 1686 (Piero Matini); Vol. III, covering 1400 to 1550 (1540 on the title page is an error), appeared posthumously in 1728 (Tartini and Franchi); Vol. IV, covering 1550-1580, appeared in 1688 (Piero Matini); Vol. V, covering 1580-1610, appeared posthumously in 1702 (Giuseppe Manni; some copies have the erroneous date 1700 on the title page); Vol. VI, covering 1610-1670, appeared posthumously in 1728 (Tartini and Franchi).

[149] For example: II, 1686, pp. 32 (Pietro Laurati=Lorenzetti), 70 (Bartolommeo Bologhini=Bolgarini), and 85 (Bartolo di Fredi); VI, 1728, p. 92 (Rutilio Manetti). The anonymous *Autore di questo secolo* referred to in the life of Jacopo Torriti (I, 1681, p. 41) is identifiable as Mancini.

[150] For example: I, 1681, pp. 27 (*Apologia* after the life of Cimabue) and 43 (Ugolino da Siena; the identification of the *moderno Autore Toscano* with Mancini is confirmed by the printing of his name in the margin of the first edition).

[151] Baldinucci, *Notizie*, III, 1728, p. 228: ". . . Monsignor Giulio Mancini in un suo Manoscritto lasciò notato, ch'egli fosse di un certo suo immaginato castello, chiamato Rivatero, perchè in una denunzia, che si trova aver fatto il Soddoma al Pubblico di Siena l'anno 1531. di tutti i suoi beni, secondo l'ordine, che ne venne allora in quella città, egli scrisse Giovanni Antonio Soddoma di Bucaturo; avendo il detto Mancini, se pur non fu errore di chi copiò il suo manoscritto, letto in cambio di Bucaturo, Rivatero: o pure errò

incidentally, has occasioned the expenditure of an astonishing amount of ink by later writers.[152] A version of this *Denunzia* and a note relating to "Rivatero" as a potential birthplace for Sodoma are to be found in one only of the Mancini manuscripts known to the present writer—in No. II, among the additions on the last four pages.[153] This unique passage is however clearly

l'Ugurgieri, che notò la denunzia, scrivendo Bucaturo, in luogo di Rivatero . . . La verità però si è, che in Archivio della Città di Siena, fra l'antiche scritture, si trova *Magnificus eques Dominus Johannes Antonius de Razzis* (sic) *de Verzè Pictor, alias* il Soddoma per rogo di Ser Baldassar Corte 1534. Sicchè pare che si possa concludere coll'Ugurgieri, che per la parola Verzè sia stato voluto significare il castello di Vergelle . . ."

[152] For example: (i) Isidoro Ugurgieri Azzolini, *Le Pompe Sanesi*, Pistoia, 1649, II, p. 356 (the author is the *Ugurgieri* referred to in the previous footnote); (ii) Guglielmo della Valle, *Lettere Sanesi*, III, Rome, 1786, pp. 244 ff.; (iii) S. Borghesi and L. Banchi, *Nuovi Documenti per la Storia dell'Arte Senese*, Siena, 1898, p. 456; (iv) Cesare Faccio, *Giovan Antonio Bazzi*, Vercelli, 1902, pp. 201 ff. and 222 f.; (v) Robert H. Hobart Cust, *Giovanni Antonio Bazzi*, London, 1906, pp. 22 and 260 ff.; (vi) Emil Jacobsen, *Sodoma und das Cinquecento in Siena*, Strasbourg, 1910, pp. 75 f. The sources for the text of the *Denunzia* (which is surely a fake) have hitherto been supposed to be Ugurgieri (No. i above, 1649), and two copies of a manuscript by Alfonso Landi of 1655 (for the date, cf. Della Valle, *op. cit.*, II, 1785, p. 32) which are now in the Biblioteca Comunale at Siena (probably Cod. L. IV. 13 and 14); the texts given by the writers listed above differ, and the confusion is considerable. If anyone should wish to squeeze some further amusement out of the matter he will not only have to transcribe the Landi MSS. directly and faithfully (Nos. ii-vi collectively prevent one from finding out what Landi really wrote), but will also have to publish the version added to Cod. Palat. 597 (our MS. No. II), which, having been probably written before the publication of Ugurgieri's *Le Pompe Sanesi*, may claim to be the earliest text yet recorded of this curiosity; it has moreover (we need hardly say) certain variants from all the others!

[153] The text of the *Denunzia*, to which the date 1531 is given here, begins as follows on the fourth page from the end of the MS.: "Dinanzi à voi spettabili Cittadini sopra lo fare la lira vi si dice p[er] me M.º Gio: Ant.º Soddoma di Rivatero Sodoma . . ." It concludes on the next page "Sodoma Sodoma di Rivatero M.ro Sodoma." The annotator next inserts the note on Caravaggio referred to in note 16 of this Appendix, and then returns to Sodoma with an extract concerning him "nell'archivio." This runs "Magnificus Aeques Dñus Joannes Antonius de Bazis de Verzè pictor alias il Soddoma. Ser Baldassar Corti 1534" (for the document referred to, cf. R. H. H. Cust, *Bazzi*, 1906, pp. 4 and 332 f.). The annotator comments as follows on the penultimate page of the MS.: "Onde si hà dà notare che in q[ue]lle parole del notaro Corti dicendosi [apparently sic] dà Verze, e nella Denuntia che

the origin of Baldinucci's remarks,[154] and, though as a matter of fact it appears to have been added slightly later (not by the author himself[155]), it enables us to deduce that Mancini's *Trattato* was accessible to the Florentine writer in the first edition of the long version.

In the eighteenth century Monsignor Giovanni Bottari had access to Codex 231 of the Capponi Library (part of the Biblioteca Vaticana since 1746), and refers explicitly to this copy in his widely-read edition of Vasari's *Vite*.[156] Finally we must

fà alla lira dicendosi del Soddoma medesimo di Rivatero, che ciò sia p[er]che nel vero Rivatero sia il luogo suo nativo, e non il nome del Padre, come in tal senso si potrebbe prendere, e che conseguentemente Rivatero sia Castelletto ò Villaggio, e Verze sia la terra principale, sotto la q[ua]le sia rivatero già che il nome del Padre fù Jacomo come si esprime dalle parole del Corti.''

[154] The link between the passages quoted in notes 151 and 153 of this Appendix is reinforced by the fact that the exact words *di Rivatero* do not appear, as far as I am aware, in any of the other recorded versions of the *Denunzia*.

[155] Not only is this passage not in Mancini's handwriting, but the possibility that it might have been copied from a note by him seems to be excluded by the opening words on Sodoma (which Baldinucci must have read hastily without realizing their relevance in this connexion): "Parim.te si potrà mettere al suo luogo quanto qui di sotto si scriverà, q.le potrà servire di chiarezza à quanto si dice dall'Autore dell'opera, à favore, et in difesa del Soddoma . . .'' Moreover, as we have had occasion to observe (cf. note 77 of this Appendix, No. i), Mancini himself seems to have had no doubt at a relatively late date (*ca.* 1625) that Sodoma originated from Vercelli, and we cannot imagine why (in the event of his having discovered this material after that date) he should have added it to a provisional version of the *Trattato* which had by then been superseded by revised and improved editions—to which, as we have seen, he was actually in the habit of adding newly discovered information. That the additions on the last four pages of MS. No. II were however made at a very early date seems to be indicated by the fact that the "Vergelle" theory and the "Razzi" surname, first launched by Ugurgieri in 1649 (and of course known to Baldinucci, cf. note 151 of this Appendix), are entirely ignored by the writer; for the latter—being apparently well informed about Sienese affairs—would almost certainly have been familiar with *Le Pompe Sanesi* if it had been in existence at the time of writing. Additional support for this view of the dating seems to be provided by the mention of Teofilo Gallaccini (who died in 1641) having given the writer information about Caravaggio's pictures at Naples (cf. note 16 of this Appendix).

[156] In three volumes, published at Rome in 1759 (I and II) and 1760 (III); Cod. Capp. 231 is mentioned in note 1 of p. 681 of Vol. II. We note

mention Padre Guglielmo della Valle, the industrious historian of Sienese Art,[157] who was familiar with several Mancini manuscripts,[158] and gives us copious extracts from them;[159] in this connexion Della Valle had an opportunity to consider their reliability as a source, and was the first writer to draw attention in some detail to Mancini's limitations in the matter of strict factual accuracy[160]—a topic to which some reference should be made before concluding.

* * *

with amusement that this did not escape the eagle eye of Pierre-Jean Mariette, who wrote to Bottari for further information about Mancini (*Raccolta di Lettere sulla Pittura*, IV, Rome, 1764, p. 350, letter of 18 November 1759).

[157] Guglielmo della Valle, *Lettere Sanesi . . . sopra le Belle Arti*; I, Venice, 1782; II, Rome, 1785; III, Rome, 1786.

[158] For the MSS. known to Della Valle, cf. his *Lettere Sanesi* (especially I, p. 282, and III, p. 248), and G. Campori, *Lettere Artistiche*, Modena, 1866, pp. 241 f.

[159] The student of Mancini will find a quantity of miscellaneous material scattered here and there throughout the *Lettere Sanesi*; Della Valle's quotations are of course chosen for their bearing on Sienese Art in particular.

[160] The following three examples of Della Valle's views on Mancini may be quoted. "Non si può negare, che egli [Mancini] non isparga de' lumi sopra la storia patria in questo genere. Egli conobbe molti artisti di merito in Roma, e fù con loro in amicizia strettamente congiunto. Ma egli mostrasi appertamente nemico di Vasari, e del Lomazzo, e se la prende contro di essi più d'una volta a torto. Si desidera ne' suoi scritti l'esattezza, e la critica" (II, p. 26); "Veramente la conseguenza, che il Mancini deduce da queste premesse, viene troppo di lontano: egli sarà sempre poco creduto, scrivendo così alla buona, e non curandosi di studiare gli Autori nelle opere loro, e di raccoglierne il merito dell'esatte, ed imparziali osservazioni fatte sopra di esse più, che sopra gli scritti altrui" (II, p. 116); "Quantunque in questo trattato del Mancini vi sia meno sostanza, che parole, e più di animosità, che di critica, pure ho giudicato bene servirmene, perchè riscontrando le cose di esso lui dette, trovo che hanno per lo più un fondamento di verità, e altronde queste cose sono così mal digerite, che togliendo parte delle parole, si verrebbe a rendere vieppiù oscura la verità, che pure si vede a traverso di esse" (III, p. 183). Della Valle greatly admires Vasari (without supposing that he is invariably accurate!), and understandably resents the rather petty criticisms of him in which Mancini is inclined to indulge.

We are concerned here with the actual manuscripts rather than with the man behind them. However, though a full discussion of Mancini himself as an informant would be out of place, it may be proper to add a few words of warning on the subject. Thoroughness and reliability cannot be counted among Mancini's virtues; his methods are slipshod and he often plays fast and loose with facts. Among his more spectacular blunders was his attribution to Giotto of the frescoes in San Clemente at Rome.[161] The origin of this was doubtless (as so often) eagerness to find fault with Vasari; but his assertion acquired unmerited weight as a result of the supporting "evidence" which he adduced of an inscription which, though existing in the Church, was not properly to be related to the frescoes at all.[162] Unfortunately the attribution was given publicity by Baldinucci,[163] and, though categorically denied by Bottari,[164] continued to be a subject for argument until the last century. Even when dealing with contemporary painters—for whom he is undoubtedly a useful source—Mancini is not necessarily accurate. For example, he was personally acquainted with all three Carracci,[165] and yet describes them in one passage as the three brothers;[166] however, he very typically makes amends for this lapse elsewhere by implying that they had not the same father

[161] Cf. MS. No. III, fol. 19 verso f. and 121 recto f.

[162] Cf. comment by Theodor Schreiber on p. 108 of the article cited in note 5 of this Appendix. For another example of Mancini's misplaced zeal in "refuting" Vasari, cf. note 85 of this Appendix (denial of the attribution to Cavallini of the frescoes in Santa Cecilia).

[163] Filippo Baldinucci, *Notizie de' Professori del Disegno* [III, covering 1400-1550,] Florence, 1728, p. 80 (life of Masaccio).

[164] Cf. Monsignor Giovanni Bottari's note on p. 238 of Vol. I (Rome, 1759) of his edition of Vasari's *Vite* (life of Masaccio).

[165] For Agostino, cf. note 36 of Part I; for Lodovico, cf. p. 311 above; and for Annibale, cf. MS. No. III, fol. 66 verso (the essence quoted by Della Valle, *Lettere Sanesi*, III, p. 218) and fol. 37 recto f. (referred to by Baldinucci, *Notizie*, [III, covering 1400-1550,] 1728, p. 229, and quoted by Della Valle, *op. cit.*, III, p. 243, with the misreading of *nro* [nostro] for *mro* [maestro] apparently originating from f. 62 r. of MS. No. Vв).

[166] This appears in MS. No. II (p. 241), reappears without correction in Nos. III (f. 145 r.) and IV (f. 58 r.), and is therefore copied in No. Vа (f. 84 r.).

after all!¹⁶⁷ He contrives to produce an extraordinary muddle
over *Baldassarre da Bologna* (Baldassare Croce), who is recorded
as having died full of years and having been buried in the
Pantheon.¹⁶⁸ In actual fact Croce was still alive when this
passage was written,¹⁶⁹ and was buried in 1628 in Santa Maria
in Via;¹⁷⁰ Mancini's apparently circumstantial statement about
the tomb seems to have been the result of a mental association
between the Pantheon and the tomb of an artist called Baldas-
sare, since the building does of course contain that of Baldassare
Peruzzi. It is entirely characteristic of him that, having been
enlightened about Guercino's real identity, he failed to strike
out the old *Vita* after writing the new one, so that both the false
and the correct appear in different parts of the same treatise,
and are copied and re-copied.¹⁷¹ He is quite unmethodical
when making additions to his work: on learning about Giovanni
da San Giovanni's frescoes in the Santi Quattro Coronati he
adds a note concerning them to the *Vita* of that artist in the
Trattato,¹⁷² but omits to do likewise in the passage on the
Church in the *Viaggio*.¹⁷³ He does not appear to have read
through his text systematically with a view to reconciling it
with his written sources and eliminating the inconsistencies
within his own work.¹⁷⁴ In short, when we use Mancini as a
source for factual information it is desirable to bear in mind

¹⁶⁷ Cf. MS. No. III (f. 54 r.) : ". . . i lor Padri venner' di Cremona e furon
2 fr[at]elli sartori . . . Del p.º ne nacque Ludovico . . ." (copied in Nos. Vᴀ,
f. 195 r., and Vʙ, f. 85 r.).

¹⁶⁸ Cf. MS. No. III (f. 53 v.) : ". . . morse di grave età e dall'Accademia de
i Pittori gli fù data honorata sepultura nella Ritonda" (copied by No. Vᴀ,
f. 194 v., but No. Vʙ, f. 84 v., omits *morse di grave età*). I am indebted to
Dr. Jacob Hess for drawing my attention to this example of Mancini in one
of his more reckless moments.

¹⁶⁹ In MS. No. III it is part of the main text and is in the handwriting of
the scribe.

¹⁷⁰ Cf. Thieme-Becker, *Künstlerlexikon*, VIII, 1913, p. 138, and Baglione,
Vite, 1642, p. 199 (299).

¹⁷¹ Cf. note 40 of Part I, and p. 311 above.

¹⁷² Cf. note 89 of this Appendix (example No. iii).

¹⁷³ MS. No. III, f. 183 recto f. (ed. Schudt, pp. 69 f.).

¹⁷⁴ As an example of the small inconsistencies which abound, one might
cite Mancini's description of Caravaggio's style (*colorire*) as "seguito adesso

the sort of failings which have been summarized here. Nonetheless it remains true that, in spite of this qualification, he has much interesting material to offer us.

Yet it would be wrong to classify Mancini as a "historian"—in the restricted sense of a mere recorder of facts—and to criticize him on such a basis. Though he was always glad, for reasons of *campanilismo*, to find (as he thought) some opportunity for accusing Vasari of an error of fact, he was not primarily concerned with factual accuracy for its own sake. What really interested him were pictures and artists: pictures to enjoy, to handle, to speculate about (and indeed to speculate with[175]), and the lives, personalities and fortunes of artists.[176] He is in fact an early example of the lay enthusiast, the *dilettante* who

assai communem.te" (MS. No. III, f. 59 r.) against the statement elsewhere (cf. note 172 of Part I) that his manner "*era* communem.te seguitata" when Honthorst arrived in Rome (my italics). The question as to which of the two passages is to be accorded the greatest weight is obviously a matter for individual interpretation. Personally I prefer the second. The first is of course correct as far as it goes, but the second takes us a stage further; to record the mere existence of an important contemporary artistic movement is easy, but to realize that it is beginning to lose ground to other trends is a different matter.

[175] Mancini's successful picture-dealing activities are referred to by Giovanni Vittorio Rossi in a passage which slyly records how he kept his eyes open for paintings when visiting patients (*Iani Nicii Erythraei Pinacotheca Altera*, Cologne, 1645, p. 81): "Sed in primis oculos per cubiculum circumferebat, &, si quam ibi egregie pictam tabulam aspexisset, continuo adamabat; nam erat rerum istarum intelligentissimus; dabatque operam, ut in suam potestatem perveniret. neque id sibi erat difficile impetrare ab eo, qui suam ipsi salutem vitamque commiserat: ab aliis eas tabulas quam minimo emebat, ut carissime venderet: atque, in hoc genere mercimonii, magno cum lucro vortebatur."

[176] Mancini's propensity for anecdotes and personal gossip is apt to lead him astray when he has no first-hand knowledge of the artist concerned. But when he deals with his contemporaries we get some pleasing little vignettes which strike a genuine note. For example, Gerard the Fleming (Honthorst) is very reserved, but is well-mannered and courteous when one goes to see him in his studio. He is prepared to show visitors his paintings and does not mind working in their presence. His prices are high, but he allows a reasonable margin for the dealers, who can find a ready sale for his type of work. For their part they like doing business with him, since he is a man of his word who can be trusted to deliver a painting on the date promised —"proprietà," Mancini drily observes, "non così commune à i Pittori."

discovers that there is more in painting than meets the average layman's eye. Though his idea of instructing the gentleman to "say the right thing" strikes a somewhat artificial note,[177] Mancini was certainly not without genuine artistic feeling. He seems to have become a judge of pictures in the sense of a *connoisseur*,[178] and we may appropriately take our leave of him by quoting his little discourse on the distinguishing of copies and fakes from originals:

[MS. No. III, fol. 161 verso] ". . . alle volte avviene, che son tanto ben' imitate che è difficil riconoscerle aggiontovi, che q.ti che le voglion vendere p[er] originarie l'affumano con il fumo di paglia molle che così nella pittura introduce una certa scorza simil à q[ue]lla che gl'induce il tempo et così paiono antiche, levandogli quel color acceso e risentito della novità e recenza; oltre che per coprir più l'inganno piglian delle tavole vecchie, e sopra d'esse vi lavorano. Con tuttociò chi hà pratica scopre tutti q.ti inganni; prima se nella pittura proposta vi sia quella p[er]fettione con laquale operava l'artefice, sotto nome del quale vien proposta, e venduta, di più se vi si veda quella franchezza del mastro, et in particolar in quelle parti, che di necessità si fanno di risolutione, ne si possono ben condurre con l'imitatione, come sono in part.re i capelli, la barba, gl'occhi, che l'anellar de capelli quando si

[177] Cf. the title to Part I of the *Trattato* (quoted in note 20 of this Appendix).

[178] A medical colleague of Mancini's in Rome, writing in 1628, describes him (in what is probably partly an allusion to his activities in the artistic field) as "liberalium plurium . . . artium non tam amator, quàm exactissimus iudex & aestimator" (cf. *The Burlington Magazine*, LXXXVIII, 1946, p. 18, note 38). As we have seen (p. 303 above), another art in which Mancini was interested was that of the dance; in this connexion we may refer to an interesting passage at the end of Part I of the *Trattato* in which he says he has not made more than a cursory reference to *espression d'affetto* in painting "perche di q.º s'è trattato più à longo in q[ue]lla pò di consideratione, che p[er] spasso in gioventù feci del ballo, che venendo all'Immitation et espression d'attione et affetto, che è il fin del ballo s'è considerato i requisiti di quest'imitatione, et così in q.º proposito dell'affetto pittoresco s'è detto sol'alcune cose p[er] transito . . ." (MS. No. III, fol. 173 recto). For the *affetti*, cf. also above, p. 150.

hanno da imitare si fanno con stento, che nella copia poi apparisce et se il copiatore non li vol imitare all'hora non hanno la p[er]fettion di mastro e q.^te parti nella pittura sono come i tratti e gruppi nella scrittura, che vogliono q[ue]lla franchezza e risolutione di mastro. Il med.^mo ancor si deve osservare in alcuni [fol. 162 recto] spiriti e botte di lumi à luogo à luogo, che dal mastro vengon posti à un tratto e con risolution d'una pennellata non imitabile cosi nelle pieghe de panni e lor lume, quali pendono più dalla fantasia e risolution del mastro, che della verità della cosa posta in essere."

This bespeaks a man who has had practical experience of making up his mind in such matters.

INDEX

INDEX

Abate, Niccolò dell', 176, 208-211 (sonnet in praise of, published by Malvasia over Agostino Carracci's name), 212, 225.

Abbate, Carlo, 210.

Abbate, Nicolò, 210.

"Academic," 5, 155, 157-160, 181, 191, 195, 228.

Académie de France à Rome, 185.

Académie Royale de Peinture et de Sculpture (Paris), its close connexions with the Accademia di San Luca in the second half of the Seicento, 185 f.; contrast between it and the Accademia di San Luca of Zuccaro's day, 187 f., and that of Bellori's day, 188 f.; miscellaneous, 151 f., 181, 196 f., 206.

Accademia Clementina (Bologna), 232.

Accademia del Disegno (Florence), 162.

Accademia degli Incamminati del Disegno (Bologna, the Carracci Academy), 136, 200, 228 f., 249, 251.

Accademia degli Innominati (Parma), 162, 166, 180.

Accademia degli Insensati (Perugia), 162.

Accademia dei Gelati (Bologna), 136.

Accademia di San Luca (Rome), its early days chronicled by Romano Alberti, 157 f.; aims and character of Federico Zuccaro, the moving spirit in its first active year, 161-166, an account of which follows, 166-172; many of Zuccaro's fellow members (e.g., Giacomo della Porta, Taddeo Landini, Giuseppe d'Arpino, Giovanni Battista Navarra) failed to speak, 167 ff., while Giovanni Coscia's lecture was not his own work, 169 f.; Cristoforo Roncalli does speak, but is evidently uninfluenced by Zuccaro's theories, 170 f.; collapse of Zuccaro's attempt to establish theoretical discussion as a regular feature of the Accademia, 171 f.; Romano Alberti's comments on this, 172; lectures on theory were not revived in the five years following Zuccaro's presidency, 173-175; summary of the situation by Romano Alberti, 175 f.; our own conclusion, Zuccaro is not to be regarded as synonymous with the Accademia, 176; the Accademia in the second half of the Seicento, 184-186, 188-190; activities of Bellori (who introduced classic-idealist theory into the Accademia), and close relations with Paris, 184 ff.; differences from Paris, 188 f.; miscellaneous, 42, 152, 155-191 (Part III, *passim*), 196, 229.

Acerbi, Giacomo Antonio, 27.

Affetti, 124, 148-151, 171, 257, 271 f., 274, 330.

Aglaophon, of Thasos, 241.

Agostini, Leonardo, 237 f.

Agucchi, Annibale, 118.

Agucchi, Federico, 118.

Agucchi (Agucchia, Agocchi, etc.), Monsignor Giovanni Battista (see also under "*Trattato*, Agucchi's"), his connexion with the Ludovisi family, and his high opinion of Domenichino, 60 f.; mentions Guercino in a letter, 61; appointed *Segretario di Stato* by Gregory XV, 61; summary of his idealist theory of artistic excellence, 62 f.; its close relationship to classic art, 64 f. (and cf. 118); its less favourable attitude towards Caravaggio, who is compared with Demetrios, 65, 257; its possible application to the style of the young Guercino, 66, 73; its probable sympathy for "history" treated in the manner of Annibale Carracci, 73 f.; Agucchi's standpoint in any encounter with Guercino, 74 f.; possibility of his comments being reflected in Guercino's *S. Petronilla*, 90 ff.; biographical particulars of Agucchi, his connexion with the Aldobrandini family, 111 f.; his literary pseudonym, Gratiadio Machati, 113, 239 f.; his writings on painting, 113 f.; his association with the Carracci, 114-117; his *Trattato* not attributable to Annibale, 116 f., but the possibility of Domenichino's participation in it merits further consideration, 117 ff.; some of his letters published by Malvasia show that he discussed artistic matters with Domenichino (and at the same time bear witness to his respect for classical antiquity), 118; his association with Domenichino as recorded by Bellori and in one of Domenichino's letters, 119,

ILLUSTRATIONS

Figs. 1, 9, 13, 14, 15, 21, 22, 23, 24, 25, 29, 31, 35, 36, 39, and 41 are from photographs by Anderson of Rome.

Figs. 2, 6, 12 and 38 are from photographs by Alinari of Florence.

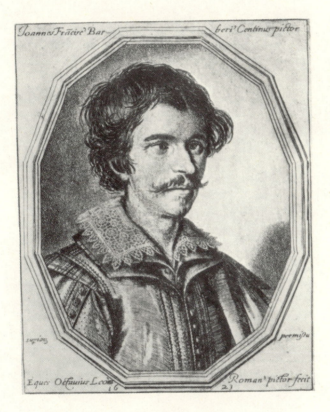

Portrait of Guercino, by Ottavio Leoni, dated 1623.

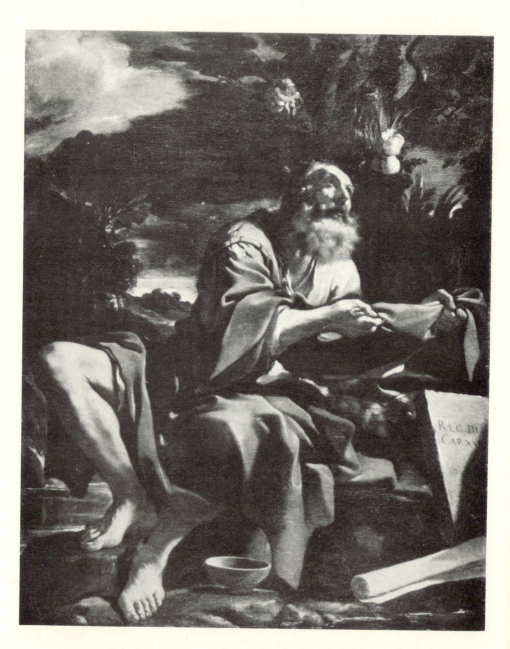

1. Guercino: "Elijah fed by Ravens." (London, private collection.)

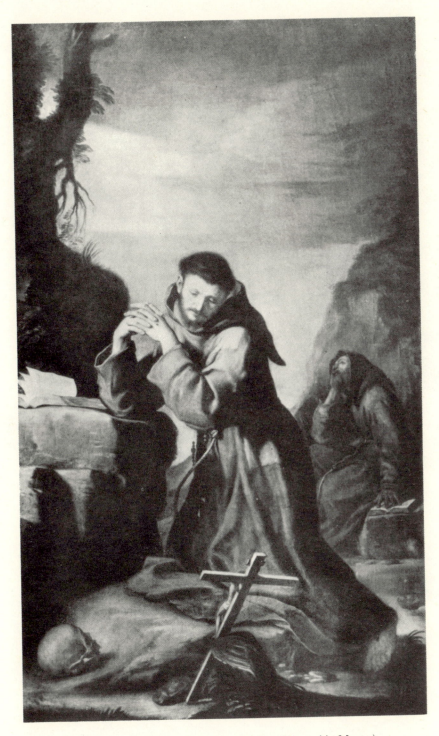

2. Guercino: "S. Francis." (Bologna, San Giovanni in Monte.)

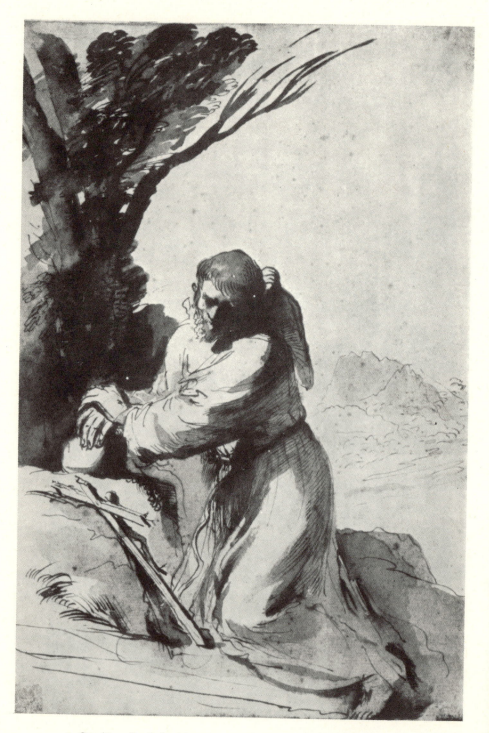

3. Guercino: Study for "S. Francis." (Windsor Castle, Royal Library.)

By Gracious Permission of H.M. The King.

4. Guercino: Detail of "S. William receiving the Habit." (Bologna, Pinacoteca.)

5. Guercino: "S. William receiving the Habit." (Bologna, Pinacoteca.)

6. Guercino: "The Purification of the Virgin." (Ferrara, Santa Maria della Pietà de'
Teatini.)

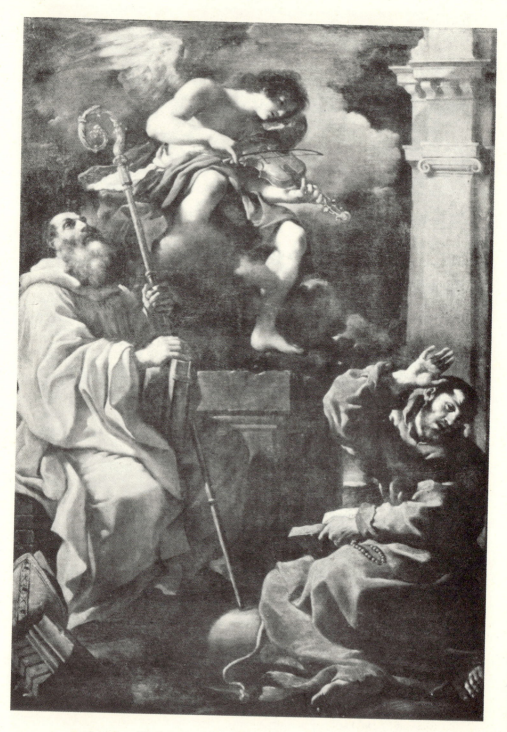

7. Guercino: "S. Benedict and S. Francis with an Angel." (Paris, Louvre.)

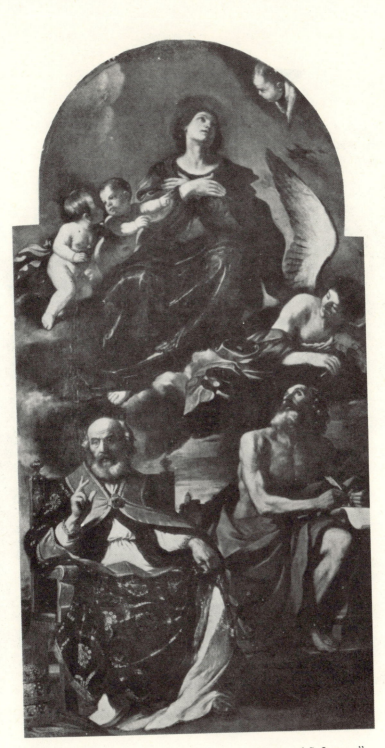

8. Guercino: "Assumption with S. Peter as Pope and S. Jerome."
(Reggio nell'Emilia, Cattedrale.)

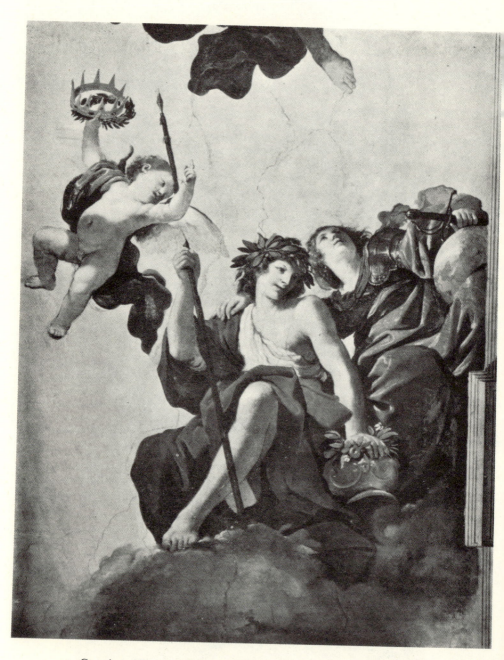

9. Guercino: Allegorical Group, detail of "Fame." (Rome, Casino Ludovisi.)

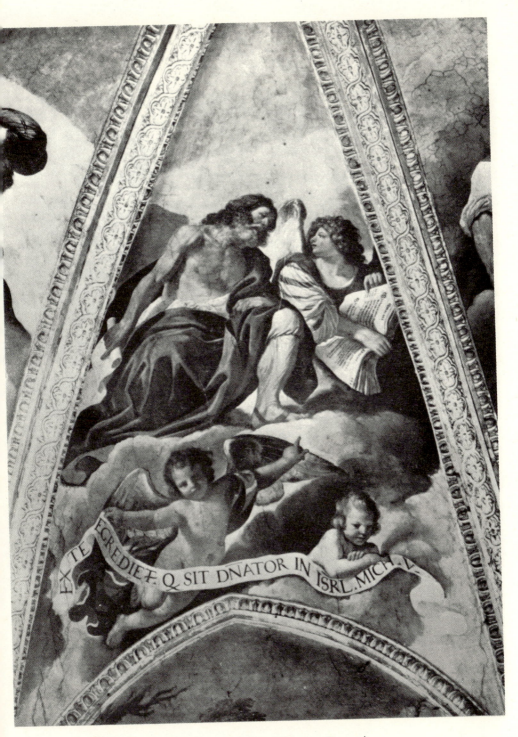

10. Guercino: "Micah." (Piacenza, Duomo.)

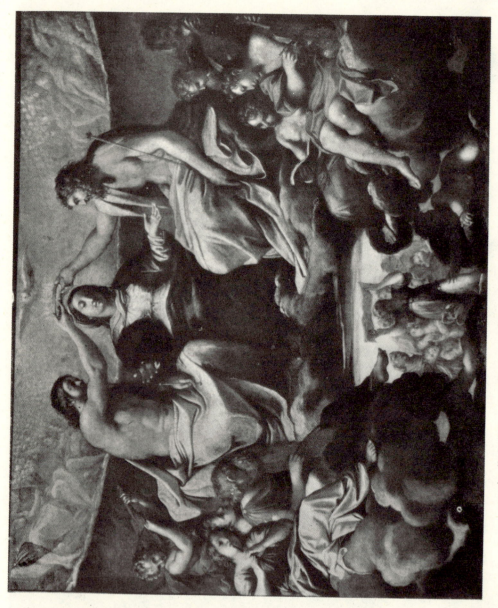

11. Annibale Carracci: "Coronation of the Virgin." (London, private collection)

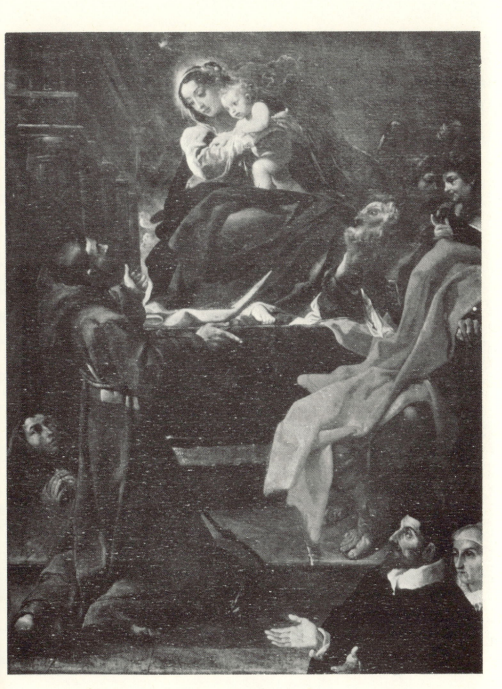

12. Lodovico Carracci: "The Holy Family with S. Francis and Donors." (Cento, Pinacoteca.)

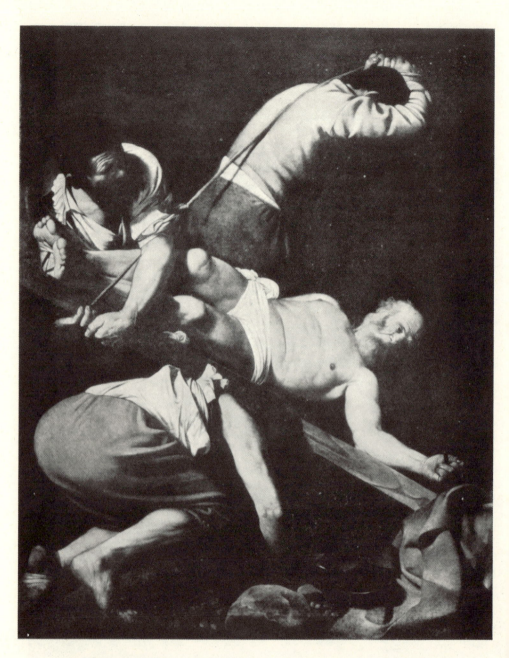

13. Caravaggio: "Martyrdom of S. Peter." (Rome, Santa Maria del Popolo.)

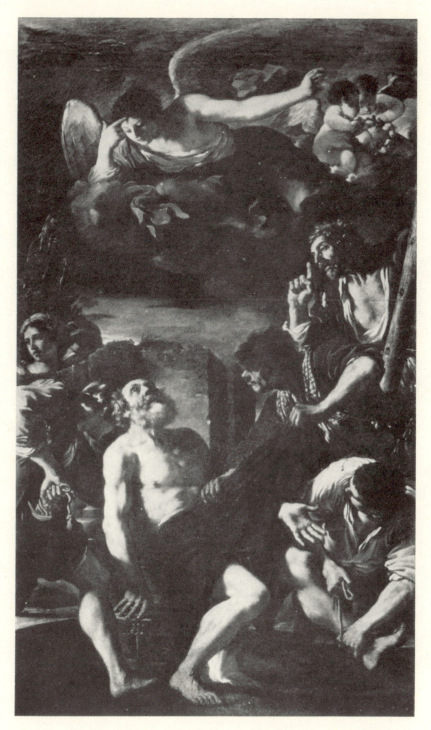

14. Guercino: "Martyrdom of S. Peter." (Modena, Galleria Estense.)

15. Guercino: "Day." (Rome, Casino Ludovisi.)

16. Guercino: Study for "S. Michael." (Waltham Abbey; collection of Sir Thomas Fowell Buxton, Bart., at Woodredon.)

17. Guido Reni: "Europa and the Bull." (London, private collection.)

18. Guercino: "S. Michael." (Fabriano, San Nicolò.)

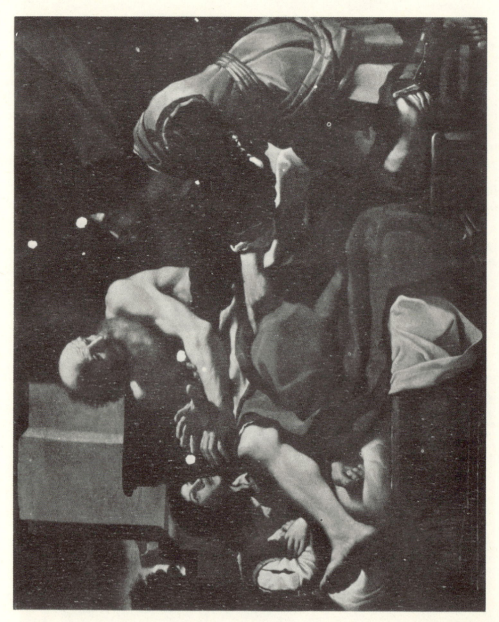

19. Guercino: "Jacob blessing the Sons of Joseph." (London, private collection.)

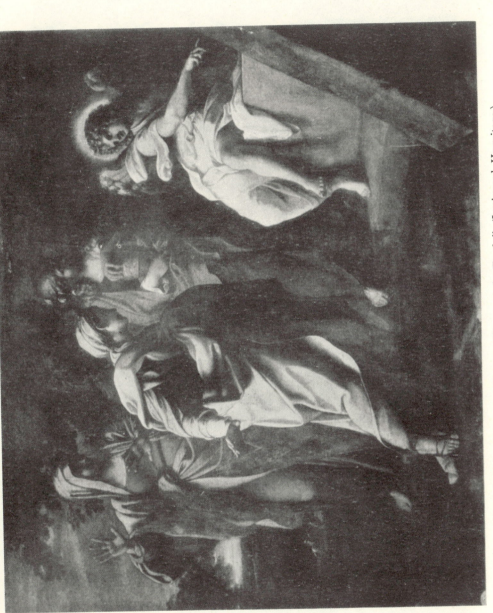

20. Annibale Carracci: "The Holy Women at the Tomb." (Leningrad, Hermitage.)

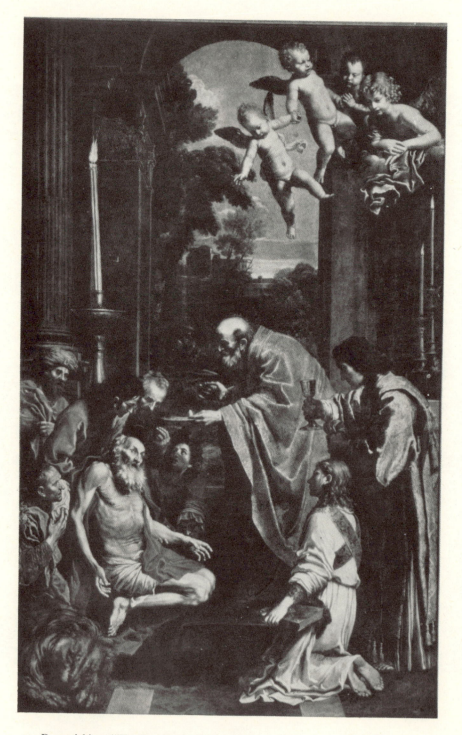

21. Domenichino: "The Communion of S. Jerome." (Rome, Pinacoteca Vaticana.)

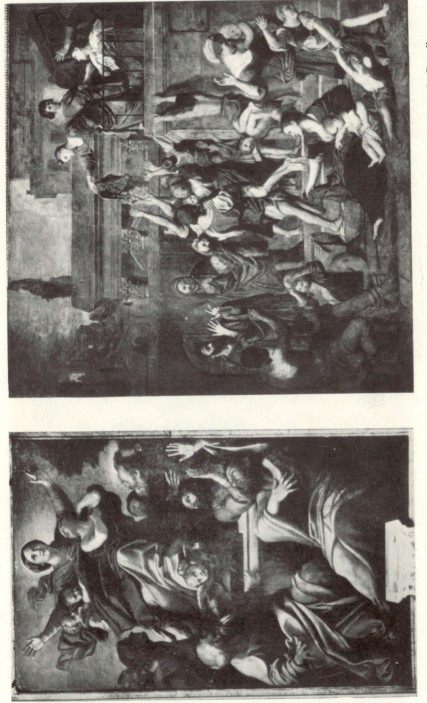

23. Domenichino: "S. Cecilia distributing Clothes to the Poor."
(Rome, San Luigi dei Francesi.)

22. Annibale Carracci: "Assumption of the Virgin."
(Rome, Santa Maria del Popolo.)

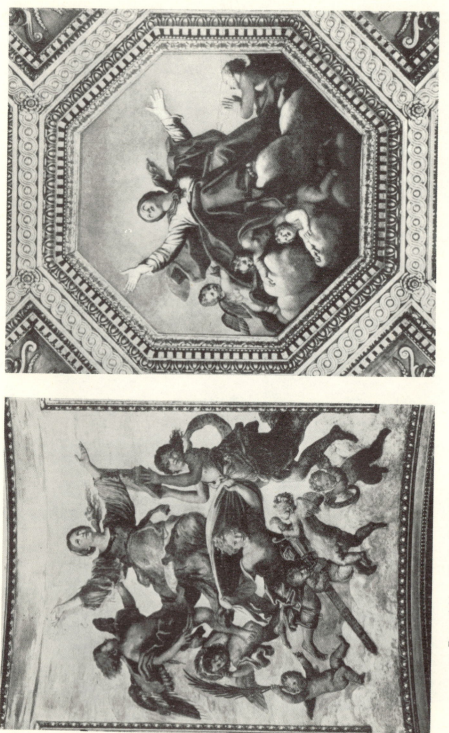

25. Domenichino: "*Assumption of the Virgin.*"
(Rome, Santa Maria in Trastevere.)

24. Domenichino: "*S. Cecilia in Glory.*"
(Rome, San Luigi dei Francesi.)

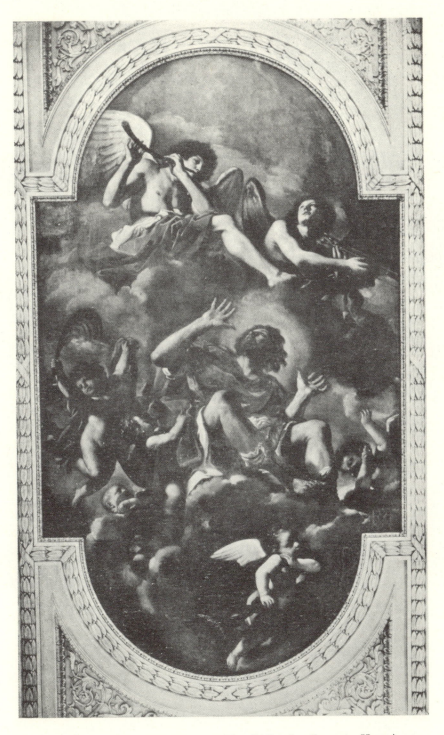

26. Guercino: "S. Chrysogonus in Glory." (London, Lancaster House.)

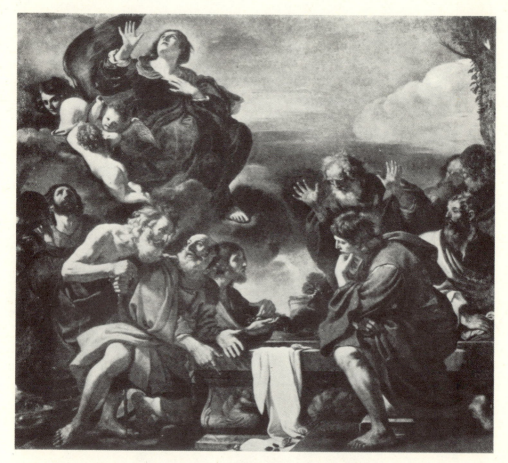

27. Guercino: "Assumption of the Virgin." (Leningrad, Hermitage.)

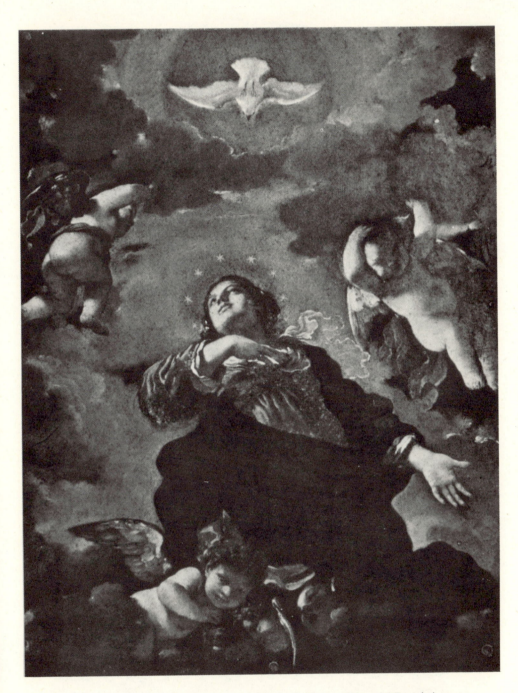

28. Guercino: "Assumption of the Virgin." (Cento, Chiesa del Rosario.)

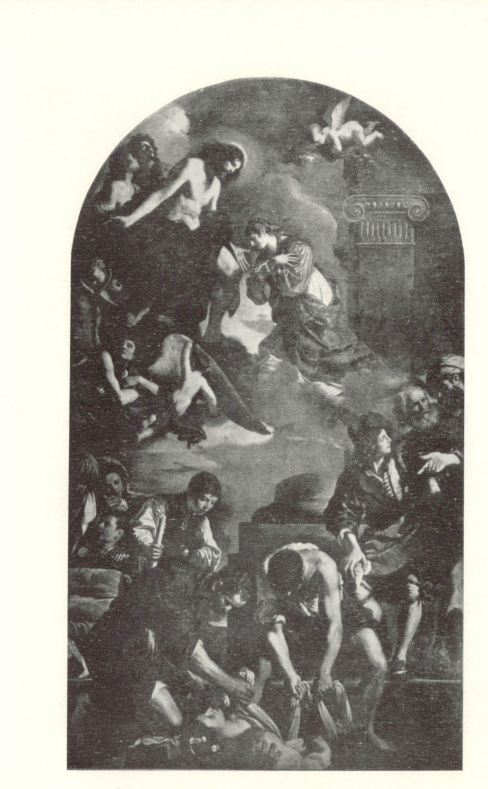

29. Guercino: "The Burial and Reception into Heaven of S. Petronilla."
(Rome, Galleria Capitolina.)

30. Guercino: Detail of "S. Chrysogonus."
(London, Lancaster House.)

31. Guercino: Detail of "S. Petronilla." (Rome, Galleria Capitolina.)

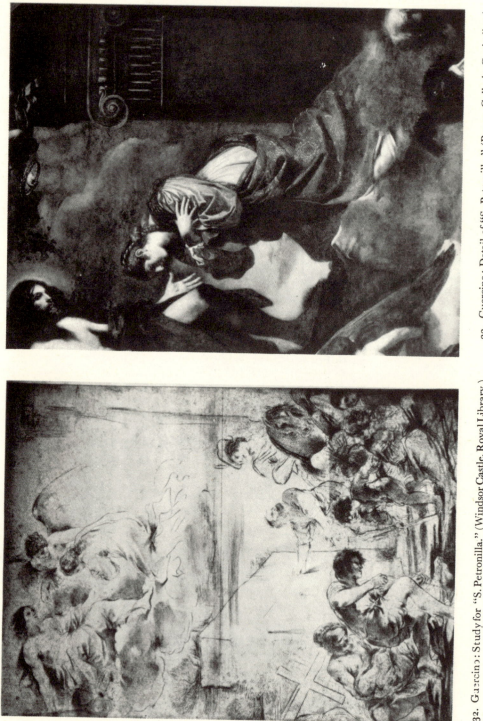

33. Guercino: Detail of "S. Petronilla." (Rome, Galleria Capitolina.)

32. Guercino: Study for "S. Petronilla." (Windsor Castle, Royal Library.)
By Gracious Permission of H.M. The King.

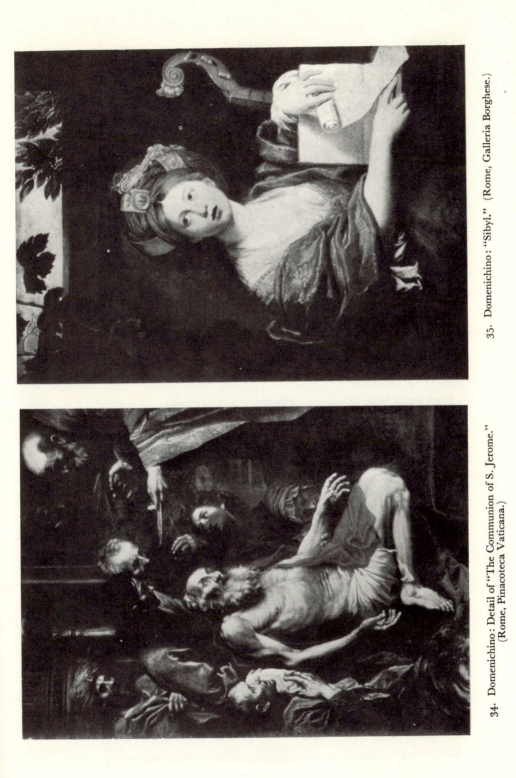

35. Domenichino: "Sibyl." (Rome, Galleria Borghese.)

34. Domenichino: Detail of "The Communion of S. Jerome." (Rome, Pinacoteca Vaticana.)

37. Guercino: "Presentation in the Temple."
(Sussex, Ashburnham Place.)

36. Domenichino: "Death of S. Cecilia."
(Rome, San Luigi dei Francesi.)

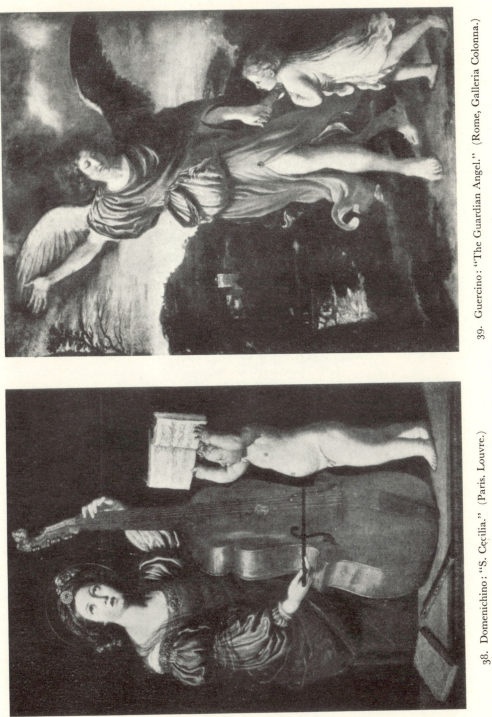

39. Guercino: "The Guardian Angel." (Rome, Galleria Colonna.)

38. Domenichino: "S. Cecilia." (Paris. Louvre.)

40. Domenichino: "S. Agnes." (London,
Hampton Court Palace.)
By Gracious Permission of H.M. The King.

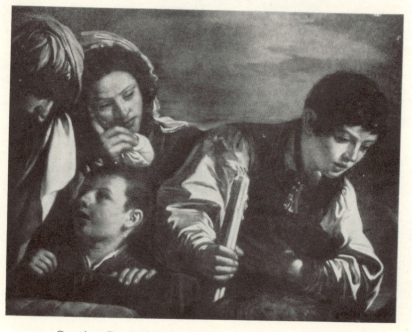

41. Guercino: Detail of "S. Petronilla." (Rome, Galleria Capitolina.)

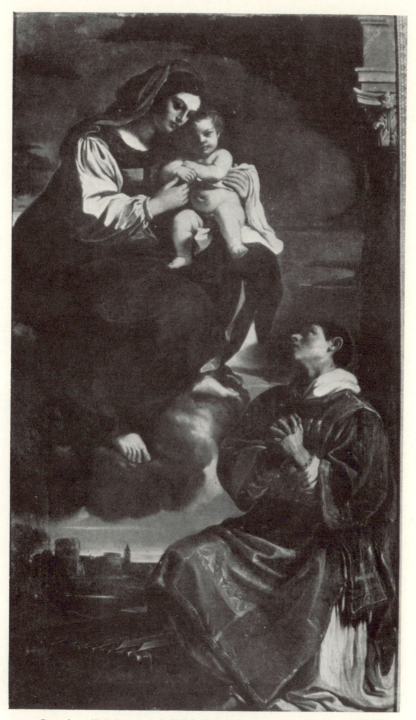

42. Guercino: "Madonna and Child with S. Lawrence." (Finale nell'Emilia, Chiesa del Seminario Arcivescovile.)

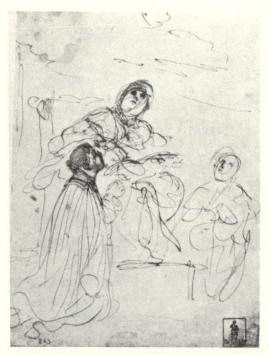

43. Guercino: Study for "SS. Gregory, Ignatius Loyola and Francis Xavier." (Rome, private collection.)

44. Guercino: Detail of "Madonna and Child with S. Lawrence." (Finale nell'Emilia, Chiesa del Seminario Arcivescovile.)

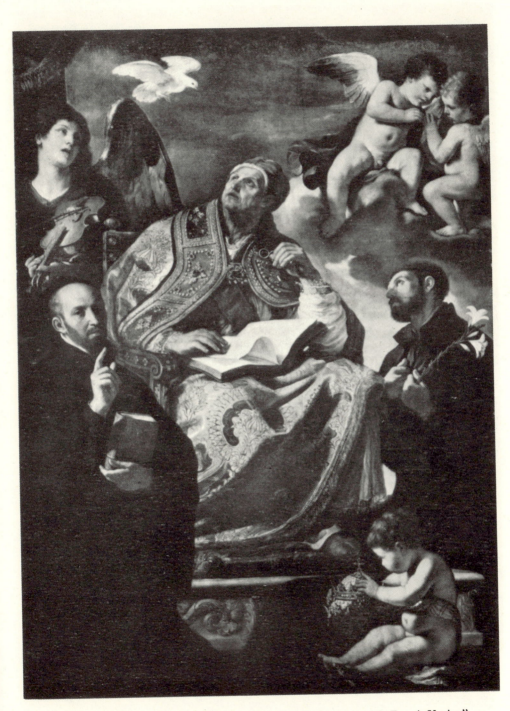

45. Guercino: "S. Gregory the Great with S. Ignatius Loyola and S. Francis Xavier."
(London, private collection.)

46. Guercino: Detail of "Venus bewailing the Death of Adonis."
(Dresden, Staatliche Gemäldegalerie.)

47. Guercino: Detail of "Elijah fed by Ravens." (London, private collection.)

48. Guercino: Detail of "SS. Gregory, Ignatius Loyola and Francis Xavier."
(London, private collection.)